THE
EVERLASTING
BLOOM

REDISCOVERING
TAIWANESE MODERN ART

不朽的青春

臺灣美術再發現

永劫不死的方法只有一個，就是精神上的不朽。
至少對我們藝術家而言，只要用血汗創作而成的作品還沒有被
完全毀滅之前，我們是不會死的。

黃土水，〈出生於臺灣〉, 1922

There is only one method to become immortal,
and that is through spiritual immortality.
At least for us artists, as long as the works
made with our sweat and blood are not obliterated, we will not die.

Huang Tu-Shui, "Born in Taiwan," 1922

不朽的青春——臺灣美術再發現
展期｜2020.10.17-2021.01.17
地點｜MoNTUE北師美術館

指導單位｜文化部
主辦單位｜國立臺北教育大學北師美術館、財團法人福祿文化基金會
協辦單位｜山口縣立美術館、台陽畫廊、台灣50美術館、呂雲麟紀念美
　　　　　術館、李石樵美術館、李梅樹紀念館、李澤藩美術館、防府
　　　　　市、松本市美術館、河上洲美術文物、林之助紀念館、長
　　　　　流美術館、阿波羅畫廊、南畫廊、屏東縣政府、秋惠文庫、
　　　　　財團法人陳進紀念文化藝術基金會、國立臺中教育大學、
　　　　　國立臺灣工藝研究發展中心、國立臺灣美術館、國立臺灣博
　　　　　物館、寄暢園、郭雪湖基金會、福岡亞洲美術館、臺北市立
　　　　　太平國小、臺北市立太平國小校友會、臺北市立美術館
　　　　　(依單位首字筆畫順序排列)
合作單位｜財團法人福祿文化基金會北投文物館、財團法人公共電視文
　　　　　化事業基金會
贊助單位｜美術館之友聯誼會
設備支援｜SENNHEISER 森海塞爾
媒體協力｜TAAZE讀冊生活網路書店、志祺七七 X 圖文不符、典藏
　　　　　ARTouch.com、非池中藝術網 、故事StoryStudio
活動協力｜或者書店

開放時間｜週二至週日10:00–18:00，週一及國定例假日休館
地址｜臺北市大安區和平東路二段134號
電話｜+886 2 2732-1104 #63492、#83401

The Everlasting Bloom: Rediscovering Taiwanese Modern Art
Date｜2020.10.17-2021.01.17
Venue｜MoNTUE, Museum of National Taipei University of Education

Supervisor｜Ministry of Culture
Organizers｜Museum of National Taipei University of Education
　　　　　　Fu Lu Culture Foundation
Co-Organizers｜Apollo Art Gallery, Chan Liu Art Museum, CHEN Chin Art
　　　　　and Culture Memorial Foundation, Chi Chang Yuan, Formosa
　　　　　Vintage Museum, Fukuoka Asian Art Museum, Heshangzhou
　　　　　Arts & Antiques, Hofu City, Kuo Hsueh-Hu Foundation, Lee
　　　　　Tze-Fan Memorial Art Gallery, Li Mei-Shu Memorial Gallery,
　　　　　Li Shih-Chiao Art Gallery, Lin Chi-Chu Memorial, Lu Yun-
　　　　　Lin Memorial Art Museum, Matsumoto City Museum of
　　　　　Art, Museum 50 of Taiwan, Nan Gallery, National Taichung
　　　　　University of Education, National Taiwan Museum of Fine
　　　　　Arts, National Taiwan Craft Research and Development
　　　　　Institute, National Taiwan Museum, Pingtung County
　　　　　Government, Taipei Fine Arts Museum, Taipei Municipal
　　　　　Taiping Elementary School, Taipei Municipal Taiping
　　　　　Elementary School Alumni Association, Taiyang Gallery,
　　　　　Yamaguchi Prefectural Art Museum (in alphabetical order)
Collaboration Partner｜Beitou Musuem of Fu Lu Culture Foundation
　　　　　　Taiwan Public Television Service Foundation
Sponsor｜Museum Friends Association
Equipment Support｜SENNHEISER
Media Partners｜Art Emperor, ARTouch.com, Simple Info, StoryStudio Inc.,
　　　　　　TAAZE
Event Partners｜Or Book Store

Opening Hours｜Tuesday to Sunday 10:00–18:00. Closed on Monday &
National Holidays
Address｜No. 134, Sec.2, Heping E. Rd., Da'an Dist., Taipei, Taiwan
Phone｜+886 2 2732-1104 #63492、#83401

藝術家

丸山晚霞、河合新藏、藤島武二、呂璧松、石川欽一郎、西鄉孤月、富田溪仙、那須雅城、小澤秋成、
川島理一郎、鹽月桃甫、鄉原古統、木下靜涯、梅原龍三郎、小原整、陳澄波、黃土水、山崎省三、
鮫島台器、呂鐵州、林克恭、郭柏川、廖繼春、李梅樹、顏水龍、藍蔭鼎、何德來、立石鐵臣、
陳植棋、陳進、楊三郎、李澤藩、林玉山、郭雪湖、李石樵、張萬傳、陳德旺、劉啟祥、陳清汾、
陳敬輝、洪瑞麟、張義雄、呂基正、鄭世璠、林之助、廖德政、蕭如松

（依出生年排序）

特別邀請｜藝術很有事、木漏類比

總策畫｜林曼麗
策展研究團隊｜顏娟英、蔡家丘、邱函妮、黃琪惠、楊淳嫻、張閔俞

Artists

MARUYAMA Banka, KAWAI Shinzo, FUJISHIMA Takeji, LU Pi-Sung, ISHIKAWA Kinichiro, SAIGO Kogetsu, TOMITA Keisen,
NASU Masaki, OZAWA Shusei, KAWASHIMA Riichiro, SHIOTSUKI Toho, GOBARA Koto, KINOSHITA Seigai, UMEHARA Ryuzaburo,
OHARA Hitoshi, CHEN Cheng-Po, HUANG Tu-Shui, YAMAZAKI Shozo, SAMEJIMA Taiki, LU Tieh-Chou, LIN Ko-Kung,
KUO Po-Chuan, LIAO Chi-Chun, LI Mei-Shu, YEN Shui-Long, RAN Yin-Ding, HO Te-Lai, TATEISHI Tetsuomi, CHEN Chih-Chi,
CHEN Chin, YANG San-Lang, LEE Tze-Fan, LIN Yu-Shan, KUO Hsueh-Hu, LI Shih-Chiao, CHANG Wan-Chuan, CHEN Te-Wang,
LIU Chi-Hsiang, CHEN Ching-Fen, CHEN Jing-Hui, HUNG Rui-Lin, CHANG Yi-Hsiung, LU Chi-Cheng, CHENG Shih-Fan,
LIN Chih-Chu, LIAO Te-Cheng, HSIAO Ju-Sung（in year-of-birth order）
Documentary Special Collaboration｜Inside the Arts PTS Production Team, komorebi

Producer｜LIN Mun-Lee
Research and Curatorial Team｜YEN Chuan-Ying, TSAI Chia-Chiu, CHIU Han-Ni, HUANG Chi-Hui,
YANG Chun-Hsien, CHANG Min-Yu

序

從臺灣美術的再發現裡，
見證不朽的青春

「永劫不死的方法只有一個，就是精神上的不朽。至少對我們藝術家而言，只要用血汗創作而成的作品還沒有被完全毀滅之前，我們是不會死的。」

這段文字出自黃土水第二度入選東京帝展時所撰寫的創作感言〈出生在臺灣〉，1920年他成為入選帝展的首位臺灣籍藝術家時，還是個尚在東京美術學校修業的青年，但在這短短數語裡，不僅可以感受到彼時他對於創作的熱情，同時也托出了這位早慧的藝術家為自己所設下的終生目標。1930年因病逝世時，黃土水年僅三十六歲，時至今日，在喟嘆其過於短促的生命同時，我們也真實地體會到，他以自身的經歷證成了精神的不朽足以超越肉身的生命。

以「不朽的青春——臺灣美術再發現」為名的這個展覽，是一項重建臺灣美術史工程的成果展現。隨著臺灣社會與藝文生態的發展，產官學界對於臺灣美術史的關注的確與日俱增，然而卻也在相關過程裡，讓我們不斷意識到這其實是個持續在與時間賽跑的任務。因為覺察到在已入藏公立美術館且獲得良好保存的作品之外，其實還有許多珍貴的前輩藝術家作品散落於政府其他部門或民間，而持有者不一定有能力負擔專業的修復與典藏條件，致使它們處在持續劣化的狀態，為此，美術史學者顏娟英提出了一項研究計畫，期望能廣泛普查這些作品所在之處，並藉由研究、修護與展覽，讓它們得以重現在觀眾眼前。

此展中的第一個「再發現」，便是對於這些珍貴資產的積極覓尋，而在研究團隊的努力與相關人士的奧援下，也的確讓我們得以在這個展覽中與許多幾乎從未公開展示的重要作品重逢。例如黃土水於東京美術學校的卒業之作《少女》胸像，此前一直由其就讀與任教的臺北市太平國小所典藏，相距於此作完成的1920年，已近一個世紀的光陰，為了迎接這位「百歲少女」的現身，我們特別邀請到東京藝術大學森純一教授為其進行修復，期望讓觀眾真實地感受到藝術家曾賦予她的清純溫婉氣質。另一件在此前鮮少曝光的是林之助入選府展並獲得最高榮譽總督賞的作品《好日》，許多美術史研究者過去均僅能從圖錄中得見，此次在藝術家倪朝龍、林慧珍夫婦的積極促成下，順利獲得私人藏家慷慨借展。

這項再發現的工作亦遠至與臺灣美術史發展關係密切的日本，透過日方學者與多家機構的襄助，包括陳澄波受曾任臺灣總督的上山滿之進所委託繪製的《東臺灣臨海道路》；鹽月桃甫為了參與首屆臺府展所繪製的《萌芽》；以及深具傳奇色彩的日本藝術家西鄉孤月，早在1911年旅行至臺灣時所繪製的膠彩畫《臺灣風景》等，均將在睽違近百年之後於此展中重返故鄉。

正是在發掘這些重要作品的過程中，讓我們深刻感受到，雖然它們的風格與材質迥異，卻

有共通的意涵，那就是藝術家創作生命的本質。這也是為什麼在縝密的歷史爬梳之外，我們也想藉由此展，特別彰顯這個對於藝術創作本質的再發現，也就是對於藝術家而言，其創作生命的本質或意義便是追求精神的不朽，過去如此，現在如此，未來也將必然如此。

對我而言，這個展覽的發生有其脈絡，從任職臺北市立美術館館長時，我便高度關注臺灣美術史的梳理工作，並在2000年與日本靜岡縣立美術館共同執行「東亞油畫的誕生與開展」，同時期也與館內同仁策劃「臺灣東洋畫的探源」等兩個重要的展覽。後來在籌劃北師美術館創建時，也在創館的「序曲展」裡展開與東京藝術大學大學美術館的緊密合作，之後並策劃了「臺灣的近代美術—留學生們的青春群像（1895-1945）」於該館展出，同時並舉辦國際學術研討會，也因為這個展覽，而引發後續由東京藝術大學大學美術館主辦的「日本近代洋畫大展」在北師美術館展出。正是因為對臺灣美術史領域持續的參與，讓我深知顏娟英教授這項研究計畫的重要性與迫切性，便責無旁貸地全力協助，很高興能夠獲得財團法人福祿文化基金會張純明董事長的大力支持，讓這項研究計畫得以順利進行。

這個展覽之所以能夠實現，有著許多專業人士的投入，首先是研究團隊一年多來所獲致的豐富成果，緊接著是為使這些珍貴的發現能夠獲得最理想的呈現，北師美術館的館員所發揮策展的專業與執行力，公共電視「藝術很有事」節目更是主動參與，長期跟拍，美術館也企劃了作品修護的紀錄片，這所有的努力，都是期望能更為立體與深入地讓觀眾感知那些層次豐富的歷史與記憶。最後更要感謝文化部給予展覽經費的全面支持，讓我們能夠完善展覽所需的各項重要條件。

對我來說，這個展覽意味著臺灣美術史一個新的里程碑，除了有別於過往的研究取徑之外，這項實踐也很難得地集結了國內外官方與民間諸多機構和個人的協力，我相信正是臺灣前輩藝術家們留存於作品中的熱切精神，才足以召喚出這股集體力量的投入。除了展覽之外，我們也規劃了多場講座、座談會，期望藉由各種不同面向的推動，獲得廣泛民眾的認識與認同，進而珍視這些凝縮著藝術家創作精神的作品，讓它們得以持續獲得悉心的維護與保存，進而能夠面向一代又一代的臺灣人，綻放其不朽的青春！

<div style="text-align: right;">

林曼麗

國家文化藝術基金會董事長

</div>

Preface

Attesting to the Everlasting Bloom in the Rediscoveries of Taiwanese Modern Art

There is only one method to become immortal, and that is through spiritual immortality. At least for us artists, as long as the works made with our sweat and blood are not obliterated, we will not die.

This passage is taken from Huang Tu-Shui's writing, entitled "Born in Taiwan," written when he was selected into the Teiten (Imperial Art Exhibition) in Tokyo for the second time. In 1920, when he became the first Taiwanese artist to be featured in the Teiten, he was still a young art student at Tokyo Fine Arts School. Yet, these few sentences have not only conveyed his passion for artistic creation, but also indicated the lifelong goal of this intellectually precocious artist. In 1930, when Huang died of an illness, he was merely thirty-six of age. Until today, as we lament his premature death, we can also substantially perceive how the artist has transformed his life journey into the spiritual immortality that transcends the existence of physical life.

Entitled *The Everlasting Bloom: Rediscovering Taiwanese Modern Art*, the exhibition marks an achievement of reconstructing Taiwanese art history. As the society and cultural environment of Taiwan develop, the industry, government and academia have all been paying more and more attention to Taiwanese art history; and in this process, however, we have also realized that it signals a competition with elapsing time. While many artworks are now included and well-conserved in the collections of public art museums, there are still quite a considerable number of artworks by early Taiwanese artists that remain in the possession of other governmental organizations or individuals, who might not be able to afford professional conservation and storage. Consequently, these works are in a state of continuous deterioration. To target this issue, art historian Yen Chuan-Ying has proposed a research project with the objectives to conduct an extensive survey to locate these works and bring them back into the public eye through research, restoration and exhibition.

The first "rediscovery" in this exhibition has been the active pursuit of these valuable treasures; and because of the research team's effort and the assistance of related personnel, the audience are finally able to reunite with many of these artworks, most of which have never been in public display. For instance, Huang Tu-Shui's *Bust of a Girl*, produced for his graduation from Tokyo Fine Arts School, has been in the collection of Taipei Municipal Taiping Elementary School. Since the completion of the sculpture, almost a century has passed. In order to welcome this "one-century-young" girl, Professor Mori Junichi from Tokyo University of the Arts is specially invited to restore the work so that the audience can fully appreciate the pure tenderness and elegance crafted by the artist. Another work that has rarely be shown is Lin Chih-Chu's *Nice Day*, which was selected into the Futen (Taiwan Governor-General's Office Art Exhibition) and awarded the exhibition's highest honor, the Governor-General Prize. In the past, art history researchers could only get a glimpse of this piece in exhibition catalogues. This time, due to the vigorous effort of the artist couple Ni Chao-Long and Lin Hui-Jen, the work is successfully loaned from a private collector and included in this exhibition.

This journey of rediscovery has even brought us to Japan, which has a close relationship with the development of Taiwanese modern art. Through the kind assistance of Japanese scholars and many institutions, several important works once again return to Taiwan after nearly a century. These include Chen Cheng-Po's *East Taiwan Seaside Road* commissioned by the former Governor-General of Taiwan, Kamiyama Mitsunoshin; Shiotsuki Toho's *Budding* created for the first exhibition of the Futen; and the gouache masterpiece, *Landscape in Taiwan*, by legendary Japanese artist Saigo Kogetsu, who painted the work when he traveled in Taiwan in 1911.

It is precisely during the process of unearthing these major works of art that we have deeply perceived a crucial fact: despite their obvious differences in style and media, these works all share one common significant implication, which is

the essence of the artists' creative life. This is why we hope to specifically highlight the rediscovery of the nature of artistic creation through this exhibition in addition to thorough and elaborate research of history—for artists, the very essence or sole meaning of their creative life is to pursue spiritual immortality; it is the case in the past, at present and will surely remain the same in the future.

For me, the realization of this exhibition also falls into a personal context. When I served as the director of Taipei Fine Arts Museum, I became much involved in the construction of Taiwanese modern art, and collaborated with Japan's Shizuoka Prefectural Museum of Art in 2000 to co-organize the crucial exhibition, *Oil Painting in the East Asia: Its Awakening and Development*. In the meantime, I also co-curated with my colleagues to present another major exhibition, *The Origins of Toyoga in Taiwan*. Afterwards, when preparing the establishment of the Museum of National Taipei University of Education (MoNTUE), the museum's inauguration exhibition, *MoNTUE Special Opening*, marked a close collaboration with Tokyo University of the Arts, which later gave birth to another exhibition, *The Modern Art in Taiwan – Works by Foreign Students in their Youth (1895-1945)*, presented at The University Art Museum, Tokyo University of the Arts. An international seminar also took place in concurrence with this exhibition, because of which the special exhibition, *Yōga: Modern Western Paintings of Japan*, organized by Tokyo University of the Arts was afterwards presented at MoNTUE. Because my continuous involvement in the field of Taiwanese modern art history, I understand the importance and urgency of Professor Yen Chuan-Ying's research project, and feel duty-bound to offer my full assistance. I am also tremendously glad that the research project receives the generous support from Chairman Chang Suming of Fu Lu Culture Foundation, and has progressed smoothly.

This exhibition is the fruition of many professionals' dedicated input. Firstly, the research team has worked on the project for over a year to produce such remarkable results; and then, the staff of MoNTUE have employed their curatorial expertise and executive power to present these precious finds in the most ideal way. The Public Television Service's program, "Inside the Arts," has also taken the initiative to participate in the process and document the project. The museum has also produced a documentary featuring the process of artwork restoration. All these endeavors aim to enable the audience to more multidimensionally and deeply perceive the rich layers of history and memory. Finally but importantly, we thank the Ministry of Culture for the full support and funds, which have allowed us to perfect various crucial factors in producing the exhibition.

This exhibition, for me, marks a new milestone of Taiwanese art history. Apart from its departure from the past research route, its realization also beckons at an unprecedented collaboration of multiple domestic and foreign governmental institutions, private organizations and individuals. I believe that it is indeed the artistic zeal crystalized by the works of these Taiwanese early artists that irresistibly summons such a collective power. The exhibition is also accompanied by multiple lectures and talks; and through these multifaceted efforts, it is our sincere hope that a wide range of audience can learn about, identify with and further cherish these artworks that have solidified the creative spirit of the artists so that they can continue to be carefully conserved while continually demonstrating the everlasting bloom to the future generations of Taiwanese!

LIN Mun-Lee

Chairman of National Culture and Arts Foundation

序

「不朽的青春——臺灣美術再發現」特展，眾人引頸盼望，終於開展了。

一年前（2019年），財團法人福祿文化基金會經國藝會董事長林曼麗教授促成以民間組織，支持由中央研究院歷史語言研究所顏娟英研究員所帶領的專業研究團隊，展開為期兩年的臺灣現代美術史研究計畫「風華再現——重現臺灣現代美術史研究計畫」。

自1920年以來，臺灣許多的年輕畫家，經過在國外的新時代洗禮，帶回竭盡心力的歷練與珍貴的結晶，綻放出對臺灣在地熱情的探討與時代的思索。2020年研究團隊即以長年鑽研臺灣美術史的專業，不辭辛勞，在第一年階段性地將其在時代洪流中被淡出公眾視線的精彩作品挖掘呈現。

本展以「研究」為核心，加強美術館與學術界的深度合作，並針對策展討論展覽敘事及作品選件，充分結合藝術史與展示專業，藝術史學者不僅是研究專家，也是創造展覽的共同協作者，此次是打造展示效果與堅實研究基礎兼具的展覽。2020年10月17日由福祿文化基金會與北師美術館再度攜手合作舉辦「不朽的青春——臺灣美術再發現」展，忠實呈現這項研究計畫最豐碩的成果。

本基金會也以一步一腳印地踏踩在臺灣土地上，為這片土地留下更多深刻的事蹟與美好的記憶。在此謹以福祿文化基金會感謝為本展無私出借珍貴收藏作品的公私立美術館、畫廊、收藏家及藝術家家屬等，特別是在全球遭受新型冠狀病毒肆虐之際，日本的福岡亞洲美術館、防府市／山口縣立美術館、以及松本市美術館等三家公立美術館仍同意出借重要典藏作品在臺灣展出，對此致上最高謝意！

誠摯邀請此刻在臺灣關心臺灣美術的大眾朋友們，一起來仔細品味、賞析這豐富的藝術篇章及精彩作品。

張純明

財團法人福祿文化基金會董事長

Preface

The Everlasting Bloom: Rediscovering Taiwanese Modern Art is finally open for public viewing amidst much anticipation.

In 2019, facilitated by Professor Lin Mun-Lee, Chairperson of National Culture and Arts Foundation, Fu Lu Culture Foundation began supporting the research team led by Dr. Yen Chuan-Ying, Research Fellow at Institute of History and Philology, Academia Sinica, for their two-year research project, "Splendor Revisited—Representing Taiwanese Modern Art History."

Since 1920, many young Taiwanese artists immersed themselves in the new era and foreign culture before bringing back their hard-earned experiences and precious works that materialized their zealous exploration of Taiwanese culture and their reflection on the times. In 2020, the research team has employed their long-term expertise on Taiwanese art history and industriously present the first-year research results, including the rediscoveries of brilliant works that have been buried in the vicissitudes of time and out of the public eye until now.

The exhibition revolves around "research" to reinforce a close collaboration between art museums and academia. In terms of the curatorial content, the exhibition narrative and selection of artworks have been extensively discussed to fully integrate art history and exhibition production. Therefore, the art historians are not only art experts but also collaborators to create an exhibition that manifests both remarkable exhibition effect and solid research. On October 17, 2020, Fu Lu Culture Foundation has once again worked with the Museum of National Taipei University of Education to co-organize *The Everlasting Bloom* and faithfully present the bountiful fruits of this research project.

Fu Lu Culture Foundation has steadfastly strived to preserve more profound things and wonderful memories for Taiwan. On behalf of the Foundation, I would like to thank all the public and private art museums, art galleries, collectors and families of artists for their selfless, generous support by loaning the precious artworks. In particular, as the world is taken by the pandemic of COVID-19, three public art museums in Japan, including Fukuoka Asian Art Museum, Hofu City and Yamaguchi Prefectural Art Museum as well as Matsumoto City Museum of Art, have kindly loaned their collections to be displayed in Taiwan, for which I express my utmost gratitude.

I cordially invite everyone who cares about Taiwanese art to thoroughly savor and appreciate this abundantly rich chapter of art and all the splendid artworks.

CHANG Suming

Chairman of Fu Lu Culture Foundation

凡例

1. 本書為「不朽的青春——臺灣美術再發現」展覽圖錄，展覽內容來自財團法人福祿文化基金會支持之「風華再現—重現臺灣現代美術史研究計畫」之研究
 成果，包含繪畫、雕刻、馬賽克作品圖版，及相關文字、文獻，特此致謝。
2. 文中多次出現之官方美術展覽會使用簡稱如下。「臺展」：臺灣教育會主辦之美術展覽會（1927-1936）。「府展」：臺灣總督府文教局主辦之美術展覽
 會（1938-1943）。「省展」：臺灣省全省美術展覽會（1946-2006）。「文展」：日本文部省美術展覽會（1907-1918）。「帝展」：帝國美術院美術展覽會
 （1919-1934）。「新文展」：新文部省美術展覽會（1937-1943）。
3. 作品名稱如為美術館典藏，依照各館現今典藏品名，唯因新研究史料出現更正題名之作品例外。
4. 生卒年標示：展出藝術家僅於展品標題與藝術家小傳標示生卒年，外文譯名或重要者，於首次出現時標示生卒年；藝術家小傳內文，除外文譯名外，其餘
 人名皆不標示生卒年。
5. 藝術家小傳內的出生地縣市名稱採用今日行政區劃，機構學校、美術團體等以歷史名稱為主。

THE EVERLASTING BLOOM
REDISCOVERING TAIWANESE MODERN ART

目次 Table of Contents

他們的青春‧不朽的作品
THE BLOOMING YOUTH‧
EVERLASTING WORKS OF ART

文／顏娟英

中央研究院歷史語言研究所研究員

Text / YEN Chuan-Ying

Research Fellow, Institute of History and Philology, Academia Sinica

黃土水、陳植棋的年代是一個高舉青春夢想，務實描述自我面貌的年代，同時也是知識青年胸懷壯志、奮不顧身、犧牲奉獻的時代。臺灣從清末中國的一隅被割讓給日本，成為帝國南進的殖民基地，臺灣青年作為受歧視的被殖民者，深深體會亞細亞孤兒的身世之悲。島民從口說多種形式的「臺語」，被迫學習，逐漸改為口說日語；從傳統認知中瀟湘八景式的文人山水，轉變為接受西方洗禮之日本現代觀點下的臺灣八景。殖民政府為改造島民的國民精神，推行公學校國民教育，加強國語（日語）教育以及實業學習。在此全民學習改換語言與文化意識的歷程中，畫家所經歷的典範轉移只不過是其中的一小部分。1920年10月臺灣人黃土水首次入選東京帝展，殖民政府遂利用此事當作文化看板大肆宣揚；而故鄉的青年則將他視為臺灣追求現代文明的傑出榜樣。成名藝術家有如被拱入名人堂，成為力爭上游的勵志傳說，備受社會的仰慕，但個人成功的背後所付出的代價之大，卻是我們後人所難以想像。

日治時期臺灣沒有美術學校和美術館，甚至罕見鑑賞者與贊助家，新時代青年在小學或師範教育裡受到美術啟蒙，卻沒有出路，只能效法黃土水飄洋過海赴日本留學，進入美術學校，乃至於入選東京官方展覽會，才能暫時掙脫殖民地政府的種種壓制，得以學習西方新時代的思潮與文化，進而回饋鄉土，提高臺灣的文化素養，凝聚臺灣人自我認同的意識。年輕畫家以寫實的態度描繪自己與家人的畫像，過程裡摸索學習表達自我的訴求，並在觀看尋找中發現故鄉獨一無二的人文特色。

歷經七年的學習，黃土水於1922年春完成學業，從東京美術學校研究科畢業；他已經連續入選帝展兩回，並接受官方媒體邀請發表創作感言〈出生在臺灣〉。這時他不過二十七歲，卻自認已過人類平均壽命（五十歲）的一半，誓言在珍貴的餘生努力創作更優秀的作品，使「人類的生活更加美化」。「永劫不死的方法只有一個，就是精神上的不朽。至少對我們藝術家而言，只要用血汗創作而成的作品還沒有被完全毀滅之前，我們是不會死的。」肉體的生命短暫，藝術作品卻可以永恆不朽。抱持這樣的信念，他毅然驅使自己用盡血汗創作，1930年底剛完成浮雕鉅作《水牛群像》石膏模（圖I，臺北中山堂藏）隨即病歿，享年三十五歲五個月。

圖I：黃土水，《水牛群像》，1930，臺北中山堂藏。

Fig. I: Huang Tu-Shui, *Water Buffalo*, 1930. Collection of Taipei Zhongshan Hall.

The era of Huang Tu-Shui and Chen Chih-Chi was one that championed youthful dreams and pragmatic delineation of one's self; it was also an era when young intellectuals embraced great aspirations and devoted themselves to their causes regardless of any dangers and sacrifices. After China ceded Taiwan to Japan at the end of Qing dynasty, the island became a colonial base for the Japanese empire to advance into the south. Taiwanese youths, as the colonized and discriminated inhabitants of the colony, had personally and deeply experienced the sorrow of being "the orphans of Asia." From speaking various Taiwanese vernaculars, the island inhabitants were forced to learn and gradually adopt Japanese. Aesthetics-wise, the traditionally identified literati landscape in the style of the Eight Views of Hsiao and Hsiang Rivers was also converted into the Eight Scenes in Taiwan shaped by the Japanese modern perspective, which was in turn influenced by the West. To reform the national spirit of the island's inhabitants, the colonial government also implemented the policy of national education via public schools to reinforce the learning of national language (Japanese) and practical subjects. In the course of adopting the new language and altering the cultural consciousness on an island-wide scale, the paradigm shift that these painters underwent was merely a small portion of the overall historical process. In October 1920, Huang Tu-Shui became the first Taiwanese artist to be selected into the Teiten (Imperial Art Exhibition) in Tokyo. The colonial government in Taiwan consequently utilized Huang's achievement for cultural propaganda and extensively publicized the matter, whereas the young people in Taiwan viewed Huang as a distinguished role model of Taiwan's pursuit of modern civilization. The reputed artist was therefore put on the pedestal, and his story of striving to be the best made him an inspirational figure admired by all. However, the later generations could never possibly imagine the tremendous sacrifices behind such personal success.

There were no art schools and art museums in Taiwan under the Japanese rule, and art connoisseurship and patronage were little to none. After the youths of the new age received their initial art education in elementary schools or normal schools, they had no other ways to further develop their skills but to follow Huang Tu-Shui's example and travel across the ocean to study in art schools in Japan. Only after being selected into the official art exhibition in Tokyo could they temporarily break free from the oppressive measures of the colonial government to follow closely modern Western thoughts and culture. Furthermore, they wish to eventually reciprocate their homeland by elevating the cultural quality in Taiwan and solidifying Taiwanese people's self-identity. Young painters adopted a realistic approach to create portraits of themselves and their family, while exploring ways to express their appeals in the process, observing and seeking the unique humanistic characteristics of their homeland.

In the spring of 1922, after seven years of training, Huang Tu-Shui finished his study and graduated from Tokyo Fine Arts School's graduate department. By then, he had already been selected into the Teiten twice, and was invited by the official media to publish an essay titled "Born in Taiwan." At this time, he was only twenty-seven years old, but he believed that he had spent half of his life according to the average life expectancy of people at the time (which was fifty years old) and vowed to create more brilliant works with his remaining, valuable life to "further beautify the human life"—"there is only one method to become immortal, and that is through spiritual immortality. At least for us artists, as long as the works made with our sweat and blood are not obliterated, we will not die." The life of the flesh might be momentary, but the works of art can be everlasting. Upholding this belief, the artist relentlessly dived into his creative work, and died of an illness shortly after he finished the plaster mold of his

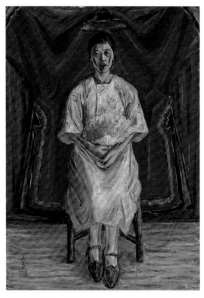

圖II：陳植棋，《夫人像》，1927，油彩、畫布，家屬藏。

Fig. II: Chen Chih-Chi, *Portrait of Wife*, 1927, Oil on canvas. Collection of the artist's family.

圖III：黃土水，《釋迦出山像》，1927，銅，臺北市立美術館、國立臺灣美術館、高雄市立美術館典藏。

Fig. III: Huang Tu-Shui, *Shakyamuni Descending the Mountain*, 1927, Bronze. Collection of TFAM, NTMFA and KMFA.

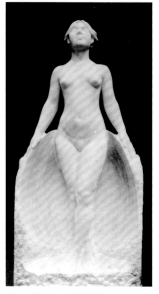

圖IV：黃土水，《甘露水》，1921，大理石，下落不明。

Fig. IV: Huang Tu-Shui, *Water of Immortality*, 1921. Collection unknown.

同年，黃土水學弟，為石川欽一郎稱作鬼才的陳植棋從東京美術學校油畫科畢業，10月榮獲第二次入選帝展，卻旋以過勞罹病，緊急送醫，於次年4月辭世，年僅二十六歲又三個月。纏綿病榻時，他自知留學巴黎、成為專業畫家之夢已然渺茫，惟其信念依然堅定不移。他給妻子寫的絕筆信中說：「最喜歡的還是畫畫，就算是因為繪畫而倒下去，也不後悔。」三年前畫家為妻子創作的《夫人像》（圖II，家屬藏）不僅代表他對家人，更蘊含對臺灣這片土地的熱愛；他深信此畫一如其他作品，都將永垂不朽。這次展出的《桌上靜物》（圖44），看似隨意放置的果物，取材自畫家成長經驗中最常用的器具以及自家後院種植的水果，鮮豔欲滴的紅色在桌面上蔓延開來。畫家曾說紅色代表：「以赤誠的藝術力量讓島上人的生活溫暖起來」。新一代的藝術家前仆後繼，懷抱一片赤誠與滿腔熱血，獻出對故鄉無私的愛，才能在當時艱困的環境中持續創作，完成不朽的傑作。

作品是「朽」或是「不朽」，除了決定於創作者

的精神與智慧高度，能否長期保存當然也是至關重要的條件。臺灣的自然天候不利於保存藝術品，而且臺灣遲至1980年代中才開始創立美術館，此前漫長的歲月裡，家屬扮演了收藏的重要角色。許多盡職的家屬傾盡全力保護已故藝術家的作品，有名的例子如陳植棋、顏水龍、陳澄波、李梅樹、陳進、劉啟祥、呂基正、李澤藩、何德來、鄭世璠等人的家屬，即便畫家離世已久，仍竭盡心力保護他們遺留下來的作品。然而，作品要能夠成為不朽，還是需要客觀、良好的保存條件：控制溫濕度、避免光害的現代化設備及保存空間；硬體之外，具備素養的專業修復師對作品的及時修復、定期保養，亦為不可或缺。

黃土水留存世間的作品並不多見，我們熟知的有前述中山堂的石膏《水牛群像》以及《釋迦出山像》（圖III，翻銅作品收藏於北美館、國美館與高美館）。而他引以自豪的大理石作品更為罕見。1921年他入選第三回帝展的等身大理石雕《甘露水》（圖IV）屢屢傳聞仍收藏於台中，但迄今為止我們未能親眼看見此作品。這次展覽承蒙臺

relief masterpiece, *Water Buffalo* (fig. I; collection of Taipei Zhongshan Hall), at the end of 1930, ending his brief sojourn in this world that lasted merely thirty-five years and five months.

In the same year, Chen Chih-Chi, who entered Tokyo Fine Arts School later than Huang and was called a mad genius by Ishikawa Kinichiro, graduated from the school's oil painting department, and was selected for the second time into the Teiten in October; but he soon fell ill and hospitalized immediately. In April of the next year, Chen departed from this world at the age of twenty-six and three months. When he was confined to his sick bed, Chen knew his chance of realizing his dream of studying in Paris and being a professional painter was slim, but his faith had kept him determined. In his final letter to his wife, the painter wrote, "Painting is still my favorite. So, I have no regret to have fallen ill because of painting." Painted three years ago, Chen's *Portrait of Wife* (fig II; collection of the artist's family) not only expressed his love for his family but also his love for Taiwan. He firmly believed that this work, like his other works, would last forever. On view in this exhibition is his *Table Top Still Life* (fig. 44), which features fruit and objects arranged in a random manner. The artist drew his inspiration from his experience of growing up, and painted objects he used most often in life and fruit picked from the family's backyard with a vibrant red table top that visually spread across the image. The artist once stated that the color red symbolized to "warm up the life of this island's people with the sincere power of art." One after another, artists of this new generation, propelled by sincere and passionate fervor, dedicated their selfless love for their hometown, a love that had kept them making art and creating their everlasting masterpieces despite difficult circumstances.

Whether or not a work of art can be "everlasting" not only depends on its creator's spiritual and intellectual capacity but also relies on the long-term convervation of the work. The natural climate in Taiwan has put the artworks in disadvantage, and art museums in Taiwan were established as late as in the mid-1980s. Before art museums appeared, artists' families have played an important role of collecting art. Many of them have exerted their strength to protect artworks by deceased artists. Some well-known examples include Chen Chih-Chi, Yen Shui-Long, Chen Cheng-Po, Li Mei-Shu, Chen Chin, Liu Chi-Hsiang, Lu Chi-Cheng, Lee Tze-Fan, Ho Te-Lai and Cheng Shih-Fan. Although the artists might have passed away a long time ago, members of their families have still dutifully and diligently tried the best to protect their artworks. However, for an artwork to be immortalized, objective and ideal conditions of conservation are necessary— modern equipment and storage space for preventing light damage and controlling temperature and humidity and in addition to hardware, professional conservators with proper training are prerequisite for the timely restoration and periodical maintenance of artworks.

Huang Tu-Shui's surviving works are not many. The ones that we are familiar with include the abovementioned plaster work, *Water Buffalo* displayed in Zhongshan Hall and *Shakyamuni Descending the Mountain* (fig III; cast bronze sculptures included in the collections of Taipei Fine Arts Museum [TFAM], National Taiwan Museum of Fine Arts [NTMFA] and Kaohsiung Museum of Fine Arts [KMFA] respectively).His marble sculptures, which he was highly proud of, are even rarer. In 1921, his *Water of Immortality* (fig. IV), a life-size marble sculpture, was selected into the 3rd Teiten. The piece has been said to be in Taichung, but no one has been able to personally see this work so far. With the kind support of the Taipei Municipal Taiping Elementary

北市立太平國小以及校友會支持，借展校方慎重珍藏將近一百年的大理石《少女》胸像（圖1）作品，並由北師美術館聘請東京藝術大學森純一教授進行修復工作，將再次以清純溫潤的面容、盼望夢想實現的神情與觀眾見面，著實令人興奮不已。

不朽的傑出藝術作品既不可複製，也是珍貴的動產，一百多年來，許多作品不可避免從畫家或家屬手中流散出去，下落不明；有的甚至遭到八七水災（1959年）等經常性的天災以及各種人為疏忽所損壞。作品有幸能保存迄今，除了家屬的盡職守護，民間私人收藏家的奔波收集和致力保存也居功厥偉。趕在1983年12月最後幾天成立的臺北市立美術館，最初嚴重缺乏現代美術相關專業人員，策展方向與自身定位猶搖擺不定，直至1986年9月才出現第一任館長黃光男先生。約同一時間臺北自1970年代後期，一間間私人畫廊安靜地出現在許多新型商業大樓裡，直接推動了中產階級的鑑賞與藝術市場的熱絡發展。在我們研究團隊進行田調過程中，發現此時期直到1990年代所形成的一批私人收藏家裡，有好幾位特別「古意」的藏家，忠誠地守護著數量可觀的收藏。他們彷彿老畫家的知音，藉著收藏前輩藝術家的作品學習臺灣歷史，繼續傳承臺灣文化的共同記憶與認同。然而隨著他們逐漸老去、甚而凋零，如以收藏紀元畫會作品聞名的呂雲麟（1922-1994），這些代表臺灣文化精粹的美術作品極有可能漸為世人所遺忘，甚至乏

人管理維護，自然風化。民間私人收藏需要更多藝術史家正面看待，而公部門單位更須摒除官僚心態，認真看見社會文化的實際需要，唯有兩造間共同合作，臺灣美術史的傳承才不至於長期斷裂，臺灣集體文化記憶的重建也才會更接近真實。

臺灣上世紀末陸續成立的三大美術館——北美館、國美館與高美館，各自具備良好條件的庫房與正式編制的研究、策展人員，三十多年來三館也確實積極地收藏珍貴的美術作品。正因為公立美術館提供永久可靠的保存條件，就在我們調查的過程中，又陸續有家屬以及美國順天美術館將驚人的大批作品捐入美術館。然而為何還有許多珍貴作品散落各地？這恐怕不是容易回答的問題。

本研究團隊最初提出的研究課題便是集中調查尚未進入公家美術館典藏的珍貴作品，期待藉由研究與展覽，將作品再次公諸於世。作品中有些長期散落在非美術館的公家單位，如自然博物館、文化局或學校；有些則散落在民間，包括家屬與私人收藏。此次借展單位的陣容龐大，展出畫作中有許多受到良好的保護，有些卻曾被長期冷落；幸而在籌備展覽的過程中，作品都能夠得到正確修復的機會。最後，站在研究者的立場，我們必須強調，若要作品真正成為不朽，除了必須滿足物質條件，如設備良好的庫房，還需要建設觀眾精神上的認同，亦即需要提高國人的鑑賞能力，才能將更多藝術家與不朽的作品納入臺灣文

School and its alumni association, Huang's marble *Bust of a Girl* (fig. 1), which has been carefully stored by the school for nearly a century, is showcased in this exhibition. Before the public display, the Museum of National Taipei University of Education (MoNTUE) has invited Professor Mori Junichi from Tokyo University of the Arts to restore the bust and bring back for the audience the fresh, elegant visage and the look of hoping to realize one's dream. This is truly exciting and much anticipated.

A remarkable everlasting piece of art is irreplicable and a precious asset. Throughout more than a century, many valuable works have unavoidably gotten away from the artists or their families, and their whereabouts have become unknown. Some were even damaged in frequent natural disasters, such as the August 7 Floods (1959), and different types of human negligence. Those that have fortunately been kept until today owe to the conscientious families and private collectors, who have strived to collect and devoted themselves to preserve these works. TFAM, which was inaugurated near the end of December in 1983 had a severe lack of professional staff with adequate modern art knowledge at the very first beginning, and its curatorial direction and position were wavering as well. It was not until the September of 1986 that TFAM had its first director, Mr. Huang Kuang-Nan. Meanwhile, around the same time in Taipei in the late 1970s, many private art galleries emerged in new commercial buildings and directly fueled bourgeois connoisseurship and lively development of the art market. During the research team's field investigation, we have found that a group of most sincere and modest private collectors, formed from this period until the 1990s, has been loyally guarding a large number of art collections. Like bosom friends to the early painters, they have learned Taiwanese history through collecting the artworks by these early artists while continuing the collective memory and identity of Taiwanese culture. However, as collectors in this group have aged or even passed away, such as Lu Yun-Lin (1922-1994) who was known for his collection of works by artists in Chi-Yuan Painting Society, the artworks that have crystalized the essence of Taiwanese culture might be gradually forgotten, and even lack proper management

and conservation. More art historians must adopt a positive attitude towards private art collections; and the public sector needs to renounce the bureaucratic mindset to make an effort in identifying the real needs of society and culture. Only through the collaboration of the two, the historical legacy of Taiwanese art could be preserved over time without unwanted gaps, and the reconstruction of Taiwan's collective cultural memory could truly reflect reality.

At the end of the last century, Taiwan's three major art museums – TFAM, NTMFA and KMFA – were successively established. Each equipped with ideal vaults as well as official research and curatorial staff within the institutions, the three major art museums have steadfastly and actively acquired precious artworks over more than three decades. It is because the public art museums can provide permanent and reliable storage of artworks, during our research process, some of the artists' families and the Sun Ten Museum in the US have continually and respectively donated an impressive number of artworks to the art museums. So, then, why are there still many valuable works scattered in different places? This is perhaps not a question that can be easily answered.

Since the beginning, the topic of this research team has been to concentrate on precious works that are not yet included in collections of public art museums, with the objective to publicize these works via research and exhibition. Some of the works have been dispersed in various public institutions that are not art museums, for instance, natural museums, local departments of cultural affairs or schools; and some are in the possession of the artists' families and private collections. This exhibition therefore has loaned artworks from an extensive number of institutions, organizations and people. Many of the works on view have been well-protected, but some have been neglected for a long time. It is fortunate that all the artworks could be properly restored during the preparation of the exhibition. Finally, as researchers, we must emphasize that for these works to be truly everlasting, apart from fulfilling necessary material conditions such as well-equipped vaults, it is imperative to elicit audience's recognition as well as enhance Taiwanese people's connoisseurship so that more artists and

化的基因資料庫;這點迫切需要藝術史家、美術館策展單位,以及教育推廣者積極地投入,共同耕耘。

本次展覽,「不朽的青春──臺灣美術再發現」,共展出約七十四件作品,為了方便觀眾更順暢地欣賞並理解畫作,分為六個導覽主題:

一、 破曉的覺醒

以第一代留學生黃土水、顏水龍等作品為主,他們為了突破殖民地臺灣的種種限制,憑藉著追求創作與新知識的自我覺醒,奮不顧身地渡海到東京、京都、巴黎學習。其留學上進之心未必能得到家人的諒解,也沒有足夠的經費,但他們破釜沈舟的決心終於衝破黑暗,為臺灣更多有志青年帶來黎明的曙光。

二、生命的凝視:

以人物畫為核心,展現畫家在描繪自我、家人乃至於原住民的過程中,逐步摸索並表達一己的文化認同。以「生命的凝視」來形容這批早期人物畫,除呈現畫中人與自我形象的對話充滿了生命的回憶與期許,同時也突顯出畫家創作之際的深刻內省。

三、風土的踏查:

最早從1920年代開始,年輕的臺灣畫家就結伴搭火車南北旅行寫生,是行旅也是追尋,他們飽覽家鄉各地的風景特色,臺灣的地景生態在他們的創作中愈見清晰。

四、歲月的憶念:

這批靜物畫忠實地記錄生活的經驗與回憶,畫家筆下的日常風土提煉自過往的美好回憶,如書房、餐桌上熟悉的食物與器皿,偶而也從旅遊紀念品中收集到創作的靈感。

五、傳統的變革:

涵蓋水墨畫到現代膠彩畫的發展。由於文人水墨畫在臺灣的傳統基礎不深,日治時期很快便接受了西化改革後強調寫生觀的新日本畫潮流,發展出臺灣膠彩畫傳統,從而開拓了許多嶄新的題材。

六、旅人之眼:

從明治末年起,就有日本畫家來到南方的新殖民地臺灣創作寫生,他們中有的舉辦展覽以換取旅費,有人為官方的新國土觀光宣傳而貢獻心力。在日本新生代畫家的行旅中,臺灣成為前往中國與東南亞的中繼站,甚至也有從歐洲留學返航時

their works could be the "genetic database" of Taiwanese culture. To achieve this goal, all art historians, curatorial departments in art museums and educators are urgently needed for their active input and collaborative effort.

The Everlasting Bloom: Rediscovering Taiwanese Modern Art features seventy-four works. To facilitate a better viewing exhibition and help the audience understand the artworks more deeply, the exhibition is divided into six themes:

I. The Dawn of Awakening

The section primarily displays works by the first generation of artists who studied overseas, including Huang Tu-Shui, Yen Shui-Long and others. In order to break through the limitations of colonial Taiwan, they had relied on their self-awakening in pursuing artistic creation and new knowledge and valiantly travelled to study in Tokyo, Kyoto and Paris. Their desire to learn and study overseas might not be understood by their families, nor did they have ample funds. Yet, their unwavering resolution finally led them through the darkness and ushered in the light of dawn for more aspiring Taiwanese youths.

II. The Gaze of Life

With figure painting as the core, the section features how the artists explored and expressed their cultural identity in the process of delineating themselves, their family and the indigenous community. Describing this group of early figure paintings with "the gaze of life" is a way to both highlight the memory of life and expectation informing the dialogue between the painted figures and the artists' self-image, but also to foreground the deep introspection carried out by the artists in their creative journey.

III. Surveying Customs and Landscape

As early as the 1920s, young Taiwanese painters had travelled together by train to sketch between northern and southern Taiwan. These trips were travels but also symbolized

their collective quest. While fully observing the scenic characteristics of different places in their homeland, the landscape and ecology of Taiwan also became more and more distinct in their works.

IV. Remembrance of Passing Years

The still lifes on view in the exhibition truthfully document past living experiences and memories. The everyday scenes and customs painted by the artists have been extracted and refined from heartwarming memories, such as a study, familiar food and utensils on dining table; occasionally, they also drew inspiration from souvenirs collected during their travels.

V. Reforming the Tradition

The section covers the development from ink painting to modern gouache painting. Literati ink painting did not have a deep and solid foundation in Taiwan; therefore, during the period of Japanese rule, the wave of new Japanese-style painting that emphasized on sketching from life – an idea resulted from the Westernized reform – was quickly accepted, giving birth to the tradition of Taiwanese gouache painting, along with many fresh subjects in painting.

VI. The Traveler's Eye

Since the end of the Meiji period, there had been Japanese painters who visited this southern colony called Taiwan to sketch and paint. Some of them would present exhibitions to cover their travel expenses, whereas some would assist the government in publicizing and promoting the new national territory. In the travels of the new generation of Japanese painters, Taiwan became an intermediate stop to China and the Southeast. Some even stopped briefly in Taiwan to paint when returning to Japan from Europe where they were educated. These painters had expanded the artistic vision of Taiwan in a more global way.

Over a year ago, because of the profuse encouragement of Mr. Lee Tsung-Che, who has cared about the development

暫時停留創作，讓觀察臺灣的美術視野開展出寬闊的世界觀。

一年多前，由於長期關心臺灣美術史研究發展的李宗哲先生積極地鼓勵鞭策，以及國立臺北教育大學林曼麗教授的居間奔走，獲得財團法人福祿文化基金會張純明董事長大力贊助本研究團隊為此展覽進行一年的調查、研究；基金會執行董事張玟珍女士實際護持團隊的工作。研究團隊成員包括臺灣師範大學蔡家丘副教授、臺灣大學邱函妮助理教授、黃琪惠博士、楊淳嫻博士、郭懿萱博士候選人（2019年3月至9月）與張閔俞碩士（2019年10月迄今）。此外，兩位長期重要的盟友：遠在福岡心繫臺灣的呂采芷老師──多年來秉持「鍥而不捨，金石可鏤」的精神，為我們追蹤到消失將近百年的鹽月桃甫大作《萌芽》；以及鈴木惠可博士候選人──由於這一年升格成為母親，無法加入團隊工作，但始終支援、協助我們的研究工作。臺北市立美術館雷逸婷助理研究員，以及東京藝術大學博士生柯輝煌參與撰寫作品圖說，為本圖錄增添光輝。北師美術館總監劉建國先生與專員王若璇女士跟隨我們的足跡，奔走拜訪各地的藏家，並聯絡國外借展單位，擔負起策劃展覽的艱困工作。公視「藝術很有事」製作人徐蘊康女士的製作團隊在下半年加入合作，進行影視訪問記錄工作，大力協助展覽的推廣。研究過程中承蒙許多畫家家屬以及私人收藏家的接待，如龔玉葉女士敞開大門歡迎我們，寄暢園藝術文化基金會張郭玉雨女士、張順易先生從不厭倦的溫情款待，陳鄭添瑞醫師等誠摯熱情地提供調查、攝影以及反覆研究的機會；調查中我們首次參觀了高雄「台灣50美術館」，見識館長郭鴻盛先生如何獨自撐起一間收藏精緻、陳列完美的美術館，誠然是畢生難忘的啟發。為了尋找中部藏家，團隊曾不止一次拜訪臺中市畫家曾得標老師（1942-2020），以及倪朝龍教授、林慧珍教授，他們親切地傾囊相授的長者風範記憶猶深，感念在心。此外，許多公家單位如國立臺灣博物館、臺中教育大學美術系、新竹教育大學等多位專家學者，盡力配合我們的反覆研究與調查工作，在此謹代表研究團隊致上由衷的謝意。

of research about Taiwanese art history for years and the much appreciated organization by Professor Lin Mun-Lee of National Taipei University of Education, the research team received generous support from Chairman Chang Suming of Fulu Culture Foundation as well as substantial backing from the foundation's executive director, Ms. Chang Wen-Chen, and embarked on a year-long investigation and research work for this exhibition. This research team is constituted of Associate Professor Tsai Chia-Chiu of National Taiwan Normal University; Assistant Professor Chiu Han-Ni of National Taiwan University; Huang Chi-Hui, PhD; Yang Chun-Hsien, PhD; PhD candidate Kuo Yi-Hsuan (March to September 2019); and Chang Min-Yu (October 2019 to present). In addition, the research has two long-term allies: Fukuoka-based Ms. Jessica Tsaiji Lyu-Hada, who has always had Taiwan in her heart and spent years to track down Shiotsuki Toho's masterpiece, *Budding*, with a steadfast and mountain-moving spirit. PhD candidate Suzuki Eka, though was not able to join and work with the team this year because of the birth of her child, has consistently supported and assisted with the research work. Taipei Fine Arts Museum's curator, Lei Yi-Ting, and PhD student at Tokyo Univesrity of the Arts, Ko Hui-Huang, have taken part in writing artwork introductions, adding more brilliance to this catalogue. Executive Director Liu Chien-Kuo of MoNTUE and the museum's exhibition coordinator Wang Rocean have accompanied us to visit collectors in various places around Taiwan and assisted in loaning artworks from foreign institutions and organizations, shouldering the challenging task of organizing the exhibition. The production team of Ms. Hsu Yun-Kang, the producer of Public Television Service's "Inside the Arts," joined the project in the second half of the year and produced a series of TV interviews and documentation to promote the exhibition. During the research process, many of the artists' families and collectors have kindly received the research team with open arms: Ms. Kung Yu-Yeh welcomed us sincerely. Mrs. Chang Kuo Yu-Yu and Mr. Chang Shun-I of Chi Chang Yuan Art and Culture Foundation have tirelessly received us with cordiality. Dr. Chen Cheng Tien-Jui ardently offered us many opportunities of investigation, photography and study. In the field study, we have also visited for the first time

the Museum 50 of Taiwan in Kaohsiung. Solely operated by the museum director, Mr. Kuo Hong-Sheng, it is an art museum with an exquisite, perfectly displayed collection and an unforgettable inspiration. To look for collectors in central Taiwan, the research team also repeatedly visited the Taichung-based painter, Tseng Teh-Biao (1942-2020), as well as Professor Ni Chao-Long and Professor Lin Hui-Jen, whose friendly instruction and respectful demeanor had left a deep impression in our mind and filled our hearts with gratitude. Finally but importantly, the extensive and repeated research and study has been made possible with the assistance of many experts and scholars from various public institutions, including National Taiwan Museum, National Taichung University of Education's Department of Fine Arts and Hsinchu University of Education. I hereby express our sincere gratitude on behalf of the entire research team.

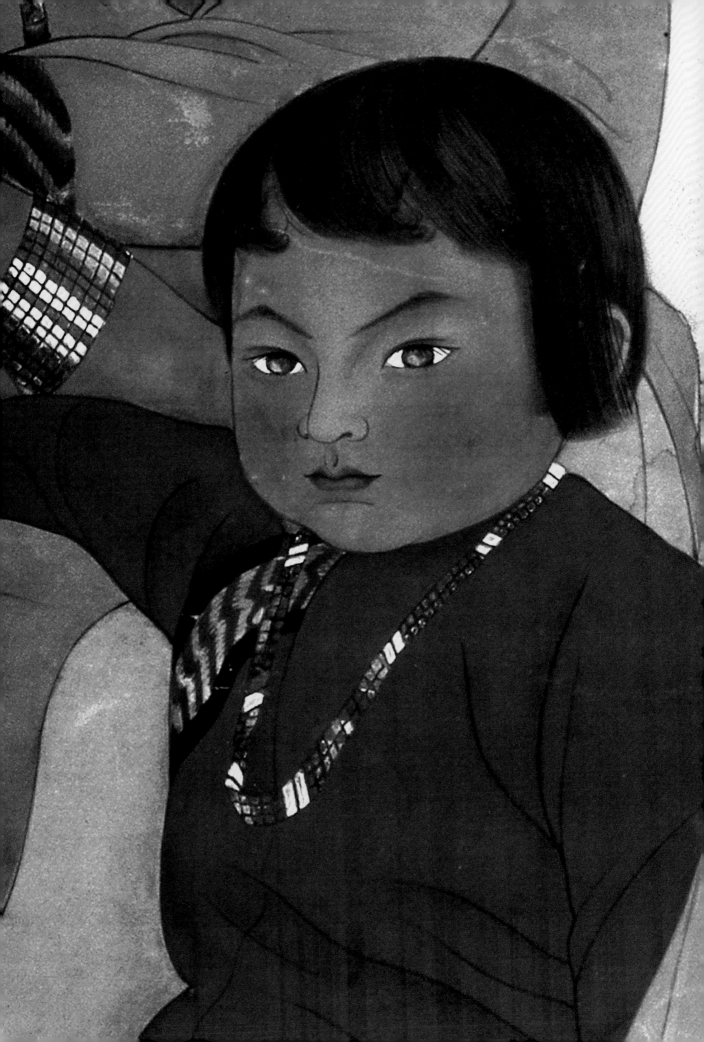

I

破曉的覺醒

The Dawn of Awakening

I

破曉的覺醒
THE DAWN OF AWAKENING

文／顏娟英

中央研究院歷史語言研究所研究員

Text / YEN Chuan-Ying

Research Fellow, Institute of History and Philology, Academia Sinica

清領時期，臺灣誠然邊陲之地，既未建立文化主體性，地方政府更是欲振乏力。進入日治時期，臺灣的年輕人雖然透過學校教育接觸到現代化的思潮，然而不論在語言、思想、政治還是文化上，處處受到殖民政府的規範，宛如陷入狹隘的牢籠中。1915年來自臺北艋舺木匠家庭的黃土水（1895-1930），由於天分早露，就讀國語學校（後改為師範學校）時受到總督府賞識，破格推薦，進入東京美術學校雕塑科木雕部，並於1920年秋天入選日本帝國美術展覽會，成為媒體力捧的新生代臺灣之光，為身在混沌黑夜處境中的臺灣知識份子照亮了學習美術專業以改變命運的可能路徑。同樣在師範學校就讀時接觸寫生觀念，從此打開一扇心靈之窗，認識到赴日學習藝術創作可能性的，還有陳澄波（1895-1947）、陳植棋（1906-1931）與李梅樹（1902-1983）等多位畫家。臺南出身的顏水龍（1903-1997）則是在任教時受到日本同事的指點前往東京，靠著半工半讀方式進修，準備投考美術學校，兩年後終於如願以償，進入東京美術學校油畫科。

還有些人幼年時期就被家人決定送往日本就學，成為臺灣接受現代文明的先鋒。淡水的陳敬輝（1911-1968）四歲時由養父帶往京都，寄養在日本友人家中，從幼稚園起就讀，直到二十二歲從京都繪畫專門學校學成歸國。新竹的何德來（1904-1986）則是在八歲時被養父送往東京讀小學，期間飽嚐日本同學霸凌的滋味；後來返臺就讀臺中一中，因決心學習美術而重返東京。重回日本初期生活並不順利，隻身在異鄉遭遇1923年關東大地震，幸有日本人木邑一家收容他。歷經三次應考，1927年終於進入東京美術學校油畫科。而他最終成為木邑家的女婿。臺南的劉啟祥（1910-1998）出身名門之後，公學校畢業後隨同家族成員前往東京，就讀私立青山學院中學部；在順利完成文化學院美術科學業之後，啟程前往巴黎繼續學習。

他們來自不同的社會階層，有著不同的地緣關係，而在各自奮力爭取出國學習的過程中，先後在異鄉的美術學校匯聚。他們的青春是苦澀而早熟的，為創作理想的臺灣文化圖像昂首闊步，犧牲生命在所不惜，沒有絲毫的遲疑甚或浪漫。他們之中大多數因父母早逝，或被收養而遠離原生家庭，孑然一身、義無反顧地前往日本留學；陳澄波在1924年虛歲三十之際毅然辭去教職，追隨前輩的腳步抵達東京。陳植棋則來自三代單傳的小地主家庭，因為領導學潮遭師範學校退學，被迫中斷學業，幸而在師長的遊說下，家長才同意他遠離家鄉另尋出路。

從師範學校出身意味著美好前途的保證，他們卻

During the reign of Qing dynasty, Taiwan was simply a peripheral place that lacked cultural subjectivity with a somehow sputtering local government. After entering the period of Japanese rule, although Taiwanese youths were able to study modern thoughts via school education, they were still very much regulated by the colonial government in terms of language, thinking, politics and culture, as if they were living in a narrow and restricted cage. In 1915, Huang Tu-Shui (1895-1930), who grew up in a carpenter family in Taipei's Monga, was unprecedentedly recommended by the Office of Taiwan Governor-General for his talents after he graduated from National Language School (later reorganized as the Normal School), and was accepted into Tokyo Fine Arts School's Department of Sculpture without examination, where he studied in the Wooden Sculpture Division. Huang was selected into Japan's Teiten (Imperial Art Exhibition) and became Taiwan's pride among the new-generation artists extoled by the media, bringing the light of hope to all young Taiwanese intellectuals as an example that showed them it was possible to change one's fate through learning art. Other artists who also learned the concept of painting from life in the Normal School and consequently became aware of the possibility of studying art in Japan included Chen Cheng-Po (1895-1947), Chen Chih-Chi (1906-1931) and Li Mei-Shu (1902-1983). Yen Shui-Long (1903-1997), who was born and grew up in Tainan, was advised by his Japanese colleague to go to Tokyo when he was a school teacher. Back then, he worked part-time to prepare for the art school exam. After two years of hard work, he finally realized his goal and entered the Oil Painting Department of Tokyo Fine Arts School.

Some artists were sent by their family to be educated in Japan when they were little and eventually became pioneers in Taiwan's acceptance of the modern civilization. Born in Tamsui, Chen Jing-Hui (1911-1968) was brought to Kyoto by his adopted father at the age of four to be raised by the family's Japanese friend. Chen's education in Japan began with studying at the kindergarten and continued until he graduated from Kyoto City Technical School of Painting at twenty-two years old and returned Taiwan. Ho Te-Lai (1904-1986), who was born in Hsinchu, was sent to study at an elementary school in Tokyo by his adopted father at the age of eight, during which he was severely bullied by his Japanese classmates. Later, he returned to Taiwan to study at Taichung First Senior High School, where he became determined to study art and went back to Tokyo. At first, his life in Japan was met with difficulties, and he was alone when the Great Kanto Earthquake hit Japan in 1923. Fortunately, he was taken in by the Kimura family, and after taking the exam three times, he was finally accepted into Tokyo Fine Arts School's Oil Painting Department and eventually became the family's son-in-law. Liu Chi-Hsiang (1910-1998) was born in an eminent family in Tainan. After graduating from the public elementary school, he went to Tokyo with his family and began studying at the private Aoyama Gakuin High School. Later, after he completed his education at Bunka Gakuin's College of Art and Literature, he moved to Paris, where he continued studying art.

Coming from different social strata and with dissimilar geographical relations, these artists had, in the process of striving for studying abroad, successively come to the art school in the foreign country. Their youth was bitter and precocious. To create the ideal images of Taiwanese culture in their mind, they had stridden with their heads high and could sacrifice their lives without any hesitation, even to the point of being romantic. Most of them had lost their parents at a young age, or had been adopted and separated from their biological parents. Being alone in life, they were determined to pursue education in Japan. In 1924, Chen Cheng-Po resolutely resigned from his teaching position at the nominal age of thirty and followed his predecessors' footsteps to Tokyo. Chen Chih-Chi was the only son of a family that only had one male offspring in three generations. He was expelled from the Normal School for being a student movement leader in and was forced to stop his education. Fortunately, his teachers

都放棄了一般人羨慕的教職，走上純粹創作之路；然而，當時臺灣人幾乎不認識藝術創作的價值，即使家中父老也無法理解遠赴東京或巴黎學習藝術究竟有何用處。歷經數年刻苦學習，卻要面對家鄉不重視文化藝術的社會現實，以及學習創作難以為繼的痛苦；空有一技之長，卻無立足之地，唯有在一年一度官方展覽會上博取短暫的聲名。陳澄波不得已再度漂流到上海，尋找教書與創作的機會，但是不出幾年就在中日即將開戰的陰影下被迫還鄉。

黃土水、陳植棋懷抱著滿腹理想，正值創作顛峰之時卻因過勞而早逝；陳澄波則喪生於二二八的政治迫害，無法實現繼續學習西洋藝術的夢想，留下來的作品也為數不多。顏水龍靠著臺中後援會的熱心募款，加上預支畫作費用，終赴巴黎留學，並在一年後獲得入選秋季沙龍的榮譽，然而他省吃節用，艱苦備嘗，還差點因肝病客死異鄉。極少數幸運兒如陳清汾（1910-1987）、劉啟祥、楊三郎（1907-1995），能有開明而富裕的家長支持，在經濟上不虞匱乏，得以在藝術之都充分體驗多采多姿的留學生活。

第一代臺灣美術留學生在日本也曾受到種族歧視，二十歲方抵東京的黃土水就常面對無知的日本人提出「臺灣生蕃割人頭」的問題，讓他深惡痛絕，更發憤立志要發揚臺灣的生態環境與文化，他的創作題材始終不離開臺灣的田園風光。身為臺灣第一位雕刻家，黃土水曾說，世間之苦事莫過於成為藝術家。他天天守著石材不停地敲打，較常人多付出數十倍的辛勞，然而即使同樣身為臺灣人的其他留學生，卻也無法認同或理解

他。儘管如此，他認為人生苦短，藝術家只要能留下表現臺灣自然風光的優秀作品，其靈魂便能永垂不朽。1931年春，顏水龍在巴黎的世界殖民地博覽會場，深受各地原始藝術之美所震撼，觀賞流連之際，萌生一個心願，回臺灣後奉獻一己之力，研究、調查原住民以及漢人的傳統工藝，因此契機，他日後致力於推廣實用美術工藝，以及公開於都會街頭的馬賽克公共藝術；成為臺灣結合傳統手工藝與文創產業之先驅。這些臺灣青年去國懷鄉，在學習現代美術的過程中隨著視野漸開，時時刻刻反思、懷想如何提升殖民地臺灣的現代文化建設。他們背負著遠大的理想努力創作，不但是為個人力爭上游，更期許改變臺灣的社會風氣，凝聚整體新時代的文化認同並提升生活的美感質地。

留學生中有一位值得敬佩的優秀女性，臺灣第一位專業女畫家；新竹香山出身的陳進（1907-1998）。她於第三高女畢業後，在老師的鼓勵與父親的支持下前往東京學習日本畫，從十八歲開始直到戰爭結束，歷時二十年。陳進意識到身為殖民地新女性模範的榮耀與責任，始終兢兢業業努力創作。1934年她入選帝展一舉成名，同年11月前往屏東高女任教，每年授課一學期，持續三年之久。她決心學習原住民文化，並以排灣族人為題材進行創作，兩年後推出氣勢磅礴、本土特色鮮明的《三地門社之女》（圖5）再次入選帝展。

接著，值得比較的是同樣在東京受日本畫訓練，較陳進小十歲，卻只比她晚三年到東京求學的林之助（1917-2008）。他和陳進一樣出身於富裕的

persuaded his parents to let him leave his hometown and find another path in life.

Having a diploma from the Normal School should have been a promise of a bright future; but these artists gave up their teaching positions coveted by most people and dived into the world of artistic creation. However, Taiwanese people at that time were almost ignorant of the value of art-making, and even their family could not grasp the point of traveling to Tokyo or Paris to study art. After years of diligent learning, the artists still had to face the fact that culture and art were not of much importance back home as well as the torment of being unable to support themselves through art-making. With excellent artistic skills but no place to bring their talents into full play, their only chance was to earn a brief reputation in official art exhibitions. Chen Cheng-Po even had to drift again to Shanghai to seek opportunities to teach and create, only to return to Taiwan after a few years because of the looming Sino-Japanese War.

Embracing lofty ideals and aspiration, Huang Tu-Shui and Chen Chih-Chi died prematurely due to exhaustion at the prime of their creative life, whereas Chen Cheng-Po died in the political oppression of the February 228 Incident and was unable to realize his dream of continuing studying Western art, leaving only a comparatively small body of works behind. Yen Shui-Long, on the other hand, was eventually able to study in Paris depending on the support of a group of patrons and advances of painting commissions, and subsequently won the distinction of being showcased in the Salon d'Automne (Autumn Salon) after a hardworking year. However, he still scrimped and saved, leading a difficult and frugal life that almost caused his life due to a liver disease in the foreign land. Only a few artists, such as Chen Ching-Fen (1910-1987), Liu Chi-Hsiang and Yang San-Lang (1907-1995), were very lucky to have sufficient support from their open-minded and affluent parents, and were able to live without financial worries, and fully experienced overseas the colorful life afforded by the capital of art.

The first-generation Taiwanese art students studying in Japan also encountered racial discrimination. When he first arrived in Tokyo at twenty-years old, Huang Tu-Shui often had to deal with offensive questions asked by insensible Japanese regarding "the practice of head-hunting by barbaric aborigines in Taiwan," which he loathed deeply. He had consequently vowed to make Taiwan's natural environment and culture known to the world. His subject matter always featured Taiwan's idyllic landscape. Being the first Taiwanese sculptor, he once stated that the most arduous task in the world was being an artist. Day after day, he kept carving and hammering on stones, working ten times harder than other people. Even other Taiwanese students did not identify with or understand him. Nevertheless, he believed that life was bitter and transient, and as long as he could leave behind brilliant works featuring Taiwan's natural landscape, his soul could become immortalized. In the spring of 1931, Yen visited the International Colonial Exhibition in Paris, and was profoundly impressed by the beauty of primitive art. As he viewed and moved through the exhibition, a wish germinated in his mind: after he came back to Taiwan, he would devote his life to study and research about the traditional crafts and arts of the indigenous and Han communities. Because of this opportunity, he later endeavored in promoting applied arts and crafts as well as mosaic public art that could be seen in cities and streets, making him the pioneer of integrating traditional handicraft into the cultural and creative industry. These Taiwanese youths had left their countries but held their homeland dear in their mind. While learning modern arts, their vision was expanded as they continuously reflected on and yearned for the improvement of Taiwan's modern cultural construction. Shouldering lofty ideals, they dived into the world of art-making not only for their personal success but also for the hope of bettering the social atmosphere in Taiwan to solidify the cultural identity of the new era and to elevate the texture of aesthetic living.

Among these Taiwanese students studying abroad, there was a highly admirable and remarkable woman, who became Taiwan's first female painter in history. Born in Hsinchu's Xiangshan, Chen Chin (1907-1998) graduated from the Third Girls' Senior High School (now Zhongshan Girls' High School). Afterwards, with her teacher's encouragement and the support of her father, she travelled to Tokyo and began learning and exploring Japanese-style painting for two decades, from the age of eighteen to the end of the war. Chen had been aware of her own role as a model new woman from the colony, along with the glory and responsibilities that came with this role. Therefore, she had always been cautious and conscientious in artistic creation. In 1934, she made her reputation when her work was selected into the Teiten, and in the November of the same year, she began teaching at Pingtung Girls' Senior High School, where she taught one semester every year for three consecutive years. She was determined to study the indigenous culture, and picked topics of the Paiwan people as her subject. After two years of diligent

仕紳家庭，聰明乖巧，飽受父母師長的愛護。1939年從帝國美術學校畢業後，作品陸續入選日本畫院展、兒玉希望畫塾展，1940年《朝涼》（國立臺灣美術館藏）入選紀元二千六百年奉祝美術展，一舉成名。相對於前一批留學生，林之助並沒有繼續在日本奮鬥爭取更多展覽會成績的壓力，反而在1941年10月正式返鄉定居，在府展中連續取得特選榮譽，成為臺中畫壇的領導人物。這次展場中，創作年代僅相差七年的陳進《三地門社之女》（圖5）與林之助《好日》（圖6），同樣以描寫母女為主題，生活空間頗不相同；前者表現嚴謹而莊重，後者則顯得悠閒而不失自律，對比相當有趣。

總之，這些有志青年為克服殖民地臺灣學習環境的不足與美術館等資源的匱乏，前往日本甚至巴黎，窮盡心力研究新知識與技術，尋求突破的機會，塑造自我文化認同的形象，夢想有朝一日臺灣的藝術也能在世界的舞臺嶄露頭角。

1920年代，當臺灣第一代藝術家前仆後繼地遠赴他鄉，學習藝術之際，我們也不能遺忘此時旅居在臺灣創作、教學的日本美術家石川欽一郎（1871-1945）與鹽月桃甫（1886-1954）。石川欽一郎於1907年初次抵達臺北，任職總督府陸軍部，最後成功轉型為專業美術教育家，以明亮、秀麗的水彩畫風廣受歡迎。他主要任教於臺北師範學校，並熱心組織課外習畫班，推動水彩畫創作與公開美術展覽，積極投身演講活動，在臺灣掀起一場現代美術文化運動。鹽月桃甫曾入選日本文展，1921年來臺，任教於臺北的中學、高校，直到戰爭結束被遣返歸國。他深入臺灣

高山，讚嘆其神聖性，驚訝於原住民保存了不受現代社會污染的文明，認為是臺灣珍貴價值的根源。兩位雖在中等學校美術老師的職位上無法培養很多專業畫家，然而，他們都曾殷切地鼓勵有志學生以創新觀點勇敢描繪家鄉的風光，留下青春的圖像。1927年，兩位畫家偕同文教局、教育會與民間代表等，籌備臺灣美術展覽會，此即我們熟悉的臺展、府展制度的開端。

最後，臺灣美術史上還有一位重要的盟友：立石鐵臣（1905-1980）。立石出生臺北，小學三年級才隨父親遷返日本。按照他自己的說法，壯年盡情揮灑創作油畫的充實歲月都在臺灣度過，也由於接觸到臺灣風光，才確立前半期的畫風。1933年起，他以臺灣風景為題材的作品受到臺灣及日本畫壇的矚目；1934年在臺北參加臺陽美術協會創立，1939年定居臺北，直到戰後1948年被遣返為止。

今天檢視這段臺灣早期美術史，不禁令我們深深為之動容。這些年輕藝術家決心破釜沉舟，衝破殖民社會的種種限制，飄泊異鄉，勤奮學習，努力創造臺灣新時代的青春圖像，他們熱愛鄉土、勇敢無畏的精神分外值得我們敬佩與效法。

work, she presented the magnificent *Woman of Sandimen* (fig. 5), which was highly emblematic of regional characteristics and was again showcased in the Teiten.

Lin Chih-Chu (1917-2008), who also studied nihonga in Tokyo, was a good example to compare with Chen Chin. Ten years younger than Chen, Lin came to study in Tokyo only three years later than his female predecessor. Like Chen, he grew up in an affluent gentry family. A smart, docile child, he was loved and cared for by his parents and teachers. After graduating from Teikoku Art School (Imperial Art School) in 1939, his works had been featured in the Inten (Exhibition of Japan Visual Arts Academy) and the studio exhibition of Kodama Kibo. In 1940, his *Bathing in the Morning* (collection of National Taiwan Museum of Fine Arts) was selected into The Art Exhibition Celebrating the 2600th Year, which made his fame in the art scene. Unlike the previous generation of Taiwanese students in Japan, Lin did not have the pressure to stay in Japan and strive to be seen in more art exhibitions. Instead, he chose to move back to Taiwan in October 1941. Since then, he had continually won the honor of Special Selection Prize in the Futen (Taiwan Governor-General's Office Art Exhibition) and became a leading figure in Taichung's painting circle. On view in this exhibition are Chen Chin's *Women of Sandimen* (fig. 5) and Lin's *Nice Day* (fig. 6), which were created only seven years apart and both featured the subject of mother and daughter, albeit in utterly different living environment. The former looks conscientiously painted and dignified, whereas the latter seems leisurely but not without self-discipline, forming an interesting comparison.

In short, these aspiring youths had overcome the issues of inadequate learning environment and resource, such as art museums, in colonial Taiwan, and travelled to Japan and even Paris, where they endeavored with all their might to acquire new knowledge and techniques for a chance of making breakthroughs while shaping the image of their cultural identity and hoping that Taiwanese art could one day shine brightly on the world stage.

In the 1920s, while the first generation of Taiwanese artists were successively traveling abroad for art education, we should not forget the Japanese artists who had journeyed to Taiwan and settled down on this island, among whom were Ishikawa Kinichiro (1871-1945) and Shiotsuki Toho (1886-1954). Ishikawa arrived in Taipei in 1907. He first served at the Army Division at the Office of Taiwan Governor-General before

successfully reinventing himself as a professional art educator that was widely popular for his bright-colored, refined watercolors. He mainly taught at Taihoku (Taipei) Normal School, and was enthusiastic in organizing extracurricular painting classes to promote watercolor painting and public art exhibitions. He was active in giving lectures and speeches, igniting a modern art and cultural movement in Taiwan. Shiotsuki's work had been selected into Japan's Bunten (Ministry of Education Arts Exhibition). He arrived in Taiwan in 1921, and taught in junior and senior high schools in Taipei until he was deported back to Japan after the war. He had explored Taiwan's high mountains and was amazed by their sublime and sacred presence while being surprised by how the indigenous community had preserved their culture untainted by modern society, which he believed to be the root of precious Taiwanese value. The two artists, though could not nurture many professional artists as junior high school art teachers, had ardently encouraged aspiring students to portray the landscape of their homeland with fresh perspectives and create the images from their youth. In 1927, they had also joined Taiwan's Bureau of Culture and Education, the Taiwan Education Association and other civil representatives to organize the Taiwan Fine Art Exhibition, which marked the beginning of the Taiten and Futen (Taiwan Governor-General Art Exhibition) that we have become familiar with today.

Lastly but importantly, there was another crucial ally to Taiwanese art history, whose name was Tateishi Tetsuomi (1905-1980). Tateishi was born in Taipei and only moved back to Japan with his father when he was a third-grader. According to the artist, his years of freely creating oil paintings during his prime were all spent in Taiwan, and his painting style in the first half of his career was established because of his immersion in the Taiwanese landscape. In 1933, he caught the attention of both the Taiwanese and Japanese painting circles with his works featuring Taiwanese landscape. In 1934, he partook in the establishment of Tai-Yang Art Association. He had lived in Taipei since 1939 until he was deported after the war in 1948.

Looking back upon this early period of Taiwanese art history today, one cannot help but feeling deeply moved. These young artists, with adamant resolution, had shattered the limitations of the colonial society, enduring the life of drifting in foreign lands while diligently learning to create the images of their youth in a new era of the Taiwan history. Their fervent love for their homeland and fearless spirit have made them a role model for all Taiwanese.

黃土水 HUANG Tu-Shui（1895-1930）
少女 Bust of a Girl

大理石雕 Marble, 28.0 x 35.0 x H50.0 cm, 1920
臺北市太平國小典藏 Collection of Taipei Municipal Taiping Elementary School

1920年3月24日，位於日本上野公園的東京美術學校舉行畢業典禮，隔日舉辦向大眾展示的「畢業製作陳列會」。其中，時年二十五歲的臺灣青年黃土水，也在雕刻科木雕部畢業生之中，成為第一位畢業於東京美術學校的臺灣人。《少女》胸像是他製作的畢業作品，日文原名為《ひさ子さん》。

模特兒少女肩上披著毛皮披肩，下身穿著和服，頭髮在背後以蝴蝶結綁起，看似位家庭十分富裕的日本女兒，也帶著一種日本大正時期（1912-1926）的摩登情趣。黃土水為了刻出物體質感而相當費心，相對於毛皮之捲毛，頭髮部分刻了一條條極細的直線，臉頰表面光滑完美；雖然使用大理石，卻能呈現出非常柔滑的皮膚彈性。除了這些細部功夫外，整體的造型，從任何角度來看皆為完整，使觀者感到寧靜的人體重量。

收藏此件作品的太平國小，前身為日治時期創設的大稻埕公學校，黃土水於1911年3月從該校畢業，且在1915年3月國語學校畢業後至赴日前的半年，在此母校擔任教導。1920年10月日本皇族久邇宮邦彥王夫婦來訪臺灣，《臺灣日日新報》報導該月29日下午久邇宮夫婦參訪大稻埕第一公學校（該校於1917年改稱大稻埕第一公學校，1922年又改名太平公學校），看到黃土水製作的大理石「少女半身像」（文獻，頁245）。因此可以推測，黃土水於1920年3月東美校畢業後，同年這件作品就被學校收藏著。1920年秋天黃土水入選日本帝展，作為第一位入選帝展的臺灣藝術家，開始露出檯面。這件作品，是他還是位無名年輕學生時所製作，但其石雕技術已足夠成熟，刻畫出具有清爽氣質的一位少女，堪稱他短暫卻光輝之創作生涯的出發點。（鈴木惠可）

On March 24th, 1920, Japan's Tokyo Fine Arts School located in Ueno Park held the graduation ceremony. A graduation exhibition opened to the public the following day. Huang Tu-Shui, a twenty-five-year-old young Taiwanese artist was also a graduate of the wood sculpture class of the sculpture department, making him the first Taiwanese to graduate from Tokyo Fine Arts School. This bust titled Girl was his graduation work. Its original Japanese title was *Hisako-san* (ひさ子さん).

The model wears a fur shawl over the shoulders and a kimono underneath. Her hair is tied up with a bow in the back. She seems to be a daughter of a wealthy Japanese family. Her style is typical of the Taishō era(1912-1926) with a modern touch. Huang took great care to characterize the texture of objects: the curly hair of the fur, the fine straight lines of the girl's hair, and the smooth skin on her face. While the sculpture is marble, the skin appears smooth and plump. Besides the meticulous details, the overall presentation of the piece looks complete in every angle. Its human quality evokes a sense of serenity.

This sculpture is part of Taipei Municipal Taiping Elementary School's collection. The school was founded during the Japanese

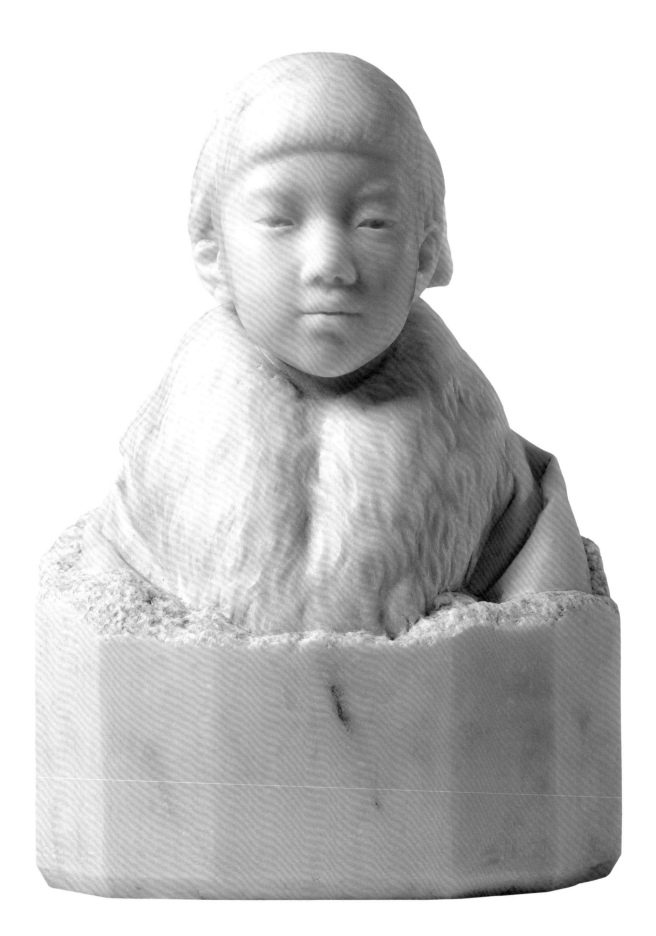

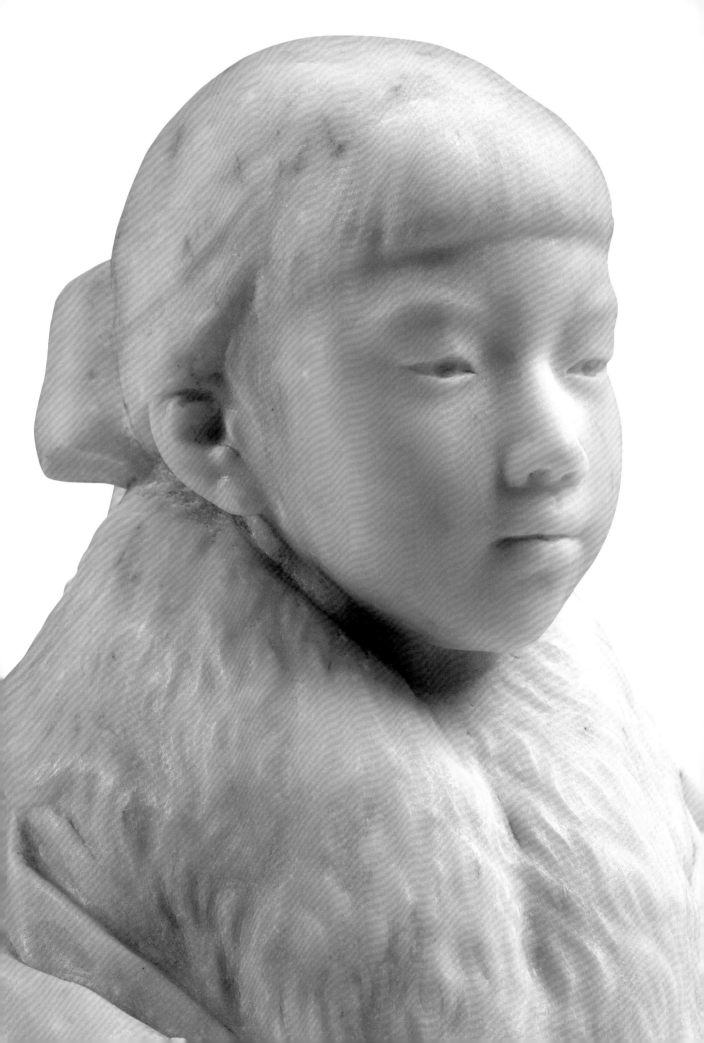

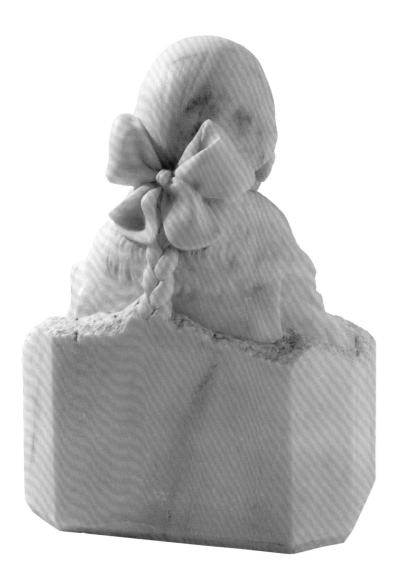

rule and named Daitōtei Public Elementary School at the time. Huang graduated from here in March 1911 and also taught here for half a year before he left for Japan after he graduated from the National Language School (Kokugo Gakko) in March 1915. In October 1920, members of the Japanese imperial family, Prince Kuni Kuniyoshi (Kuni-no-miya Kuniyoshi) and his wife visited Taiwan. According to the news on *Taiwan NichiNichi Shinpo*, the imperial couple visited Daitōtei First Elementary School (the school was renamed Daitōtei First Public Elementary School in 1917, and again renamed Taiping Public Elementary School in 1922), and saw the marble sculpture,

Girl, by Huang (Documents, p. 245). Therefore, It can be thus assumed that the school obtained this piece the same year after Huang graduated from Tokyo Fine Arts School in March 1920. Huang was selected for the Japan Imperial Art Exhibition (Teiten) in the fall of 1920, and emerged in the art scene as the first Taiwanese to be selected for this exhibition. Huang was still an unknown young student when he created this sculpture, but his stone carving techniques were already mature enough to portray a lovely young girl. This sculpture marked the beginning of his brief yet brilliant career. (SUZUKI Eka)

鹽月桃甫 SHIOTSUKI Toho (1886-1954)
萌芽 Budding

油彩、畫布 Oil on canvas, 65.5 x 80.5 cm, 1927
私人收藏 Private Collection

鹽月桃甫從1921年渡臺至戰後被遣返日本，有四分之一個世紀以臺灣為家，孜孜不倦地以臺灣為主題創作出無數佳作。其龐大的作品群戰後散逸，傳世的戰前作品極少。鹽月參加臺府展的三十一件作品，向來都只能從圖錄的黑白照片來想像其原貌。新發現的《萌芽》不僅是目前所知唯一倖存的臺府展作品，還是特地為首屆臺展繪製的大作，深富歷史價值。就色彩而言，從當時的畫評可知鹽月的用色享負盛名，此畫終於讓我們一睹其設色用筆技巧的真貌。從題材角度視之，該作的「出土」凸顯了風景畫在鹽月作品群中的重要性，提供珍貴的線索來探討風景畫對鹽月的意義。鹽月其實創作過諸多風景畫。除了原住民主題外，臺灣風土也是鹽月表達心目中臺灣形象的重要題材。

本件左下角署名「Siotuky 1927」，背後畫框以紅字記有畫名「芽ぐむ」（萌芽）。據鹽月弟子們所述，此畫描繪臺北植物園內一景，臺展後長年展示於老師執教的臺北高等學校（今國立臺灣師範大學），為師生們所熟知。事隔九十餘年，植物園歷盡滄桑，但池子的位置基本沒有改變。依據1935年植物園出版的《臺北植物園》一書，及林業試驗所生物系呂錦明前主任賜教，確定畫中景點為植物園臘葉館東邊的水池，是由池子南岸描繪東北邊池岸的景色。判斷根據除了水池、土堤的方向外，右上角背景的赭紅色部分也提供了決定性的線索。上述《臺北植物園》提到，水池北邊隔著小路微偏東邊的地點有一時髦的建築，是會議室。這棟有赭紅色傾斜屋頂的建物目前已不復存在。

畫面中的常青植物綠意盎然，不過鹽月的構圖聚焦於中心裸露的落葉木樹幹、樹枝，烘托出早春萌芽，新芽若隱若現、生機萌動的氣息，象徵初生的臺展，傳達畫家對臺灣美術所抱之希望。鹽月替此首展所寫的評語，也用「萌芽」來形容參展作品朝著目標伸展、成長的氣魄。（呂采芷）

From traveling to Taiwan in 1921 to being deported back to Japan, Shiotsuki Toho lived in Taiwan for a quarter of a century and had steadfastly created many excellent works featuring topics related to Taiwan. Most of his works were however lost after the war, and only a few created before the war were preserved. Thirty-one of Toho's works were featured in the Taiten (Taiwan Fine Art Exhibition), and we have only been able to imagine what the original works would look like based on black-and-white images in the exhibition catalogues. This newly discovered *Budding* is not only the only of Toho's works featured in Taiten, it was also a large piece specifically painted for the official exhibition, giving this work much historical value. Based on the art reviews from that period, Toho was highly praised for his use of colors, and this work finally gives contemporary audience a chance to observe his techniques of using colors and brushwork. In terms of the subject matter, the "unearthing" of this piece highlights the importance of landscape in Toho's oeuvre and provided valuable clues to further study the significance of landscape for the artist. Toho had painted many landscapes. Apart from indigenous subject matter, therefore, Taiwan's landscape was a crucial topic for the artist to visualize the image of Taiwan in his mind.

The lower left corner of the painting was signed with "Siotuky 1927," whereas the artwork title, Budding ("芽ぐむ"), was written at the back of the frame. According to Toho's pupils, the work depicted a scene in the Taipei Botanical Garden. After it was showcased in the Taiten, the painting had been displayed in Taihoku High School (now National Taiwan Normal University),

and both the faculty and students were familiar with this piece. Since then, ninety years have passed and the botanical garden underwent much change, but the location of the pond has basically remained the same. According to the 1935 publication, *Taipei Botanical Garden*, and information provided by Lu Chin-Ming, the former director of the Biology Department under the Forestry Research Institute, it is confirmed that the pond in the painting is the one on the eastern wing of the Herbarium in the botanical garden. The artist would have stood on the southern edge of the pond to delineate the view of the northeastern edge. In addition to the direction of the pond and its bank, the ocher red portion on the upper right corner in the image also serves as a decisive clue. In the above-mentioned *Taipei Botanical Garden*, there was a rather modern architecture located slightly to the east of the pond, next to

the nearby path—it was the conference hall with a ocher red, slant rooftop. The building no longer exists today.

In this painting, the perennial plants were lush and thriving. However, Toho placed the focal point of the composition on the exposed trunks and branches of deciduous trees, a way to foil the budding season of the early spring, conveying a lively atmosphere when fresh sprouts were about to reveal themselves. It symbolized the newly launched Taiten as well as the artist's expectation of Taiwanese art. In his comment for the first Taiten, Toho also described the selected works as "buds" that were reaching their goals and demonstrating the force of growth. (Jessica Tsaiji LYU-HADA)

石川欽一郎 ISHIKAWA Kinichiro (1871-1945)
河畔 Riverside

油彩、畫布 Oil on canvas, 116.5 x 90.5cm, 1927
阿波羅畫廊收藏 Collection of Apollo Art Gallery

如果說，日本江戶時期（1603-1867）流行徒步旅行的驛站美術，例如歌川廣重（1797-1858）的浮世繪《東海道五十三次》描繪從東京日本橋出發到京都，沿途驛站風光；那麼，明治時期（1868-1912）水彩畫流行的主題則是航海美術。日本結束鎖國政策後積極接受西方文明，畫家們也紛紛旅行歐亞大陸，學習新知識，記錄各地風情。在

《石川欽一郎古寫真相冊》，私人收藏，李梅樹紀念館提供

此大變動的時代，還有些舊政府的官僚士族被驅離中央，來到殖民地臺灣旅行、工作。

石川欽一郎1907年抵達臺北，任職於總督府陸軍部，擔任通譯官，最後成功轉型成為美術教育家，並以明亮、秀麗的水彩畫風廣受歡迎。他積極組織課外習畫班，推動水彩畫創作，更舉行美術展覽、演講活動，在臺灣掀起一場現代美術文化運動。

1927年他參與籌備首屆臺灣美術展覽會，擔任審查人，也繪製三幅作品，其中最大的是這幅《河畔》，描繪從萬華向大稻埕望去的淡水河風光，紫色的大屯火山群橫踞遠方，氣勢雄偉。天空翻騰的白雲與河面開闊的光影變化是這幅畫的視覺重點，右岸的紅色帆船在光影間散發出異國情調。《河畔》當年在展場上就被點名收藏；1945年8月日本天皇宣布戰敗，這幅畫輾轉出現在街頭路邊日本人鋪草蓆賣家當的攤位上。幸而一位明眼的周姓醫師認出它的價值，毫不猶豫地買下，此畫遂珍藏在診所超過半個世紀。（顏娟英）

If the popular artistic trend during Japan's Edo period (1603-1867) was "the art of station" featuring the various stations in wayfarers' journey, such as *Fifty-three Stations on the Tokaido*, a series of ukiyo-e woodcut prints by Utagawa Hiroshige (1797-1858) that depicted the sceneries between Tokyo's Nihonbashi to Kyoto, the widely favored watercolor theme in the Meiji period(1868-1912) would certainly be "the art of seafaring." After the isolationist foreign policy in Japan was ended, the country opened up to the West, and many Japanese painters had travelled to Europe, where they learned new knowledge and recorded local

sceneries and customs. In such vicissitudinous era, some of the bureaucrats and officials from the old government, banished from the central government, had toured or worked in colonial Taiwan.

Ishikawa Kinichiro arrived in Taipei in 1907. He was first appointed as an interpreter officer under the Army Division in the Taiwan Sotofuku (the Office of Taiwan Governor-General). Later, he successfully reinvented himself and became an art educator, who was well-received for his bright-colored, refined watercolors. He was also active in organizing extracurricular classes to promote

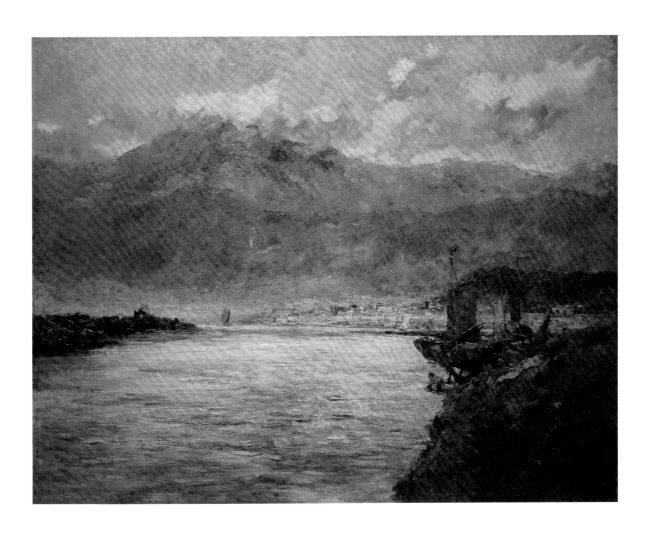

watercolor painting, presenting art exhibitions and giving lectures, and consequently prompted a modern art and cultural movement in Taiwan.

In 1927, he joined the preparation for the first Taiten, in which he was a reviewer. He also created three paintings for the exhibition, among which the largest one, *Riverside*, portrayed the landscape of Tamsui River seen from Wanhua (Monga) towards Dadaocheng. In the work, the purple Datun Volcano Group lay in the distant background in a majestic, awe-inspiring manner. The surging white clouds and the varying light bouncing back from the expansive river's surface constituted the painting's focal point, while a red sail on the glistening water close to the right bank added an exotic feel to the painting. *Riverside* was selected and acquired when it was still on view in the exhibition. After the Emperor of Japan announced Japan's surrender in the war in August 1945, the painting appeared on a straw mat on the streets, where Japanese were monetizing their possessions. Fortunately, a doctor, whose family name was Chou, recognized the painting's value with a discerning eye and purchased it right on the spot without any hesitation. Since then, the painting has been treasured and preserved in the doctor's clinic for over half a century. (YEN Chuan-Ying)

陳植棋 CHEN Chih-Chi (1906-1931)
淡水風景 Tamsui Landscape

油彩、畫布 Oil on canvas, 73.0 x 91.0 cm, 1925-1930
家屬收藏 Collection of Artist's Family

陳植棋是臺灣早期畫壇中猶如流星般一閃而逝的畫家，在他不過數年的繪畫生涯中，留下了不少令人印象深刻的作品，在家屬的細心保管下，才能留存至今。本件作品是陳植棋淡水風景中的代表作，在本次開展前特別修復，恢復畫作原有的風采。

據家屬所述，作品是在陳植棋的連襟林煇焜宅所繪。林煇焜出身淡水望族，他本人也是長篇小說《命運難違》（1933）的作者。林宅位於重建街的協興段，由於道路拓寬房屋拆除，昔日光景已難追尋。不過，透過陳植棋的畫作，可引領觀者回到過去。從林宅眺望出去，眼前是三層厝街依山而建層層疊疊的聚落。左方的紅色磚樓與遠方的紅樓相呼應，隔著淡水河，觀音山優雅的身姿映入眼簾。

淡水依山傍河，在十八世紀已成為詩文吟詠的題材。此地「如畫般」的風景，也是畫家最熱門的寫生聖地。日治時期畫家曾將淡水與塞尚（Paul Cézanne，1839-1906）描繪的南歐山城疊合起來。1934年的文章中也曾這麼形容淡水：「天空如南歐般地蒼藍，海如地中海般地紺碧……，山上有白雲的建築，河上有波浪的舞踏，夏天的淡水風光，如畫、如詩。鮮紅色的城堡中蘊含了豐富的歷史，灰色的廢墟中有著多變的傳說。」

陳植棋描繪淡水的黃昏時刻，夕陽映照在紅色磚牆與屋頂上，閃閃發光。水面與山坡上，也可見到對於光線的細緻描寫。褐色的屋瓦與紅色磚屋，搭配上綠樹，形成了典型的臺灣風光。陳植棋喜愛野獸派色彩鮮明的大膽畫風，不過，後來他也開始研究塞尚風格，在本件作品中，也可見到他重視建築物與空間結構之間的關係。不過，陳植棋並不強調淡水的歐風意象，而是以臺灣的傳統建築為基調，創造出一片自然與人文交響的和諧風景。（邱函妮）

Among the early Taiwanese painters, Chen Chih-Chi was like a shooting star that shone briefly but brightly. In his painting career of merely several years, the artist left the world with quite a few impressive works, which have been carefully preserved by his family and kept until today. This work is one of Chen's iconic pieces featuring the landscape of Tamsui, and has been specially restore to regain its former glory.

According to Chen's family, this work was painted at the residence of the artist's brother-in-law, Lin Hui-Kun. Lin grew up in a well-known family in Tamsui, and was the author of the novel, *Inviolable Destiny* (1933). The Lin residence was located in Chongjian Street's Xiexing Section, and had been demolished due to a road-widening project; so, it is now impossible to revisit this scene of the past. Nevertheless, Chen's painting has enabled the spectator to have a glimpse of the bygone days. Looking out from the Lin's residence, one could see that the clusters of houses in San-Tseng-Tso were built in keeping with the mountain's terrain. The redbrick Western-style house on the left echoed the Red Castle in the background, and across Tamsui River was the elegant and dignified Guanyin Mountain.

Tamsui, in the embrace of mountains and rivers, was already a celebrated subject in the 18th-century poetry and literature. Its

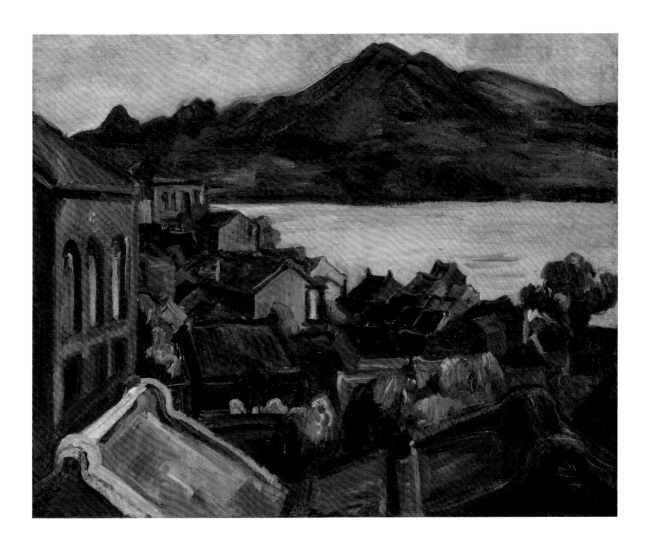

picturesque scenery has also made it a hotspot for painters who came here to sketch and paint. Painters in the period of Japanese rule once compared the local landscape to the Southern European mountain villages depicted in the works of Paul Cézanne (1839-1906). In an article of 1934, its author described Tamsui in the following words: "The sky was cerulean like that of Southern Europe, and the ocean was as azure as the Mediterranean Sea… Up on the mountains were buildings below white clouds, and down the hills were rippling waves on the river. The Tamsui landscape in summer was like painting and poetry. The sanguine-colored castle spoke rich history, and in the gray ruins housed varied legends."

Chen portrayed the dusk hours in Tamsui when the glimmering sunset bounced on the red brick walls and rooftops. From the water surface and hillsides, one could observe how the painter elaborately delineated the light. The combination of brown roof tiles, redbrick houses and green trees formed a typical Taiwanese scenery. Chen admired the Fauvist bold style characterized by vibrant colors, but he had also studied Cézanne's style later. This painting also reveals his emphasis on the spatial relationship between the depicted buildings. However, Chen did not focus on Tamsui's European image but rather using traditional Taiwanese buildings as his foundation to create a harmonious landscape interwoven with nature and culture. (CHIU Han-Ni)

陳進 CHEN Chin (1907-1998)
三地門社之女 Women of Sandimen

膠彩、絹 Gouache on silk, 147.7 x 199.9 cm, 1936
福岡亞洲美術館典藏
Collection of Fukuoka Asian Art Museum

1920年代，臺灣新女性若想出人頭地，必贏得父母親全力支持為後盾，同時需具備堅毅婉約的個性，摒除世間人的萬般議論，推遲婚姻大事，有如修行者般勇敢守護自己的信念，卯足全力學習方得成就。勇猛精進的畫家陳進便是出身殖民地臺灣，屹立不搖的唯一女性代表畫家。

1934年她以《合奏》入選帝展日本畫部，成為臺灣第一人。畫中貴婦身形曼妙，是畫家以姊姊為模特兒所畫；事實上，陳進更常自己充當相機前的模特兒，反覆研究如何擺出高雅動人的姿勢入畫。畫家因入選帝展一舉成名，卻在同年11月前往屏東高女，每年授課一學期，持續了三年。她下決心，創作

當地排灣族人題材，以臺灣特色向日本畫壇進軍。這幅畫主題為母愛，畫面核心為母親哺乳，其旁環繞著三位老少，畫家以拿手的美人畫技法，一絲不苟地描繪她們深邃的五官，明亮的大眼睛。雖然少了華貴的家具與飾品，她們穿著部落素樸的長衣，姿態端莊優雅，宛如身在淨土中。巨大的畫作乃是畫家經過無數次與模特兒協調，逐一速寫、修正、攝影，構圖打稿、拼貼修改，接著在紙本畫出大幅底稿（文獻，頁290-291），確認無誤後，返回東京，借用上野公園內寺院的大廣間作為工作室，將底稿貼在白絹布背面，描出輪廓，再認真上色，才終於完成，並且打動審查員，入選文部省美術展。（顏娟英）

During the 1920s, if a modern Taiwanese woman wanted to have a successful career, she would need the full support from her parents. She would also have to be strong and resilient against criticisms from society. She would have to delay marriage and defend her own beliefs with near-religious fervor while working tirelessly to achieve success. Chen Chin is a shining example of this. Tough and relentlessly diligent, Chen was the only female painter raised in colonial Taiwan and was able to create a lasting legacy for herself.

In 1934, Chen Chin's *Ensemble* was the first of Taiwanese artists to be selected for the Japanese-style paintings (nihonga) of the

Japan Imperial Art Exhibition, or Teiten. The slender-figured women in the painting were modeled after her sister. In fact, Chen Chin often doubled as her own model in front of the camera and studied meticulously how to pose with elegance. She rose to prominence after being selected for the Teiten but decided to teach at Pingtung Girls' Senior High School in November that year. She taught one semester each year for three years. She was determined to paint the local Paiwan indigenous people and introduce Taiwan's culture to the Japanese art scene.

The subject matter of this painting is maternal love. The mother feeding her baby is at the center and surrounded by two children

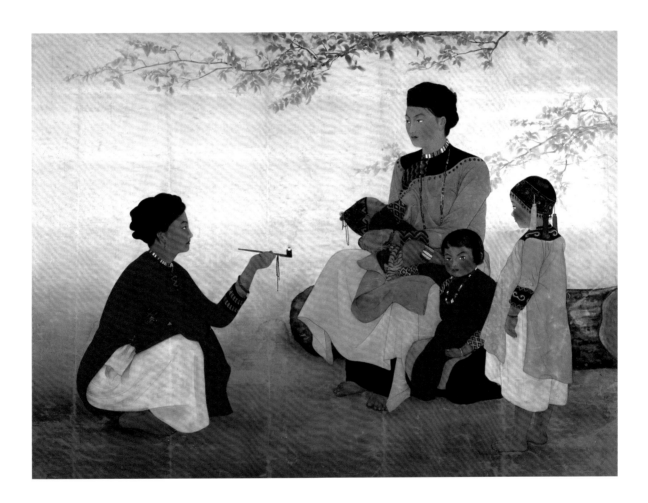

and an adult. Chen is a master of the Japanese bijinga (paintings of beautiful women) techniques and portrays the defined facial features of these female subjects in great detail, in particular, their bright eyes. They are wearing traditional robes of their community with grace and elegance, as if they were living in a paradise. The giant painting was completed after repeatedly communicating with the models to draw sketches of each person, make revisions and take photographs before drafts were created, arranged and modified(Documents, pp. 290-291). After that, a draft of the group was drawn on paper and verified. After returning to Tokyo, Chen borrowed a large studio of the temple inside Ueno Park, where the large draft was stuck onto the back of the silk canvas. The outline was traced on the front side and then colored meticulously to complete the final work, which impressed the reviewing committee members and was selected into the Bunten (Japan's Ministry of Education Arts Exhibition). (YEN Chuan-Ying)

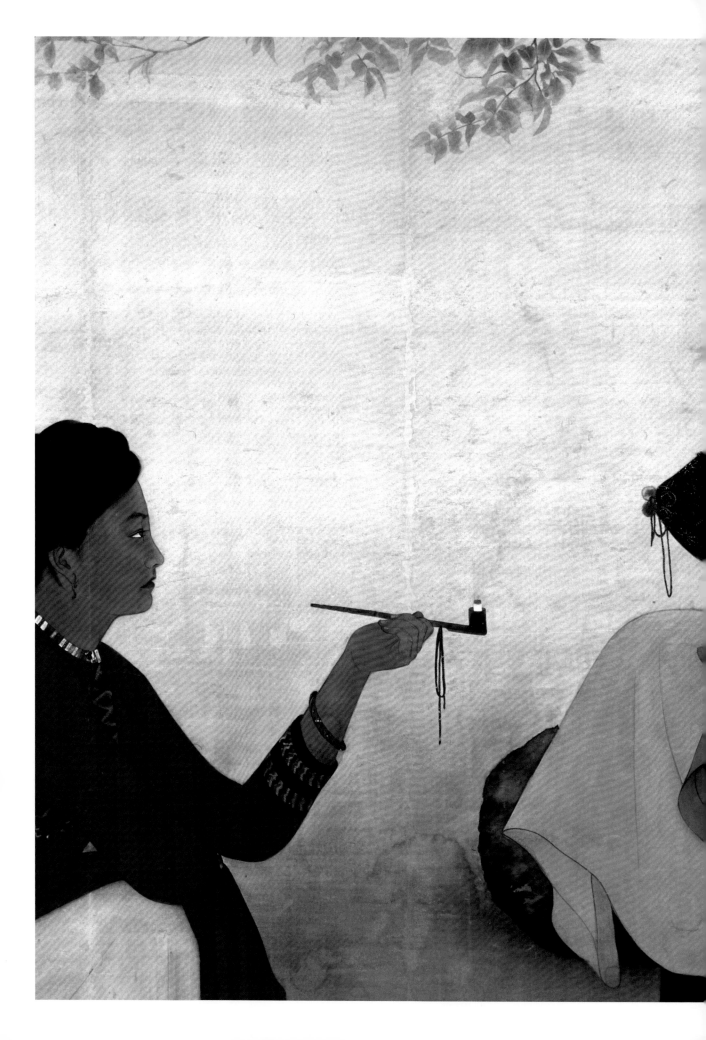

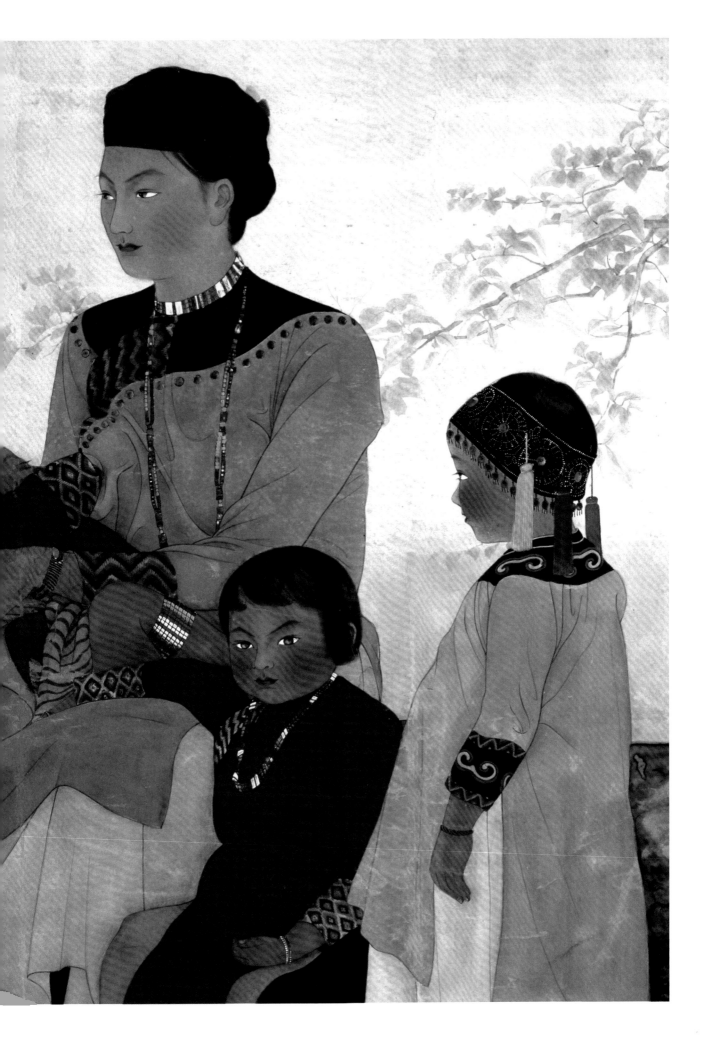

林之助 LIN Chih-Chu（1917-2008）
好日 Nice Day

膠彩、紙 Gouache on paper, 165.0 x 135.0 cm, 1943
私人收藏 Private Collection

林之助出生於臺中大雅。十一歲隨同兄長赴東京求學，兩人又先後進入帝國美術學校日本畫科學習，畢業後再師從兒玉希望（1898-1971）。畫家成長於大正時期（1912-1926）富有的鄉紳家庭，喜好音樂、美術、舞蹈；身手柔軟靈巧，性情溫和。1940年春天返鄉度假時，在母親的安排下結識了理想的另一半，從此生活中的妻子經常成為畫家創作的靈感來源。

年輕母親著剪裁俐落的改良式臺灣衫，帶著幼小的女兒上街買菜，女兒也許累了，丟下手中的扶桑花，撒嬌要求母親抱她。任憑女兒用盡全力拉扯她的右手，母親兀自站立不動，耐心等待女兒平靜下來，理性溝通的時刻。構圖上直線與斜線併陳的張力，不僅出現在兩人身軀的動線，也體現於母女雙腳對峙的姿勢；尤其女兒穿著紅色木屐，雙腳前後交錯，活潑有力。母女衣著時髦，飽滿的藍黃色調和諧互補，而兩人裙襬的波動則蕩漾著柔和的旋律；一旁地上的花朵像是從容等待再度被撿起的瞬間。在簡潔穩定的構圖中，觀眾隨著畫家兼父親細膩關愛的眼神，自在地融入平凡生活中的點滴幸福。這幅畫入選最後一回府展特選，並獲得總督賞的最高榮譽。（顏娟英）

Lin Chih-Chu was born in Daya, Taichung, and started studying in Tokyo with his elder brother at the age of eleven. Afterwards, they were both accepted in the Nihonga Department of Teikoku (Imperial) Art School, and studied with Kodama Kibo (1898-1971) after graduation. The artist grew up in a wealthy gentry family during the Taisho period (1912-1926). He liked music, art and dance; he was also supple and agile, and had a temperate temperament. When he returned home for vacation in the spring of 1940, he met an ideal partner in life through his mother's arrangement. Since then, his wife became a source of inspiration for the artist.

In this painting, the young mother wore a modified Taiwanese costume that had a well-executed cut, and took her little daughter out for grocery shopping. The toddler was probably tired and threw away the hibiscus flowers in her hands, willfully asking her mother to carry her. Despite the daughter's pulling on her right hand, the mother stood adamantly and patiently waiting for her daughter to calm down and to be reasoned with. The compositional tension created with juxtaposing vertical and slant lines, which are shown by the figures' physical movements as well as the feet of the mother and daughter who are clearly in a standoff. The daughter wearing a pair of red geta (Japanese wooden clogs) had one of her feet in the front and one at the back, looking vivacious and strong. The mother and daughter both dressed stylishly. The saturated blue and yellow complemented each other in a harmonious manner, and the fluttering hems of their clothing conveyed a sense of rhythm. The flower on the ground composedly awaited the moment to be picked up again. In this simple, stable composition, the spectator seems to follow the affectionate eyes of the fatherly painter and naturally perceive the happiness of everyday life. This painting was selected into the last Futen (Taiwan Governor-General's Office Art Exhibition), and was awarded the highest honor of the Governor-General Prize. (YEN Chuan-Yin)

47

顏水龍 YEN Shui-Long (1903-1997)
港風影 Harbor Winds and Shadows

油彩、畫布 Oil on canvas, 65.0 x 80.0 cm, 1932
國立臺灣博物館典藏 Collection of National Taiwan Museum

1909年，顏水龍六歲時父母親雙亡，幼年開始過著自律嚴謹的孤單生活。從臺南教員養成所畢業後，任教母校下營公學校。兩年半後他前往東京打工留學，1929年從東京美術學校西洋畫研究科畢業。面臨畢業即失業的痛苦，他考慮到高山上擔任警察，認識臺灣原住民部落文化，後來接受師長的援助，前往巴黎留學。

在異鄉盤纏有限，他連賴以生存的麵包都要節制地取用，卻仍每天勤奮地學習。畫家物質與創作兩頭煎熬，1931年終於以《蒙特梭利公園》（臺北市立美術館藏）、《少女》入選秋季沙龍；然而不久卻因為過勞又營養不良而病倒。朋友介紹他到南部氣候溫和的坎城，寄宿在法國人家裡接受照顧，療養身體。

這幅是畫家初到此地的作品。冬天安靜祥和的海岸，停泊著許多遊艇；三三兩兩的居民帶著小狗出來散步。背對著遼闊的海天，前景三位旅人停下腳步若有所思。中央的金髮少女身形瘦削，表情溫柔，臉向前望著地面；左邊側身戴漁夫帽的少年肩披格子圍巾；兩人身軀迫近畫面，緊緊倚靠著，色調黯淡而沈重。相形下，右邊與他們略有些距離的少女身形嬌小，著金黃色洋裝，溫暖而輕盈。在他們背面海岸線與地平線之外，還有縱橫交錯的道路，地面被切割而分裂。旅人內心期待著溫暖，現實卻令人徬徨。（顏娟英）

Yen Shui-Long lost both of his parents in 1909 when he was six years old, and therefore lived a self-disciplined, solitary life since childhood. After graduating from Tainan Teachers' Training School, he became a teacher at his alma mater, Xiaying Elementary School. Two and a half years later, he headed for Tokyo, where he continued to work while studying, and graduated from the Western painting class of Tokyo Fine Arts School in 1929 . Graduation also meant facing the harsh reality of finding employment. Yen mulled it over to become a police officer in the mountain area and learn the culture of Taiwan's indigenous communities. He later received aid from his teachers and studied in Paris.

With limited means in the foreign country, Yen even had to restrain his daily consumption of bread. Yet, he worked diligently every day to advance his learning. In 1931, the struggling artist's two paintings, *Montsouris Park* (Collection of Taipei Fine Arts Museum) and *Portrait of a Young Girl* were selected for Salon d'Automne, the annual art exhibition held in Paris. Soon after that, he fell ill due to exhaustion and malnutrition. With the help of friends, he moved to mild-weathered Cannes in southern France, where he stayed with a French family while recuperating.

Harbor Winds and Shadows was one of Yen's first paintings after he

arrived in Cannes. The coast is quiet and serene in winter. Many yachts are docked here. Some local residents are out walking their dogs. With their back to the vast sky and sea, the three travelers in the foreground seem pensive as they made a stop. The blond girl in the middle has a slender figure and a tender look on her face. Facing forward, she is looking down on the ground. The young man on the left is wearing a fisherman's hat and plaid scarf. Depicted in dull and somber colors, he and the young girl, leaning close to each other, are placed quite near to the viewer. In contrast, the girl on the right is farther apart from them. She is petite and wearing a golden yellow dress, and her image is warm and light. In the background, the coastline and the horizon extend, and so the crisscrossing streets, seemingly dividing the ground. The travelers look forward to warmth but feel unsure in the face of the reality. (YEN Chuan-Ying)

顏水龍 YEN Shui-Long (1903-1997)
明妮莉小姐 Mlle Minelli

油彩、紙板 Oil on paperboard, 35.0 x 27.0 cm, 1932
私人收藏 Private Collection

這幅小畫製作於坎城，原收藏者是與畫家情如兄弟的林攀龍（林獻堂長子，1901-1984）。除了右上方畫家簽名紀年外，背面有鉛筆書寫痕跡「Mlle Minelli」，明妮莉小姐，可能是畫家在當地認識的女士，就如同1931年入選秋季沙龍的《少女》（不存），據說是描繪畫家的鄰居。

林攀龍1930年再度赴德國留學，每到巴黎必帶畫家上高級餐廳用餐，聆賞歌劇或音樂會，並且鼓勵他安心創作。1932年初畫家移居坎城休養時，林攀龍已返回家鄉。同年秋天，畫家準備返臺卻旅費無著，林攀龍獲消息，立即請父親匯去六佰法郎。這件作品曾出現在畫家返臺後的滯歐作品展，推測最後成為獻給好友誠摯的謝禮。

林攀龍曾讚嘆畫家的肖像畫，能夠「深入人們潛在意識的海底深處，發掘出其中所藏的寶庫。」畫中近距離特寫暗金色頭髮的年輕婦女側面像，她雙眼明亮，鼻子瘦削高挺，小嘴緊閉，皮膚白裏透紅，戴

顏水龍1933年於臺北舉辦滯歐作品展

著黑呢帽，表情堅毅而專注，像是一位樸素的職業婦女模樣。

年輕畫家留學期間是否曾有異性知己呢？他不忘坎城畫具店有位女店員常送他食物，臨別還贈送一瓶香水作紀念。畫家也記得在巴黎時與知名的日本女性作家林芙美子（1903-1951）一起參觀畫廊、創作寫生。後者在1932年1月中旬的日記寫道，為送別顏水龍赴坎城，中國館子裡聚集了各路人物。顯然，異鄉遊子的畫家人緣還不錯。（顏娟英）

This small painting was completed in Cannes and originally the collection of Lin Pan-long (Lin Xian-tang's eldest son, 1901-1984), a close friend of Yen. Besides the painter's signature and year on the top right corner of the painting, the words "Mlle Minelli" were written on the back in pencil. She was likely a woman Yen met while in Cannes. Just as the model of *Portrait of a Young Girl* (No longer extant), which was selected for the Salon d'Automne in 1931, she was said to be a neighbor of Yen.

Lin Pan-long studied in Germany again in 1930. He always took Yen to fine restaurants and operas or concerts when he was in Paris. Lin also encouraged Yen to focus on his art. When Yen headed for Cannes in the early 1932, Lin had returned to Taiwan. In the fall of the same year, Yen was preparing to return to Taiwan but had difficulty paying for his trip. Lin immediately asked his father to wire 600 francs to Yen when he received word of Yen's trouble. This painting appeared in an exhibition showing Yen's

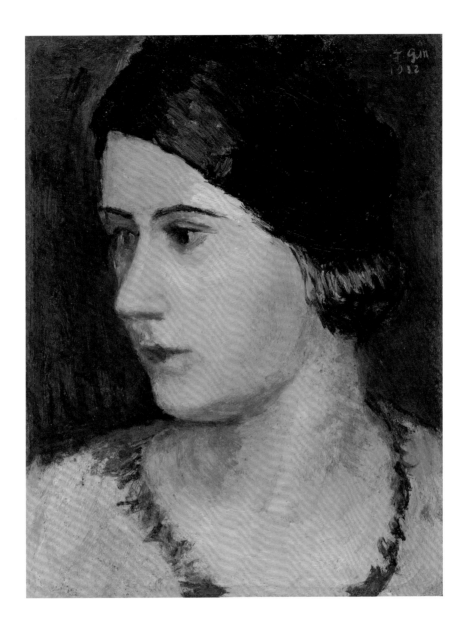

works during his sojourn in Europe and was presumed to have been given to Yen's good friend as a gift of thanks.

Lin praised Yen's ability to paint portraits that are capable of "penetrating the depth of human consciousness and uncovering the treasures that are hidden within." The portrait is a close profile of a young woman with dark blond hair. She has bright eyes and pointed nose. Her lips are tightly closed, and a tinge of red shows through her fair skin. She wears a black bonnet and seems strong and focused, likely a simple working woman.

Did Yen have any close female friends during his stay overseas? He remembered a female clerk at the art supply store he frequented in Cannes, who often gave him food and offered him a bottle of perfume as a parting gift before he left. Yen also remembered spending time together with the famed Japanese female writer Hayashi Fumiko while he was in Paris, either visiting art galleries or creating art. Hayashi wrote in her diary in mid-January, 1932 that the send-off party for Yen's departure to Cannes at a Chinese restaurant was full of people of all kinds. Apparently, Yen was quite popular. (YEN Chuan-Ying)

9

劉啟祥 LIU Chi-Hsiang (1910-1998)
有樹幹的景物 Landscape with Tree Trunks

油彩、畫布 Oil on canvas, 52.6 x 72.5 cm, 1930
家屬收藏 Collection of Artist's Family

有關劉啟祥1932年赴法前的創作，過去因作品散逸而難窺其貌，僅於展覽會圖錄中留有三張黑白圖版，風景畫包括1930年二科展《臺南風景》、1931年臺展《札幌風景》。如今在畫家日本友人悉心保存下，數幅戰前作品重見天日（文獻，頁284-289），本件即為其中之一，因簽有「1930 K. Ryu」字跡，認定為畫家就讀東京文化學院第三年的創作，亦是目前尚存原作中紀年最早的一件。

劉啟祥是同時代畫家中與二科會關係最密切的一位。當陳澄波、廖繼春等人相繼進入東京美術學校，以帝展為目標時，他卻反其道而行，選擇石井柏亭（1882-1958）等二科會名家創設的東京文化學院美術科就讀。往後他多次入選二科展、成為正式會員，在這個以分庭抗禮之姿和官展互別苗頭的在野團體中綻發光芒。

本幅風景主題單純，描繪空曠土地上成排的住屋與樹林。天際線、土坡的弧線上下呼應，傾斜的屋簷、樹幹由正中央垂直的煙囪得到平衡的力量。畫中沒有人物，錯落有致的房舍水平延伸，散發著寧靜悠揚的韻律感。此畫地點不明，也許是鄰近東京都的某處郊區。1923年畫家抵達東京求學時，郊外住宅區正因關東大地震過後，配合都市變遷急速成長。然而畫家表達造型、構圖的旨趣，顯然多過定義風景的所在。在烈日照拂下，木造房屋簡化為色塊，左方屋瓦直接連成一搶眼的多邊圖形。將樹幹單純化並強調明暗區別的作法，也常見於安井曾太郎出品二科展的《桐の花咲く庭》（1927）諸作。

此種重視平面造型的表現，與法國畫家塞尚（Paul Cézanne）、布拉克（Georges Braque，1882-1963）相通，和諧統一的灰白色系令人聯想到馬爾凱（Albert Marquet，1875-1947）的風景畫。這些特徵顯示，畫家正依循留法的老師有島生馬等人，開始對二科引進的法國後印象派、野獸派等風格加以嘗試應用。此作透露其摸索二科路線的學習軌跡，無疑是理解畫家早期畫風一塊失而復得的珍貴拼圖。（張閔俞）

Liu Chi-Hsiang's works created before he went to France in 1932 were mostly scattered and hard to find. There are only three black-and-white plates in exhibition catalogues, among which are two landscape paintings, including *Landscape in Tainan* featured in the 1930 Nikaten (Nika Association Exhibition) and *Landscape in Sapporo* in the 1931 Taiten. Because of the artist's Japanese friends, who carefully preserved Liu's paintings, several of Liu's works created before the war are now unearthed (Documents, pp. 284-289); and this painting is one of these works. Signed "1930 K. Ryu," one could be certain that this painting was created when the artist was in his third year at Tokyo's Bunka Gakuin, making the work the earliest among Liu's existing originals.

Among his peer painters, Liu was the most closely associated with the Nika Association. When Chen Cheng-Po, Liao Chi-Chun and others were studying at Tokyo Fine Arts School and aimed for being showcased in the Teiten (Imperial Art Exhibition), Liu contrarily chose to study at the Bunka Gakuin's Fine Arts Department, founded by renowned artists in Nika Association, among whom was Ishii Hakutei (1882-1958). Afterwards, he was selected into the Nika Association Exhibition several times and became an official member of the association, shining brightly in this private art group that was capable of competing with the official exhibition.

The painting portrayed a simple theme of landscape, delineating rows of houses and woods on the vast, empty land. Whereas the skyline corresponded to the curve of the slope, the slant roofs

and tree trunks were balanced by the vertical chimney in the center. Devoid of any figure, the houses with uneven height extended horizontally, expressing a quiet and lingering sense of rhythm. The location depicted is unclear; it was perhaps a rural area near Tokyo City. When the artist arrived in Tokyo to pursue education in 1923, the suburban regions were in rapid development, a result of drastic urban changes after the Great Kanto Earthquake. Nonetheless, the artist clearly placed his emphasis on the exploration of form and composition rather than the landscape. Under the fierce sun, the wooden houses were simplified as color blocks, whereas the tiled roofs on the left merged into an eye-catching polygonal shape. Furthermore, the approach of simplifying the tree trunks and contrasting the bright side with the shadowy side could be found in other artists' works,

such as Yasui Sotaro's *Garden of Paulownia Blossoms* (1927) also showcased in the Nika Association Exhibition.

Such expression that highlighted the two-dimensional form is reminiscent of Paul Cézanne (1839-1906) and Georges Braque (1882-1963), whereas the harmonious, unified, grayish white tone reminds us of the landscapes by Albert Marquet (1875-1947). These features showed that the painter was following his teachers who studied in France, such as Arishima Ikuma and others, and was experimenting on Post-impressionist and Fauvist style introduced by the Nika Association. Therefore, this painting reveals Liu's exploration of the Nika route and is undoubtedly a precious retrieved puzzle that can help us understand Liu's early painting style. (CHANG Min-Yu)

立石鐵臣 TATEISHI Tetsuomi (1905-1980)
稻村崎 Inamuraqasaki

油彩、畫布 Oil on canvas, 72.0 x 91.0 cm, 1930s
寄暢園收藏 Collection of Chi Chang Yuan

本件作品是立石鐵臣少數留存下來的戰前創作，也是理解他早年風格的重要作品。不過，這件作品並非戰前就收藏於臺灣，而是在因緣巧合下，近年從鎌倉一地流傳至臺灣。

1905年，立石鐵臣出生於臺北東門一帶。他的父親義雄在殖民統治初期來到臺灣，任職於總督府，1913年舉家返回日本。直到1933年重新踏上臺灣的土地之前，他居住在東京與鎌倉一帶。立石曾自述：「我曾經住過臺灣、東京、鎌倉，但我最留戀的土地是鎌倉。我想這是因為我在這裏度過青春時光，也在這裏開始畫畫的緣故。」

這件作品描繪的是鎌倉市西南方的稻村崎一帶的風景。這裏距離立石年輕時曾住過的材木座，不過數公里之遙，這一帶又稱為湘南海岸。立石最初在此地向跡部直治學習日本畫，然而他在老師的畫室中接觸到西方美術，逐漸傾心於西洋畫。1926年，立石景仰的油畫家岸田劉生（1891-1929）從京都搬

到鎌倉養病，經友人的介紹得以登門拜訪，更讓他決心轉向油畫之道。隔年，他以《滑川初秋》入選第一回「大調和展」，展覽會的審查員除了岸田劉生以外，也包括了立石後來追隨的畫家梅原龍三郎（1888-1986）。

從畫風來看，《稻村崎》應該不是立石在鎌倉初學油畫時所繪。畫面中可見到熟練的技法，寒暖色調的搭配也十分協調。深紅、粉橘、粉紅等色塊，既描寫土地的質感，也表現出強烈的光影變化。畫作採取俯瞰視角，從高處眺望相模灣，中景是稻村崎的海岬，最遠處是浮在海面上的江之島。躍動的筆觸與色彩，以及具有韻律感的構圖，可見到梅原龍三郎畫風之影響。1936年立石從臺灣返回東京，到1939年來臺定居前的這段期間，經常前往鎌倉與湘南海岸一帶寫生，推測本件作品的創作年代可能是在1936至1939年之間。漂泊不定的立石，在湘南海岸寫生時，或許懷想起青春壯志，也將此刻的心情寄託於繚亂的雲彩與落日當中吧。（邱函妮）

This work is one of the handful surviving works created by Tateishi Tetsuomi before the war, and an important piece to understand his early style. Nevertheless, the painting was not always in Taiwan before the war. Instead, only recently it was brought to Taiwan from Kamakura in Japan due to some serendipitous circumstances.

Tateishi Tetsuomi was born near Taipei's Dongmen in 1905. His father Tateishi Yoshio came to Taiwan at the dawn of the colonial period, and worked in the Office of Taiwan Governor-General. The family moved back to Japan in 1913, and before the artist revisited Taiwan in 1933, he lived in Tokyo and Kamakura. He once stated, "I have lived in Taiwan, Tokyo and Kamakura, but

Kamakura is the one that I cannot bring myself to leave. I guess it is because I spent my youth here and began painting here as well."

This painting depicted the landscape in Inamuragasaki located in the southwest to Kamakura and was only a few kilometers away from Zaimokuza, where Tateishi lived in his younth. The area has been known as the "Shonan-kaigan" (Shonan coastline). It was in Kamakura that the artist first studied nihonga (Japanese-style painting) with Atobe Naoharu; however, he later came across Western-style art in his teacher's studio and gradually gravitated towards the latter. In 1926, oil painter Kishida Ryusei (1891-1929) moved from Kyoto to Kamakura to recuperate from his

illness. Tateishi had always been an admirer of Kishida, and was able to visit him through his friend's introduction. The visit made him determined to shift to oil painting. The next year, he was selected into the first round of the Daichowa Art Exhibition with *The Early Autumn of Namerikawa*. The reviewers of the exhibition included Kishida and Umehara Ryuzaburo (1888-1986), by whom Tateishi was later mentored.

Judging from the style, *Inamuragasaki* was not painted when Tateishi had just begun learning oil painting in Kamakura. The techniques show a sense of mastery, and the mixture of cold and warm colors is balanced as well. The artist used maroon, pastel orange and pink to delineate the texture of land while creating an intense interplay of light and shadow. An overlooking perspective was adopted to depict Sagami Bay from a higher vantage point. In the midground was the cape of Inamuragasaki, and Enoshima was in the distant background, seemingly floating in the sea. The vibrant brushstrokes and colors, along with the rhythmic composition, showed the influence of Umehara. In 1936, Tateishi returned to Tokyo from Taiwan, and before he moved back to Taiwan in 1939, he often painted en plein air in Kamakura and along the Shonan coastline. This work was possibly painted between 1936 and 1939. The artist, who had drifted in his life, perhaps thought of his ambitious youthful days when painting outdoor by the Shonan seaside, and subsequently incorporated his feelings into the unruly, colorful clouds and sunset. (CHIU Han-Ni)

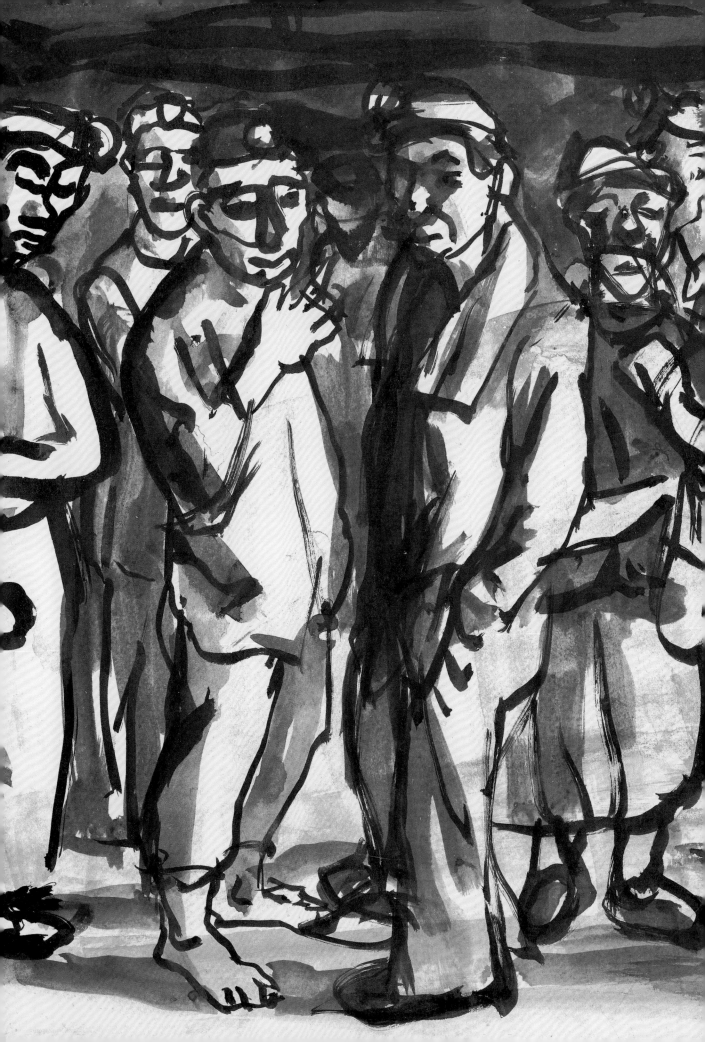

II

生命的凝視

The Gaze of Life

生命的凝視
THE GAZE OF LIFE

文／顏娟英

中央研究院歷史語言研究所研究員

Text / YEN Chuan-Ying

在歐洲歷史上，肖像是人物畫的核心，具有高度公眾性，一幅唯妙唯肖的畫像不但能反映畫像主人的崇高地位，還能延續甚至取代畫中主人的物質存在。故而，貴族權勢階級聘用畫家來為已逝或在世者製作紀念肖像，具有高度社會政治意義，也有一定的市場價值。日本殖民政府統治時期，效法西方傳統，聘請母國藝術家來臺製作日本權貴的官方紀念肖像以及銅像。

殖民地臺灣最早積極接受西方文明，慷慨為子弟爭取教育機會，推動成立臺灣文化協會的霧峰富豪林獻堂，於1927年5月偕其子赴歐美旅行，歷時一年多，期間廣泛考察各地博物館，對於倫敦的國立肖像館等文教設施印象深刻，留下詳細的記錄。1931年初，接受朋友為其祝壽的好意，聘請傳統畫師潘春源以及東京美術學校畢業的張秋海製作夫婦兩人肖像；他對張秋海的西洋畫風特別滿意。1934年自巴黎返國的顏水龍長期受到林家照顧，出於回報，他主動為林獻堂夫妻製作肖像畫。然而，真正建立起肖像畫招牌的是畫家李石樵。李石樵擅長人物畫，1936年他以鉅作《楊肇嘉氏家族》（182 x 259公分，國泰集團收藏）入選日本第一回新文展，從此大約八年的時間，經常在臺中長住，接受當地以地主階層為主的畫像委託。林獻堂也在1941年接受李石樵為他們夫婦製作肖像畫。很可惜這幾位名家為林獻堂夫婦製作的畫像如今都不知去向；這是否也反映出肖像畫在臺灣家族傳統中，仍沒有被視為值得傳承的珍貴資產，這點頗值得我們進一步思考。整體而言，日治時期人物畫作除了在展覽會場上爭光之外，市場需求仍然相當有限；二戰結束後，由於族群衝突加上戒嚴時期白色恐怖，人物畫作走向衰頹。

人物畫描繪的對象涵蓋世間芸芸眾生，但對於臺灣畫家而言，既然沒有商業需求，則往往偏好具有私密性記憶與意義的人物畫。許多畫家，不論油畫家或日本畫家，都製作過自己父母親乃至祖父母的畫像，可說是展現自身專業才能以回饋家人的紀念。除了長輩畫像之外，帶有個人紀念性質的親友肖像，對於創作者來說亦特別珍貴。彷若在妻子的形貌中描繪了對未來共同經營幸福家庭的承諾，顏水龍為新婚妻子繪製的畫像（圖14），表現出畫家強烈的自我投射與濃厚的感情。此外，又如未能參加這次展覽的陳植棋著名代表作《夫人像》（1927，50號，家屬收藏）：華麗的畫面中，妻子碩大的身影反映出畫家力爭上游的苦心，也潛藏著畫家與現實世界奮力抗衡的痛苦。相較之下，劉啟祥的《肉店》（圖13）則透露出他與年輕妻子新婚生活的甜蜜，彷彿洋溢著輕快的旋律。

In European history, portrait formed the core of figure painting and was highly public. A realistic portrait not only could reflect the illustrious status of its subject, but would also continue and even replace the physical existence of the subject. Therefore, the aristocratic and powerful class have always commissioned painters to create portraits of the deceased or the living for the purpose of commemoration. Portrait has therefore conveyed much socio-political implication and has had a certain degree of market value. During its rule, the Japanese colonial government in Taiwan copied the Western tradition and hired Japanese artists to Taiwan to create memorial portraits and statues of Japanese officials.

Wufeng-based magnate Lin Hsien-Tang, who facilitated and founded the Taiwan Cultural Association and was the earliest person in colonial Taiwan to actively embrace Western civilization while generously fighting for opportunities of education for later generations, traveled through Europe and the US with his son in May 1927. Their journey lasted over one year, during which they extensively visited museums. He was deeply impressed by the cultural and educational facilities of London's National Portrait Gallery, and had recorded his visit in great detail. At the beginning in 1931, he accepted his friends' kindness for his birthday, and commissioned traditional painter Pan Chun-Yuan and painter Zhang Chiu-Hai, who was a Tokyo Fine Arts School graduate, to paint portraits of his wife and himself. He was especially satisfied with Jang's Western-style painting. Yen Shui-Long, who returned to Taiwan in 1934, had received much support from the Lin family over the years. To reciprocate, Lin also painted a portrait of Lin and his wife. However, the artist who really established himself as a portrait painter was Li Shih-Chiao. Li specialized in figure painting. In 1936, his large masterpiece, *The Family of Yang Zhaojia* (182x 259 cm; collection of Cathay Group), was selected into Japan's 1st Shin Bunten (New Ministry of Education Arts Exhibition), after which he lived mostly in Taichung for eight years and accepted portrait commissions of local landed gentries. Lin Hsien-Tang and his wife also had Li paint their portrait in 1941. Unfortunately, the portraits painted by these renowned masters are now lost. Maybe this proves that portraits, in the history of Taiwanese families, have not been appreciated as assets of value to be passed down through generations, which is something that worth more thoughts. In general, the genre of figure painting, in addition to compete in art exhibitions during the period of Japanese rule, had only a limited market. After the end of WWII, the genre gradually declined due to conflicts between ethnic communities and the White Terror during the period of martial law.

The subjects depicted in figure painting can include all walks of life in this world. For Taiwanese painters, however, because there was no commercial demand, their figure paintings were often informed by private, personal memories and meanings. Many painters, oil and Japanese-style painting alike, had all painted portraits of their parents and even their grandparents, which could be viewed as their way of reciprocating and commemorating their family with their professional skills. In addition to making portraits of family elders, portraits of family and friends for personal commemoration were particularly precious for the artists. Portraying his wife to convey the promise of co-creating a happy family, Yen Shui-Long's portrait of his wife after the couple just got married expressed the painter's strong self-projection and profound affection (fig. 14). Another example would be Chen Chih-Chi's iconic masterpiece, *Portrait of the Wife* (1927, 50F; collection of the artist's family), which is not included in this exhibition—the splendid image shows the large figure of the wife, which not only reflects the artist's endeavor in striving for the best in his career, but also implies the painter's struggle to balance between his life and reality. In comparison, Liu Chi-Hsiang's *Butcher's Shop* (fig. 13) revealed his sweet, married life shared with his newly wedded wife, seemingly overflowing with a joyful melody.

Painting one's lovely children would naturally fill an artist's

描寫可愛的子女,自然心情愉悅,畫家呂基正大膽地用舞臺效果來烘托女兒端莊秀麗的形象(圖17)。描寫手足,李石樵的心情則大不相同:為了進入東京美術學校就讀,李石樵決心破釜沈舟,毅然放棄教職,前往東京苦學三年,1931年春終於入學油畫科。夏天他返鄉,以弟弟為模特兒繪製畫作(圖11)。弟弟為他分擔家中繁重的農務,他以此畫參加臺展,盼與弟弟分享入選的榮耀。此時李石樵不過二十三歲,他的藝術之路卻已歷盡滄桑:幾個月前,前輩雕刻家黃土水因過勞客死異鄉,接著,敬重的學長陳植棋不幸病故;他們的未竟志業「創造福爾摩沙的藝術」似乎都落在他的肩膀上。畫中的弟弟衣著體面,年少老成,身子顯得有些單薄。這位畫中主人於隔年感染了流行的傷寒病而去世。

最難捨是摯愛的親人臨終的樣貌,《病房》(圖12)可說是畫家李澤藩強忍哀痛執筆記錄的創作。畫家的二哥中學即留學京都,以優異成績從廣島師範學校畢業後,留任廣島中學執教物理科,同時擔任業餘管弦樂團指揮。卻沒想到三十九歲時因牙疼就醫,治療過程不慎感染細菌,病情急速惡化;時逢戰爭,醫藥資源匱乏,醫生也束手無策。李澤藩代表家人遠赴廣島,卻只能在隔離病房外徘徊。寬敞的病房內,病人躺在鐵床上,模糊的身形彷彿因痛苦而扭動著,

窗外的天地明亮而寧靜,樹林裡座落著幾棟房屋,猶如遠方的故鄉風景正輕柔地撫慰著病人。何德來更難割捨結褵四十多年的愛妻;他以《背影》(圖15)初夏的翠綠象徵無盡的思念,將亡妻短暫的生命化為永恆的琴音。愛妻彈奏三弦的背影反映畫家內心的寂寥,她即將遠行,消失於混沌的天地,唯有畫家的筆觸仍在憶念中徘徊留戀。

洪瑞麟尊崇十九世紀的法國畫家魯奧(Georges-Henri Rouault,1871-1958)與梵谷(Vincent Van Gogh,1853-1890);他深受人道主義影響,人物畫作品的主題大多是勞工與弱勢族群;例如日本東北山形雪地的農民,以及臺北瑞芳礦區的礦工。特別的是,畫家筆下沒有抗議的血淚,也沒有流離失所的迷惘;相反地,這些卑微的人物身上散發出溫暖的光輝,自在而坦然地流露艱難生活的點滴(圖19、圖20)。陳敬輝畢業自京都市立繪畫專門學校,1932年返臺後任教於淡水中學與女學校。他窮其一生描繪與新時代接軌的女性畫像,例如氣質端莊的學生,或帥氣自信的職業婦女。畫家晚年不幸罹患重症肌無力症,卻仍將木條綁在背脊上,堅持繼續作畫、教書。這幅畫像是他去世前三個月所作,芭蕾舞者動靜自如,簡練的線條如同旋律般流暢,彷彿歌頌著生命的

heart with delight. Lu Chi-Cheng boldly employed stage effect as a way to foil his daughter's elegant and refined image (fig. 17). Li Shih-Chiao's work, on the other hand, was painted in a different mood: in order to study at Tokyo Fine Arts School, Li resolutely gave up his teaching job and spent three years in Tokyo to study painting before he was finally accepted into the school's Oil Painting Department in the spring of 1931. He returned home that summer and painted a portrait with his younger brother as his model (fig. 11). His younger brother had taken over the family's heavy farming work for him, so Li hoped to enter the Taiten with this painting and share the honor with his young brother. At that time, the painter was only twenty-three years old, but he had already experienced much destitute and sorrow in his artistic journey—simply a few months ago, Huang Tu-Shui, who was Li's artist predecessor, died of exhaustion overseas; and then, Chen Chih-Chi, Li's respected senior in school died of an illness. Their unrealized goal of "creating the art of Formosa" had seemed to fall on Li's shoulders. In the painting, Li's younger brother was nicely dressed, youthful-looking and overly mature, with a slightly frail physique. Unfortunately, the person depicted in the portrait contracted typhoid and passed away the year after the painting was finished.

The look of one's beloved family members on their deathbed is always hard to let go. *Hospital Room* (fig. 12) was a painting created by Li Tze-Fan while bearing incredible agony. Li's second brother had lived and studied in Kyoto since junior high school. After he graduated from Hiroshima Normal School, he stayed at the local middle school and taught physics; at the same time, he was the conductor of an amateur orchestra. Little did he know that the treatment of an aching tooth at the age of thirty-nine would lead to a bacterial infection that deteriorated rapidly and ended with the worst-case scenario—his disease coincided with the warfare at the time, which had led to the scarcity of medical resources. So, the doctors were not able to treat his infection. Li Tze-Fan travelled to Hiroshima with the hope of his entire family but could only pace up and down outside the hospital isolation room. In the spacious room, the patient was lying on a metal hospital bed. The blurry figure seemed to be wiggling because of the suffering. Outside the window was a bright and quiet vista, with a few houses sitting in the woods. The entire view looked like the landscape of the patient's homeland, providing gentle comfort. For Ho Te-Lai, it was equally difficult to bid farewell to his beloved wife, to whom he had married for more than four decades. He symbolically expressed the endless remembrance with the lush green of early summer in his painting, *Playing a Three-stringed Lute (Rear View)* (fig. 15), converting his late wife's brief life into eternal music of the lute. The rear view of his wife playing the three-stringed lute reflected the artist's solitude, as he knew that she would soon embark on the eternal journey and disappear into the formless cosmos, leaving the artist behind to express his lasting remembrance with his paint brush.

Hung Rui-Lin revered the nineteenth-century French painter Georges Rouault (1871-1958) as well as Vincent Van Gogh (1853-1890). Deeply influenced by humanism, Hung's figure painting mostly depicted the subject matter of laborers and underprivileged groups, such as farmers working in the snow of Yamagata in northeastern Japan and miners in Taipei's Ruifang mining field. Above all, Hung did not portray his subjects with vehement protests nor with a sense of being lost and desolation. Contrarily, these humble figures exuded a warm glow as they candidly and somewhat nonchalantly faced the hardship in life (fig. 19, 20). Chen Jing-Hui graduated from Kyoto City Technical School of Painting. In 1932, he returned to Taiwan and began teaching at Tamsui High School and Tamsui Girls' High School. The painter devoted his life to delineating the image of women of the new era, for instance, elegant and graceful students or cool and confident career women. In his later years, Chen was diagnosed with myasthenia gravis, but he would still himself to tie wooden sticks on his back and continued painting as well as teaching. This painting was created three months before the painter

可貴（圖18）。1963年在臺灣師範大學任教的林玉山隨著團隊安排，首次到蘭嶼、綠島旅行。畫家長年在校以寫生花鳥的生態出名，習於快速掌握眼前所見景物的特點，即時或憑著回憶，在紙上振筆直繪。這幅《蘭嶼少女》中，畫家巧妙地利用雅美族的鼓腹小口壺，寬闊的芭蕉葉與蜿蜒的藤蔓，一再呼應少女豐滿曼妙的身姿（圖23）。

人物畫主題區還有兩件以原住民為題材的作品，創作者皆為日本人。其實，最早以原住民為創作主題並一舉成名的，是雕刻家黃土水。1920年他以《蕃童》入選日本帝展，這件塑像是一位赤裸的男孩坐在大樹根上，雙手握笛頂住鼻孔吹奏，表現排灣族的樂器特色。然而，這件作品的模特兒是就近從東京找來的，黃土水並沒有充裕的時間與經濟能力親自調查臺灣的原住民文化，於是他將接下來的創作主題轉向鄉村牧童與田園風光。而鹽月桃甫畫作《刺繡》（圖21），則是他長期關注原住民文化生態，進出山區旅行寫生，隨手拈來的小品。畫家將這幅畫送給顏水龍當做紀念。鹽月曾高度讚賞後者1933年在臺北舉辦的巴黎作品個展。1935年，顏水龍受邀至蘭嶼現場寫生一個月，開啟他日後原住民題材的創作之路。鹽月這幅《刺繡》除了描繪原住民手工技藝，也代表兩代畫家彼此惺惺相惜、結盟守護原住民文化的共通心意。雕刻家黃土水孤獨病逝東

京，但是在臺灣，他有一位忠實仰慕者：鮫島台器。後者原來是基隆鐵道部的職員，業餘愛好雕塑。他有幸得到贊助，經黃土水引薦前往東京學習。作品《山之男》（圖22）表現出身型魁梧，肌肉結實的原住民形象，也反映出這位藝術家單純直率的個性。

戰後初期藍蔭鼎創作的《永樂市場（市場風景）》（圖24），刻意描寫除夕市場上忙碌採購的市井小民景象。畫家宛如透過報導攝影的觀點，逐一掃過市場的每個角落，鏡頭抓住歡樂、喜氣洋洋的民眾。人物畫脫離私密的個人空間，畫家描寫臺北庶民生活百態，送給一位重要的美國官方朋友作為旅遊紀念。這幅畫預示著畫家將改變人生，積極走向國際化的舞臺，更將跨足多元的視覺影像媒體，展開眾所矚目的「文化大使」生涯。

passed away. The ballerina looked relaxed and composed. The simple yet refined contour flowed melodiously, making the portrait a celebration of the value of life (fig. 18). In 1963, Lin Yu-Shan, who was teaching at Taiwan Provincial University of Education (now National Taiwan Normal University), traveled with a tour group to Orchid Island (Lanyu) and Green Island. Lin was known for his bird-and-flower paintings, and was accustomed to quickly capturing and recording the features of his subjects on the spot or painting later based on his memory. In *Girl on Orchid Island*, the painter cleverly used Tao people's globular, small-mouthed jar, wide banana leaves as well as twisting and turning devil's ivy to echo the young girl's plump, curvy figure (fig. 23).

There are two more paintings featuring the subject of indigenous people on view in this section of figure painting. They were both created by Japanese artists. As a matter of fact, sculptor Huang Tu-Shui was the first to achieve fame with an indigenous subject. In 1920, he was selected into the Teiten with *Aboriginal Child*, a sculpture of a naked indigenous boy sitting on a large tree stump and playing a nose flute in his hands, demonstrating the unique characteristics of the Paiwan musical instrument. However, the model of this sculpture was found in Tokyo. Since Huang did not have sufficient time and financial means to personally investigate Taiwanese indigenous culture, he later shifted his creative focus to child shepherds and idyllic landscape. Shiotsuki Toho's *Embroidery* (fig. 21) was a small painting created spontaneously when the painter, who had studied the indigenous cultural ecology for a long time, traveled and sketched in the mountainous region. Shiotsuki gifted this painting to Yen Shui-Long, whose 1933 solo exhibition in Taipei featuring works created in Paris were highly praised by Shiotsuki. In 1935, Yen was invited to visit Orchid Island, where Yen stayed for a month to sketch, and the trip marked the beginning of his creative work featuring indigenous subject matter. *Embroidery* not only depicts the handicraft of the indigenous people, but also symbolizes the dedication to guard the indigenous culture cherished

and shared by two painters from different generations. Huang Tui-Shui died of an illness alone in Tokyo, but he had a loyal admirer in Taiwan, whose name was Samejima Taiki. Originally an employee at Keelung's Railway Bureau, Samejima had been an amateur sculptor. Recommended by Huang Tu-Shui, he was fortunate to study in Tokyo through sponsorship. *Man of the Mountains* (fig. 22) portrays the image of a brawn, muscular indigenous male, and reflects the artist's uncomplicated, unpretentious personality.

Ran Yin-Ding's *Yongle Market (Market Scenes)* (fig. 24) created after the war depicts common people busy doing grocery shopping in the market around the lunar New Year's Eve. The painter adopted a photo-journalistic viewpoint to scan and capture every corner of the market, recording the delighted crowd in a joyful atmosphere. Departing from portraying a private individual space, the figure painting delineates the multifaceted life of Taipei citizens. This painting was created as a token to commemorate the journey of an American official and a friend to the artist. It also beckoned at a turn of the artist's life, as he would soon step into the international art scene, and later, engage in a more diversified practice involving media of visual image, embarking on an illustrious career as a "cultural ambassador."

李石樵 LI Shih-Chiao (1908-1995)
四弟像 Younger Brother

油彩、畫布 Oil on canvas, 116.5 x 91.0 cm, 1931
李石樵美術館收藏 Collection of Li Shih-Chiao Art Gallery

1931年是李石樵面臨生離死別、喜悅悲傷交織的一年。首先是長女出生，然後是經過三年紮實的素描訓練後終於考進東京美術學校西洋畫科，好友陳植棋卻突然過世，作品《男子像》榮獲第五回臺展特選，隔年胞兄、胞弟、兄嫂、姪兒等人接連因斑疹傷寒而過世。他因此被迫中斷學業，緊急返臺處理家務。然而李石樵對藝術創作的執著驅使他再度赴東京完成學業。即便家人強烈反對並切斷經濟援助，他立志一定要入選帝展，才能揚眉吐氣。1933年終於如願以《林本源庭園》入選第十四回帝展，在接受記者採訪時他說：「我家沒有錢可以充分地支持我，而且去年臺灣流行傷寒病，兄、嫂與弟弟一時間都死亡。讓我也不得不放棄對創作的希望，然而我抱持著至少也得入選一次帝展的決心，不顧生死地創作來參加，如今幸而圓滿達成，不勝歡喜與感激。」

《四弟像》即李石樵入選第五回臺展的《男子像》。畫中四弟李堆鍛戴著流行的巴拿馬帽，穿著黑藍色對襟仔衫與白色長褲。他坐在藤椅，雙手交握靠在扶手上，略微低頭，帶點憂鬱、若有所思的神情。藤椅背後是牆壁，左邊露出木桌的一角，空間十分有限。光源從左上方照射下來，人物左臉頰、雙手與長褲特別明亮；光線的處理恰如其分，使得人物身處空間並不會感到侷促。全幅以黑褐色調為主，並適時調和白、紅、藍色而使色彩層次豐富。這幅四弟畫像為李石樵帶來臺展特選的高度肯定，然而隔年卻變成不幸死於傷寒的李堆鍛的一幅遺像。李石樵體會到人生的無常，反而激勵他在藝術創作的道路上倍加堅持與努力。（黃琪惠）

The year of 1931, for Li Shih-Chiao, was a year that the joy of life was tainted with the sorrow of death. Firstly, his eldest daughter was born, and after three years of solid sketch training, he was finally accepted into Tokyo Fine Arts School's Department of Western-style Painting. Afterwards, his good friend Chen Chih-Chi suddenly passed away, and then, his work *Portrait of a Man* was awarded the Special Selection Prize in the 5th Taiten. The next year, his elder brother, sister-in-law, younger brother and nephew all passed away due to typhoid. He was therefore forced to stop his learning and immediately returned to Taiwan to take care of family affairs. However, his determination in making art took him back to Tokyo later to finish his education. Even if his family strongly opposed his decision and cut off his financial support, he was still resolute to be selected into the Teiten (Imperial Art Exhibition) so that he could lift his head high. In 1933, his wish was finally granted as his *Garden of Lin Benyuan* made the 14th Teiten. In an interview, he said, "My family has no money to fully support me, and I lost my elder brother, my sister-in-law, my younger brother all to typhoid when the epidemic swept Taiwan last year. I was forced to give up creation. However, I was determined to at least be selected into the Teiten once, and continued painting regardless. Now, my wish finally came true, and I am overwhelmed with joy and gratitude."

Younger Brother was Li's *Portrait of a Man* showcased in the 5th Taiten. In the painting, Li's younger brother, Li Tui-Tuan, wore the popular Panama hat, a navy "tuì-khim-á-sann" (a type of Taiwanese button-down shirt) and white trousers. He sat on a rattan chair, with his hands resting on top of each other and his elbows on the armrest. His head was slightly lowered, with a somewhat melancholic, brooding look on his face. Behind the chair was the wall, and a corner of the wooden table protruding

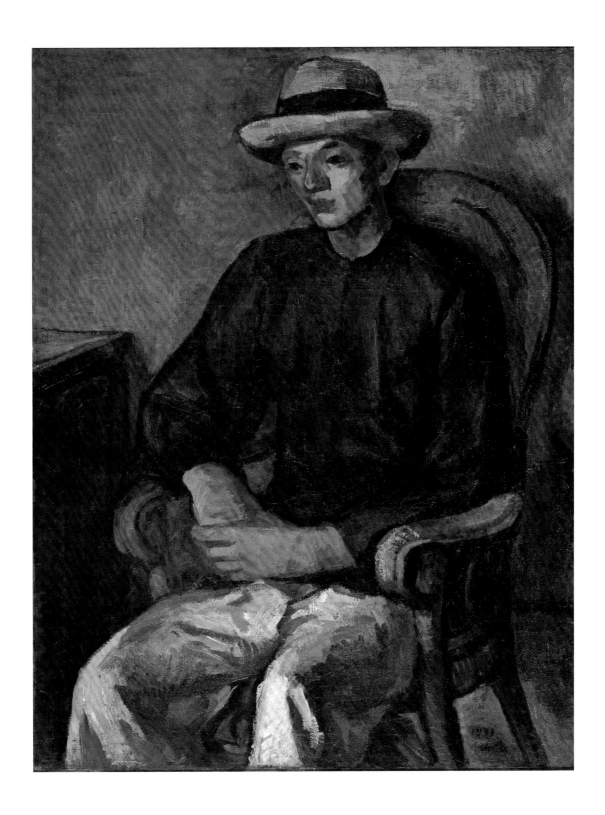

from the left side in a seemingly compact space. The light came from the upper left, brightening up the figure's left cheek, his hands and trousers. The light was rendered perfectly, which made the overall space look bigger rather than confining. The painting was predominantly in a dark brown tone, mixed appropriately with white, red and blue that added more layers to the colors. This portrait of his younger brother won the artist the Special Selection Prize in the Taiten; however, it also became the commemorative portrait of Li Tui-Tuan who unfortunately died of typhoid the next year. The impermanence of life had strengthened Li Shih-Chiao's resolution and made him more diligent in his journey of artistic creation. (HUANG Chi-Hui)

李澤藩 LEE Tze-Fan (1907-1989)
病房 Hospital Room

水彩、紙 Watercolor on paper, 78.0 x 58.0 cm, 1940
李澤藩美術館收藏 Collection of Lee Tze-Fan Memorial Art Gallery

本件作品從落款的「皇紀二千六百年」可知創作於1940年。畫家使用柔和的用色描繪整體，特別是將戶外的山景，以淡雅卻繽紛的色調表現出來。相較於室內線條分明，室外的風景使用較少輪廓線，似乎暗示著光影在空氣中的傳遞。室內深淺不一的褐色表現木質斑駁的特性，畫家對於顏色的高度掌控，準確堆疊出光影變化。淡藍色的數筆點綴，除了延續戶外場景的柔光氛圍之外，也和諧了構圖色彩。

李澤藩的人物畫作品，大多以親友入畫，且畫中背景常以真實生活場景作為搭配。而本件作品的主角為畫家的二哥李澤祁，李澤祁先生在日本重病之際，由畫家前往病房照料，然作品完成後便不幸離世。相較於李澤藩其他的人物畫像大多有清晰的面容，本作人像模糊不清，彷彿暗示著畫家對於親屬患病的苦楚不忍描繪。人像上的白色點綴，強化了光線；並藉由室內門窗的構圖和木條紋路的方向，將觀者視線集中於人物身上，再延伸至戶外。門上雖貼著表示此為重症病房的「面會謝絕」告示，但由於整體色調柔和，讓《病房》這件作品充滿靜謐氛圍，彷彿訴說著畫家期許兄長病情好轉的念想。（郭懿萱）

It can be inferred that this work was created in 1940 according to the inscription, which states "Japanese imperial year (kōki) 2600." The painter used a soft palette to portray the overall image, especially depicting the mountains outside the window with light yet splendid color tones. Comparing to the vividly delineated indoor space, the outdoor vista was removed of a clear outline, possibly implying the transmission of light in air. The varying shades of brown in the room brought out the mottled quality of the wooden material. The artist's mastery of color could be observed from the precise layering of colors to create the change of light and shadow. A few brushstrokes of light blue not only continued the mild atmosphere of the outside, but also made the composition and colors more balanced.

Lee's figure paintings mostly featured his friends and family, and the background of such works usually adopted a setting in real life. Depicted in this painting was the artist elder brother Lee Tze-Chi, whom the artist looked after when hospitalized in Japan due to a severe illness. However, after the painting was completed, Lee Tze-Chi unfortunately passed away. Unlike the artist's other figure paintings that showed clear visage of the figures, the figure in this painting was rendered blurry and unrecognizable, as if the artist could not bear to record his brother's suffering. The white brushstrokes on the figure reinforced the light, whereas the doors and windows of the room, along with the direction of the wooden floor, concentrated viewers' line of vision towards the figure before moving beyond the window to outdoor landscape. Although the notice "No visitors" posted on the door indicated that this hospital room was for the severely ill, the overall soft palette filled the work *Hospital Room* with a sense of serenity, conveying the artist's wish that his brother could recover soon from his illness. (KUO Yi-Hsuan)

劉啟祥 LIU Chi-Hsiang (1910-1998)
肉店 Butcher's Shop

油彩、畫布 Oil on canvas, 117.0 x 91.0 cm, 1938
家屬收藏 Collection of Artist's Family

1937年3月底，劉啟祥與笹本雪子（1918-1950）結婚；這幅作品是他婚後連續三年創作的新婚圓舞曲系列之一，妻子是他的最佳模特兒。劉啟祥出身臺南柳營世家，開祖是鄭成功征戰開臺的大將；父親曾任區長等官職，家境殷實。啟祥十二歲時父親辭世，長他兩歲的哥哥成為一家之主，在後者的鼓勵下，啟祥次年便赴日就讀學風開明、重視人文素養的青山學院中學部與文化學院。他自幼喜愛文藝，嫻熟小提琴，這時又學習鋼琴、柔道與馬術，可謂體智兼備；二位兄弟也稍後陸續前來留學，彼此照顧。1932年返臺舉行個展後，夏天與楊三郎共乘輪船前往巴黎。

在巴黎的進修歲月，劉家提供充分的經濟支援，他除了勤勉地在羅浮宮臨摹名作，更在畫室聘用模特兒、延攬小提琴與法語家教，過著優遊自在的生活。然而歐戰的陰影逐漸逼進，只得於1935年秋天返抵臺灣，隔年再度到東京目黑區購屋定居，繼續創作生涯。

這幅作品的少婦頭戴俏皮的貝蕾帽，身穿金黃色洋裝，雙手提著藍色大籃子於腹前，緊貼她背後，立著一位戴高帽的肉販，其神情活潑躍動，毋寧更像是伴侶的變裝；前景還有一位頭戴錐形帽的年輕人背影，三人的棕色系帽子趣味不一，構成愉悅流轉的動線。桌案上的肉塊有如跳動的音符，彷彿呼應三人的旋律。經解剖處理的豬胴倒栽懸掛著，腹部一道紅色的開口卻宛如向上揚起的波浪。直立的方柱頂住桌案與天際，帶來構圖穩定感，也分隔愉悅的人物與肉攤，營造出多重空間中，現實與虛幻交錯切割的效果。少婦正面直立，金黃色均勻明亮，散發出溫柔可親的氣息。

雖然已經進入戰爭初期，身在東京的畫家夫妻此刻仍陶醉在新婚溫馨的都會生活。畫中少婦穿著無袖洋裝，推測時序進入夏季，9月這幅畫入選二科會展；11月他們的長男，也將是畫家的耿一誕生。（顏娟英）

In late March 1937, Liu Chi-Hsiang and Sasamoto Yukiko (1918-1950) got married. This painting is part of the Wedding Waltz series, which the artist had continued for three years after he married his wife, who was also his best model. Liu was born in a family with illustrious history in Tainan's Liuying. The originator of the family was one of the generals that assisted Koxinga to conquer Taiwan. Liu's father was the district administrator, and the family was indeed well-off. Liu lost his father when he was twelve, and his elder brother who was two years older became the head of the family. With the encouragement of his elder brother, Liu departed for Japan the year after his father passed away, and studied first at Aoyama Gakuin High School and later Bunka Gakuin's College of Art and Literature. Liu had loved culture and arts since little and played the violin well. He also learned the piano, practiced judo and picked up horse riding during this period, intellectually and physically training himself well. Later,

his two brothers also studied in Japan, allowing the brothers to look after one another. In 1932, after he returned to Taiwan and presented his solo exhibition, he traveled to Paris with Yang San-Lang by sea in that summer.

While studying in Paris, Liu's family provided him sufficient financial support. In addition to diligently imitating masterpieces in the Louvre, the artist also hired models for painting in his studio while practicing the violin and learning French with tutors, leading a carefree life. However, as the shadow of the war loomed ahead in the Continent, Liu had no choice but returning to Taiwan in the fall of 1935. The next year, he moved to Tokyo, where he purchased a house in Meguro and continued painting.

In this work, the young woman wore a chic beret and a golden dress, holding a large blue basket before her abdomen. Standing

closely behind her was a butcher wearing a tall hat. His face looked lively and animated. In a way, he was like the woman's companion. In the foreground was another young person, who wore a cone-shaped hat. Each of the three figures' brownish hats conveyed a different charm and collectively constituted a joyful, fluid movement. A piece of meat on the table was like a jumping musical note that echoed the melody composed of the three figures. The dissected pig's corpse hung upside down, with a red opening in the stomach that somehow looked like a rising wave. A vertical square post extending from the table to the top stabilized the composition, and separated the pleasant-looking figures and the butcher's stand, creating an effect of dividing and juxtaposing reality and fantasy in the multilayered space. The young woman stood upright and faced the front, and the golden color of her dress was evenly painted and illuminous, exuding a tender and friendly air.

Although the painting was painted at the dawn of the war, the painter and his wife living in Tokyo still enjoyed the urban life informed by the marital bliss. In the painting, the young woman wore a sleeveless dress, so the season was probably early summer. In September, this work was selected into the Nika Association Exhibition; and their eldest son, Liu Keng-I, who would become a painter in the future, was born in the November of the same year. (YEN Chuan-Ying)

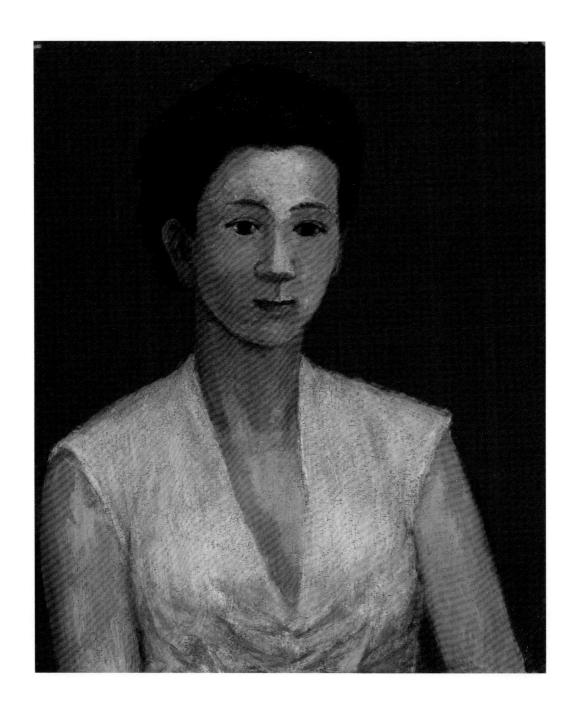

顏水龍 YEN Shui-Long (1903-1997)
妻子（顏夫人） Artist's Wife (Mrs. Yen)

油彩、畫布 Oil on canvas, 60.5 x 50.0 cm, 1942
家屬收藏 Collection of Artist's Family

《妻子》像以溫暖飽滿的紅色調為背景，妻子額頭飽滿，五官細緻，明亮的眼睛散發出嫻靜的氣質。她身穿自己設計，剪裁合身的白色深V字領上衣，幽雅地襯托其鵝蛋形臉龐與纖細的長頸。對顏水龍而言，白色，特別是白衣女子，顯得格外高雅時尚，這是他1932年在坎城貼身觀察、揣摩野獸派個性畫家梵‧鄧肯（Kees van Dongen，1877-1968）創作的心得。畫中人的表情愉悅而溫柔，充滿了對於兩人即將攜手共同經營理想家庭生活的期待。

1942年，顏水龍經朋友熱心介紹，認識臺南地方名門後代，洋裁學校女老師金焄治，她曾留學東京，手巧心細，勤樸獨立。兩人理念相近，情投意合，很快地決定白頭偕老，在臺南神社舉行婚禮。此刻正值戰爭非常時期，畫家正投入南部民間手工藝調查與生產工作，既無家長支持，又居無定所，捉襟見肘的情況下，幸賴許多朋友合力協助，才順利完成這場人生大事。個性內斂的畫家，對此經歷記憶深刻，並永懷感恩之情。

畫家，特別是兩袖清風的顏水龍，送給新婚妻子最真誠的紀念物無非是記錄她青春年華的畫像。在他們攜手同行的人生道路上，畫家繼續為妻子畫像，有用來鼓勵、安慰她的，晚年更有幾幅是懷念老伴的。（顏娟英）

Artist's Wife features a warm and saturated red tone in the background. The wife has a round forehead and delicate facial features. Her composure and refinement show through her bright eyes. She wears a form-fitting, white V-neck blouse designed by herself, bringing out her oval face and slender neck in a graceful manner. Yen Shui-Long believed that women appeared especially elegant and stylish in white. It was an observation he made while living in Cannes and learning from Fauvist painter Kees van Dongen (1877-1968) in 1932. In the portrait, Yen's wife looked pleasant and gentle, full of hope for a family and life they were about to build together.

In 1942, Yen met Jin Chua-Zhi, the daughter of a prestigious family in Tainan and teacher of a western-style dressmaking school. Having studied in Tokyo, she was skilled with her hands, meticulous, hardworking and independent. The couple shared similar values and were fond of each other. Very soon, they decided to spend their lifetime together and held the wedding at the Tainan Shrine. At the time, the country was at war. Yen was devoted to the investigation and production of local handicraft. Without support from their parents, a permanent residence and a lack of financial means, it was because of many friends and their assistance that the couple was able to complete this momentous event. This experience left indelible marks in the memory of the reserved painter, who never forgot the gratitude he held.

For a painter, especially someone like Yen Shui-Long whose situation was not affluent, the sincerest gift he could give to his wife was no doubt a portrait that recorded the prime of her youth. As the couple went through their journey in life together, Yen continued to paint portraits of his wife. Some were to encourage her, some to console her, and even a few painted in his late years to commemorate his life-long companion. (YEN Chuan-Ying)

何德來 HO Te-Lai (1904-1986)
背影 Rear View (Playing a Three-stringed Lute)

油彩、畫布 Oil on canvas, 38.0 x 45.0 cm, 1973
家屬收藏 Collection of Artist's Family

「何德來二十八歲　妻秀子二十六歲　夫婦的誓願」何德來長期以日文短歌抒發心情，內容包羅對故鄉的憶念、寫景與記錄戰爭的苦難，甚至座右銘；這首短歌是1931年10月婚禮當天的誓言。

這幅畫從室內到室外，天地間塗滿了嫩綠色；熱氣蒸騰的夏天，院子裡蟬鳴唧唧，室內小風扇悠悠地轉著。畫中女子面對庭院專心彈奏三弦，膝前還放著一把箏琴；她身著短袖洋裝，端正踞坐，背對著觀者，身後黑影邐連不斷，彷彿從地面支撐著她單薄的身子。這是描繪秀子生前最後一個炎熱的夏日，她不停地揮汗練琴，直至病倒。1973年初畫家在妻子的墓石上親自刻下：「真善美聖處女般　每月優雅的琴音　吾妻秀子」

何德來出身貧困農家，幼年時被迫與生父母分離，成為新竹大地主的養子。1912年德來再次離家，剪去長辮，獨自到東京就讀小學。初到學校遭受同學霸凌的痛苦經驗令他難以忘懷，但他一生始終嚴以律己，寬以待人，關懷生命。中學返臺，就讀臺中一中；四年級時決心學習美術，遂重返東京準備投考美術學校。此時期房東木邑一家待他親切如家人，其後長女秀子與畫家結為藝術伴侶。畫家堅持不賣畫，寧可過著儉樸的生活，全心創作，並勉勵同好與追隨者：「不要忘記，畫筆是血管，畫架是自己的身體，顏料是血液。」

德來畫如其詩，構圖簡潔明朗。這幅畫浮現了畫家記憶中的生活場景，妻子自幼投入琴藝，正如同畫家堅持作畫，兩人相知相惜，彼此守護；在和煦的陽光下，樸實溫暖的家洋溢著畫家對妻子的深情與思念，令人動容。（顏娟英）

"Ho Te-Lai, twenty-eight years old. His wife, Hideko, twenty-six of age. The vow to be married couple." Ho Te-Lai had always expressed his feelings with Japanese tanka (thirty-one syllabled verse). His tanka comprised a wide range of topics, including memories of his homeland, commemoration of a scene, suffering incurred by warfare, and even his motto. This tanka was his vow spoken on the wedding day in October 1931.

In the painting, both the indoor and outdoor space were filled with a light green color. In the sizzling heat of the summer, cicadae were chirping in the garden and the small electric fan was slowly turning. The woman in the painting, with her facing the garden, was immersed in playing a three-string lute, with a zither lying in front of her knees. She wore a short-sleeve, western-style dress, sitting upright with her back to the spectator. Her shadow stretched behind her, as if it was supporting her frail body. This painting recorded the last burning summer before Hideko passed away. She practiced the three-string lute diligently until she fell ill. In 1973, the artist personally carved the following epitaph on his wife's tombstone: "Immaculate as Truth, Kindness and Beauty. Elegant lute music filled every month. My endearing wife, Hideko."

Born in an impoverished farmer's household, Ho was separated from his biological parents and adopted by a well-off landowner in Hsinchu. In 1912, he left home again, got rid of his queue and began his elementary school education alone in Tokyo. At first, he was bullied by his classmates, and the pain left a deep impression in his mind. Throughout his life, Ho was strict with himself, magnanimous to others, and always cared about the living. He returned to Taiwan for the middle school education at Taichung First High School, and in the fourth grade, decided to

study art. Later, he returned to Tokyo and began preparing the entrance exam of the art school. His landlord, the Kimura family, was kind to him and treated him like one of their own. The eldest daughter of the Kimuras later married the artist and became his companion in life and art. Ho insisted on not selling his painting, and preferred a simple life, dedicating all his time to artistic creation. He also encouraged his fellow artists and followers to "never forget that the paint brush is one's blood vessel, the easel the body, and the paint the blood."

The composition of Ho's painting, like his poetry, was simple and open. This work visualized a daily scene from the artist's memory. His wife had played the lute since childhood, just like the painter who insisted on painting steadfastly. The couple was like-minded and cherished each other's company. Under the pleasant sunlight, the unadorned, warm house seemed to brim with the artist's affectionate remembrance of his wife, making the image incredibly moving. (YEN Chuan-Ying)

16

林之助 LIN Chih-Chu （1917-2008）
少女 Young Lady

膠彩、紙 Gouache on paper, 43.0 x 46.0 cm, 1951
私人收藏 Private Collection

林之助從小赴日，接受完整的日本教育與學院美術訓練。1939年從東京帝國美術學校日本畫科畢業後，繼續進入兒玉希望畫塾學習。同年入選兒玉畫塾展的《小閒》（臺北市立美術館典藏），取材森永糖果商店附設咖啡店的女服務生聊天的片刻，這是現代職業女性忙裡偷閒的共有經驗，簡潔的構圖形式，色調和諧清雅，使畫面產生潔淨明快的現代感，充滿優雅的都會生活氣息。隔年他創作的《朝涼》（國立臺灣美術館典藏）入選紀元二千六百年奉祝展。這幅畫以布滿畫面的牽牛花為背景，描繪全身側面、短髮的和服女性，與依偎的公羊、小羊對望的場面。畫中投射未婚妻形象的女性，高雅大方，整體氣氛溫馨和諧，寫實中帶有細緻的裝飾性。

戰後林之助以風景和花鳥畫創作為主，少數女性像則延續戰前清新的寫實畫風，並賦予更簡約凝鍊的形式。本幅《少女》以家人為形象描繪，畫中的女子位於深綠色的橡膠樹葉前，眼神略為低垂，若有所思。俐落的短髮造型與清秀的五官，皆與《小閒》、《朝涼》中的女性描繪類似。畫家以細緻的線條勾勒少女的肩頸、露肩的白色上衣，以及右手貼著臉龐的輪廓；圓弧簡化的身軀造型，展現素淨優雅的現代感，恰如其分地捕捉純潔少女的形象。少女修長的肩頸、橢圓的身形及表現性的手勢，皆令人聯想起林之助喜愛的畫家莫迪里亞尼（Amedeo Modigliani，1884-1920）描繪妻子珍妮・赫布特妮（Jeanne Hebuterne）的肖像，同樣充滿真摯情感及美麗、純潔的形象。林之助或許受到莫迪里亞尼的啟發，並吸收轉化至膠彩畫的表現上，選擇以單純的線條、素雅的色彩，描繪少女的恬靜與含蓄之美。（黃琪惠）

Lin Chih-Chu went to Japan as a child and received complete Japanese education and academic art training. After he graduated from the Nihonga (Japanese-style painting) Division of Teikoku Art School in Tokyo in 1939, he continued studying painting at Kodama Kibo's art studio. Lin's *Recess* (Collection of Taipei Fine Arts Museum), which was featured in the art studio's exhibition in the same year portrayed a moment of conversing waitresses at Morinaga Candy Shop's café and depicted modern career women taking a break at work, a common experience for these women. The simple, neat composition as well as the balanced, elegant colors of the image created a lucid and lively feeling of modernity, conveying a sophisticated atmosphere of urban living. The next year, the painter's *Bathing in the Morning* (Collection of National Taiwan Museum of Fine Arts), was selected into The Art Exhibition Celebrating the 2600th Year. The painting, with a background covered with morning glories, depicted the profile of a short-haired woman in kimono looking at a billy goat and a kid that are looking back at the woman. Lin delineated the woman in a graceful and well-poised manner, projecting the image of his fiancé onto his subject. The overall atmosphere is warm and harmonious, and the realistic delineation is embellished with exquisite decorativeness.

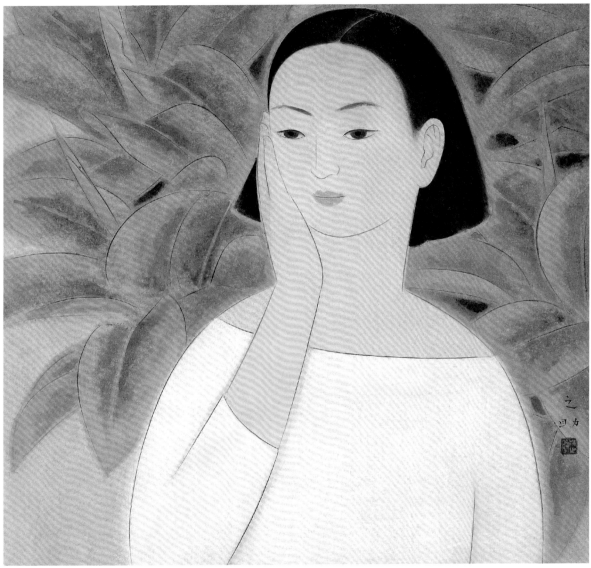

©林之助基金會

After the war, Lin mainly painted landscape and bird-and-flower painting. He only created a few female portraits that continued his fresh, realistic pre-war painting style and with a more simplified and refined form. The artist based *Girl* on the image of his family member. The girl in the painting stands in front of dark green rubber tree leaves. Her line of vision slightly lowered and she seemed to be immersed in thoughts. Her sleek short hair style and delicate features are reminiscent of the women portrayed in *Recess* and *Bathing in Morning*. Lin used fine lines to draw out the contour of the girl's shoulders, neck, her shoulder-baring white top and her right hand touching her face. The rounded, simplified form of the torso displays a simple, elegant modern feeling, perfectly capturing the girl's image of innocence. The girl's elongated neck, the contour of her shoulders, her oval figure and expressive hand gesture bring to mind the sincere, beautiful and pure image that is the portrait of Jeanne Hebuterne painted by her husband, Amedeo Modigliani (1884-1920), whom Lin admired very much. Perhaps Lin was inspired by Modigliani, absorbing and translating Modigliani's style into gouache expression, and chose to portray the quiet and understated beauty of the girl with simple lines and elegant colors. (HUANG Chi-Hui)

17

呂基正 LU Chi-Cheng (1914-1990)
少女小玫 Little Vivian

畫布、油彩 Oil on canvas, 45.5 x 37.9 cm, 1964
私人收藏 Private Collection

這幅描繪女兒小玫胸像的畫作散發出一股懾人心魂的氣息。少女好像在舞臺上，燈光聚焦在清純無邪的臉龐，頭上繫著紅色大蝴蝶結，披肩秀髮，濃厚烏黑，隱沒在墨綠色背景中。畫家描寫女兒的手法充滿戲劇性的舞臺效果，令人聯想到日本油畫家岸田劉生（1891-1929），後者曾以超過十年時間不斷地製作長女麗子一系列神秘而美麗或怪誕的形象。兩位畫家對女兒的鍾愛非常相似，惟表現手法截然不同。劉生的手法寫實細膩，卻時而隱含著嘲諷世人的味道；基正的筆觸簡潔快速，接近表現主義，畫面安穩踏實。小玫身著白色荷葉邊圓領衣裳，與黑色線條形成強烈的對比，整體畫面澄靜明亮，更趨近魯奧（Georges Rouault）寧靜帶有宗教意味的人物畫。

小玫安靜地望著父親，他們彼此間有著無法撼動的信賴感。從小父親就常牽她的小手到公園內的博物館，樓上樓下轉悠著看畫展。她相信每件畫作都是畫家一步一腳印、辛勤耕耘的成果。體格壯碩的父親常常扛著畫具與登山繩索外出數天旅行寫生，回來時一定攤開許多畫作，佔滿整個牆面，興奮地為她和母親解說高山上變化莫測的風雲、森林與陡峭的山稜線。父親是小女孩心中無可取代的英雄；女孩是畫家心中堅毅慧黠的天使。這幅小小的畫像不僅保存了女兒童稚的秀麗，更留下父女永難忘懷的親情印記。（顏娟英）

This is a captivating portrait of the painter's daughter, Vivian (Hsiao Wen). It looks as if the young girl is standing on stage, with a spotlight focused on her pure and innocent face. She wears a large red bowtie on her head. Her thick, long dark hair cascades down her shoulders and disappears into the background. Lu Chi-Cheng's use of dramatic stage effect with his daughter's portrait is reminiscent of Japanese oil painter Kishida Ryusei (1891-1929), who spent over ten years painting a series of mysterious, beautiful and grotesque images of his daughter, Reiko. Both painters loved their daughters deeply; however, their portrayals are distinctly different. Kishida's techniques are realistic and detailed, yet his paintings can be seen as a veiled satire of humanity. Lu's clean and rapid brushstrokes are closer to expressionism, and his image seems solid and grounded. Vivian's garment is white with a flounced collar, forming a stark contrast with the black lines. The overall picture is clear and bright, more similar to the serene portraits with religious implications by Georges Rouault (1871–1958).

Vivian looks at her father quietly. There is an unshakable trust between them. Since she was little, her father would take her by the hand while leisurely strolling inside museums and looking at paintings. She believes that every painting is the result of the artists' tireless hard work. Her father would often pack his tools and climbing ropes to go for a painting trip for days. When he returned, he always laid out paintings that took up the entire wall. He would talk to her and her mother excitedly about the changing weather in the mountains, the forests, and the steep mountain ridgeline. Her father is an irreplaceable hero to the girl, and the girl is a strong and wise angel in her father's eye. The completion of this small portrait had left another indelible mark in the loving relationship between the father and daughter. (YEN Chuan-Ying)

陳敬輝 CHEN Jing-Hui (1911-1968)
舞者 Dancer

膠彩、紙 Gouache on paper, 36.7 x 51.7 cm, 1958
長流美術館收藏 Collection of Chan Liu Art Museum
款識：戊戌之歲三月，敬。鈐印：敬輝。Inscription: Jing, March 1958. Seal: Jing-Hui

陳敬輝自幼被送往日本京都寄養在中村先生家，及長進入京都市立美術工藝學校、京都市立繪畫專門學校，接受完整的美術學院訓練，並與中村春子結為連理。1932年畢業後舉家返臺定居淡水，陸續任教淡水女學校與淡水中學。1933年以《路途》獲得臺展東洋畫部特選，成為畫壇矚目的東洋畫家。陳敬輝擅長人物畫，入選臺展的作品以女性人物畫為主，尤其以學生作為描繪對象，筆下的女性呈現細緻、清秀與明朗的風格。王白淵認為他擅長美人畫，具有線條餘韻嫋嫋的特色。戰後陳敬輝繼續任教淡江中學，也持續創作女性人物畫，無論時尚或庶民女性皆描畫得吸睛動人。

《舞者》原為畫冊中的一頁，畫冊中尚有林玉山、陳進、郭雪湖、林之助、許深州等人的作品。陳敬輝以淡墨線條、淺膚色描寫一位女性芭蕾舞者坐在地上的側面背影。他運用各種變化的線條描繪舞者身形、芭蕾舞衣、頭髮與髮帶等。舞者凝視著地面，雙手抱著左膝，嘴唇微張，享受調息休憩的片刻。陳敬輝另一幅《芭蕾舞少女》大作，描繪兩位舞者坐在椅上整理髮式或休息，似乎正在等待上場表演，姿態相當自然生動。1950年第五屆的省展，畫家展出《舞餘少憩》，顯示其偏愛舞蹈女性的題材。這件小品《舞者》，人物姿態與表情的掌握也十分傳神。（黃琪惠）

Chen Jing-Hui was sent to Kyoto when he was little, and lived with the Nakamura family. When he grew up, he studied at Kyoto City Technical School of Painting, where he received complete academic training in arts. It was during this period he got married to Nakamura Haruko. In 1932, after he graduated, he moved back to Taiwan and settled down in Tamsui. He first taught at Tamsui Girls' High School and then Tamsui High School. In 1933, he was awarded the Special Selection Prize in the category of toyoga (also known as nihonga; Japanese-style painting) with his *On the Road*, and became a much anticipated toyoga painter. The women in his paintings manifested a delicate, elegant and refined style. According to Wang Pai-Yuan, Chen specialized in bijinga (Japanese painting of beautiful women), and his work demonstrated the lingering charm of the genre. After the war, Chen taught at Tamsui High School, and continued created figure paintings featuring the topic of female figures. Whether chic, fashionable ladies or common women, they always appeared attractive and charming in his work.

Dancer was originally a page from a painting album, which also included works by Lin Yu-Shan, Chen Chin, Kuo Hsueh-Hu, Lin Chih-Chu and Hsu Shen-Chou. The artist used light ink line and light skin color to portray the back of a ballet dancer sitting on the floor from the side. Using the variation of line to delineate the dancer's figure, her tutu, her hair and hair band. The dancer was gazing at the floor, with her arms around the left knee and her lips slightly parted, seemingly taking a break. Chen's another larger painting, *Young Ballet Dancers*, featured two dancers sitting on chairs and fixing their hair or resting. They seemed to be waiting for their turn to perform, and looked natural and vivid. In the 5th Taiten in 1950, the artist exhibited *Resting After Dancing*, indicating that the artist favored the motif of female dancers. This small piece, *Dancer,* also demonstrated his mastery of capturing the pose and expression of his subject. (HUANG Chi-Hui)

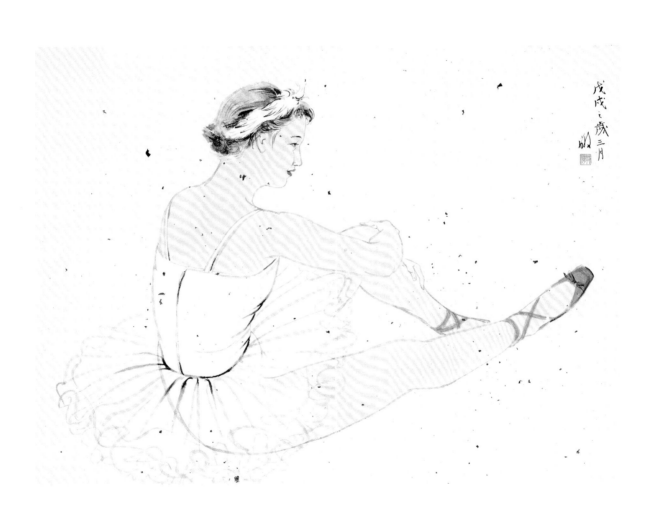

洪瑞麟 HUNG Rui-Lin (1912-1996)
等發工資 Payday

水墨淡彩、紙 Ink and watercolor on paper, 38.0 x 52.5 cm, 1959
私人收藏 Private Collection

命運的偶然，個人的選擇，促成臺灣美術史上獨一無二的奇蹟：礦工畫家洪瑞麟。1938年，廿七歲的年輕畫家由日本學成歸國便面臨長兄過世，父母年邁，為了擔負家計，他前往畫家倪蔣懷（1894-1943）經營的瑞芳二坑煤礦工作，從採煤工人、管理階層，一路做到礦長。沒有人預想到，這個黑漆漆的礦坑將會產出其生涯創作的最高峰：「第一度走下礦坑的我……幾乎立刻地，我就決定了這是我繪畫要表現的，一生的事業。」為了作畫方便，洪瑞麟甚至自行研發輕便畫具，他以竹管裝筆，以底片盒裝墨汁，工作用的記事簿，翻過頁就成為速寫簿。素描功力深厚的他，便這樣在礦場中畫下了幾千幅人物速寫。

畫面上群聚約十來名礦工，正等待著領取工資。有的人手插褲袋，或雙手抱胸，一縷輕煙從指間的香菸竄出，沉默表情中難掩疲憊。畫家以墨線飛快勾勒出礦工寬厚的臂膀、大手、因久蹲而痀僂的雙腿，臉上卻流露出一絲睥睨。最後以棕、綠淡彩為整幅畫面略作修飾。來自地底的那抹幽暗，彷彿是他們身上去不掉的顏色。

最前方三人直直面對畫家，可見他們意識到自己正在入畫，卻顯得一派輕鬆。據說剛開始時，礦工們也對「畫家」的行為感到好奇陌生，後來習以為常，紛紛接受了這位被暱稱為矮肥洪仔的夥伴「所喜歡的事」。洪瑞麟亦表示：「我與他們工作在一起，歡笑在一起，甚至結婚在一起（我娶了工頭的女兒），當然，苦難也在一起……我的畫就是他們的日記，也是我的反省。」唯有經由真誠的藝術之筆，方能帶領我們穿越社會對於職業、美醜的俗見，直接看到勞動者的莊嚴與生命本質吧！（楊淳嫻）

Serendipity in life combined with personal choices had created a unique miracle in Taiwanese art history—the name of the miracle is Hung Rui-Lin, also known as the "miner painter." In 1938, the twenty-seven-year-old painter returned to Taiwan after finishing his education in Japan, and found himself faced with the death of his elder brother and the livelihood of his aged parents. To shoulder the responsibility of taking care of his family, he started working at the Second Mining Field run by the painter Ni Chiang-Huai (1894-1943). He first worked as a coal miner, and then moved up to the management, and finally became the mine supervisor. Unexpectedly, the pitch-black mine would produce the culmination of his creative career: "The first time I walked down the mine… almost immediately, I knew this was the life-long subject matter that I wanted to paint." In order to paint more conveniently, Hung even invented his own portable painting equipment, using bamboo tubes to store paint brushes and film canisters to carry ink. Notebooks used at work became his sketch books as he drew on the back of used pages. With solid techniques in sketching, Hung produced thousands of figure sketches in the mine.

In this painting, a dozen of miners gathered together, waiting to collect their wage. Some of them had their hands in their pockets; some crossed their arms over the chest, with a wisp of

cigarette smoke rising from between their fingers. Fatigue could be seen on their quiet faces. With ink lines, the painter swiftly sketched the miners' broad shoulders, large hands and their bent legs due to squatting for long hours, along with their proud look. To complete the work, Hung used light brown and light green to embellish the overall image. A fraction of underground gloom seemed to be the unmistakable color of the miners.

Three of the miners in the front had their faces towards the painter, but looked rather relaxed despite the knowledge of being the painter's subject. It was said that, at first, the miners felt curious and strange about the behavior of the "painter"; but

as time went by, they grew accustomed to it and came to accept what their co-worker – they nicknamed the artist "Fatty Hung" – "liked to do." According to the painter himself, "I worked with them, laughed with them, and even became related to them by marriage (I married the team leader's daughter). Of course, I suffered with them, too… My paintings are their journals as well as my way of self-contemplation." It is true that only through the honesty of art could we look beyond prejudices that society imposes on occupations and appearances, and directly perceive the dignity of the laborers and the essence of their life. (YANG Chun-Hsien)

洪瑞麟 HUNG Rui-Lin (1912-1996)
礦工 Miners

油彩、木板 Oil on panel, 53.0 x 33.0 cm, 1956
私人收藏 Private Collection

在礦坑黝暗而狹小的空間裡，依稀可見四、五個正在工作中的身影。畫面上方隱隱可以看到木質梁架，四周岩壁形成一團漆黑，凝神看去，暗中仍有著灰、棕、藍、綠等色。光源聚集於畫面中央，由厚塗所製造出來的筆觸肌理，讓光線顯得跳躍不定且顏色混濁。畫家站在坑道另一端進行描繪，由於背光的緣故，人體與岩層的顏色幾無分別，簡直像是礦坑的一部份；唯有被光照到的地方，才能看到裸露的紅棕色肌膚，大半身軀仍陷在那綠濁的陰影之中。

洪瑞麟曾描述坑內作畫的狀態，唯一的光線來自礦工所戴的安全頭燈，當三五工人聚在一起工作時，在光的互相映照下，方能看清楚形體輪廓。但那是一種無時無刻不在晃動的光，形成難以定焦的視覺經驗。不僅如此，地底下高溫高濕的環境，每每讓礦工皮膚發紅，汗流到內褲都穿不住。空氣中充滿粉塵，老鼠、蟑螂橫行，不時還會被煤屑或木屑的碎片刮傷。臺灣的煤礦層多夾在傾斜岩層中間，因此礦工必須蹲著，甚至躺臥工作，長久下來，容易產生關節炎、一氧化碳中毒、矽肺病等職業傷害。更怕的是遇上落磐或爆炸等公安意外，臺語俗諺「入坑挖塗碳，性命賭一半」，堪稱是賭命換錢的工作。

洪瑞麟說：「採礦者的辛苦不是一般地上人所能完全了解的。」隨著臺灣煤礦業沒落，礦工的身影也逐漸淡出歷史舞臺。然而就在臺灣美術史上，有著一位「礦工畫家」，以其畫筆為他眼中的「黑色神祇」留下永恆的讚頌：「苦力之極限，昇華為神性！」（洪瑞麟〈礦工頌〉）（楊淳嫻）

In the dark and narrow mine tunnel, there seemed to be four or five figures working in the space. On the top of the image, one can indistinctly see the wooden beams, whereas the surrounding rocky walls are delineated in black. A closer inspection reveals other colors, such as gray, brown, blue and green. The center of the painting is the only illuminated area, and the thick application of paint creates vivid texture that makes the light flicker and the colors blurry. The artist depicted the scene from another end of the tunnel. Against the light, the human bodies seemed to be in the same color as the rock stratum, seemingly merging with the mine tunnel. Only under the limited source of light could one see the bare red-brown skin, but most of the body was still engulfed in the muddy green shadow.

When describing the situation of painting in the mine, Hung said that the only source of light was the miners' headlights. When a few of them gathered together, their headlights shone on each other, revealing their clear contours. However, such light source was in constant movement, forming an out-of-focus visual experience. Moreover, the humid, hot underground environment always made the miners' skin red. They would sweat so much that they even could not bear to wear underpants. The air was filled with dust, whereas rats and roaches roamed freely; and when not paying attention, one might get scratched by fractured pieces of coal or wood splinters. Taiwan's coal strata were mostly between tilted rock strata, so miners had to crouch or even lie down when they worked. In the long run, they might suffer from arthritis, carbon monoxide poison and silicosis. A worse fate was collapses or explosions in the mines; hence the Taiwanese saying, "digging coal in the mine is staking half of one's life." Being a miner was simply trading one's life for money.

Hung once stated, "those on the ground could never really understand the miners' hardship." As Taiwan's mining industry declined, the presence of the miners faded into the past. However, the "miner painter" in Taiwanese art history used his paint brush to create his eternal celebration of what he called "the black deity," paying his homage by saying "the extreme limit of manual labor can be sublimated into divinity!" (Hung Rui-Lin, "Ode to Miners") (YANG Chun-Hsien)

鹽月桃甫 SHIOTSUKI Toho (1886-1954)
刺繡 Embroidery

油彩、三夾板 Oil on plywood, 35.0 x 24.0 cm, 1930s
顏水龍舊藏 Previous Collection of YEN Shui-Long

綠色山林裡，有位姑娘坐在樹下石頭上，自在地伸直雙腳，專注刺繡的神情讓她紅色身影顯得更美麗。她頭戴鑲有貝殼的額帶，身穿小圓領長衣，膝下以黑布裹腿。身旁左右各有一樹，頭頂和腳下是金黃色的天地，好像將她包圍起來，護衛著她。畫家隨身攜帶做為畫布的小塊三夾板去旅行，在現場對著人物用粗筆痛快淋漓地寫生；充分描繪、掌握人物堅強有力的靈魂，正是他喜愛而嫻熟的題材。

排灣族分布在臺灣南部大武山系，逐漸擴散至屏東、臺東境內。排灣族傳統文飾刺繡，通常是在一塊布面上繡出精美的幾何花紋或動物、人物紋，再縫貼在衣服的開襟、袖口或下擺等地方作為裝飾。

鹽月桃甫個性浪漫，率真不拘小節；作品曾入選日本文展，三十六歲時卻毅然辭去工作，到臺北任教於中學、高校，直到戰爭結束被遣返歸國。他數次深入臺灣東海岸旅行，對臺灣高山讚嘆不絕：「阿里山雲海是華麗的，紅檜巨木林是古典的，新高山脈（玉山）則是壯麗的；而大霸尖山則是莊嚴怪奇。」他深信高山的神聖性，認為臺灣幸而有居住在高山的原住民：他們守護山林，保存純潔不受現代文明污染的文化；他們是臺灣珍貴價值的根源。

鹽月桃甫將這幅畫作為禮物，送給他所欣賞，也同樣愛惜、保護原住民文化的臺灣畫家顏水龍。（顏娟英）

In the lush green mountain forest sits a girl on a rock under a tree. Casually extending her feet, the way she is focusing on her embroidery work makes this lady in red even more beautiful. She is wearing a headband decorated with shells, a round-collar robe, and black leggings. There is a tree on both her left and right sides. The sky above her head and the ground below her feet are a golden color and seem to envelop and protect her. Shiotsuki brought a small piece of plywood with him as his canvas and wholeheartedly enjoyed painting the portrait with thick strokes. He fully portrayed and captured the strong, powerful spirit of the subject he portrayed, which is a subject matter he loved and mastered.

The Paiwan indigenous people originally inhabited the Dawu Mountain Range in southern Taiwan and gradually expanded to Pingtung and Taitung. Traditional Paiwan embroidery is often created on a piece of fabric, featuring intricate geometric patterns, animals or people. The patch is then sewed onto the front, cuffs or hem of the garment as decoration.

Shiotsuki is a romantic, candid, and easygoing person. His work had been selected for the Bunten (Japan's Ministry of Education Art Exhibition). Nevertheless, at the age of 36, he decided to quit his job and moved to Taipei to teach middle and high school until he was repatriated after the end of war. He traveled to Taiwan's east coast several times and was amazed by Taiwan's high mountains: "The Alishan Mountain's sea of clouds is magnificent; the giant Taiwan Red Cypress forest is classic; Mount Niitaka (Mount Jade) is majestic, and the Dabajian Mountain is stately and outlandish." He believed in the sanctity of high mountains and considered Taiwan to be lucky to have indeginous people living in the mountains. They protect the forests and preserve the pure culture from being contaminated by modern civilization. They are at the core of Taiwan's precious value.

Shiotsuki Toho gave this painting to a Taiwanese painter he admired, Yen Shui-Long, who also cherished and helped protect the indeginous culture. (YEN Chuan-Ying)

鮫島台器 SAMEJIMA Taiki (1898 - 卒年不詳)
山之男 Man of Mountains

銅 Bronze, 15.5 x 10.0 x H 36.0 cm, 1935
台灣50美術館收藏 Collection of Museum 50 of Taiwan

鮫島台器曾在基隆從事臺灣總督府鐵道部工作約十年，其間開始以雕塑為業餘愛好，1929年辭職後，正式踏入雕塑家之路。同年獲得幣原坦、倉岡彥助等著名在臺日籍人士支援，以及黃土水的介紹，赴東京成為北村西望（1884-1987）的弟子。赴日第三年，以《望鄉》（1932）首度入選帝展，次年也以《山之男》（1933）入選，開始在昭和時代（1926-1989）前期的日本雕塑界大展身手。

1935年春天所製作的此件作品，題名與1933年入選帝展作品相同，造型也相當類似。一位臺灣原住民青年，身上只戴著帽子及腰間的一塊布，兩隻胳膊在胸前交叉，雙腳踏著地面，眼睛望向前方。他帶的砍刀和槍，以及躺在腳下的一隻狗注視著與主人一樣的方向，表示去狩獵前的情景。鮫島擅長製作身強體壯的男性裸體像，《山之男》也是同樣類型的作品，但是唯一以臺灣原住民為主題之作。

1935年前後，是鮫島在臺、日之間頻繁來往，貫注精力創作的時期。1934年底，他曾將作品《小楠公》獻給日本皇太子，並提到其理由：「繼承已過世的恩人黃土水之意志，想要為臺灣表現氣概。」此時期鮫島改掉本名盛清，開始使用「台器」的名稱，取了臺灣的「台」之一字，或許表示他對臺灣的特別思念。戰後鮫島的活動幾乎都被遺忘，入選帝展的代表作品目前也皆下落不明，此件雖是小品，卻可接觸到他曾經創作的、具有臺灣特色之作品風格。（鈴木惠可）

Samejima Taiki worked at the Railway Bureau of the Government-General of Taiwan in Keelung for around 10 years. During this time, he took up sculpting as a hobby. He resigned from his post in 1929 and officially began his career as a sculptor. In the same year, he received help from renowned Japanese in Taiwan, including Shidehara Taira and Souoka Gennjo, and was recommended by Huang Tu-Shui to study under Kitamura Seibo (1884-1987) in Tokyo. During his third year in Japan, Samejimaj was selected into Teiten (Japan Imperial Art Exhibition) for the first time with *Looking Towards the Homeland* (1932). He made the list again the following year with *Man of the Mountains* (1933) and started to shine in Japan's sculpting community during the early Showa period (1926-1989).

Made in the spring of 1935, this work bears the same title and a similar look as the piece selected for the 1933 Teiten. A young man of Taiwan's indigenous community wearing a hat and a loin cloth has his arms crossed in front of the chest. His feet stand firmly on the ground, and his eyes are looking straight ahead. He carries a machete and a gun with him while a dog is crouching at his feet, also looking ahead. This is the scene before going hunting. Samejima was skilled at sculpting strong, robust male nudes. *Man of the Mountains* is also a piece of the same genre but the only one featuring Taiwan's indigenous people.

The years around 1935 was a period when Samejima frequently traveled between Taiwan and Japan while fully concentrating on his creation work. At the end of 1934, he dedicated his work *Kusunoki Masatsura* to the prince of Japan, and stated his reason "to commemorate his benefactor Huang Tu-Shui and his ideal by featuring the spirit of Taiwan." During this period, Samejima changed his name "Morikiyo" to "Taiki." Using the kanji character "台" from Taiwan (台灣) was perhaps his way of remembering Taiwan. Samejima's works after the war have largely been forgotten. The works selected for the Teiten exhibitions have also been lost. While a small piece, Man of the Mountains shows the Taiwanese traits in Samejima's artistic style. (SUZUKI Eka)

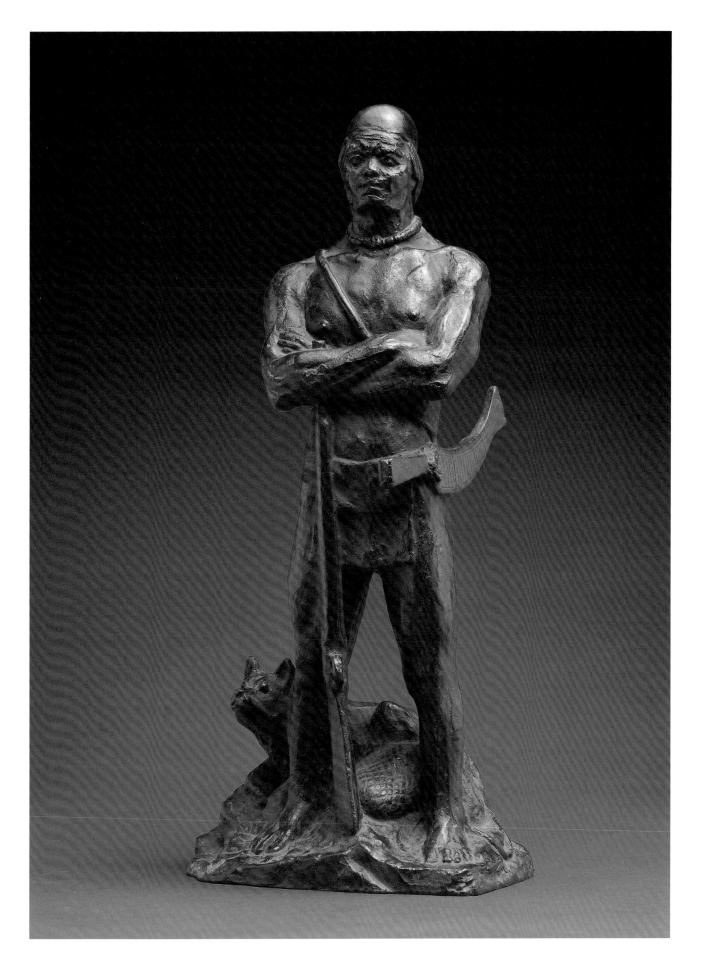

林玉山 LIN Yu-Shan (1907-2004)
蘭嶼少女 Girl on Orchid Island

彩墨、絹 Ink and color on silk, 56.0 x 43.0 cm, 1963
私人收藏 Private Collection
題款：時癸卯晚春桃城人玉山作。鈐印：玉山。

Inscription: By Yu-Shan from Taocheng (Chiayi), late spring of 1963. Seal: Yu-Shan

19 63年林玉山參加蘭嶼遊覽寫生團。蘭嶼是一座火山島，位於臺灣島東南外海，全島地勢起伏，富有熱帶雨林的珍貴生態。黑潮環流帶來飛魚，因此港澳邊聚集達悟（雅美）族出海捕魚的拼板舟。當時蘭嶼尚未發展觀光業，風俗民情相當純樸，林玉山沿途速寫蘭嶼的風景與人物，回來後創作多件蘭嶼主題的作品，包括這幅《蘭嶼少女》。

畫中微側站立的達悟族少女，右手托住頭頂的陶壺，她身著白色系的傳統服飾，袒露左肩的短衣與金色條紋的短裙，搭配盤髮的飾帶、貝殼製的耳飾與項鍊。濃眉大眼的美麗臉龐，迷人的專注神情，古銅色肌膚略帶豐滿的身材，呈現原住民少女自然

清純、健美的形象。此作令人聯想昔日法國畫家安格爾（Jean-Auguste-Dominique Ingres，1780-1867）創作的《泉》（The Source, 1856），同樣展現少女的青春氣息與生命的活力。

《蘭嶼少女》與另一幅《蘭嶼所見》描繪背負小孩的達悟族婦女站在拼板舟前的表現手法類似，皆運用圓轉俐落的線條勾勒女性的身軀與服飾，強調達悟族人的文化特色。而《蘭嶼少女》更以濃淡粗細的流暢筆墨描寫少女身旁的芭蕉葉與綠蘿，這樣的佈局巧思不僅烘托少女挺立的身影，而且增添畫面活潑的生意。這幅作品曾在1993年東之畫廊舉辦的「臺展三少年畫展」中展出，後由私人珍藏至今。（黃琪惠）

In 1963, Lin Yu-Shan took part in a sketching tour group to Orchid Island(Lanyu), a volcanic island, with tropical forest and precious ecology, located off the southeast corner of Taiwan. The Kuroshio, also known as the Black Current, brings flying fish to the island, so the tatala boats used by the Tao (Yami) people for fishing can be seen in its harbor and on the shore. When the artist visited Orchid Island, there was no tourism whatsoever, and the local customs and tradition were still very primitive. During this trip, Lin made a lot of sketches of sceneries and people on the island. After he returned to Taiwan, he created many works featuring topics related to Orchid Island, including *Girl on Orchid Island*.

In this painting, the Tao young maiden stood slightly sideways, with her right hand holding the pottery jar on her head. She wore white traditional Tao clothing—a short top baring her left shoulder and a short skirt with gold stripes. Her hair was brought together to the back with a hair band, and she wore earrings and a necklace made with shells. With distinct eyebrows, large

eyes and a beautiful face, she looked charming and focused. Her copper skin and slightly plump figure embodied the fresh, natural and athletic image of indigenous girls. This work reminds us of *The Source* (1856), the masterpiece by the French painter Jean-Auguste-Dominique Ingres (1780-1867), which also exudes a similar youthful air and vitality of young maidens.

The techniques of expression used in *Girl on Orchid Island* is similar to that of Lin's another painting, *A View of Orchid Island*, which features a Tao woman carrying a child on her back by a tatala boat. Lin used rounded, well-executed line to delineate the female figure and clothing, emphasizing the cultural characteristics of the Tao people. In *Girl of Orchid Island*, he also drew the banana leaves and devil's ivy with flowy ink lines with varying shades. The ingenious arrangement not only foils the girl's upright figure, but also adds a lively quality to the image. This work exhibited in East Gallery's exhibition of 1993, Three Young Artists of the Taiten, and has been in private collection since then. (HUANG Chi-Hui)

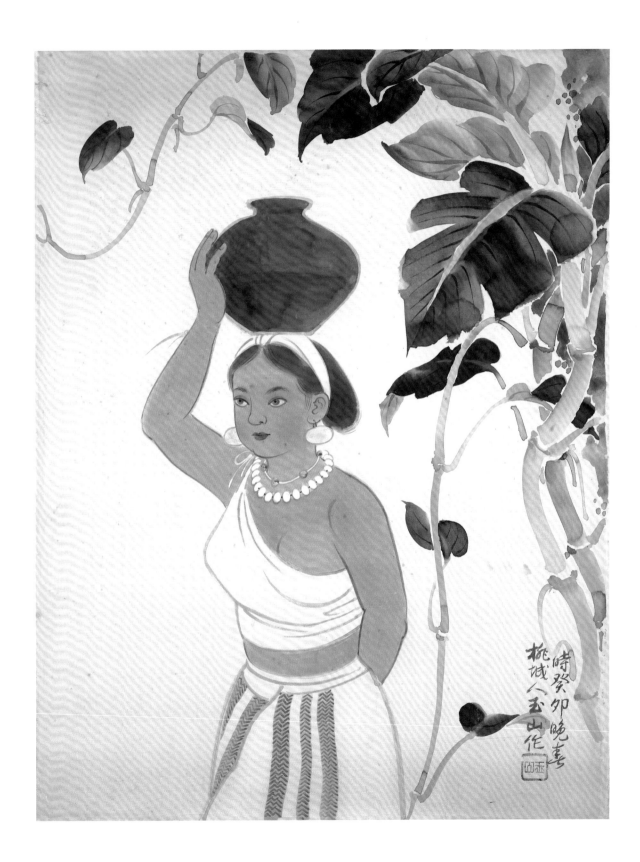

一千九百五十七年

寫於　台灣　台北市

農曆十二月卅日

永樂市場

藍蔭鼎

RAN-INTING.

TAIWAN (FORMOSA)

24

藍蔭鼎 RAN In-Ting (1903-1979)
永樂市場（市場風景）Yongle Market (Market Scenes)

彩墨、紙 Ink and color on paper, 18.5 x 142.0 cm, 1950
台陽畫廊收藏 Collecion of Taiyang Gallery
款識：一千九百五十年農曆十二月卅日，寫於臺灣臺北市永樂市場，藍蔭鼎RANINTING. TAIWAN (FORMOSA)
鈐印：藍蔭鼎印
Inscription: December 30, 1950 of the lunar calendar. Yongle Market, Taipei City, Taiwan. RANINTING. TAIWAN (FORMOSA).
Seal: Ran In-Ting

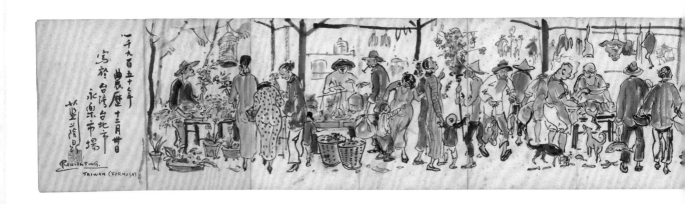

這件長摺冊頁形式的水墨作品，描繪臺北市大稻埕地區最繁榮的永樂市場。封面題字為「市場風景」，畫面由右至左展開，宛如電影鏡頭般由近至遠地帶出各攤位間穿梭忙碌的景象：若以第一頁為市場的入口，首先看到賣菜蔬的攤位，旁邊地上擺著幾籠被圈著的生雞鴨；緊接著是賣生鮮海產的攤位，水盆裡、攤位上滿滿的鮮魚；肉攤在鮮魚類的隔壁，老闆身邊徘徊著幾隻正在撿食的小狗；從畫面中段開始可以看到作為背景的棚架，懸吊著曬乾的魚或肉類；糖葫蘆或小玩具的攤販總能吸引住孩子們的目光；市場的另一頭是賣食料雜貨的攤位；有趣的是，最後一個攤位賣的是盆栽鮮花，表達出生活當中不可或缺的悠閒雅趣。

由整幅畫作的內容看來，畫家對於市場生態頗為熟悉，除了《永樂市場》之外，尚有幾幅描繪市場的速寫與水彩小品，均集中於1950至1960年間。藍蔭鼎在戰前的創作中即有以城市生活為主題的作品，不同的是，此時畫風加入更多水墨畫的技巧與氛圍。在此件作品當中，人物為畫面的重心，然而市場活動雖然繁複，卻絲毫沒有擁擠雜亂的感覺，畫家以簡潔的水墨線條來駕馭整體格局，每個人物的動作也千姿百態，摺冊形式更增添了賞玩畫面的趣味。

此作原為許伯樂（Robert B. Sheeks）所有。許伯樂於1949年來臺，任美國新聞處（USIS）首任處長，隨即結識藍蔭鼎，更邀請他共同投入為臺灣廣大農民出版圖文並茂的《豐年》雜誌（1951），接著促成畫家於1954年赴美訪問四個月。藍蔭鼎以此件描繪市場風景的作品相贈，可能是有感於許伯樂對於臺灣的深厚了解，以及感謝他在臺美文化交流上的諸多襄助。（楊淳嫻）

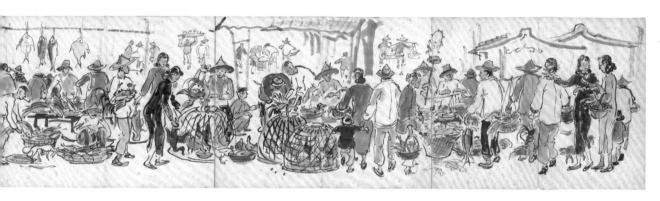

This ink painting in the form of a long folding album depicts the most prosperous Yongle Market in Taipei's Dadaocheng. The inscription on the cover reads "Market Scenes," and the album unfolds from right to left, introducing boisterous scenes of different vendors and stands from the nearest to the distant like a cinematographic take in a film. Taking the first page as the market entrance, the first subject depicted is the vegetable vendors, and next to them are several cages of chicken and ducks on the ground. Then, the painting shows fishmongers selling fresh seafood, with basins and stands filled with fresh fish. The butcher's stands are next to those of the fishmongers, with a few puppies lingering around and looking for food. From the middle section of the painting, one can see the shed in the background, with dried fish or meat hanging from the cross bars. Vendors peddling candied fruit or trinkets catch children's attention. On the other end of the market is the grocery stall. Interestingly, the painting ends with a florist stand selling potted plants and flowers, indicating that refined pleasure in life is indispensable.

Judging from the overall content of the painting, the artist was very familiar with the market ecology. In addition to *Yongle Market*, the artist also created a few sketches and small watercolors featuring the market during the 1950s and 1960s. Before the war, Ran had painted works depicting urban life. What makes this work different is that the artist applied more ink painting techniques and expressed the ambience of ink painting in his work at this period. Foregrounding the figures, the painting does not look crowded at all despite the busy activities in the market. With simple and clean ink lines, the artist clearly mastered the overall scale while giving each figure individual expression. The form of folding album also increases the pleasure of viewing the image.

This painting was previously in the collection of Robert B. Sheeks, who arrived in Taiwan in 1949 and served as the founding director of the United States Information Service (USIS). After assuming the post, he soon made the acquaintance with Ran, first invited him to join the publication of *Harvest* (1951), a magazine issued for promoting Taiwanese agriculture and farmers with both texts and pictures, and then facilitated the artist's four-month visit to the United States in 1954. Ran therefore painted this work of the market scenes as a gift for Sheeks, perhaps because he was touched by Sheeks' deep understanding of Taiwan and to thank him for the assistance he provided in terms of the Taiwan-US intercultural communication. (YANG Chun-Hsien)

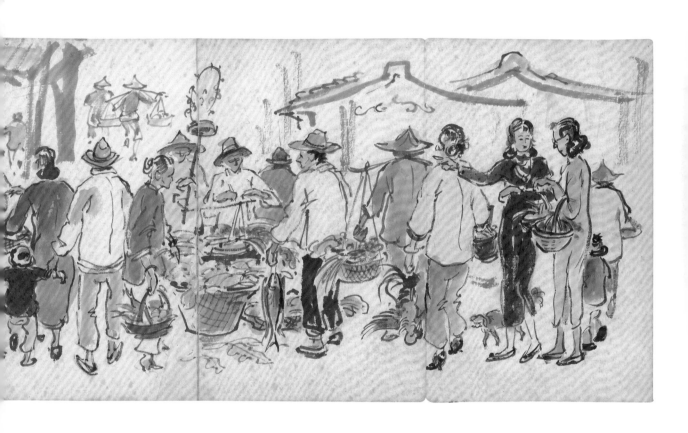

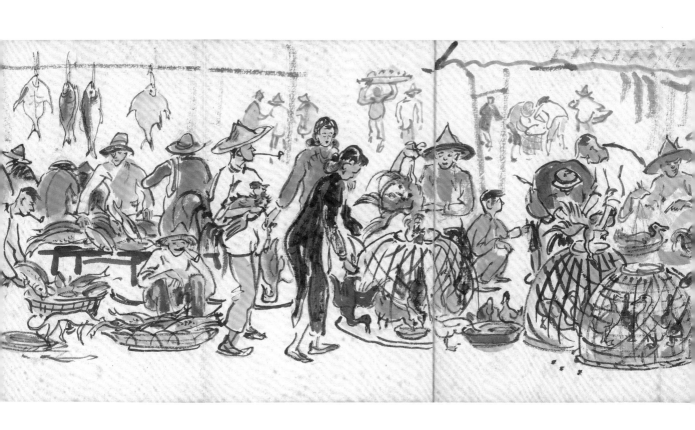

III

風土的踏查

SURVEYING CUSTOMS
AND LANDSCAPE

風土的踏查
SURVEYING CUSTOMS AND LANDSCAPE

文／邱函妮

國立臺灣大學藝術史研究所助理教授

Text / CHIU Han-Ni

Assistant Professor, Graduate Institute of Art History, National Taiwan University

在「風土的踏查」中所介紹的是對台灣風景在造型上的探索與創造，展出作品的創作年代從1920年代後半一直到1980年代為止。在這些「十人十色」的作品中，我們似乎可以看到臺灣風景畫從誕生、開展到終結的一個生命歷程。

本展中有多件作品曾展出於臺灣美術展覽會（簡稱臺展）中，體現出臺灣美術的成立與日本統治下所移植的美術制度有強烈關係。另外，展品之一的陳澄波《東臺灣臨海道路》（1930，圖27），是受曾任臺灣總督的上山滿之進委託所繪製的作品。上山在任內實施了幾項重要的文化政策，包括於1927年開設的臺灣美術展覽會。在臺展中可見到許多以臺灣風景為題材的作品，或許與展覽會強調表現臺灣地方特色的傾向有關。不過，對於臺灣風景的探索與創作動機，並不能只從展覽會的機制來加以解釋，其中還包含了更多複雜的面向。例如，日本人觀看臺灣風景的角度，以及他們如何使用新的媒材來表現異地風景。臺灣人以新媒材與畫風來描繪家鄉風景時，則面臨到認同的問題。另外，灣生第二代的日本人對於臺灣風景的看法，又與第一代來臺的日人畫家和臺人畫家有所不同。這或許是我們在觀賞這些作品時所必須進一步思考的問題。

早在1907年就來到臺灣的水彩畫家石川欽一郎，對於臺灣風景觀的建立以及水彩畫的推廣，有著莫大的貢獻與影響力。他不僅創作許多風景畫，也勤於撰寫文章來說明他對臺灣風景的觀察與思索。他認為對於風景的觀察與思考，與觀者自身的鑑賞力有很大的關係，因此提高鑑賞力是很重要的事情。石川的《驛路初夏》（1930，圖25），不僅是他在臺展中展出的作品，其所描繪的地點，也顯示出與他奔波於臺灣各地推廣美術教育的工作有關。石川欽一郎曾先後在國語學校與臺北師範學校任教，因而啟發了不少學生走上繪畫創作之道，如陳澄波、陳植棋、李澤藩、李石樵等人。接替石川教職位置的是小原整，他在1932年來臺。鄭世璠曾先後受教於李澤藩與小原整。對許多臺灣學生而言，在學校中所遭遇到最初的美術經驗，就是以畫筆來描繪身邊的風景，這種踏實地觀看與探索家鄉風景的態度，可說是臺灣風景畫的原點。臺灣畫家從這個原點出發，經過多方的學習與長年的研究，發展出具有自我風格的風景畫創作。

此外，也不能忽視灣生第二代日人畫家對於臺灣風景的探索。立石鐵臣可說是一個典型的例子。本展展出立石兩件少見的戰前創作，包含被分類在「破曉的覺醒」主題中的《稻村崎》（1930s，圖10），以及本主題的《風景》（約1941，圖32）。《稻村崎》顯示出立石鐵臣的創

The works featured in "Surveying Customs and Landscape" demonstrate the formal exploration and creation of Taiwanese landscape, and span a period from the second half of the 1920s to the 1980s. From these paintings by "ten artists of ten styles," we seem to glimpse the complete journey of Taiwanese landscape painting, from its birth, its full blossom to the end.

Many works on view in this exhibition were exhibited in the Taiwan Fine Arts Exhibition (or, Taiten), indicating a strong connection between the formation of Taiwanese art and the art systems transplanted from Japan under the Japanese rule. Moreover, Chen Cheng-Po's *East Taiwan Seaside Road* (1930; fig. 27), also on view in the exhibition, was commissioned by the former Taiwan Governor-General, Kamiyama Mitsunoshin. During his term, Kamiyama had implemented several crucial cultural policies, including establishing the Taiten in 1927. The Taiten had showcased a large number of works featuring the subject of Taiwanese landscape. This was perhaps because the exhibition had a tendency of emphasizing on showing Taiwanese local characteristics. Nevertheless, the exploration of Taiwanese landscape and the creative motive could not simply be explained by the mechanism of official exhibitions because there are more complicated dimensions, for instance, the Japanese artists' perspective on the landscape in Taiwan and their use of new media to interpret exotic landscape. When Taiwanese artists employed new media and adopted new painting style to portray the landscape of their hometown, they also engaged in the issue of identity. In addition, the second-generation Japanese artists born in Taiwan viewed Taiwanese landscape in a way different from that of the first-generation Japanese in Taiwan and Taiwanese painters. These are questions that we are encouraged to reflect on when viewing these landscapes.

Watercolorist Ishikawa Kinichiro came to Taiwan in 1907, and had greatly contributed and influenced the vision of Taiwanese landscape and the popularity of watercolor painting. In addition to being a prolific landscape painter, he was also a diligent writer, producing articles advocating

his observation of and reflection on Taiwan's landscape. For Ishikawa, the ability of observing and thinking about landscape was intricately related to the viewer's connoisseurship, so it was tremendously important to enhance people's competence to appreciate art. Ishikawa's *Ancient Road in Early Summer (Countryside)* (1930; fig. 25) was not only exhibited in the Taiten, the depicted location also pointed to his work as an art educator, which had brought him to many places around Taiwan. He had first taught at the National Language School, and later, Taihoku (Taipei) Normal School, and had inspired many of his students to pursue an artist career, among whom were Chen Cheng-Po, Chen Chih-Chi, Lee Tze-Fan and Li Shih-Chiao. Ohara Hitoshi succeeded Ishikawa's teaching position and came to Taiwan in 1932. Cheng Shih-Fan was taught first by Lee Tze-Fan and then Ohara. For many Taiwanese students, the first art experience they had ever had was to portray their surrounding landscape with a brush. This attitude of focusing on making observation in the field and exploring the landscape of one's hometown constituted the origin of Taiwanese landscape painting. Taiwanese painters had started from this point of departure and undergone the process of learning from different sources and years of study to craft and develop their highly individualistic landscape painting style.

The exploration of Taiwanese landscape by second-generation Japanese painters born in Taiwan should not be ignored, either. Tateishi Tetsuomi is a typical example in this aspect. On view in this exhibition are two of Tateishi's pre-war paintings, which are indeed rare. One is *Inamuragasaki* (second half of the 1930s; fig. 10) included in "The Dawn of Awakening," and the other is *Landscape* (c.1941; fig.32) featured in this section. The former shows how Tateishi's work has been influenced by Japan's modern Western-style painting in the 1920s to the 1930s. For example, Umehara Ryuzaburo, who painted *Taiwanese Maiden* (1933; fig.72) included in "The Traveler's Eye," was Tateishi's teacher. He had also advised Tateishi to visit Taiwan for searching creative inspiration. The other painting *Landscape* of 1941 was in the collection of

作受到1920至1930年代日本近代洋畫影響的一個
面向，如本展「旅人之眼」主題中《臺灣少女》
（1933，圖72）的創作者梅原龍三郎，就是立
石的老師，他曾建議立石到臺灣尋找新的創作方
向。另一件約創作於1941年的《風景》，為鄭世
璠舊藏品，顯示出立石與臺灣畫家之間的交友關
係，畫面中流露出他悠遊於臺灣風景中的愉快心
情。

本展中還有數件描繪淡水風景的作品，時代從
1920年代後半一直到1980年代，顯示出臺灣風景
畫從日治時期到戰後的巨大變化。淡水依山傍
河，「如畫般」的景色，在日治時期就已是熱門
的風景描繪景點。展品中年代最早的是陳植棋描
繪淡水紅瓦綠樹的典型臺灣風光的作品（1925-
1930，圖4），以及戰後郭柏川、張萬傳等人，以
各自擅長的繪畫語彙，在風景中表現自我，呈現
出完全不同的淡水風貌（圖33、圖35）。陳德旺
的《觀音山遠眺》（1980，圖36），最大限度地
捨棄了對實景的描繪，而將造型單純的觀音山視
為探究繪畫本質的研究課題。

探索風景畫的造型與本質等問題，在戰後歷經時
代變化與政權轉換，畫家們面臨到更多的挑戰，
無論在題材與風格上，都進行了更多的嘗試與自
我突破。在本主題中，值得注意的是廖繼春、林
克恭與呂基正的風景畫創作。廖繼春充滿律動感
的筆觸表現與濃烈的色彩運用（1965，圖37），
打破他戰前較為冷靜且抑制的風格，把情感寄託
於畫筆之中，讓已為人熟知的景色，再生新風。
相較於廖繼春的鮮豔色彩，林克恭純淨而典雅的
風景畫（1960s，圖38），令人聯想起瑞士畫家
霍德勒（Ferdinand Hodler，1853-1918）的作品，
他以簡練的造型與低彩度的色調，創造出一個既
表現外在景致，也呈現內心世界，具有象徵性的
風景。呂基正耗費將近四十年的時間探索、描繪
臺灣山岳畫，他以紮實的寫實功力，精確地掌握
千變萬化的山景（1962，圖41、1976，圖42、
1982，圖43），並以高度簡約的描繪手法，表現
了山岳的精神，創造出既具象又有抽象意境的個
人風格，為臺灣風景畫豐饒多彩的時代畫上了一
個完美的句點。

Cheng Shih-Fan, showing Tateishi's friendship with Taiwanese painters. In this painting, the painter's joy of immersing himself in the landscape of Taiwan is vividly visible.

Also, there are several paintings featuring the landscape of Tamsui in this exhibition. They were created between the second half of the 1920s and the 1980s, demonstrating the drastic changes that had taken place in Taiwanese landscape from the period of Japanese rule to the post-war era. Embraced by mountains and rivers, the "picturesque" vista of Tamsui had already been a hotspot for landscape painters during the period of Japanese rule. Among the works on view in this exhibition, Chen Chih-Chi's painting is the earliest one, and depicts a typical Taiwanese scenery with red-roof houses and green trees (1925-1930; fig. 4). After the war, Kuo Po-Chuan, Chang Wan-Chuan and other artists had employed their distinctive painting vocabularies to express themselves through landscape, unveiling the different looks of Tamsui (fig. 33; fig. 35). Chen Te-Wang's *A Distant View of Guanyin Mountain* (1980; fig. 36) departed extensively from realistic delineation and explored the nature of painting through portraying the simple shape of Guanyin Mountain.

After the vicissitudes of time and political regime in the post-war era, artists had encountered more challenges when exploring the form and nature of landscape painting, and had consequently conducted more experiments and pushed themselves for breakthrough in terms of subject and style. Subject-wise, the landscapes by Liao Chi-Chun, Lin Ko-Kung and Lu Chi-Cheng are particularly worthy of our attention. Liao's use of rhythmic brushwork and intensely vibrant colors (1965; fig. 37) broke away from his rather cool and restrained style before the war. The artist projected his emotions into his painting, giving new life to well-known landscape. Comparing to Liao's lively palette, Lin's pure, elegant landscape painting (1960s; fig. 38) brings to mind the work of Swiss painter Ferdinand Hodler (1853-1918). Lin used simplified forms and a palette of low saturation to create a symbolic landscape

that portrayed the external scenery while visualizing the inner world. Lu spent nearly four decades exploring and depicting Taiwan's mountains. He used solid realist techniques to precisely capture the multifarious mountain landscape (1962; fig. 41, 1976; fig. 42, 1982; fig. 43), and manifested the spirit of mountains with the approach of highly refined delineation. Lu created a personal style that displayed both figurative portrayal and abstract conception, giving the perfect end to a rich, colorful era of Taiwanese landscape painting. (CHIU Han-Ni)

石川欽一郎 ISHIKAWA Kinichiro (1871-1945)
驛路初夏（郊野）Ancient Road in Early Summer (Countryside)

水彩、絹 Watercolor on silk, 62.0 x 77.0 cm, 1930
屏東縣政府典藏 Collection of Pingtung County Government

石川欽一郎於1930年第四回臺展展出本作，當時臺展圖錄中記為《驛路初夏》，同時展出另一件《平和鄉》。1920年代後期石川因擔任北臺灣公小學校美術講習會教師，經常奔波各處，也藉機旅行寫生，將許多作品與隨筆，圖文並茂地即時發表於《臺灣日日新報》上，或是進一步製作成展覽會作品。《平和鄉》一作據報紙報導，為描繪東勢水鄉的水彩畫。在此之前，石川便曾於1928年11月連續數日發表題為《東勢の秋》的圖文。

關於《驛路初夏》雖無明確的文獻紀錄是描寫何處，不過石川於1930年展出該作前的7月，曾發表關於苗栗街景的圖文，其中如7月26日夕刊版3的插繪（文獻，頁272），取景角度與樹木房舍的配置便與本作頗有雷同。石川並記述此處為苗栗南部大湖街道的入口，可見牛車、臺車、汽車、與旅人往來，「有著難捨的驛路風情」。由此推測本作可能是石川在夏天行旅至此後進一步的創作。

本作也呈現日本近代風景畫中「道路山水」的風格，以單點透視描繪隨道路展開的風景。相較於插繪的構圖，本作的視野更為開闊，提高了水平線，夾道的樹木高聳蒼鬱，屋舍的排比更具延伸的視覺效果，並以豐富的暖黃色調呈現苗栗山城的初夏氣息。可見畫家調整視點和構圖，配合色彩等來經營畫面。將觀察時序變化與風土人情的感受，加以調和而理想地展現。（蔡家丘）

Ishikawa Kinichiro exhibited this work in the 4th Taiten in 1930. The painting title was recorded as *Ancient Road in Early Summer (Countryside)* in the exhibition catalogue. In the same exhibition, he also showed another work, entitled *Pinghe Village*. In late 1920s, Ishikawa taught art seminars for public elementary schools in norther Taiwan, and had many opportunities to travel and sketch in different places. He would then publish his drawings and sketches, along with writings on *Taiwan Nichinichi Shinpo (Taiwan Daily News)*, or further develop these sketches into works for exhibitions. *Pinghe Village*, according to the newspaper, was a watercolor drawing depicting the rural landscape of Dongshi. Before the publication of this drawing, Ishikawa had already consecutively published various drawings and writings for several days under the title of "Autumn of Dongshi" in the November of 1928.

There is no conclusive records of the location depicted in *Countryside (Ancient Road in Early Summer)*. However, in July 1930, before the painter exhibited this work, he had published writings and drawings of Miaoli's streetscape, among which the illustration published in section 3 of the evening newspaper on July 26 (Documents, p. 272) had many similarities to this work in terms of the perspective and the arrangement of the trees and houses. Ishikawa recorded that the illustration depicted the entrance of Dahu Street in southern Miaoli, where ox carts, push carts, cars and travelers could be seen, demonstrating "a nostalgic air of ancient roads." This work, therefore, could be a later creation after Ishikawa travelled to the location in summer.

This work also demonstrates the style of "road landscape" in early modern Japanese landscape, which adopts a single perspective to portray the landscape unfolded along a road. In comparison to the composition of the illustration, this work shows a wider view and a more elevated horizon. The trees along the sides of the road are towering and green, and the arrangement of the houses creates an extending visual effect. The artist used a rich, warm yellow tone to delineate the early summer atmosphere of the mountain town in Miaoli. One could observe how the painter adjusted the perspective and composition while using colors to construct the entire image, converting his observation of the seasonal change and perception of the landscape and customs into an idealized picture. (Tsai Chia-Chiu)

楊三郎 YANG San-Lang (1907-1995)
村之入口 Entrance of a Village

油彩、畫布 Oil on canvas, 60.0 x 73.0 cm, 1929
河上洲美術文物收藏 Collection of Heshangzhou Arts & Antiques

楊三郎於1920年代中期留學關西美術學院，不但開始創作作品入選臺展，可能還因為學校老師田中善之助（1889-1946）為春陽會會員的關係，也參加該會的展覽。1928年楊三郎以《滿州風景》入選第六回春陽會展，隔年以本作《村の入口》入選第七回春陽會展。事實上1926年時他的老師田中善之助便曾來臺，隔年以數張臺北風景畫作入選春陽會展。田中的風格沿襲春陽會創作的旨趣，選擇並非名所勝跡而是戶外自然的一景，仔細觀察描繪，藉此表現對土地的濃厚情感。

楊三郎的這件作品，據當時報導指出，描繪的是士林一帶的風景。畫家以疏密錯落的筆觸與肌理，用心安排紅色的房舍、屋簷，與綠色樹叢等在畫面上的位置，沿著道路土坡前後掩映，猶如強調彼此緊密地共生，形成畫面的重心。如此也反映其學畫過程中，吸收了如岸田劉生（1891-1929）、田中善之助等春陽會畫家對土地風景的關懷方式，轉而探索自己的家鄉。（蔡家丘）

Yang San -Lang studied at Kansai Art Academy in the mid-1920s, during which he had not only created works that were selected into the Taiten, but also joined the exhibition of Shunyokai (Shunyo Art Association) because of his teacher from the school, Tanaka Zennosuke (1889-1946). In 1928, Yang was selected into the 6th Shunyo Art Exhibition, with *Landscape of Manzhou*; and the next year, *Entrance of a Village* was featured in the 7th Shunyo Art Exhibition. As a matter of fact, Tanaka had visited Taiwan in 1926, and was selected into the Shunyo Art Exhibition for several painting featuring the sceneries of Taipei. Tanaka's style followed the creative principle of the association. He did not choose well-known sights as his subject matter but random outdoor, natural sceneries, for which he delineated with close observation to express his strong feelings for the land.

This painting, according to a newspaper report at the time, portrayed the landscape in the area of Shihlin. With both dense and sparse brushstrokes and texture, the artist elaborately arranged the placement of the red houses, roofs and green trees along the road and the slope, which partially covered each others. The arrangement seemed to emphasize their coexistence and formed the focal point of the painting. This approach also reflected that Yang had assimilated the idea of focusing on land and landscape exemplified by the painters in Shunyokai, such as Kishida Ryusei (1891-1929) and Tanaka Zennosuke, and turned his attention to explore his homeland. (TSAI Chia-Chiu)

陳澄波 CHEN Cheng-Po (1895-1947)
東臺灣臨海道路 East Taiwan Seaside Road

油彩、畫布 Oil on canvas, 69.5 x 130.5 cm, 1930
山口縣防府市收藏（Collection of Hofu City, Yamaguchi Prefecture）

本作品長年下落不明，2015年由撰寫上山滿之進傳記的兒玉識先生，發現收藏於日本山口縣防府市立防府圖書館的一件風景畫，即是陳澄波繪製於1930年的作品。上山滿之進（1869-1938）曾擔任第十一任臺灣總督（1926-1928）。卸任之際，他將臺灣官民贈送的紀念金捐給臺北帝國大學，作為原住民研究的經費，並撥出一部分，委託陳澄波製作繪畫以作為紀念（文獻，頁273-277）。描繪的地點似乎也是由上山所決定，最後從幾個候補地當中選出「東海岸之達奇利海岸」。

這件作品描繪的是面臨太平洋，斷崖絕壁連綿蜿蜒的美景——清水斷崖。臨海道路正是沿著斷崖所開通的道路，也是連接宜蘭與花蓮的唯一道路。現在稱為蘇花公路的臨海道路，原本是步道，在1927年上山的任期中，開始進行改修工程，1932年完工，從此可通行汽車。從畫作的取景角度來看，可能是在現今的花蓮縣崇德寫生繪製。前景道路蜿蜒，路上有對穿著原住民服飾的人物，引導觀者望向中景處的斷崖。描繪山崖岩壁與綠色植被的扭動筆觸，

顯示陳澄波的風格特徵。不過，或許為了強調實景地貌，用筆顯得較為謹慎抑制。斷崖擁抱著海灣，風平浪靜，僅在岸邊鑲上了一條白色波浪，激起幾朵浪花。海上浮著一葉小舟，岸邊幾艘泊船，樹叢中露出幾座屋頂，暗示這裏有個村落，應該是描繪居住此地的太魯閣族的Tkijig（達吉利）部落。

自日本統治初期，殖民政府與太魯閣族之間就發生了多次慘烈的戰役。1914年太魯閣之役終結後，日本政府為加強統治，將太魯閣族從山上遷移至平地。蘇澳到花蓮間的道路開通，對統治者而言，也意味著臺灣東部地區的平定。1927年，上山視察臺灣之際，從宜蘭到花蓮的交通，必須從蘇澳港乘船，再從花蓮港上岸。或許上山意識到臨海道路的改修工程，對統治與開發臺灣東部地區的重要性，因而開始這項工程。不過，道路工程尚未完工，上山就在1928年卸任。1930年，上山選擇臨海道路的風景作為紀念，也表示了他對這項道路建設的關心。（邱函妮）

This work had been lost for years. In 2015, it was rediscovered by Kodama Shiki, the author of Kamiyama Mitsunoshin's biography. He found out that a landscape in the collection of the Hofu City Library in Japan's Yamaguchi Prefecture was indeed Chen Cheng-Po's painting created in 1930. Kamiyama Mitsunoshin (1869-1938) was the 11th Taiwan Governor-General (1926-1928). Upon his retirement from the position, he donated his commemoration money from Taiwanese officials and citizens to Taihoku Imperial University (now National Taiwan Univesrty) to fund the indigenous research, while a part of the money was allotted for commissioning Chen Cheng-Po to paint a commemorative work

(Documents, pp. 273-277). The subject of the landscape was probably chosen by Kamiyama, who eventually picked "the Tkijig shore on the East Coast" from several options.

This work features the vista of a continuous, winding coastal cliff along the shore of the Pacific—the well-known Chingshui Cliff. The coastal road was constructed along the cliff, which was the only road connecting Yilan and Hualien and the precedent of the Suhua Highway today. It was originally a trail. The construction of the road began in 1927, during Kamiyama's term of office, and was completed in 1932. Since then, the road could accommodate

transportation vehicles. From the perspective of the painting, the artist might have painted the work in today's Chungde in Hualien County. On the winding path in the foreground, a couple of figures in indigenous attire could be seen, leading the spectator's line of vision towards the cliff in the middleground. The sinuous brushstroke depicting the mountain cliff and lush vegetation is the artist's stylistic feature. Perhaps to realistically highlight the terrain, the brushwork seemed more careful and restrained. Partially hugged by the cliff, the bay looked calm and peaceful. Only a trim of white waves fringed the coast, with a few visible splashes. A tiny boat floated on the sea, and some were on the shore. Amidst the treetops were several rooftops, indicating the existence of a village. It was probably the Truku Tkijig Village.

Since the beginning of Japanese rule, the colonial government and the Truku people had engaged in many rather severe battles. In 1914, after the Truku War, the Japanese regime relocated the Truku people to flat land from the mountains to reinforce the governance. The inauguration of the road between Suao and Hualien, for the ruler, meant the pacification of eastern Taiwan. When Kamiyama inspected Taiwan in 1927, he had to board the ship from Suao Harbor and land on Hualien Harbor so he could move between Yilan and Hualien. He perhaps realized then that the construction of the coastal road was of much importance to the governance and development of eastern Taiwan. Nevertheless, he left the office in 1928, before the construction was completed. In 1930, Kamiyama chose this landscape of the coastal road as a commemoration, which displayed how much he cared about this construction project. (CHIU Han-Ni)

陳澄波 CHEN Cheng-Po (1895-1947)
南郭洋樓 A Western-style House in Nanguo

油彩、畫布 Oil on canvas, 53.0 x 65.0 cm, 1938
私人收藏 Private Collection
題記：一九三八澄波 Inscription: Cheng-Po, 1938

首次公開展出的《南郭洋樓》，掀開一頁早已為人遺忘的彰化市榮景。畫中展示了一棟前衛的現代主義建築，同時也提供我們認識早逝的英才陳澄波與臺灣中部的連結線索。

這棟洋樓位於八卦山下南郭路，建坪約200-250坪，樓高兩層，當時是全彰化最為氣派的現代洋樓。南郭原屬清代彰化城南門外，1920年劃入彰化郡，1933年併入彰化市。1922年彰化郡郡役所（今彰化縣政府）遷移至此，同時興建高階官員宿舍區，配合彰化公園、溫泉等設施的興建，以及武德殿（1930）、公會堂（1933）等，開發成高級文教區。

建築採現代主義風格，方正橫長的幾何區塊結構，以中央入口為中軸，左右對稱，兩邊各一大房開方型窗，與一小房配兩細長窗，設計不失變化與巧思。一樓右側面內縮成有車寄的入口，供人力車停靠。三樓左側樓梯出口有弧形裝飾窗，右側設植物攀爬的花架。建築目前雖因失修而荒蕪，但格局架構保持完整，整體輪廓簡約素雅；正面外牆所貼黑色小磁磚及玄關地面彩磁拼成的花毯猶保存完好。畫面中，面對道路的傳統磚房是屋主商行的事務所；道路左拐，便是如今被指定為古蹟的「南郭郡守官舍」區。大門口前停放著一輛人力車，只見一對紳士夫妻與一位女學生悠閒地迎面走向洋樓。道路另一邊的農田，有位婦人正牽牛吃草，畫面疏朗開闊，溫馨宜人。

屋主李丙戌（1883-1957）熱心公益，曾受日本紅十字社特別表揚（1935），並捐款成立彰化中學（1942）。1937年，他購地自建洋樓，為長子舉行婚禮。1932年6月，在上海新華藝專任教的陳澄波將妻小送回臺灣，7月在臺中舉辦十天的洋畫講習會；彰化市名人楊英梧提供工作室，邀請畫家長駐創作。次年陳澄波返臺定居，仍經常到此地寫生創作，並接受仕紳委託製作肖像畫等作品。出身彰化的臺灣新民報記者林錦鴻（1905-1985），是他臺北師範學校的學弟兼畫友，同時也是李丙戌女婿。1938年，陳澄波接受委託作畫，紀念這棟別出心裁的摩登洋樓落成。（顏娟英）

Exhibited for the first time, A Western-style House in Nanguo unveils a long forgotten chapter of Changhua's prosperous past. The painting features a modernist building, and at the same time, provides a piece of clue that connects the talented artist who has died too young with central Taiwan.

This two-story Western-style house sits on Nanguo Road at the foot of Bagua Mountain, which is approximately 661 to 826 square meters. It was the most magnificent Western-style modern house in the entire Changhua. In Qing dynasty, Nanguo was outside the south gate of Changhua County, and was only included in 1920, and further merged into Changhua City in 1933. In 1922, the Changhua County Hall (now Changhua County Government) was moved to Nanguo, and an area of dormitories for high-ranking officials was created at the same time, along with other facilities, such as Changhua Park and hot springs. Together with Wude Hall (1930) and the county's public hall (1933), the area was developed into a high-class cultural and education district.

The modernist architecture shows a geometric structure comprising rectangular and square cubes. With the entrance in

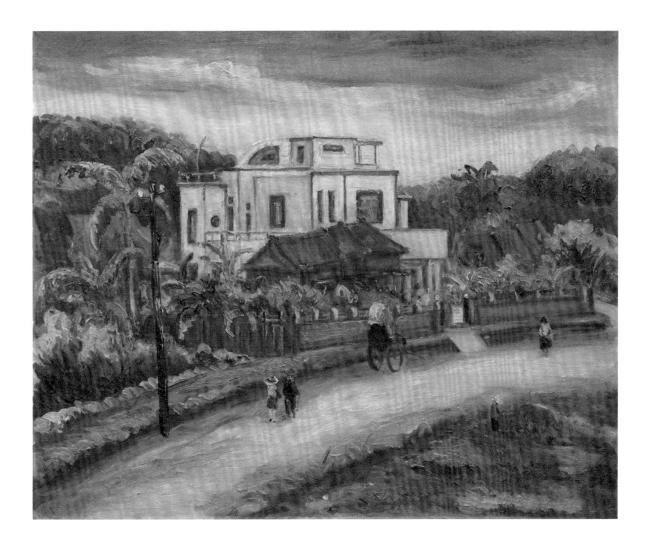

the middle as the central axis, the house looks symmetrical. On either side of the house, there is one large room with a big square window and one smaller room with two elongated, rectangular windows, demonstrating a clever variation of design. The right side of the first floor is retracted for a carriage porch, where rickshaws could park. An arch window decorates the left-side staircase on the third floor, whereas there is a pergola on the right side. Although the house is currently in a dilapidated state, the scale and structure remain intact. The overall silhouette of the building is refined and elegant. The small black tiles on the façade and the floral mosaic made of colorful tiles on the entrance hall's floor are all well-preserved. In the painting, the traditional brickhouse facing the road was the office of the house owner's company. Turning left from the main road was the "Official Residence of Nanguo Magistrate," which has been designated a historical heritage now. In the painting, a rickshaw parked outside the front entrance. A gentry couple and a female student were leisurely walking towards the house. Across the road was an open field, where a woman was watching over her grazing cow. The entire image shows an unblocked, open view that is relaxing and restful.

The master of the house, Li Ping-Shu (1883-1957), was a charitable person. He had been honored by the Japanese Red Cross Society (1935) and had funded the establishment of Changhua Junior High School (1942). In 1937, he purchased the land to build the Western-style house, where his eldest son would have his wedding. In June 1932, Chen Cheng-Po, who was at the time teaching at Shanghai's Hsin-Hua Art Academy, sent his wife and children back to Taiwan, and held a ten-day Western-painting seminar in Taichung in July. The Changhua-based personage, Yang Ying-Wu, offered the painter a studio space to work in the city. The next year, Chen returned and settled down in Taiwan, and had frequented Changhua, where he would paint from life and accept portrait commissions from local gentries. Also born in Changhua was the reporter for Taiwan New People Newspaper, Lin Chin-Hung (1905-1985), who was Chen's younger school mate and a peer painter from Taihoku (Taipei) Normal School; he was also Li Ping-Shu's son-in-law. In 1938, Chen accepted the commission to paint this painting to commemorate the completion of this ingeniously designed house. (YEN Chuan-Ying)

何德來 HO Te-Lai (1904-1986)
農村風景（臺灣，新竹）Countryside Landscape (Hsinchu, Taiwan)

油彩、畫布 Oil on canvas, 61.0 x 50.5 cm, 1933
家屬收藏 Collection of Artist's Family

何德來出生於新竹，去世於東京目黑區。臺灣與日本可說是滋養他一生成長與創作最重要的兩個地方。1927年，他入學東京美術學校西洋畫科，在和田英作（1874-1959）門下勤奮學習；隨即加入同校前輩廖繼春、陳澄波與顏水龍等人，共同組成赤陽會，爭取官展以外的發表空間。1932年，畢業後短暫回到故鄉，組織新竹美術研究會，振興地方美術風氣；此幅作品即創作於隔年。該研究會雖然為期短暫，卻播下了現代美術的芽苗。

此作以簡潔俐落、剛直有力而富有彈性的的筆法捕捉故鄉景色，不拘泥於描繪對象的形象準確度。畫家在意的是不同色塊與線條相互碰撞所產生的整體力量感；他巧妙應用樹木、樹叢與農田、蜿蜒的溪流相互掩映，製造出景深的視覺效果。作品中蓬勃的風景，正代表他對於家鄉美術發展的期許吧。何德來創作生涯中，除了早年實地寫生，晚年更不斷地追憶故鄉，寄予深切的關愛，同時隨著歲月的耕耘，畫中的故鄉意義不斷地衍伸。

畫家個性淡泊，一生從未參加官方展覽，與世間的聲名始終保持著一定距離。他秉持「貢獻社會」的精神，戰後一度在東京自宅經營過小畫室，卻從不收學費，有如大隱隱於市。儘管畫家現實生活不盡如意，但畫布上的世界，卻提供他得以身心安住的「理想故鄉」。（柯輝煌）

Ho Te-Lai was born in Hsinchu, and passed away in Meguro, Tokyo. It is fair to say that Taiwan and Japan were two most important places that nurtured his life and art. In 1927, Ho entered the Western Painting Department of Tokyo Fine Arts School, and studied diligently with Wada Eisaku (1874-1959). He soon joined the Chiyang (Red Sun) Painting Society co-founded by his predecessors, including Liao Chi-Chun, Chen Cheng-Po and Yen Shui-Long, who aimed to expand the space for publishing artworks apart from official exhibitions. In 1932, he returned to his hometown for a short period of time after he graduated, and organized the Hsinchu Art Research Society to invigorate the local art scene. This work was created the year after he returned home. Although the society only existed briefly, it had indeed planted the seeds of modern art.

This painting captures the scenery of Ho's hometown with simple, powerful yet flexible brushwork. Instead of fixating on the precise image of the depicted subject, the artist put his emphasis on the overall sense of power stemmed from the clashes between different color blocks and lines. He subtly utilized the interweaving trees, bushes, farms and the meandering creek to produce the visual effect of depth. The flourishing landscape perhaps symbolized the artist's expectation of the artistic development in his hometown. Throughout his creative career, Ho had steadfastly created paintings outdoors in the early years, but in his silver days, he constantly reminisced his hometown through his works, expressing heartfelt care and love. As time progressed, the meaning of hometown in Ho's work had evolved as well.

The painter did not care about renown and had never participated in official exhibitions, always keeping a certain distance from worldly fame. He upheld the ideal of "devotion to society," and had once opened a small painting studio at his home in Tokyo, teaching students for free, like a wise hermit hiding in the city. Although his real life was not entirely satisfactory, the world he created on canvas had provided him "an idealized hometown," where he could find peace. (KO Hui-Huang)

李澤藩 LEE Tze-Fan (1907-1989)
新竹國小所見 Hsinchu Elementary School

水彩、紙 Watercolor on paper, 54.0 x 78.0 cm, 1939
李澤藩美術館收藏 Collection of Lee Tze-Fan Memorial Art Gallery

李澤藩於1907年生於新竹，1921年接受父親建議前往臺北師範學校就讀，如同當時臺灣第一代西洋畫家一般，接受石川欽一郎的指導，因此在1928年之後入選臺展之作，多可見到「道路山水」的寫生取向。然而不同於石川的是，李澤藩的臺展作品，筆觸更為扎實、厚重，且畫中形體更為明確、具象，同時在主題上多可見到他對新竹風土的關懷，例如新竹城隍廟及山景。

本作創作於1939年，採取由室內望向室外的視角，前景的窗沿與左右兩側的建築，將觀者視線集中於校園運動場以及遠方的客雅山、藍天，形成舞臺的效果。比較中景與遠景，畫家使用較為簡略、抽象的筆法描繪運動場上的人群和樹叢；卻以明確的輪廓線與塊面的色彩，將遠方山脈的形體勾勒出來。除了形體的明確度不同外，畫家使用深厚的綠色描繪山景，穩定畫面中心，讓觀者的視線更加聚焦於此。與本幅創作於同年的臺展入選作《馬武督連山》，同樣以新竹山脈入畫，然而後者無論在前景的房舍群或遠方的山脈，多以躁動的筆觸表現，不同於本作處理建築與山群時的穩重感，可見李澤藩在描繪山景、周圍建物時，應是考慮著整體氛圍來營造。向來不以「畫家」而以「美術教育者」自詡的李澤藩，或許企圖在以「新竹第一公學校」為主題的本作中，傳達出教育者對於學校、新竹家鄉的責任感吧。（郭懿萱）

Lee Tze-Fan was born in Hsinchu in 1907. In 1921, he took his father's advice and entered Taihoku (Taipei) Normal School, and was mentored by Ishikawa Kinichiro like many Taiwanese first-generation Western-style painters. Therefore, his works created after 1928 that were selected into the Taiten demonstrated the characteristics of painting from life emphasized in "road landscape." Different from Ishikawa, however, was that Lee's works selected into the Taiten showed solider and heavier brushstrokes, and the forms in his paintings were more distinctive and figurative. His subject matter expressed his attentiveness to Hsinchu's local sceneries and customs, such as Hsinchu City God Temple and mountain landscape.

This painting was created in 1939 and adopted a perspective of viewing the outdoor space from an indoor space. The windowsill in the foreground and the buildings on both sides focalize the spectator's line of vision on the school's sports ground, Keya Mountain in the distance and the blue sky, producing the effect of a proscenium. Comparing the middleground and the background, the artist used simple, abstract brushwork to draw the people on the sports ground and the trees, but delineated the shape of the distant mountains with well-defined contours and blocks of colors. In addition to the clearness of forms, the dark, dense green used to portray the mountains also stabilized the image, drawing the spectator's attention to the center. This work and Lee's another piece showcased in the Taiten in the same year, *Mawudu Mountain Range*, both portrayed the mountains in Hsinchu. However, the houses in the foreground and the distant mountains in the latter were all depicted by lively brushstrokes, which differed from the solid stability manifested by the architecture and mountains in this work. Therefore, when portraying mountain landscape with surrounding buildings, Lee probably took the overall atmosphere into consideration. The artist had never called himself a "painter" but an "art educator". It is likely that this painting, which featured Hsinchu First Public Elementary School, aimed to convey the artist's sense of responsibility towards the school and his hometown. (KUO Yi-Hsuan)

鄭世璠 CHENG Shih-Fan (1915-2006)
山村 Mountain Village

油彩、畫布 Oil on canvas, 50.5 x 65.0 cm, 1941
家屬收藏 Collection of Artist's Family

此作定名為《山村》，畫家使用各式的綠色與大地色系交互配合著運用，並在中景橫列低矮的平房，堆疊出空間感；同時透過不同深淺的綠色，營造出山中的綠意盎然與生機勃勃。左側使用藍綠色突顯遠方山影與陽光天色的映照，因此在畫幅不大的作品中，可以感受到山脈的層次感。前景一道細長彎曲的道路，帶領觀者進入畫面，最終道路盡頭沒入遠山，看似綿延不絕。鮮明且細長的土黃色，對比周圍繁複堆疊的綠色，更顯現深山的交通不易與自然樸實。

鄭世璠早年就讀新竹第一公學校時師事李澤藩，後於1930年進入臺北第二師範學校普通科，與許多臺灣第一代西洋畫家一樣，跟隨石川欽一郎學習水彩，專研寫生技法與觀察事物的能力。然而1932年石川離臺，鄭世璠轉向接替的老師小原整學習油畫，作品中開始出現印象派躁動的筆觸，與後期印象派簡化且具有鮮明色彩的樣貌。本幅創作於1941年，同年度的作品包含目前典藏於臺北市立美術館的《後街》，與國立臺灣美術館的《後車路風景》。比較三幅作品，本作明顯屬於印象派風格，不同於另外二幅具有厚實輪廓線與繽紛色彩。此作傳達的樸質感與鮮明紛繁的筆觸，應可視為鄭世璠

向石川欽一郎學習道路山水寫生，以及向小原整學習外光派技法，兩種不同歷程而自我摸索的印證。

透過此次修復過程的X光檢測，發現本作底層另有一幅作品。據背框殘留之作品標籤，研究團隊推測底層應為1939年第二回府展之際，鄭世璠所提出卻落選的《鳳凰樂舞之圖》。猜測畫家應是使用落選作品的畫布，重新製成新作，因而有畫布上並存兩層作品的情況。在物質缺乏的年代，或許藝術家時有使用舊畫布重新作畫之習慣。（郭懿萱）

Entitled *Mountain Village*, the painter used a combination of green and earth colors, matched with low bungalows in the middleground, to layer out the depth of space. Meanwhile, the different shades of green conveyed the lushness and vitality in the mountains. On the left, the distant teal mountains formed a contrast to the bright sky, allowing the spectator to perceive a sense of layers in a modest-sized painting. A winding road unfurling in the foreground leads the spectator into the image. The road eventually dives into the far mountains, creating a sense of continuity. The bright, thin, earth-yellow strip contrasts to the intricately layered green nature on both sides and further highlights the remoteness and primitiveness of the distant mountains.

When Cheng Shih-Fan was a student at Hsinchu First Public Elementary School, he was taught by Lee Tze-Fan. Afterwards, he was accepted into the General Education Department of Taihoku (Taipei) Second Normal School in 1930. Like many Taiwanese

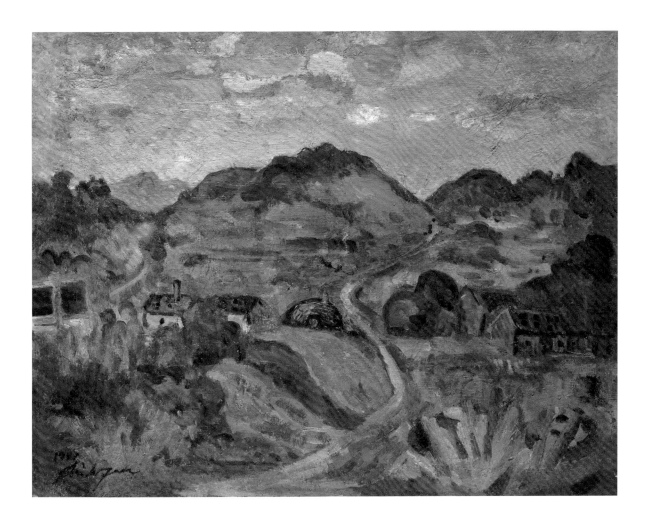

first-generation Western-style painters, he studied watercolor with Ishikawa Kinichiro to focus on improving his techniques of painting from life and ability of making observation. Ishikawa left Taiwan in 1932, and Cheng later studied oil painting with Ohara Hitoshi, who succeeded Ishikawa as the school's art teacher. Since then, Cheng's work began to show lively brushstrokes reminiscent of Impressionism, along with simplified, vibrant colors that characterized Post-impressionist paintings. This painting was created in 1941. In that year, Cheng also painted *Back Street*, which is now in the collection of Taipei Fine Arts Museum, and *Scenery of the Rear Road* that is currently in the collection of National Taiwan Museum of Fine Arts. Comparing the three paintings, it is clear that this work follows the Impressionist style, whereas the other two display solid contours and striking colors. The unadorned quality and vivid, inextricable brushstrokes in this painting prove that this work indicates the artist's self-exploration

after having undergone two different types of training—first learning skills of road landscape and painting from life from Ishikawa, and later, acquiring plein-air techniques from Ohara.

While repairing the work for the exhibition, an X-ray inspection shows that there is another painting under the current one. Judging from the incomplete label left on the back of the frame, the research team infers that the covered painting might be Cheng's *A Scene of Phoenix Dance*, which the artist submitted for the 2nd Futen (Taiwan Governor-General's Office Art Exhibition) in 1939 but failed to make the exhibition. Therefore, it is presumed that the artist re-used the rejected painting to paint a new work; hence, the co-existence of two paintings on the same canvas. In the era when materials were scarce, perhaps the artist had the habit of reusing canvases and painting over old works to create new ones. (KUO Yi-Hsuan)

立石鐵臣 TATEISHI Tetsuomi (1905-1980)
風景 Landscape

油彩、木板 Oil on panel, 24.0 x 33.0 cm, c. 1941
鄭世璠舊藏 Previous Collection of CHENG Shih-Fan

透過前景彎曲的樹幹，可見到湛藍的天空下是一棟紅瓦白牆的建築物，牆上飾以十字架，尖塔與拱窗等亦顯示出西方教會建築的風格樣式。前方成排的樹木婀娜多姿，好像在跳舞一般。原本應該是堅實穩固的建築物，彷彿也隨著扭動的筆觸搖擺起伏。這件色彩鮮明的小品畫作，充分流露出畫家下筆時的愉快心情。

畫面上沒有簽名與紀年。不過，從畫作背面的標籤可知作者是立石鐵臣。標籤上還寫著畫家當時在臺北大安的地址。立石從1940年起居住於此地。畫中所描繪的地點，對照他刊登於雜誌上的插畫，可知是描繪臺灣基督長老教臺南神學校（今臺南神學院，位於臺南市東門路）的建築（文獻，頁306-307）。該校為培育宣教人才而設立，成立於1876年，第一任校長是巴克禮牧師（Thomas Barclay，1849-1935）。

立石鐵臣在1941年的文章中曾提及在此地寫生的經過。「躺在長老教會學園的草地上仰望藍天，令人心曠神怡。……雖說是新年，但臺南天空的藍色如此厚重。看著這樣的天空不禁想著，若可以馬上黏糊糊地融化下來該有多好。把它裝入顏料的筒管中，就可以做出純正的鈷藍色了。……庭院裏的建築物十分有趣。建築和樹木的關係也是，比起淡水，更是饒富畫趣。」在這篇文章中立石還提到學校已無人跡，禮堂中的日曆停留在去年的9月26日。1940年9月，日、義、德締結三國同盟，基督教宣教師的立場岌岌可危，於是在同年的9月6日，臺南神學校舉行廢校禮拜。立石將這一天的麗日湛藍留在畫面上，卻似乎渾然不知戰爭的腳步已悄悄來臨。（邱函妮）

Behind the curved trees in the foreground was a building with red-tiled roof and white walls under the cerulean sky. The cross on the wall, its spiky tower and the arch windows indicated that this was a church building in Western architectural style. The figure-like trees in front of the building seemed to de dancing; and the supposedly solid, stable architecture also seemed to be swinging and moving with the lively brushstrokes. This small painting with vibrant colors fully visualizes the painter's blissful mood at the time.

The painting is not signed and dated. However, the label on the back indicates that its creator is Tateishi Tetsuomi. The label also shows the painter's address in Taipei's Daan District, where Tateishi had lived since 1940. With a comparison to his illustration on a

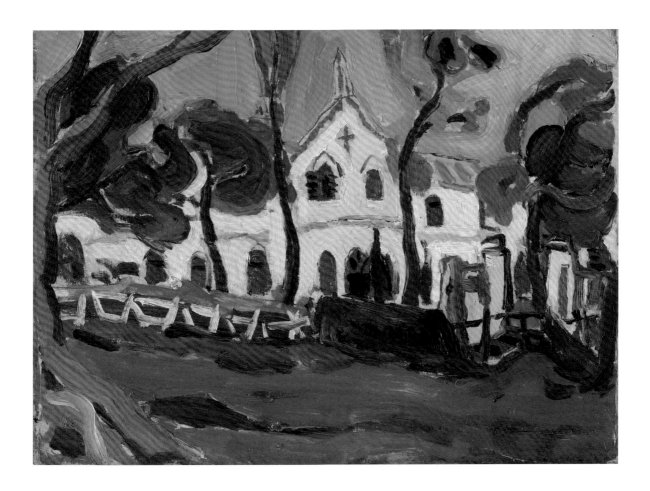

magazine, the location and the building featured in this painting is believed to be Tainan Theological School (now Tainan Theological College and Seminary) founded by the Taiwan Presbyterian Church (Documents, pp. 306-307). The school was founded in 1876 to train and nurture missionaries, and the founding principal was Rev. Dr. Thomas Barclay (1849-1935).

In an article from 1941, Tateishi mentioned the experience of painting in this place—"lying on the lawn and gazing into the sky from the school of the Presbyterian Church was a mesmerizing experience… Although it was the New Year, Tainan's sky was densely blue. Looking at the sky, I kept imagining to melt it into a soft and gooey state so that I could store it in a paint tube and make pure cobalt blue out of it… The building in the garden was intriguing, and so was the relationship between the architecture and the trees. Comparing to Tamsui, it was much more interesting to paint." In this article, Tateishi also mentioned that the school was already empty, and the calendar in the assembly hall stayed on September 26. In September 1940, Japan, Italy and Germany formed the Axis power, so the position of the Christian missionaries was in jeopardy. On September 6 of the same year, the school had its abolishment service. When Tateishi forever preserved the beautiful day with its cerulean sky in the painting, he was simply unaware of the looming warfare. (CHIU Han-Ni)

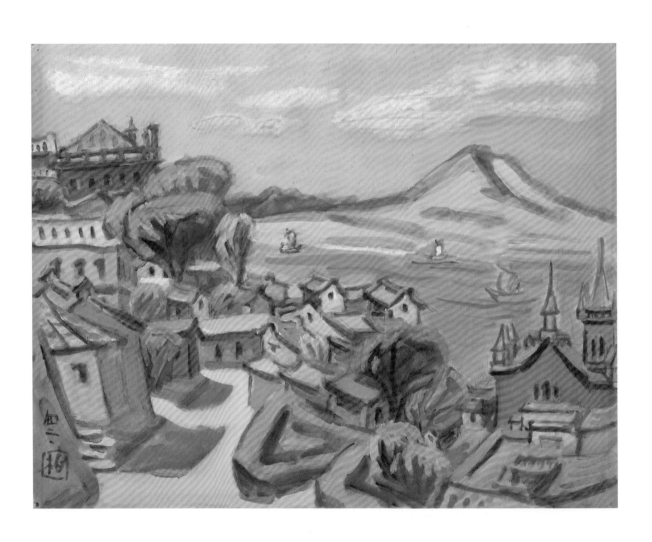

郭柏川 KUO Po-Chuan (1901-1974)
淡水 Tamsui

油彩、紙 Oil on paper, 34.1 x 45.0 cm, 1953
私人收藏 Private Collection

郭柏川居住北平期間，日本西畫家梅原龍三郎數度造訪北平，他充當嚮導，陪伴至各地旅遊寫生，建立亦師亦友的情誼。他的創作受到梅原龍三郎以日本紙作油畫的啟發，試驗以松節油和宣紙繪製油畫。1948年郭柏川返回故鄉臺南，繼續從媒材入手，創作具東方特色的油畫，發展成熟的自我風格。他除了創作孔廟等臺南風景外，也北上描繪淡水觀音山與土洋交錯的紅瓦建築。

這幅創作於1953年的《淡水》，畫家大約站在文化路上俯瞰錯落的街屋，左邊沿著下坡路的三民街會經過木下靜涯故居、白樓、紅樓等洋樓，右邊尖塔建築為淡水禮拜堂，這些都是淡水知名的地標建築。隔著航行船隻的河面，望向遠方的觀音山及藍天白雲。

臺北市立美術館典藏郭柏川同一年創作的《淡水觀音山》，取景角度非常類似，相較下這幅《淡水》空間表現層次豐富，色彩較為溫暖。畫面以紅、藍、綠與白色為主調，深色粗獷線條勾勒物像大致輪廓，淺色平塗塊面，色彩明亮，運筆簡潔明快，充滿朝氣與活力。其實淡水禮拜堂、街屋和觀音山，從日治時期以來是許多畫家前往描繪的景點，代表典型的淡水風情。郭柏川也採同樣視點描繪淡水，但在他獨特風格的詮釋下，畫面展現出陽光普照、活潑亮麗的生機。（黃琪惠）

When Kuo Po-Chuan lived in Peiping (now Beijing), Japanese Western-style painter Umehara Ryuzaburo had visited the city several times. Kuo served as the Japanese painter's guide, accompanying him to sketch in different locations. So, they built a relationship that made them friends as well as teacher and student. Kuo was inspired by Umehara's oil painting on washi (Japanese paper), and experimented on painting oil on Xuan paper with turpentine. In 1948, he returned to his hometown, Tainan, where he continued exploring different media and creating oil painting emblematic of Eastern characteristics, developing a mature and individualistic style. Apart from painting landscape and sceneries that were distinctive of Tainan, such as the Confucius Temple, he also travelled north to paint Tamsui's Guanyin Mountain and its red-tile-roof buildings of both Taiwanese and Western style.

This painting, *Tamsui*, was created in 1953. The painter presumably stood on Wenhua Road that overlooked the townhouses of uneven height. Walking down the slope of Sanmin Street on the left, one would come to the former residence of Kinoshita Seigai and well-known Western-style mansions, the White House and the Red Castle. On the right, the building with spires would be the Tamsui Church. These are all famous landmarks in Tamsui. Across the river, with several boats sailing on the river surface, Guanyin Mountain sat in a backdrop of blue sky and white clouds.

Kuo's another painting created in the same year, *Tamsui and Guanyin Mountain*, which is now in the collection of Taipei Fine Arts Museum, also reveals a vista from a similar perspective. However, this work shows more layers in the portrayal of space, and the colors used are warmer. Painted with red, blue, green and white, the painter outlined his subject with dark, bold lines. The light-colored blocks painted with the technique of flat application look bright; and the simple, unhesitant brushwork conveys a sense of energy and vitality. The Tamsui Church, the houses in Tamsui and Guanyin Mountain have been painted by many painters since the period of Japanese rule and formed a typical Tamsui landscape. While adopting a similar perspective to delineate Tamsui, Kuo's unique interpretation with his personal style gave the sunny, lively image much life. (HUANG Chi-Hui)

陳清汾 CHEN Ching-Fen (1910-1987)
淡水河邊 Tamsui Riverside

油彩、畫布 Oil on canvas, 52.7 x 65.0 cm, 年代不詳 Year Unknown
呂雲麟紀念美術館收藏 Collection of Lu Yun-Lin Memorial Art Museum

雖然目前留存並可見的作品很少，不過根據報導，陳清汾於1920至1930年代間的許多創作，尺幅均不小，入選臺灣美術展覽會、日本二科會等展覽。如1935年第九回臺灣美術展覽會特選作品為三百號的《林本源庭園》，或是描繪鳥瞰而開闊的巴黎、臺北、北京等風景。描繪淡水風景的作品，則有於1936年第二回臺陽展展出的《青い觀音山》，1939年第五回臺陽展的《淡水風景》，1937年日本一水會的《夕暮の淡水》，及省展初期的作品等等。

1932年於總督府舊廳舍舉辦個展時，老師有島生馬評其作品構圖平穩、筆調悠長而輕鬆，小澤秋成則欣賞其具稚拙與詩意的趣味。就其參加二科會的屬性，以及留在臺府展圖錄、報紙中的作品圖版來看，陳清汾於1930年代後期的風景畫創作，從寫實性描繪轉向直率而鮮明的筆調，有些近似於同為二科會畫家安井曾太郎的風格。本作描繪淡水河邊的風景，不拘泥於風物的現實形象，呈現安然自在的創作心境。（蔡家丘）

Although only a few of works by Chen Ching-Fen have left, according to the news reports, the artist created many paintings of considerable sizes during the 1920s and the 1930s. These works had been showcased in the Taiten and the exhibitions of Japan's Nikakai (Nika Association); for example, his *Garden of Lin Benyuan*, a painting of 300F (291 x 197 cm) in size that was selected into the 9th Taiten and awarded the Special Selection Prize, and other landscapes depicting the sceneries of Paris, Taipei, Beijing from an overlooking, expansive view. As for his works featuring the landscape of Tamsui included *Green Guanyin Mountain* exhibited in the 2nd Tai-Yang Art Exhibition in 1936, *Landscape of Tamsui* showcased in the 5th Tai-Yang Art Exhibition in 1939, *Tamsui at Sunset* shown in the exhibition of Issuikai (Issui Association) in 1937, and other works that made into the Taiwan Provincial Fine Arts Exhibition.

When Chen presented his solo exhibition at the former office building of the Taiwan Governor-General in 1932, his teacher Arishima Ikuma praised his works, saying that his composition was stable and his brushwork lasting and relaxing. Ozawa Shusei admired the child-like and poetic charm of his works. Based on the characteristics of the Nikakai and the plates of his works in the Taiten catalogues and the newspapers, Chen's landscapes created in the late 1930s showed a shift from realistic delineation to straightforward and vivid brushwork, which was similar to the style of another painter also in the Nikakai, Yasui Sotaro. This painting depicts the riverbank scenery of Tamsui River in a way that departs from the realistic images of the depicted objects, demonstrating the artist's carefree state of mind. (TSAI Chia-Chiu)

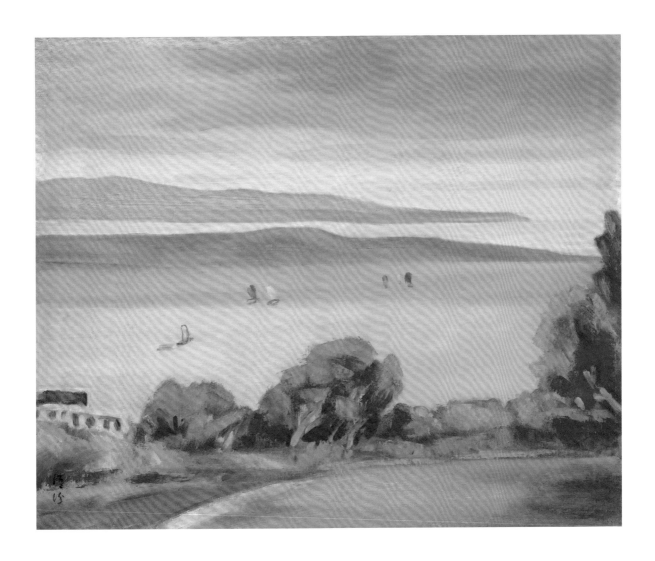

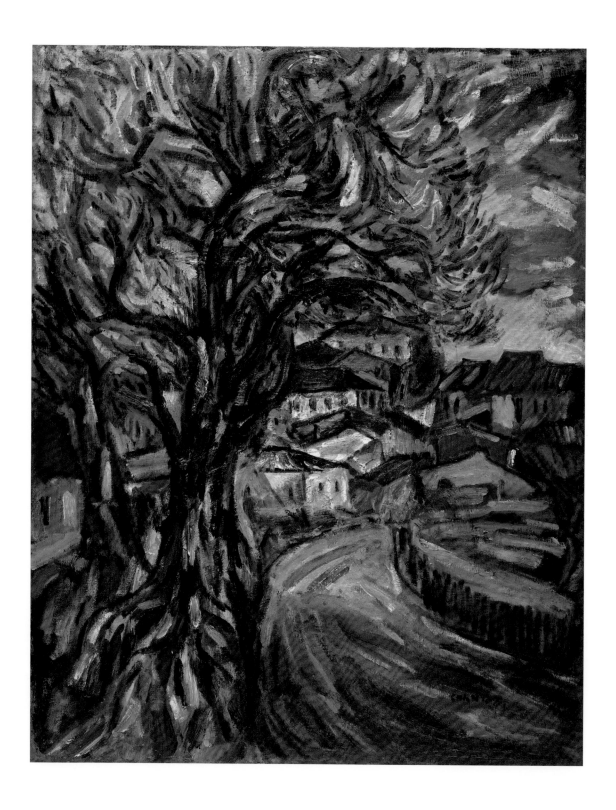

張萬傳 CHANG Wan-Chuan (1909-2003)
淡水 Tamsui

油彩、畫布 Oil on canvas, 91.0 x 72.5cm, c. 1980
私人收藏 Private Collection

整幅畫描繪的地點是淡水舊稱的「三層厝」，即今三民街一帶，座落於滬尾聚落的西北郊，上接「九崁街」，下臨「新店街」，房舍依山形層層而建，地勢陡峻，形塑出高低錯落的空間感。此處亦為洋人、漢人發展區域的交界，幾棟著名的歷史建築，如1875年落成的白樓，1899年的紅樓（達觀樓）、以及1908年的木下靜涯故居等，皆呈現出臺洋混和的風格。獨特的地理與人文景觀，吸引許多日、臺畫家來此寫生。

張萬傳出生於淡水。打從留日期間接觸到巴黎派（The School of Paris）的畫風開始，便與這種帶有強烈個性、有點邊緣、又有著異鄉情懷的獨特美感，產生了深深的共鳴。古厝是他最愛的主題，特別是

淡水白樓，只因為古厝較「親切、有味，若不畫，根本就會消失」。1992年白樓面臨拆除時，張萬傳甚至願意捐畫籌資，希望能保留這份珍貴的文化資產。

畫面上路口處有一老樹，畫家以捲曲的筆觸來描繪，翠綠的枝葉上揚至天際，與藍天白雲融合為一；多彩的枝幹延伸入地，與泥土路面的線條連成一氣。櫛比鱗次的屋頂，以直短線條來描繪，與牆面形成有如幾何切割般的趣味。從畫家所在的視角，沿著這條迂迴小路走下去，便可通往遠方也是心中那片最美的風景吧！依稀可見的是白樓的拱廊陽臺，木下故居的紅磚牆，更遠處的紅樓外觀則轉為一抹粉紅。（楊淳嫻）

The location depicted in this painting was the area of San-Tseng-Tso in Tamsui, which is now the area of Sanmin Street. It is outside the northwestern outskirt of the early Huwei settlement. Moving upward from San-Tseng-Tso was the "Chiukan Street" and going further down the hill was the "Hsintien Street." The houses in this area were built according to the mountain's terrain. The steep slope created a unique sense of space informed by high and low rooftops. The area was also where the Western community and the Han community intersected, and several historical buildings in this area have shown a mixture of Western and Taiwanese architectural style, including the White House completed in 1875, the Red Castle (Da-Guan Mansion) built in 1899, and the residence of Kinoshita Seigai built in 1908. The unique geographical and cultural landscape had attracted many Japanese and Taiwanese painters to paint here.

Chang Wan-Chuan was born in Tamsui. Ever since he was a student in Japan and learned the style of the School of Paris, he had felt a strong resonance with its intensely characteristic, somewhat marginal yet specially exotic aesthetics. Old houses

was Chang's favorite subject, in particular the White House in Tamsui. For him, old houses were "friendly and charming, and the root would disappear if they are not recorded in paintings." When the White House faced the fate of demolition in 1992, the painter was even willing to donate his paintings to raise funds for saving the precious cultural asset.

In the painting, an old tree grew at the crossing of roads. The artist portrayed it with writhing brushstrokes. The tree's verdant green leaves and branches reached upward into the sky and seemingly merged with the sky and white clouds. Its multicolored trunk, on the other hand, extended into the ground and blended with the dirt road. The closely joined rooftops were delineated with short, straight lines, forming intriguing geometric shapes with the walls. Perhaps travelling down this meandering road from where the artist stood would lead to the most beautiful distant landscape in his mind. The painting also vaguely showed the White House's balcony with arches and the redbrick wall of Kinoshita's former residence. In the distance, the exterior of the Red Castle surfaced as a fraction of pink. (YANG Chun-Hsien)

陳德旺 CHEN Te-Wang (1910-1984)
觀音山遠眺 A Distant View of Guanyin Mountain

油彩、畫布 Oil on canvas, 53.0 x 65.5 cm, 1980
南畫廊收藏 Collection of Nan Gallery

觀音山為陳德旺繪畫生涯後期的重要母題（motif），一共畫了二十九幅，分為三個系列：《觀音山》、《觀音山風景》與《觀音山遠眺》。在一個系列當中，同樣的構圖會重複畫六到十多次，從較為寫實的描繪，逐步實驗不同的色調、色彩、空間的遠近、造型的變形與簡化等等。陳德旺曾說：「正確探究要比創作更重要。」研究一幅畫並不是只求順眼、好看，還要去問是什麼東西讓我們覺得美？什麼條件造成了這種效果？他研究的是繪畫的「根」，即繪畫的本質性問題，一天二十四小時不斷地與畫對話，讓他的畫作雖少，卻越發精純。

《觀音山遠眺》描繪的是從廖德政天母畫室二樓看去的景緻。陳德旺與廖德政同為1954年所組成的「紀元美術會」創始成員，兩人交情甚篤。1970年廖德政新居落成，邀請陳德旺等人去住了一晚，整個系列的基礎便來自幾張當場的鉛筆速寫。有趣的是，廖德政表示他不記得陳德旺當時有速寫過，應該是回去後憑記憶而成。可見畫家紮實的基本工夫。

根據畫布背面的紀錄，此畫應完成於1980年。整幅畫面以球形透視（spherical perspective）的方式構成，右方有如浪濤一般的龍眼樹枝葉，與前景左方的樹叢，將觀音山溫柔地環抱在綠蔭中，黃、綠、藍的色點，以細碎的筆觸層層相疊，顏色形成了塊面，有如結晶般美麗，又有如音樂般調和。灰藍的中間色呈現出空氣感，讓遠方的觀音山若隱若現，充滿詩意。

陳德旺的學生粟耘曾評述：「陳師思眾山如一山。由於觀音山造型最單純，所以藉之一再探索。」在研究精神與藝術行動上，此舉都堪比陳德旺所欣賞的畫家塞尚（Paul Cézanne）對於聖維克多山的畢生追求。（楊淳嫻）

Guanyin Mountain was a quintessential motif in Chen Te-Wang's later painting career, during which he painted twenty-nine works divided into three series: *Guanyin Mountain*, *Landscape of Guanyin Mountain* and *Distant View of Guanyin Mountain*. In each series, Chen would paint an identical composition six to a dozen times, beginning with realistic delineation and further experimenting with different elements in term of tones, colors, distance in space, varying forms and simplification. The artist once said, "correct exploration is much more important than creation." Studying a painting is not merely pursuing eye-pleasing, nice-looking appearances but to ask what appeals to us as beautiful. What conditions could create such effect? Chen was studying the "root" of painting, which is about the nature of painting. Through ceaselessly conversing with painting, although he only produced a small body of works, his paintings had become more refined and purer through the process.

A Distant View of Guanyin Mountain features the view from the second floor of Liao Te-Cheng's art studio in Tianmu. Chen and Liao were both founding members of Chi-Yuan Painting Society founded in 1954, and were very good friends. When Liao moved into his new residence in 1970, he invited Chen and other friends to stay for a night. The foundation of Chen's series was formed by several pencil sketches created that night. Interestingly, Liao did

not remember Chen's sketching that night. So, Chen probably created the work based on his memory afterwards, which showed his solid skills.

According to the notation on the back of the canvas, the painting was presumably completed in 1980. The entire image was composed through the spherical perspective. On the right was wave-like branches and leaves of logan trees, and the trees on the left in the foreground seemed to be gently embracing Guanyin Mountain in a verdant shade. Fragmented brushstrokes of yellow, green and blue were layered together. These colors crystalized into mesmerizing planes and flowed harmoniously like music. The

neutral gray blue color produced an atmospheric veil, making the vague silhouette of Guanyin Mountain extremely poetic.

Chen's student Su Yun once said, "Chen considers all mountains as one. Guanyin Mountain has the simplest form, so he has repeatedly explored the matter through it." In terms of research spirit and artistic action, Chen's endeavor was reminiscent of the art master he admired, Paul Cézanne, who also dedicated his whole life portraying Mount Saint Victoire. (YANG Chun-Hsien)

廖繼春 LIAO Chi-Chun (1902-1976)
野柳　Yehliu

油彩、畫布 Oil on canvas, 45.5 x 53.0 cm, 1965
私人收藏 Private Collection

野柳風景區是許多臺灣人心中共同的回憶，臺灣知名作曲家葉俊麟也曾作一曲《夏天的野柳》（1987）：「一檔一檔波浪花／相爭顯嬌媚／快樂青春期」。在戒嚴時期，沿海地帶為軍事管制區。1962年臺日合資電影《海灣風雲》（又名「金門灣風雲」）在野柳取景，讓北海岸之美透過大螢幕公諸於世。事實上藝術工作者已早一步發現此地，同年「臺灣攝影獨行俠」黃則修與前新光三越董事長吳東興舉辦「被遺忘的樂園──野柳」攝影聯展，以上百卷底片捕捉奇岩怪石，大量遊客慕名而至，迫使軍方在1964年開放野柳為風景觀光區。

這幅作品繪於1965年，即野柳剛開放沒多久時。從畫家所在位置，可以清楚地看到整個野柳漁港與對面的駱駝峰。畫家以粗放的筆觸、濃厚的青綠色彩，輕快地勾勒出山體稜線。整幅畫最精彩處在於波濤洶湧的海面，正如歌詞中所提到「一檔一檔波浪花」，海中礁石隱約露出，小型漁船在白色浪花中與其相爭，非但沒有「嬌媚」之感，反而險象環生。十七世紀航行至此的西班牙人便因故將此地命名為「魔鬼岬」（Punto Diablos），名不虛傳。

廖繼春是臺灣美術界公認的色彩大師，在他筆下「客觀景物可以隨心所欲賦予各種主觀顏色，只要顏色之間能彼此調和就好。」因而畫家並沒有呈現岩石原本的土黃色，或許從逆光的角度看去，海天與山石便融為一體；然細看之下，不論山體或海面均隱藏許多顏色變化，呼應著天空的雲彩、山腳下的建築物，像是歌曲中的旋律般此起彼落，呈現出活潑的感覺，讓人回味無窮。（楊淳嫻）

Yehliu Scenic Area (now Yehliu Geopark) is a place filled of memories shared by many people in Taiwan. Renowned Taiwanese composer and songwriter Yeh Jyun-Lin had written a song called "Yehliu in Summer" (1987): "Splashing waves, one after another, competing to show its alluring beauty. What a happy, youthful time." During the period of martial law, the coastal region was controlled by the military. In 1962, the movie, *Rainbow over the Kinmen*, produced with Taiwanese and Japanese joint capital, was partially filmed in Yehliu, showing the world the beauty of the northern coast of Taiwan. In fact, artists had long discovered the charm of this place. In the same year of the film, Huang Tse-Hsiu who was nicknamed "the maverick of Taiwan's photography" and Wu Tung-Hsing, the former chairperson of Shin Kong Mitsukoshi, co-presented the photography exhibition, *The Forgotten Paradise—Yehliu*, for which they captured the peculiar rock formation of the coastal terrain. More and more tourists visited the place; and eventually the military lifted its control over Yehliu, making it a scenic area to the public in 1964.

This painting was created in 1965, shortly after Yehliu was opened up to the world. From where the artist stood, he could see the entire Yehliu Fishing Harbor and Camel Peak across the harbor. With bold and unrestrained brushstrokes as well as thick and heavy blue green, Liao outlined the ridgeline of the mountain.

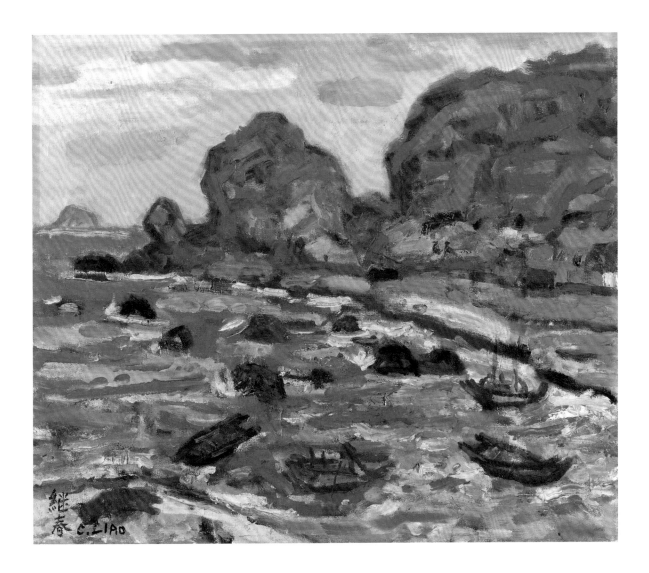

The most brilliant part of the painting is the toppling sea waves, which fits the lyric of "splashing waves, one after another." With reef rocks rearing from the water, the small fishing boats seemed to compete with the waves; but instead of a scene of "alluring beauty," it looked rather dangerous and risky. When the Spanish sailed to this place in the 17th century, they named it the "Punto Diablos" (literally, Demon's Point), which described its danger suitably.

Liao Chi-Chun was praised as the master of colors in Taiwan's art circle. Under his brush, "objective scenes and objects can be given any subjective colors as long as the colors create a harmonious balance." Therefore, the painter did not paint the rocks in their original color, which would be khaki and brown. Perhaps, from where he stood, the mountain, the sea, and the sky blended from the blacklight perspective. Nevertheless, upon close examination, both the mountain and the surface of the sea have been depicted with multiple colors, echoing the clouds in the sky and the buildings at the foot of the mountain. Like the rising and falling melody of Yeh's song, the painting conveys an incredibly lively mood that draws the spectator in again and again. (YANG Chun-Hsien)

林克恭 LIN Ko-Kung (1901-1992)
風景 Landscape

油彩、木板 Oil on panel, 38.0 x 45.0 cm, 1960s
私人收藏 Private Collection

被徐悲鴻（1895-1953）譽為「南天人物」的林克恭，放眼臺灣畫壇，少有人能如他同時兼有東西文化的深厚素養與視野。他的〈現代美學與繪畫〉一文，從符號作為繪畫語言的角度，來探討抽象畫的構成與美學意涵，立論精闢，也可視為個人創作理論的表達。

文中提到，繪畫的形、色、線都可以符號視之，具象畫與抽象畫亦然，只不過前者有客觀事物可作為對照，因而我們較容易從約定俗成的脈絡去看懂這些符號的意義；而抽象畫在創作上便無此限制，可以按照個人風格進行表現。綜觀林克恭的創作年表，便可發現他同時進行具象的與抽象的創作，兩者之間的繪畫語言也或有互通。

畫家於1956至1970年代初期任教於政戰學校與文化大學美術系，這段期間經常帶學生前往各地名勝寫生。此件作品所描繪的是基隆北海岸一帶的風景，遠方的小島即基隆嶼，亦是日治時期的基隆八景之一「杙峰聳翠」。畫面中可以看出林氏典型的繪畫語言：以優雅的線條形塑出事物最簡練的輪廓，幾何形狀的切面表現其立體構成，以冷暖色彩巧妙相間，描繪出岬角海岸奇特、多變的地質景觀，亦創造出宛如琉璃般的透明感。然而如此的視覺組合，不也正符合臺灣人所熟悉的北海岸意象嗎？遠方的基隆嶼在海天交界若隱若現，宛如仙境。林克恭筆下的風景經常予觀者神聖之感，或許便因為他能夠於具象的事物中，掌握抽象的原則，覺察出內在於俗世中的永恆之美吧。（楊淳嫻）

Praised by Hsu Pei-Hong (1895-1953) as "the great southern figure," Lin Ko-Kung was one of the few artists in Taiwanese art scene who possessed equally profound knowledge and vision of both Eastern and Western culture. His essay, "Modern Aesthetics and Painting," discussed the constitution and aesthetic implication of abstract painting from the angle of symbol as a painting language. His insightful and precise theorization can be viewed as his personal theory in artistic creation.

In this essay, Lin asserted that forms, colors and lines in painting, figurative or abstract, could all be treated as symbols. The difference was that the former had objective things as reference, so people could more easily understand the meanings of the symbols based on the conventional context. On the other hand, when making abstract painting, one could be free from such restriction and express through one's personal style. Taking a look at Lin's creative timeline would show that the artist had indeed created both figurative and abstract works at the same time and with similar or shared painting vocabularies.

From 1956 to the early 1970s, the artist was teaching at Political Warfare College and Chinese Culture University's Department of Fine Arts. During this period, he often took his students to various tourist spots to paint. This work depicts the landscape in the northern coastal region in Keelung. The islet in the distance was Keelung Islet, and one of Keelung's eight scenes from the period of Japanese rule, known as the "Perpendicular Peak of Emerald Green." The painting demonstrates vividly Lin's typical painting vocabularies—the contours were succinctly delineated with elegant lines, and the three-dimensionality of the landscape was created with geometric shapes. Together with an ingenious mixture of cold and warm colors, the peculiar and diverse geological terrain of the coast was portrayed, along with a sense of lazuli-like transparency. Such a visual combination precisely matches the image of the northern coast remembered by many Taiwanese. At the seam of the sky and sea lies the ethereal, paradise-like Keelung Islet. Lin's landscape often fills the spectator's mind with a feeling of sacredness. Perhaps it is because he has grasped the intangible principle of abstraction underlying tangible things and perceived the eternal beauty hidden within the mundane world. (YANG Chun-Hsien)

小原整 OHARA Hitoshi (1891-1974)
臺灣農家 A Farm House in Taiwan

油彩、畫布 Oil on canvas, 45.5 x 53.3 cm, 1967
鄭世璠舊藏 Previous Collection of CHENG Shih-Fan

一間褐瓦白牆、素樸的農舍座落在綠林草叢中。相對於農舍的平直塗繪，綠樹則以強烈扭轉的塊狀筆觸表現，在藍天白雲的映照下綠意盎然、生機蓬勃。這是小原整在離開臺灣二十年後畫下對農家的印象。

小原整1932年來臺接任石川欽一郎在臺北師範學校的教職，淡泊名利的他不再參選任何美展，而是全心投入美術教育的工作，直至日本統治結束為止。期間他因擔任新竹州學校美術展的審查員而屢次造訪新竹，與新竹畫家的關係特別密切。鄭世璠、陳在南就讀北師期間，受其繪畫啟蒙而邁向畫家之路，戰後也與他保持聯繫。1969年小原整再度踏上臺灣土地，在學生的陪伴下重遊新竹舊地。1974年

他過世後，鄭世璠在哥雅畫廊為其舉辦遺作展。1975年鄭世璠號召臺北第二師範學校校友成立芳蘭美術會，並舉辦第一回展，展品包括這幅《臺灣農家》，而且每年芳蘭美展必定展出小原整的作品。

小原整畫風介於印象派與後印象派之間。1935年《臺北植物園》，他描繪植物園溫室周遭的綠林風景，承襲黑田清輝（1866-1924）引進的外光派風格，畫中藉由路徑暗示空間的遠近關係，深淺的綠色調表現陽光灑落的光影變化。而這幅1967年的《臺灣農家》，使用類似梵谷（Vincent Van Gogh）的後印象派手法，粗獷而騷動的筆觸，像是表現九降風吹拂的新竹郊外景色。（黃琪惠）

A simple farmhouse with white walls and brown roof tiles sits in green grass amidst a lush wood. Comparing to the farmhouse painted with the technique of flat application, the green trees are painted with intensely twisting and broad brushstrokes, which look luxuriant and bursting with life under the blue sky and white clouds. This was Ohara Hitoshi's impression of the farmhouse after leaving Taiwan for twenty years.

Ohara arrived in Taiwan in 1932 to succeed Ishikawa Kinichiro's teaching position at Taihoku (Taipei) Normal School. Seeking no fame and wealth, he no longer submitted works to any art exhibitions but instead devoted himself to art education until the Japanese rule ended in Taiwan. During this period, he also served as a reviewer for school fine art exhibitions in Shinchiku (Hsinchu), and therefore repeatedly visited the place and was close to Hsinchu-based artists. When artists Cheng Shih-Fan and Chen Tsai-Nan were students at Taihoku Normal School, they were taught and inspired by Ohara, and later decided to pursue a career as an artist. After the war, the students also kept contact with their teacher. In 1969, Ohara once again visited Taiwan, and was accompanied by his students to revisit Hsinchu. After he

passed away in 1974, Cheng organized a posthumous exhibition of Ohara at Goya Gallery. In 1975, Cheng gathered the alumni of the Taipei Second Normal School to found the Fang Lan Art Society and presented the first exhibition of the art society, which included *A Farm House in Taiwan*. The Fang Lan Art Exhibition, which was presented every year, would always include Ohara's work.

Ohara's painting style was between Impressionism and Post-impressionism. His *Taihoku Botanical Garden* of 1935 delineated the verdant woods in the vicinity of the greenhouse in the botanical garden. Inheriting the plein-air style introduced by Kuroda Seiki (1866-1924), the artist used the path to suggest the depth of space in the painting and portrayed the interplay of the cascading sunlight and shadow with rich shades of green. On the other hand, *A Farm House in Taiwan* painted in 1967 employed Post-impressionistic techniques similar to that of Vincent Van Gogh and displayed rough, dynamic brushstrokes to portray Hsinchu's rural landscape in the wind of September. (HUANG Chi-Hui)

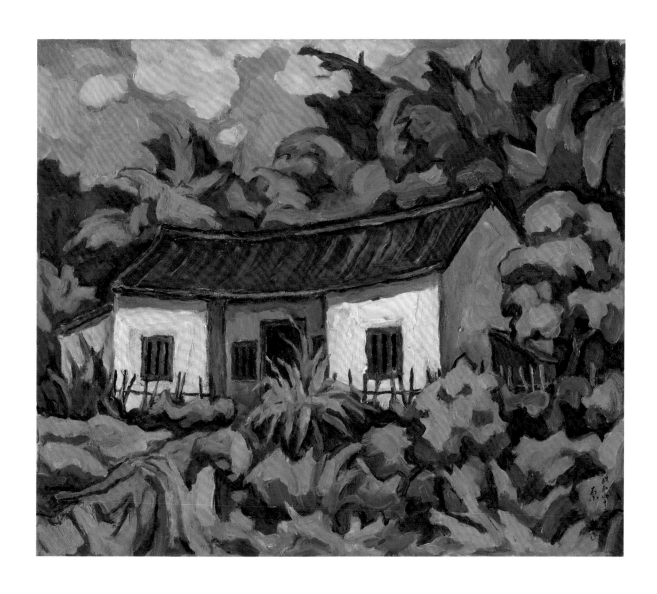

鄭世璠 CHENG Shih-Fan (1915-2006)
西門街大圓環 Roundabout on Ximen Street

油彩、木板 Oil on panel, 43.0 x 121.0 cm, 1961
家屬收藏 Collection of Artist's Family

跨足於美術界與文學界的鄭世璠，除了追隨石川欽一郎、李澤藩、小原整等著名畫家學習美術之外，對於文學與語言亦有涉獵的他，總是關注藝界發展且提筆論述。號稱「臺灣美術界活字典」的鄭世璠，其畫作與文章中亦彷彿傳達著許多臺灣美術的故事。

本幅作品中，畫家以全景畫的方式呈現大圓環，讓觀者身歷其境。畫家以飽滿的藍色與鮮明的黃色繪製天地，為西門町打造出明亮的基底。此外亦利用厚重輪廓線的有無，表現出建築群的遠近層次。1950年代起，鄭世璠的繪畫風格從寫實逐漸發展創新，開始以塊狀形式的簡化手法創作。畫面中雖然未以人物來突顯西門町的繁華，但畫家藉由厚粗的線條、寬廣的街景以及繽紛的色彩，營造出一種溫暖活潑的感覺。印證後期印象派畫家塞尚（Paul Cézanne）所說「當色彩的豐盛達到極致時，形式也就隨著充實起來」的言論。

對照1960年代的老照片與畫面上呈現的角度，畫家佇立創作的地方，正是老臺北人難以忘懷的中華商場。有趣的是，中華商場即在此畫創作的1961年正式落成啓用。前景的噴水池，隱含著許多老臺北人嬉水的記憶；遠方紅色建築後方佇立著高大白色招牌的建築應為南洋百貨。畫面中高聳大廈林立，反映出1960年代的西門町已是百貨公司最為密集之處。然而畫家刻意選擇此角度，並未將剛落成的中華商場繪於畫中，反而讓觀者可在畫面右方見到「亭仔腳」這樣的傳統紅磚街屋。如此的構圖選擇，或許是擅長說故事的鄭世璠，企圖傳達出西門町新舊文化並存的樣貌吧。（郭懿萱）

Cheng Shih-Fan engaged in both artistic and literary creation. In addition to studying art with renowned artists, such as Ishikawa Kinichiro, Lee Tze-Fan and Ohara Hitoshi, he also dabbled at literature and language, and always followed the development of the art scene, for which he would produce theoretical writings. Nicknamed "the living dictionary in the Taiwanese art circle," Cheng's paintings as well as his articles always seemed to tell many stories about Taiwanese art.

In this work, the painter adopted a panoramic view to portray the roundabout, enabling the spectator to experience the place vicariously. With saturated blue and vibrant yellow to paint the sky and ground, the artist built a bright foundation for his portrayal of Ximending. Moreover, he used the application of thick contour lines, and the removal of them, to create a sense of distance between buildings. Since the 1950s, Cheng's painting style gradually evolved from realism to an innovative style as he began simplifying objects into blocks in his painting. In this work, instead of using figures to highlight the prosperity of Ximending, the artist employed thick lines, an expansive streetscape and splendid colors to produce a warm and lively atmosphere, validating the statement of the Post-impressionist

painter Paul Cézanne, who once said, "when the color achieves richness, the form attains its fullness also."

Comparing old photographs from the 1960s to the angle of the painting, it is obvious that the artist painted the work standing at Chunghua Shopping Mall that many older Taipei residents would remember. Interestingly, the shopping mall was precisely inaugurated in 1961, the year this painting was created. The fountain in the foreground was a place that some Taipei residents had played with water. The building with a large white sign behind the red building in the distance was supposedly Nanyang

Department Store. The clusters of tall buildings reflected the fact that Ximending in the 1960s had already been a place with most department stores. However, the artist intentionally selected this angle and excluded the newly inaugurated Chunghua Shopping Mall in the painting contrarily allowed the spectator to see the traditional redbrick townhouses with characteristic storefront overhangs. Perhaps, the artist who specialized in storytelling had conceived the composition to underline the coexistence of new and old culture in Ximending. (KUO Yi-Hsuan)

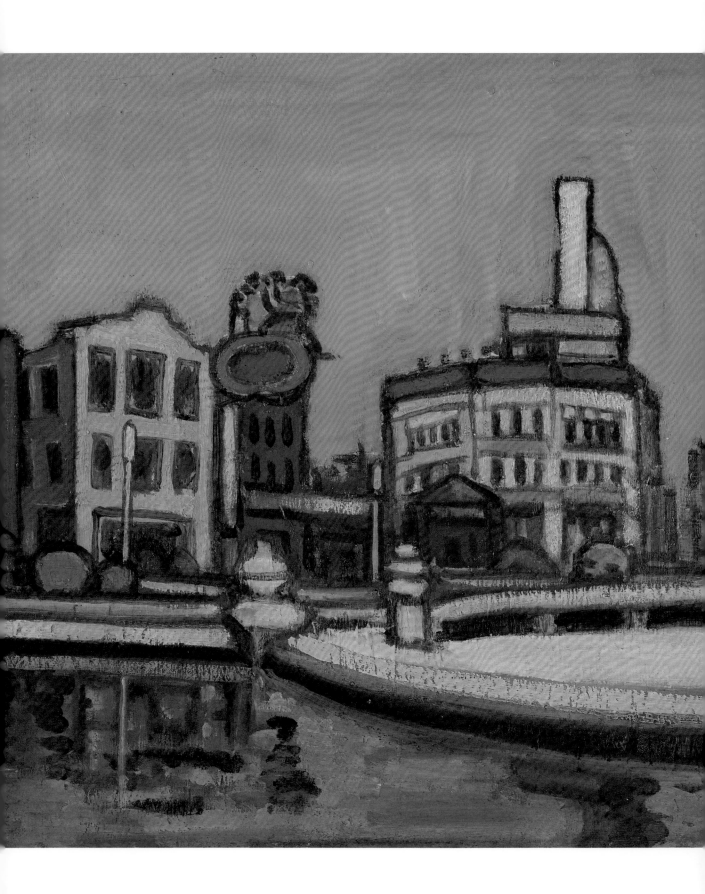

呂基正 LU Chi-Cheng (1914-1990)
雲湧高峰 Mountain Peaks with Surging Clouds

油彩、木板 Oil on panel, 91.0 x 73.0 cm, 1962
國立臺中教育大學典藏 Collection of National Taichung University of Education

曙光乍現,有如急行軍般的雲,從山谷深處湧動而上,似乎想要征服危險的崩壁與黑色山脊。險峻的主山佔據了畫面的大半,逼近畫緣上方,僅露出一小片天空。深黑與墨綠的龐大山體令人感到壓迫,也代表了大自然令人敬畏的力量。然而,前景的樹叢隔著大片雲霧,似乎正在觀看眼前雲與山對峙的戲劇性一幕。右邊雖有兩株枯木,然而秋色還停留山間,黃葉隨風搖曳。

本次能展出這件作品,可說是偶然的幸運。這是呂基正擔任第十四回省展(1963年)審查員的展出作品,亦於同年的個展中展出。作品上沒有年代標記,由於該年省展於2月舉辦,從畫面來看應是前一年的秋末冬初所繪製。這件作品長年下落不明,以往只見過畫家拍攝的黑白照片。在本次展出前,由楊永源教授發現此畫作收藏於國立臺中教育大學。據說本件作品與其他畫作原本為臺灣省教育廳所收藏,後分發至臺中師範(即國立臺中教育大學之前身)。因保存狀況不佳差點被丟棄,幸由當時任教於該校的畫家倪朝龍先生所搶救,才能保存下來。

距離畫作初次展出至今,已神隱超過半世紀。發現後經細心修復,於本展公開展示,別具意義。

這件作品是呂基正早年的山岳畫代表作之一,善用黑色與大膽的筆觸,具有強烈表現性的畫風,顯示出他早年師事林重義(1896-1944)與伊藤廉(1898-1983),受到日本獨立美術協會影響下所形成的風格。此外,畫家還使用了獨特技法,將特殊材料黏著於畫面上,藉此表現碎石崩壁與樹叢的質感。寫實與表現性兼具,可見其不拘一格的自在畫風。險峻高山與危險崩壁,對照著隨風湧動的大片雲朵,似乎表現了動靜不息的自然之理。藝評家王白淵(1902-1965)在1960年曾這麼形容呂基正的作品:「呂氏素來被稱為山岳畫家,確實他的山岳畫有他獨得的風格……山岳的嚴峻感,偉大的量感,可怕的變幻與靈魂的安息處,這是山岳給我們的一切。呂氏將這種種特異,以大的筆觸與色塊,將它表現出來。」王白淵精準地描述了呂基正此時期的山岳畫風格。本件畫作具有強烈的感染力,透過畫面,觀者不但可以領略山岳的崇高之美,也能感受到畫家在面對大自然時所油然而生的敬畏之心與驚嘆之情。(邱函妮)

At the break of dawn, rapidly moving clouds surged and rose from the depth of the valley as if they were to conquer the perilous cliffs and black mountain ridge. The precipitous peak occupied most of the image, and only a small patch of sky was revealed at the top of the painting. The sheer volume of the black and dark green mountains formed an oppressive presence and demonstrated nature's formidable power. Before the mountain clouds, the trees in the foreground seemed to be witnessing the dramatic moment of confrontation between the clouds and the mountains. Two barren trees stood on the right, but autumn still lingered in the mountains as yellow leaves swayed in the blowing wind.

It has been pure luck that this painting can be included in this exhibition. This work was exhibited in the 14th Taiwan Provincial Fine Arts Exhibition (1963), in which Lu Chi-Cheng served as a reviewer. It was also shown in Lu's solo exhibition in the same year. The date of creation was not marked on the painting. However, since that year's provincial exhibition took place in February, the painting might be painted around the end of autumn and the beginning of winter the year before. This work was lost for many years, and could only be seen in black-and-white photographs taken by the painter. Before this exhibition, Professor Yang Yung-Yuan found out that the painting was in the collection of National Taichung University of Education. It is said that this work, along with other paintings, had belonged to the collection of Taiwan Provincial Government's Department of Education, and was distributed to Taichung Normal School (now National Taichung University of Education). Due to its poor condition, it would have been thrown away. Fortunately, painter Ni Chao-Long, who was teaching at the school, was able to save and preserve this work. It has been over half a century since the painting was last shown in public. After careful and remarkable restoration, it is especially meaningful that it is on view in this exhibition.

An iconic piece among the artist's early mountain paintings, the use of black and the bold brushstrokes are highly expressive, demonstrating Lu's style informed by the influence of Japan's Dokuritsu Bijutsu Kyokai (Independent Art Association) when he studied under Hayashi Shigeyoshi (1896-1944) and Ito Ren (1898-1983). Furthermore, the painter also utilized an individualistic technique, adhering special materials to the painting surface to create the texture of collapsed debris and trees. The mixture of realistic and expressive techniques showed Lu's unrestricted painting style. The contrast of mountains with risky cliffs and the surging, rolling clouds displays the ceaseless dynamics in nature. When commenting on Lu's works in 1960, art critic Wang Pai-Yuan (1902-1965) stated that "Lu is known as a mountain painter. His mountain paintings indeed display a unique style... A sense of austerity, great volume, terrifying changes and the resting place of the soul are what mountains have given us. With large brushstrokes and color blocks, Lu has expressed these distinctive features." The art critic precisely captured Lu's style of mountain painting during this period. This painting is fiercely compelling. Viewing the image, spectators not only can grasp the sublime beauty of the mountains, but also can perceive the artist's reverence and amazement in the presence of Mother Nature. (CHIU Han-Ni)

呂基正 LU Chi-Cheng (1914-1990)
冰天雪地 Snowfield

油彩、畫布 Oil on canvas, 91.0 x 116.5 cm, 1976
私人收藏 Private Collection

一陣大雪過後，粉雪覆蓋大地，眼前變成一片如夢似幻的銀白世界。本件作品描繪的可能是合歡山雪景。合歡山位於南投縣仁愛鄉，是由七座山峰所形成的群峰山系，最高的北峰標高3422公尺。因地理位置容易匯集立霧溪的水氣，冬季易降雪，是南國民眾的熱門賞雪景點。呂基正曾在1974年描繪了另一件以雪景為主題的同名畫作，雖然都是描繪大雪過後一片冰天雪地的景色，然而表現出來的意境卻有所不同。在1974年的作品中，厚厚的白雪覆蓋了層層疊疊的山脊，瞭望群峰，彷彿令人感到切膚寒意。然而，在這件1976年的作品中，畫家描繪的是大雪過後，雪霽天晴的情景。

畫面分為前、中、後景，前景處的山坡使用白、綠色，快速地使用畫刀塗抹，描繪出鬆軟的雪地質感，積雪不深，仍可隱約看見一部分的植被與地貌。山坡的盡頭處，有一排雪松，皚皚白雪覆蓋樹梢。中景處是拔地而起的兩座險峻山峰，寶石綠的

山體與山崖上的白雪相輝映，眼前美景不禁令人屏息。山頂處的白雲似乎與遠山山頂的白雪連成一片，在陽光的映照下十分耀眼，和畫面右方背光處深黑的山壁形成強烈對比。畫家熱心地觀察自然實景，卻以主觀的心情來創作，在看似抽象的筆觸下，遠觀卻如臨實景。

呂基正的老師伊藤廉曾讚賞他的山岳畫：「山岳的骨骼雖然不變，但山容卻因天候不同而有千變萬化。呂基正君正是將山岳與自我的精神合而為一。呂君的山岳畫以強大的寫實功力來掌握不變的骨骼，這是他意志的展現。然而，青空下山皺的明暗與白雲、風聲，時而險峻，時而流暢，他熱心地觀察自然的各種面貌，在其中可察覺呂君的詩心。」本件作品在呂基正生前曾多次展出，1976年於東京舉辦的亞細亞現代美術展，他亦選取本作來參展，可見此畫被畫家視為得意的代表作之一。（邱函妮）

After a snowfall, fresh snow covered and turned the landscape into a dreamlike silver world. It is likely that the snowscape depicted in the painting is on Hehuan Mountain, which is a mountain range in Nantou County's Renai Township, comprising seven peaks. The North Peak, which is the highest of all, reaches an elevation of 3,422 meters. Due to its geographic location, water is likely to be vaporized in this area and causes snowfall, making it a popular destination of snow for people from Southland. Lu Chi-Cheng had painted another homonymous painting featuring snow-laden landscape in 1974. While frozen land after sonwfall are portrayed in both paintings, they revealed dissimilar artistic conception. The painting of 1974 features rolling mountains buried deeply in white snow. Looking at the peaks, one can almost feel the

biting chill. On the other hand, a sunny scene after heavy snow is painted in the one of 1976.

The painting can be divided into the foreground, middleground and background. The mountain slope in the foreground was painted with white and green. The artist used a palette knife to sweep and create the soft, loose texture of the snowfield. It is suggested that the snow was not thick as partial vegetation and terrain were revealed. At the end of the slope was a row of cedars with the treetops covered by snow. Two steep peaks rose in the middleground. The emerald mountains and the snow on the cliffs reflected each other's splendor, creating a breathtaking vista. The clouds around the summit seemed to merge with the clouds

above the peaks of the distant mountains, looking iridescent under the sunlight and forming a stark contrast to the dark cliff in the shadow on the right. The painter devotedly observed the natural landscape but portrayed it with subjective feelings. Although the painting is created with abstract brushstrokes, it looks rather realistic when viewing from afar.

Lu's mountain paintings had been praised by his teacher, Ito Ren, who stated, "although the integrity of the mountain remain unchanged, its visage demonstrates endless changes because of the weather. Lu has combined his own spirit with mountains. His mountain paintings grasp the unchanged integrity with solid realist techniques, and manifest his will. However, under the blue sky, the mountains with vividly contrasting folds, the white clouds and the sound of the wind sometimes seem precipitous, and at other times free-flowing. Lu passionately observes the looks of nature, and his observation reveals his poetic mind." This work had been exhibited numerous times when Lu was alive. For the Asia Modern Art Exhibition held in Tokyo in 1976, he also chose to show this painting. It is clear that, for the artist, this work is one of his masterpieces. (CHIU Han-Ni)

43

呂基正 LU Chi-Cheng (1914-1990)
奇萊雪景 Snow-covered Qilai

油彩、畫布 Oil on canvas, 80.0 x 116.5 cm, 1982
私人收藏 Private Collection

東方的第一道曙光照亮了前景山坡,綠色草坡上塗抹著黃綠、亮黃、鉛黃等明亮色彩,表現出光線的變化。白雲從山谷間蒸騰而上,山谷處以灰藍、藍、紫色描繪,既表現霧氣,也讓人無法測知山谷之深,以及與前景山坡之間的距離。呂基正擅長以對比手法來描繪山景,與前景綠意盎然的和緩山坡相對比的是以白色、藍紫色系描繪的積雪群峰,畫家熟練地驅使畫刀,刻劃出山脊堅硬鱗峋的質感,氣勢撼人。太陽即將升起,從山頂背後發射出金黃色的光芒,背光處山脊的紫色,與山頂反射日光的耀眼白雪,使得主山的色彩顯得絢麗無比。畫家以高明的色彩運用,以及確實的描寫功力,將高山的靈韻捕捉於畫面之中。

如畫題所示,畫中的主山是屬於奇萊山系。奇萊連峰位於中央山脈主稜的北段,由北峰、主峰、卡羅樓斷崖、南峰等形成雄偉險峻的連峰山系。最高的北峰標高3607公尺,主峰3560公尺。奇萊山又有「黑色奇萊」的稱號,山區氣候變幻無常,經常發生山難。攀登奇萊山對登山者而言,可說是一大挑戰。畫面中的積雪山峰,應是從主峰附近眺望卡羅樓斷崖的景色。推測是呂基正攀登奇萊山稜線時,先以畫筆速寫卡羅樓斷崖的形貌,後來在畫室中完

成了此件五十號的作品。有趣的是,從稜線上應該無法看到畫面前景的綠色山峰,可知這座山是畫家的神來一筆,藉此拉開與奇萊山之間的距離,獨自存在的冷杉,彷彿向觀者暗示畫家駐足於此,眺望眼前一片積雪高山的日出美景。

呂基正自1940年代後期開始描繪臺灣的高山,他不只前往交通易至的山區,也如探險家般走遍臺灣各地高山,留下數量驚人的畫作,被稱為「山岳畫家」。1959年在全省美展中展出《奇萊主峰》,是他描繪奇萊山的早期作品。在這件作品中,以沈鬱的色調描繪山體,呈現出莊嚴肅穆的氣氛。此後他持續描繪奇萊山,從各種角度捕捉變化多端的樣貌。本件作品描繪於1982年,是目前所知最晚的一件奇萊山畫作。此時畫家已六十八歲,卻仍然攀登具有挑戰性的奇萊稜線。不過,即使是描繪這段攀登時驚險萬分的卡羅樓斷崖,畫家卻不強調其恐怖之感,而是表現山的壯麗形貌以及屹立不搖的氣質。呂基正曾說:「看山看久了,就會有所感覺,山的那份雄偉厚重和細緻質感,都使我渴望想把她表達在畫布上。」描繪高山數十載的呂基正,在這件晚年的畫作中,彷彿也將他一生從山岳所領悟到的精神境界寄託其中。(邱函妮)

The first ray of sunlight from the east lit up the mountain slope in the foreground. The mixed bright colors, such as yellow green, bright yellow and lead yellow, expressed the change of light. White clouds floated up from the ravine, which was delineated with gray blue, blue and purple to portray the mountain mist, the unfathomable depth and the ravine's distance from the slope in the foreground. Lu specialized in using the technique of contrast to paint mountains. Forming a contrast to the lush, gradual slope in the foreground was the group of snowclad mountain peaks depicted with white and shades of blue gray. The painter skillfully used a palette knife to craft the rigid texture of the steep mountain ridges, giving them a magnificent look. As the sun rose, rays of golden light beamed out from behind the mountains.

The purple color used to depict the shadow as well as the light-reflecting, shining white snow on the mountain top made the main peak iridescent. The painter's mastery of colors and truthful portrayal captured the sublime presence of the mountains.

As the title suggests, the main mountain in the painting is the Qilai Mountain Range, which is part of the northern Central Mountain Range's principal range, comprising a series of majestic, perilous mountains including the North Peak, the Main Peak, the Kaluolou Cliff and the South Peak. The highest North Peak is 3,607 meters above sea level, and the Main Peak is 3,560 meters. Qilai Mountain is also nicknamed "Black Qilai" because many mountain accidents have taken place due to its unpredictable,

inclement weather. For mountaineers, Qilai Mountain is a severe challenge. In the painting, the landscape of the snow-covered mountains should be the view of Kaluolou Cliff observed from the Main Peak. Lu probably sketched the Kaluolou Cliff first when climbing the ridgeline of Qilai Mountain, and completed this painting of 50F (80.0 x 116.5 cm) in his studio. Intriguingly, it is unlikely to see the green peaks depicted in the foreground from the ridgeline. So, this was a genius design of the painter, who used it to create a sense of distance between the vantage point and Qilai Mountain. A single, freestanding fir seemed to imply that the artist had stood here to take in the splendid sunrise in the mountain snowscape.

Lu had started painting Taiwan's high mountains since late 1940s. He not only went to easily accessible mountain regions, but also climbed various high mountains like an explorer and left a large body of works, for which he has been called a "mountain painter." In 1959, Lu exhibited *Main Peak of Qilai Mountain*, an early painting featuring Qilai Mountain, in the Taiwan Provincial Fine Arts Exhibition. In this work, he used dark, gloom tones to delineate the mountain, conveying a stern, serious mood. Later, he continued making Qilai Mountain his subject, capturing her different looks from different angles. This work was completed in 1982, which is the latest painting of Qilai Mountain among all the known works. The painter was sixty-eight years old at the time, but he still took on the challenge of climbing the Qilai Mountain ridgeline. Despite the risk and danger presented by the Kaluolou Cliff, he did not make the terrifying threat the focal point, but instead highlighted the mountain's majestic appearance and unshakable presence. Lu once said, "when looking at the mountain long enough, you will feel something. The majestic loftiness and refined quality all make me want to portray her on the canvas." Having spent decades of painting high mountains, this jewel from his late years seemed to manifest the spiritual essence he had learned from the mountains. (CHIU Han-Ni)

IV

歲月的憶念

REMEMBRANCE OF PASSING YEARS

IV

歲月的憶念
REMEMBRANCE OF PASSING YEARS

文／楊淳嫻

國立交通大學社會與文化研究所博士

Text / YANG Chun-Hsien

PhD, Institute of Social Research and Cultural Studies, National Chiao Tung University

以西洋藝術史的觀點看來，靜物畫的分類要到了近代才逐漸確立，也顯示出此一繪畫主題與現代化之間的密切關係，意即自西方文藝復興時期以降，朝向以人為本，面對世界去探索、開展的心態，以及一個更加肯定世俗價值的歷史階段。靜物畫所描繪的對象包括：花卉、水果、動物標本、食物、貝殼、錢幣、杯盤器皿等。簡單來說，這些事物「不是活的」（inanimate），然又要表達得栩栩如生，以吸引觀者的目光。例如十六、七世紀低地國地區所流行的那些象徵奢華的靜物畫作品，以極度寫實的技巧來表達顏色與質感，這種賞心悅目的作品在藝術市場上大受歡迎。靜物畫的內容也反映出不同地區的文化與美學品味，例如同樣在十七世紀，西班牙的靜物畫（bodegón）便呈現出一種比較低調樸素的風格。

我們可以發現，雖然靜物畫的主題關聯著「人」的生活，卻是以對「物」的描寫來表現，因而從靜物畫當中也可以去展開對於視覺經驗的思考。十八世紀時，法國畫家夏爾丹（Jean-Baptiste-Siméon Chardin，1699-1779）的靜物畫便引發了啟蒙哲士狄德羅（Denis Diderot，1713-1784）去討論要如何「運用自然給予的眼睛」（keep the eye that nature gave me, and use them well）觀看事物的真實本質。到了十九世紀後期，塞尚（Paul Cézanne）更進一步在對靜物的描繪當中，注意到

當人類視覺轉換到平面時所可能產生出來的些微扭曲，從而打開了藝術的現代性思維。在二十世紀初期，當西畫觀念透過日本的美術教育而傳入臺灣時，同樣是透過「畫靜物」讓學生可以熟悉如何去觀察自然，建立起對於構圖與畫面整體效果的概念。

在臺灣美術史上，靜物畫並非繪畫的主流，甚至在早期發展時，也沒有出現過像是日本藝術家高村光太郎（1883-1956）或岸田劉生等，由文化衝擊的角度，對靜物畫展開理論性的思考。然而，這並不代表臺灣的靜物畫沒有自己的特色。從本次展覽所展出的靜物畫作品當中，我們可以清楚看到一種朝向內在情感且與生活世界緊密相連的美學表現。

本次所展出的作品於時間上橫跨了戰前到戰後的兩個階段。陳植棋的《桌上靜物》（1928，圖44）與李梅樹的《靜物》（1932，圖45）均為臺灣美術展覽會（簡稱臺展）的參展作品。從殖民地與展覽會的角度而言，或許會被認為畫家是為了表現「地方色」而特意描繪臺灣事物諸如圓桌、器皿、蔬菜水果等。然而這些事物也同樣可說是取自於畫家的日常生活。與此相同，張萬傳筆下的魚（圖48）、何德來畫中的豆腐與冰塊（圖46、圖47）、廖德政描繪的紅柿

From the perspective of Western art history, still life only gradually became an established genre in the early modern period, which also showed the intricate relationship between still life and modernity—since the Renaissance, painting had developed alongside humanism, encouraging the exploration of and an open-mind towards the world while creating a historical period that further affirmed secular values. The subject of still life includes flower, fruit, animal specimen, food, sea shell, coin, dining utensils, etc. Simply put, these are "inanimate" things, but the painters must depict them in such a lifelike manner that captures the spectator's eye. For instance, still lifes that were symbol of luxury and very well-received in Low Countries in the 16th- and 17th-century were painted with extremely realist techniques to express colors and texture, rendering these eye-pleasing works highly sought-after in the art market. The content of still life also reflects dissimilar regional cultures and aesthetic tastes; for example, the 17th-century bodegón from Spain has been known to display a more understated and simpler style.

It is clear that although the subject matter of still life is about the "human life" the painting genre has revolved around the delineation of "objects." So, it is possible to begin our thinking about visual experience through still life. In the 18th century, the still life of French painter Jean-Baptiste-Siméon Chardin (1699-1779) inspired philosopher Denis Diderot (1713-1784) and his discussion about how to "keep the eye that nature gave me, and use them well" to see the true essence of things. In late 19th-century, Paul Cézanne further noticed that, in painting still life, when human vision transitioned to the two-dimensional plane, there would be slight distortion, unfolding the modern thinking in art. In early 20th century, when Western painting concepts were introduced into Taiwan via Japanese art education, it was done through "painting still life" to familiarize students with observing nature and formulate their understanding of composition and the overall effect of an image.

In Taiwanese art history, still life was not a mainstream genre; and even during its early development, there had never been artists like Takamura Kotaro (1883-1956) or Kishida Ryusei, who began theoretical thinking about still life from the angle of cultural impact. However, it does not mean that Taiwanese still life has no unique characteristics. From the still lifes on view in this exhibition, one can vividly see aesthetic expression that introspectively explores one's emotions and is closely associated with the lifeworld.

The works featured in the exhibition, in terms of time span, cross two periods, from the pre-war era to the post-war era. Chen Chih-Chi's *Table Top Still Life* (1928; fig.44) and Li Mei-Shu's *Still Life* (1932; fig.45) were both showcased in Taiwan Fine Arts Exhibition (also known as the Taiten). From the perspective of the colony and art exhibition, they might be considered portrayals of Taiwanese objects, such as round table, utensils, fruits and vegetables, intended to demonstrate the "local color." However, the subject matters could also be said to have been taken from the artists' everyday life. Similarly, the fish in Chang Wan-Chuan's painting (fig. 48), the tofu and ice cube Ho Te-Lai's works (fig. 46, fig. 47), the persimmons depicted by Liao Te-Cheng (fig. 50), and the evergreen in Hsiao Ju-Sung's painting (fig. 51) are all extremely common things that we might take for granted and what Martin Heidegger has called "readiness-to-hand" (Zuhandenheit). Nevertheless, when they are depicted in paintings, these objects are transformed into "present-at-hand" (Vorhandenheit) that we feel strange about. Perhaps a spectator, when viewing these still lifes, would think, "why do the artists paint these objects? How are they different from what they usually appear to be?" When such questions surface in the mind, it means that the still lifes have unlocked a new space for our perception and thinking.

Still life, in fact, only takes up a portion in the oeuvre of the abovementioned artists. These things are depicted in their paintings because of the painters' life stories. For instance,

（圖50）、蕭如松所畫的萬年青（圖51）……每一件都是被我們視為理所當然，再普通不過，即海德格（Martin Heidegger）所謂的「及手之物」（Zuhandenheit, readiness-to-hand）；但當它們進入畫中，便轉變為讓我們感到陌生的「手前之物」（Vorhandenheit, present-at-hand）。或許觀者在面對這些靜物時不免會想：為什麼要畫這些？看起來是否有哪裡跟平常不同？如此便為我們的感受與思考打開了新空間。

對於上述畫家而言，其實靜物畫只佔了他們畢生創作的一部分，這些事物之所以進入畫中，背後均有一段屬於自己的生命故事。例如李梅樹所描繪的書桌，是他最敬愛的長兄所遺留之舊物；何德來畫中的那碗豆腐，則是與妻子最後一次在家共進的晚餐；《冰塊》代表了兩位畫家之間彼此惺惺相惜的美好情誼；張義雄筆下的剝皮魚頗有著中年自況的意味；張萬傳的魚畫，不只是出於個人喜好，也交織著對家族、對好友、以及對二二八的回憶；廖德政所經歷的家族迫害，更是只能以對靜物的一再描繪來自我療癒。因而這些作品與其說是靜物畫，毋寧可視為畫家的私密日記。他們以自己最熟悉的繪畫語言，對歲月的領悟與感懷，來連結畫中這些無生命的物品，讓生命留下永恆的紀念。

對觀者而言，畫面背後的脈絡也許太過私密，不易進入。但當我們將視線放回靜物本身，那種既陌生又熟悉的感覺，或許會讓我們想起，這些事物不僅存在於畫家的個人世界，也依然是我們日常生活的一部分。例如：陳植棋桌上的那盤土芭樂，還保持著只有乒乓球左右的大小，應該是沒有改良過的野生品種，許多臺灣人小時候或許還有著對那濃郁滋味的記憶。這份共有的經驗基礎，或將我們的注意力再次引領回畫面當中，以畫家所賦予的視野，用一種新的方式來觀看，那些從未被我們所注意到的線條、形狀、顏色，讓平凡的事物，可以用如此多樣的方式呈現。在觀看的同時，再次回想起那些因歲月流逝被忘卻，甚至為時代潮流所壓抑的生命故事，就像是出現在張義雄畫中的蘭嶼事物（圖49），彷彿提醒我們即便朝著現代化的方向前進，也不要忽視原住民與自然共處的生存智慧，以及世代相承的傳統文化。歷史的轉型正義，更是我們需要去進一步理解的重要課題。

張萬傳曾說：「畫的東西與生活相關，才有意義。」這句話頗能代表臺灣靜物畫的特色，其意義來自於對生活深刻的憶念（care）。在此，憶念已經不只是單純的追憶、懷念，而是一種出於對生命的熱愛，對生活的關懷，在時間的軌道上進行反思。

the desk depicted by Li Mei-Shu belonged to his beloved yet deceased elder brother. The bowl of tofu was from the very last time Ho Te-Lai had dinner with his wife at their home. *Ice Cube* marked the cherished friendship between two painters. The rough leatherjacket fish delineated by Chang Yi-Hsiung seemed to be a reflection of the middle-aged artist, whereas the fish in Chang Wan-Chuan's painting epitomized his personal preference as well as his memories about his family, good friends and the February 28 Incident. The past political oppression for his family experienced by Liao Te-Cheng's could only be healed through repeatedly painting still lifes. Therefore, these still lifes are very much their creators' personal diaries. The painters utilized the language of painting that they were most familiar with and incorporated their realization and feelings about passing time to bring together the inanimate objects in their paintings, creating their eternal memorialization of life.

For the spectator, the context behind these paintings might be too private and not easy to grasp; however, when shifting our focus back to the still lifes, the strange yet familiar feelings prompted by these paintings remind us that these things have not only existed in the personal world of the painters but in our everyday life as well. One example would be the plate of guavas in Chen Chih-Chi's painting, which were still the size of ping-pong balls. They were probably unimproved wild species. Many Taiwanese people might still remember its distinctly rich flavor from their childhood memory. With this shared experience as a basis, when re-focusing on the painting, we could adopt a new way to see the objects through the perspective provided by the artist. The lines, forms, colors that we have never truly noticed allow ordinary objects and things to be represented in a diversified way. When viewing these paintings, one might recall those life stories that have been forgotten and left in the past or even suppressed throughout the changes of time. For instance, the objects from Orchid Island in Chang Yi-Hsiung's painting (fig. 49) seem to remind us that the we should never overlook the indigenous wisdom of co-living with nature and the traditional indigenous culture that has been inherited through generations despite the progression of modernization. Furthermore, transitional justice of history is also an important subject that requires further discussion and understanding.

Chang Wan-Chuan once said, "the subject matter of painting should have its root in life so that it is meaningful." This statement is indeed fitting to convey the characteristics of Taiwanese still lifes, of which the meaning stems from the deep care about life. The care in this context therefore is not only simple remembrance and commemoration but the love of life and the attentiveness to living that manifest in one's reflection in the progression of time.

陳植棋 CHEN Chih-Chi (1906-1931)
桌上靜物 Table Top Still Life

油彩、畫布 Oil on canvas, 60.0 x 73.0 cm, 1928
家屬收藏 Collection of Artist's Family

此為第二回臺展無鑑查作品。大紅圓桌佔據了近三分之二的畫面空間，桌上陳列著幾樣帶有傳統色彩的事物：繪有七彩紋樣的白色茶壺，附圈足盤的藍綠色廣口瓶，蓮瓣盤與碗的大小剛剛好，上面放著土芭樂與文旦，是道地的臺灣味。然而，看似尋常的日常光景，當畫家以前衛的藝術手法來表現：靜物的輪廓經過簡化，呈現出陶捏手藝般的樸拙感；水果的枝梗、蓮瓣盤傾斜的角度、壺嘴與花瓶的方向，順著桌緣弧線移動而形成構圖上的多視角，將觀者視線導向桌心；粗放、細緻兼而有之的活潑筆觸，以及光潔桌面上微微倒影，許多小細節都增添了觀看的趣味。左側的黃藤椅與披在椅背上的白巾，穩定了整體的平衡感。

畫中最搶眼的，莫過於對紅色的大膽使用，有如一股豐沛的力量將畫中所有事物凝聚在一起。在畫家1927年《夫人像》與同時期的幾件靜物畫《觀音》、《葡萄》、《柿子與八角盤》中，也都使用了紅色作為畫面的重要元素。或許畫家受到野獸主義的用色美學影響，或許他活用了臺灣漢文化中代表喜慶的傳統色，不過，在《桌上靜物》完成後隔年的另一件大事，即由七星畫會改組的「赤島社」於1929年成立。陳植棋曾親口說明他心中的「赤」，意思是「以赤誠的藝術力量讓島上人的生活溫暖起來」。這幅作品可說充分展現了他的藝術理念。（楊淳嫻）

This work received review-exempt status in the 2nd Taiten. The large red table occupies nearly two third of the image. On the table are a few traditional objects: a white tea pot with a colorful pattern; a teal wide-mouth vase with a ring-footed tray; a lotus-shaped plate and a bowl in proper size, respectively with guavas and a pomelo that are typical fruits from Taiwan. However, the artist employed a rather avant-garde approach to portray this seemingly ordinary daily scene—the contours of the objects are simplified, showing an unadorned quality reminiscent of handmade pottery. The twigs and stems of the fruit, the slant angle of the lotus-shaped plate, the direction of the tea pot's mouth and the vase all followed the round table edge and formed multiple perspectives in the composition, guiding the spectator's line of vision towards the table center. The lively combination of coarse and refined brushstrokes, the subtle reflection on the clean table top, and many other details add an interesting quality in viewing the painting, whereas the rattan chair on the left, with a white cloth on its back, balanced the entire image.

The most striking element of the painting is undoubtedly the bold use of red, which brings together all objects in the painting with a vibrant force. The artist's *Portrait of Wife* painted in 1927, along with other still lifes from the same period, such as *Guanyin, Grapes, A Persimmon on an Octagonal Plate*, all have the important element of a red background. Perhaps Chen's use of color was influenced by Fauvism; or the red was an ingenious use of the traditionally festive color in Taiwan's Han culture. On the other hand, a major event in the next year after the completion of *Table Top Still Life* was the establishment of "Chi-Dao (Red Island) Group" in 1929, which was re-organized from the "Chi-Hsing (Seven Star) Painting Group." Chen once stated that "chi" (meaning red; sincere) means to "warm up the life of this island's people with the sincere power of art." Therefore, this painting can be viewed as the perfect manifestation of his ideal. (YANG Chun-Hsien)

李梅樹 LI Mei-Shu (1902-1983)
靜物 Still Life

油彩、畫布 Oil on canvas, 72.0 x 91.0 cm, 1932
李梅樹紀念館收藏 Collection of Li Mei-Shu Memorial Gallery

李梅樹向來以描繪臺灣女性著稱，靜物畫並不多，較為人矚目的是1927年入選第一回臺展的《靜物》，被視為他在進入東京美術學校前的重要作品。此後他連年參展，從未缺席，但直至第七回臺展以《自畫像》（1933）獲得特選之前，這段期間的作品較少被提及。特別是靜物畫，一般被歸類在他赴日前任教公學校時期的習作。

這件《靜物》為第六回臺展的入選作品。另有一幅被推測為1924年的相似之作，同樣是木桌上放著白菜、白蘿蔔、小黃瓜、番薯之類的常見菜蔬，圍繞著畫面正中央的南瓜。若將這兩幅作品連同1927年的《靜物》一起比較，便會發現1932年的《靜物》有些獨特的地方。首先在構圖上，可以清楚看到木

桌後方的牆面與門框，讓人意識到畫家所欲表現的是一處室內空間，光線從左方徐徐照入，畫面的色調處理得十分調和、自然。木桌上沒有襯布，刻意將光潔的質感顯露出來；桌上的菜蔬排列得格外齊整，並增加了盤裝枇杷與水杯等較為精緻的事物。諸多細節顯示畫家此時不僅能做出精確寫實的描繪，更能夠在畫面中營造出一種整體的生活氛圍。

畫中的桌子，是李梅樹大哥劉清港醫師平常所使用的。畫家敬兄如父，習畫路上更是受到長兄的大力支持。然而劉醫師病逝於1930年，帶給畫家重大的打擊，甚至不得不中斷學業，返臺處理家務。雖然靜物無語，但生活的記憶、親人的思念，似乎蔓延在畫筆之中。（楊淳嫻）

Li Mei-Shu was known for his delineation of Taiwanese women, and did not create many still lifes. The more notable ones include *Still Life* exhibited in the 1st Taiten in 1927, which has been regarded a crucial piece created before the painter entered Tokyo Fine Arts School. Since then, Li participated in the Taiten every year. It was, however, until the 7th Taiten that he was awarded the Special Selection Prize with *Self-Portrait* (1933). His works produced during this period were less mentioned, in particular his still lifes, which have been considered studies created when he was teaching at a public school before he went to Japan.

Still Life on view in this exhibition was selected into the 6th Taiten. Another similar work, which is purportedly created in 1924, also features common vegetable, such as cabbage, turnip, cucumber and yam on a wooden table, with a pumpkin at the center of the image. A comparison of these two works and *Still Life* of 1927 would reveal that *Still Life* of 1932 is rather unique among the three. Composition-wise, the wall and door frame behind the wooden table indicated that the artist aimed to depict an indoor space. The light shone from the left, and the colors of the image were very balanced and natural. Without a table cloth, the cleanliness of the table was highlighted. The vegetable was arranged in an orderly manner, and some more exquisite elements, such as a plate of loquats and a water glass, were also added. These details showed that the artist at this moment in life was not only capable of portraying his subject matter in a precise, realistic manner, but was also able to visualize an overall atmosphere of living.

The table in this painting was used by the artist's eldest brother, Dr. Liu Ching-Kang, whom Li respected as the patriarch in the family. As a painter, Li received great support from his brother. When Liu passed away due to an illness in 1930, the artist was devastated, and had to stop his learning and returned to Taiwan to take care of family business. Although still lifes are voiceless, the artist's memories of life and remembrance of his family seem to overflow from his paint brush. (YANG Chun-Hsien)

何德來 HO Te-Lai (1904-1986)
冰塊 Ice Cube

油彩、木板 Oil on panel, 27.2 x 27.2 cm, 1933
鄭世璠舊藏 Previous Collection of CHENG Shih-Fan

何德來1932年從東京美術學校西洋畫科畢業後，偕同新婚妻子秀子返回新竹，居住在北門。他滿懷理想，亟欲推動家鄉的現代美術創作與欣賞風氣。隔年他付諸行動，號召在地畫家成立新竹美術研究會，密集地舉辦公開性畫展，並開放個人畫室指導青年學子研究繪畫，本身也描繪許多新竹風土作品。不過為了專心靜養與深入研究美術創作等因素，他於1934年底再度前往日本，爾後旅居日本。1956年他返臺於臺北中山堂舉辦盛大的個展，其中《冰塊》、《老人敲鐘》讓協助辦展的後輩畫家鄭世璠甚為喜愛，展覽結束後，他贈與鄭世璠《冰塊》表達謝意。

生活中的日常物品總會吸引何德來的注視與想像，成為他筆下的創作題材。何德來如何描繪這無色無味、逐漸溶化的冰塊呢？畫中乳白色桌面上，鋁製容器內置放一個大冰塊與削冰刀，冰塊以水藍、灰白與黃色的長、短筆觸，表現塊面的量感與水滴流下的觸感。光源自右上方照射下來，對照平塗的深藍色背景，冰塊顯得光亮剔透。臺灣製冰技術從日治初期引進後，多家製冰會社相繼成立，冰塊逐漸成為人們日常的消暑聖品，一到夏天便相當暢銷，供不應求。亞熱帶臺灣的炎炎夏日，充滿生機與活力，但揮汗如雨也是人們經常的感受。何德來創作於1933年的《冰塊》，描繪夏日生活中清涼解暑的題材，正是他返家鄉期間所繪。這一年他也以野獸派的粗獷筆觸描繪新竹東區市郊景致的《夏天風景（新竹赤土崎）》，表現宛如熱浪吹拂的農村景物，同樣引人回憶與共鳴。（黃琪惠）

After Ho Te-Lai graduated from Tokyo Fine Arts School's Department of Western Painting in 1932, he returned to Hsinchu and settled down in Beimen with his newly married wife, Hideko. Full of ideal, Ho was eager to promote the creation and appreciation of modern art in his hometown. The next year, he put his idea into concrete actions by gathering together a group of local painters and establishing the Hsinchu Art Research Society. He also intensively organized public painting exhibitions, and opened his art studio to teach young students. During this period, Ho produced many works featuring the landscape and customs of Hsinchu. However, the artist moved back to Japan in 1934 for his health and to further explore art-making, and had stayed in Japan since. In 1956, he returned to Taiwan to hold a large-scale solo exhibition at Taipei's Zhongshan Hall. In the exhibition, a younger painter, Cheng Shih-Fan, who assisted Ho in organizing his solo exhibition, expressed his admiration for *Ice Cube* and *Bell-ringing Elder*; after the exhibition, Ho then gifted *Ice Cube* to Cheng to express his gratitude.

Ho's attention and imagination was always drawn to common objects in daily life, which then became his subject matter. How did the artist portray this colorless, odorless and gradually melting

ice cube? On the creamy white table was an aluminum basin containing a large block of ice cube and an ice-shaving knife. The ice cube was delineated with both short and long brushstrokes in water blue, grayish white and yellow to express the volume of the ice cube and the texture of dripping water. The light cascaded down from the upper right corner. Contrasting to the dark blue background painted with the technique of flat application, the ice cube looked bright and transparent. Since the ice-making technology was introduced into Taiwan during the Meiji period, many ice-making companies were founded, and ice cubes became an essential to dissipate the summer's heat. Every summer, ice was always very popular and highly in demand. Located in the sub-tropical region, Taiwan's summer, though very much full of life and energy, unavoidably makes people sweat. When Ho portrayed this cooling subject matter of *Ice Cube* in the summery day in 1933, he was indeed living in his hometown. In the same year, he also applied bold Fauvist brushstrokes to depict the suburbs outside Hsinchu's East District, and painted *Summer Landscape* (*Chituqi, Hsinchu*)—the painting features a rural landscape swept by hot breeze, and visualizes a scene from memory that many people resonate with. (HUANG Chi-Hui)

何德來 HO Te-Lai (1904-1986)
豆腐 Tofu

油彩、畫布 Oil on canvas, 46.0 x 53.0 cm, 1971
家屬收藏 Collection of Artist's Family

跟 我妻　是最後的晚餐了
這張畫的豆腐　思念不盡

——何德來，《私の道》

這幅安靜溫暖的小畫，實為一則具有高度私密性質的日記。畫面中，剛切好的豆腐放在盛滿清水的青花瓷碗裡，光潔的砧板上還放著刀子與棕刷，流理臺面亦被擦拭得一塵不染。畫家以其畫筆紀錄了個人生命意義重大的一刻，其中的悲劇性被包裹在日常生活的外衣底下。

1970年秋天，畫家與夫人何秀子女士外出散步，回來後秀子夫人便因發燒而入院接受治療，隔年4月才剛好轉返家，但6月時又再度入院並確診為癌症，最後於1973年離世。何德來將這段期間的心境記錄為詩文，連同《豆腐》在內的數張畫作，收錄於詩歌集《私の道》（我的路），在秀子夫人的一週年忌日出版。

何德來幼年時兩度因落水而差點結束生命，之後又因胃疾開刀，走過生死關，親眼見證二戰所造成的人心動亂，使得他很早便開始思索生死議題，曾創作出多幅以白骨為主題的作品。然而，面對與愛妻別離的痛苦，畫家選擇使用早期的寫實技法來描繪，瓷碗的花紋、豆腐與刀柄的質感、刀身上似乎映著另一幅風景，是否為兩人最後一次散步的景色？再小的環節他都極細心地一一呈現，宛如呼應著「思念不盡」的短句，將這個平凡又珍貴的時刻一再延長。即便觀者可能不了解其背後的私人脈絡，也能感到畫中的綿綿之意。

黃色在畫家的《生與死》、《常春》（1954）、《人終須一死》（1957）等作品當中，是代表希望的顏色，但也指向另一個世界。在《豆腐》當中每件事物上都泛著黃光，上方的砧板更將畫面分割為二，彷彿暗示著今生的分離。（楊淳嫻）

With my wife, this is our last supper together.
The tofu in this painting is endless remembrance.

——Ho Te-Lai, *My Way*

This small painting that exudes a feeling of quietude and warmth is a page of highly private diary. In the image, the freshly cut block of tofu was half-submerged in clear water in a blue-and-white porcelain bowl. On the clean chopping board were a knife and a coir scrub brush. The neatly wiped countertop looked immaculate. With his paint brush, the artist documented this significant moment in his life, of which the tragicness was enshrouded with the appearance of daily life.

In the fall of 1970, the painter and his wife, Hideko, went out for a walk. After they returned home, his wife spiked a fever and was eventually hospitalized. It was not until the April of the next year that she recovered and went home. However, Hideko was again hospitalized in June and later diagnosed of cancer. She passed away in 1973. The artist recorded his feelings during this period with poetry, and collected his writings and several paintings, including *Tofu*, in his poetry collection, entitled *My Way* ("私の道") which was published on the first anniversary of Hideko's death.

Ho nearly lost his life twice in his childhood when he fell into water. He had also undergone surgery for a stomach illness.

Having experienced life-threatening moments and personally witnessed the chaotic impact of war on human life, he began thinking about the issue of life and death very early on in life, and had produced several paintings featuring bones. However, when dealing the pain of forever parting with his wife, he employed realist techniques he used in the early days to delineate the ceramic bowl's pattern as well as the texture of the tofu and knife handle. The reflection on the blade seemed to reveal another landscape—could it be the last scenery the couple had seen in their last walk together? Every tiny detail was carefully painted, which echoed the expression, "endless remembrance," in his poem and indicated the hope to prolong this ordinary yet most precious moment. Viewers might not know the personal history behind the work at first, but the ever-brimming affection can be felt from the painting.

The color yellow represents hope in the artist's other works, including *Life and Death, Eternal Spring* (both painted in 1954) and *All Man Must Die* (1957); it is also the color of another world. In *Tofu*, every object seems to glisten with a yellow shine, whereas the chopping board on the top divides the image into two, seemingly implying the separation in this life time. (YANG Chun-Hsien)

張萬傳 CHANG Wan-Chuan (1909-2003)
魚・酒・水果・茶 Fish, Wine, Fruit, Tea

油彩、畫布 Oil on canvas, 45.5 x 53.0 cm, 1981
私人收藏 Private Collection

張萬傳早年以對建築風景的描繪見長，約1980年代前後，才開始大量的靜物畫創作。他曾說：「畫的東西與生活相關，才有意義。」其中又以畫魚最為著名。

魚對畫家而言，有著特別深厚的情感：是父親也是自己最愛吃的食物。至於畫魚的因緣，要追溯至1941年臺灣造型美術協會於臺南「望鄉茶室」舉辦速寫展，此為成員之一的謝國鏞（1914-1975）家裡所開設，作客的這段期間餐餐有魚，從此引發了畫家的創作慾。二二八事件發生時，張萬傳避居金山一帶，曾以捕魚維生。每日買魚，每日吃魚，先畫再吃，興起時甚至手沾醬油即席作畫，成為畫壇中津津樂道的小故事。每條魚到了畫家筆下，都能表現出自己的個性與情感。

張萬傳不僅愛吃魚，也愛喝酒。此畫以桌上那盤盛得滿滿的黃魚與規仔魚為中心，一旁還準備了洋酒、茶壺、水果等，少不了的是調味用的蒜頭、餐刀，背景則留有些許雜物增添生活感。畫面所傳遞的氣氛，就像是正等著與前來相聚的三五友人，共享一段「乎乾啦」的美好時光。粗獷的筆觸，塗抹上濃烈的顏料，以快筆刷出物體的質感與立體感，再用黑色線條做重點式的勾勒，讓畫面更增力度，此為張萬傳繪畫上的特色，充分表現出畫家豪爽的性格，與臺灣人的好客之道。（楊淳嫻）

Chang Wan-Chuan was known for his portrayal of architecture and landscape, and it was around the 1980s that he began to paint many still lifes. He once said, "the subject matter of painting should have its root in life so that it is meaningful." Among his still lifes, he was known for those featuring the motif of fish.

For the painter, fish had a sentimental significance in his life: it was his father's favorite food. The origin of having fish as his subject matter could be traced back to 1941, when the Taiwan Association of Plastic Arts presented a sketch exhibition at Tainan's Nostalgia Teahouse, which was founded by the family of Hsieh Kuo-Yung (1914-1975), one of the association member. While staying at the teahouse, fish was served in every meal, which triggered the artist's desire to paint fish. When the February 28 Incident broke out, Chang moved to a secluded place in Jinshan, and made a living as a fisherman. He would buy and eat fish every day, and would first paint the fish he bought before eating it. When feeling inspired, he would even dip his fingers in soy sauce and paint on the spot, giving the art circle many interesting anecdotes. Every fish in Chang's painting seemed to display its own character and feelings.

Chang not only loved eating fish, he was also a lover of wine. This painting has the yellow croakers and threetooth puffer at the center, surrounded with Western wine, a tea pot and some fruit. There were also garlic for seasoning and a dinner knife, whereas a few miscellaneous objects were added in the background to give the image a sense of living. The atmosphere conveyed by the painting seemed to suggest that a group of friends was expected to dine and have a good time drinking. With bold strokes and intense colors of smeared paint, the artist used fast brushwork to create the texture and three-dimensionality of the objects before outlining them with black lines to strengthen the power of the image. This approach is a distinctive feature of Chang's work, and fully displays the artist's unfettered personality as well as the hospitality of Taiwanese people. (YANG Chun-Hsien)

張義雄 CHANG Yi-Hsiung (1914-2016)
蘭嶼紀念 Scenery in Orchid Island

油彩、畫布 Oil on canvas, 80.0 x 116.5 cm, 1978
私人收藏 Private Collection

張義雄的作品當中有相當大的一部份是靜物畫，一張桌子上擺著幾只杯子，或者一張椅子上擺著瓶花等等。將他所畫的櫃子擺在玄關，便看似那裏真的有個櫃子。並不是因為畫與實景十分肖似，而是畫家似乎總能捕捉到物與物之間的無聲對話，讓他的靜物畫一點都「不安靜」，反而充滿了敘事張力。

以這幅《蘭嶼紀念》為例，構圖十分簡單，主要以放在白色襯布上的黑色大魚、陶甕、以及藍色手提袋來組成，多彩的灌木果實、白色的五爪貝、盛放魚的木盤作為點綴；然而單純明快的色彩，蘭嶼的碧海藍天與白色沙灘彷彿便在眼前。代代生活於此的達悟族是非常善用傳統生態知識（traditional ecological knowledge）的民族，生活中所使用的器物，均與當地的動植物有著緊密的連結，例如家家戶戶必備的貝灰（Mabcik），便是以畫中的五爪貝來製作。

整幅畫裡最醒目的，莫過於木盤上那尾口牙外出、全身黑鱗遍布的剝皮魚（kolitan）了，因其外皮粗糙，必須剝去魚皮方能食用。在達悟族對魚的分類當中，將這種長相兇惡的魚稱為「男人吃的魚」（rahet，意指「壞魚」），連盛裝的木盤也有所區分。

當年張義雄在延平北路上受一陌生人委託，出資請他到臺灣各地寫生風景，因而來到了蘭嶼。達悟族人自然原真的生活方式，或許讓他憶起打從少年時期的心願，便是要作一個「富野心、夢想赴遠洋捕大魚的漁夫」，在藝術的國度中盡情航行、豐收。而就在七〇年代之際，他也終於實現了遠赴巴黎的夢想。這幅畫紀念著雙重的意義，既是達悟族的傳統之歌，也唱著張義雄自己的人生之歌。（楊淳嫻）

A large portion of Chang Yi-Hsiung's oeuvre is constituted of still lifes, whether a few glasses on a table or a vase on a chair. Placing his painting of a cabinet in a house's entrance, it might look like a real cabinet is sitting there. This is not because the painting is extremely realistic but because the artist could always capture the silent dialogue between objects, which fills his still lifes with narrative tension rather than simply being "still."

Scenery in Orchid Island, for example, has a simple composition constructed with a large black fish, a pottery urn and a blue handbag, all placed on a white table cloth, embellished with bush berries, a white hippopus clam and a wooden plate to place the fish. The pure, bright colors remind viewers of the azure sea and sky of Orchid Island (Lanyu), along with its white sandy beaches. The Tao people have inhabited the island generation after generation and have a remarkable grasp of traditional ecological knowledge. The things used in their everyday life are closely associated with local flora and fauna; for instance, "mabcik" (shell powder) that can be found in every household is made of hippopus clams featured in this painting.

The most notable element in the entire painting is the buck-toothed kolitan (rough leatherjacket fish) covered with black scales. This type of fish has very coarse skin, and is only edible when the skin is removed. The Tao people classify this mean-looking fish as "the fish for men" ("rahet," meaning "bad fish"), and even has a special wooden plate for it.

Chang Yi-Hsiung was commissioned by a stranger on Yanping North Road, who financed him to sketch in around Taiwan. It was because of this commission that Chang visited Orchid Island. The

natural, primal way of the Tao people perhaps reminded him of his youthful dream, which was to be "an ambitious fisherman who dreamed to travel the distant seas and catch giant fish." In the world of art, he had indeed voyaged and reaped abundance. In the 70s, he had finally realized his dream of visiting Paris. This painting's meaning is therefore twofold: it is a tribute to the Tao tradition as well as a celebration of Chang's own life. (YANG Chun-Hsien)

廖德政 LIAO Te-Cheng (1920-2015)
紅柿 Persimmon

油彩、畫布 Oil on canvas, 50.0 x 60.5 cm, 1973-1976
南畫廊收藏 Collection of Nan Gallery

相對於文學界曾出現的「傷痕文學」，臺灣美術史上也有過一種「傷痕美術」，廖德政便是其中的代表。這幅不大的畫作，如畫家在背面自題，前後琢磨近四年時間，是以創作療癒自身的過程。「傷痕文學」用文字詳細追溯人們所遭遇的莫名迫害，敘述心靈受到摧殘以致傷痕累累的經過；廖德政並不逕直描述遭受迫害的寫實情節，而是在靜物畫上反覆抒發難以化解的憂傷與哀怨。

廖德政祖父是豐原的仕紳地主，慷慨捐輸社會公益。父親廖進平（1895-1947）追隨蔣渭水，參與臺灣民眾黨的政治活動，屢被日本警察拘留。廖德政學生時代是一位溫柔內向的文藝青年，沈醉於文學與音樂。1945年8月，他在東京美術學校就讀期間被徵調到兵工學校服役，目睹廣島原子彈爆炸的一刻。次年春天畢業返臺。1947年2月27日，天馬茶房槍聲響起時，獻身政治的父親正在隔壁開會。幾天後，家人四散逃難，畫家暗夜中翻牆至美國副領事家避難，逃過一劫；父親卻從此音訊全無。

這幅畫題材極為單純：庭院摘下的果物與陶罐。三兩串柿子連著枝葉，擺滿方形書桌，推擠到牆角的窗邊。金黃色光輝下，擁擠的桌面吸引觀者的視線巡迴俯視；一顆顆新鮮的柿子結實飽滿，兩兩成組，緊緊連結；模糊的綠色枝葉在桌上蔓延，將果實圍困，猶如纏祟不去的夢魘。笨重的陶罐延伸桌面至窗際，然而，粗重的牆柱切割、阻隔室內與室外；垂直交叉的界線造成明顯的壓迫感，畫家彷彿受困在狹隘的室內，窗外的風景遙遠而虛幻。（顏娟英）

In literature, there is a genre called "trauma literature"; in Taiwanese art history, there is also "trauma art," and Liao Te-Cheng was a representative figure in this genre. This modest-sized painting, according to the artist's inscription on the back, took almost four years to complete, which also marked a process of self-healing through creative work. "Trauma literature" traces in detail the oppression people have suffered, describing the detrimental impact on one's mind and its traumatic results. Contrarily, Liao did not give straightforward, realistic delineation of the oppression, but repeatedly blended the inconsolable grief and sorrow into still lifes.

The artist's grandfather was a local gentry in Fengyuan, who was generous and charitable. His father, Liao Ching-Ping (1895-1947), was an activist who followed Chiang Wei-Shui in political activities organized by Taiwanese People's Party, and therefore, had been detained by Japanese police several times. When the artist was a student, he was a gentle, shy literary youth immersed in literature and music. In August 1945, as a student at Tokyo Fine Arts School, he was drafted to serve in an ordnance school, during which he witnessed the explosion of the atomic bomb. After he graduated the next spring, Liao returned to Taiwan. On February 27, 1947, when the gun shots were heard at Tianma Tea House, his politically activist father was in a meeting next door. A few days later, the Liaos were forced to disperse and escape. The artist climbed over a wall at night to seek shelter in the house of the American vice consul, and dodged the subsequent calamity; his father, on the other hand, was lost and never heard of since that day.

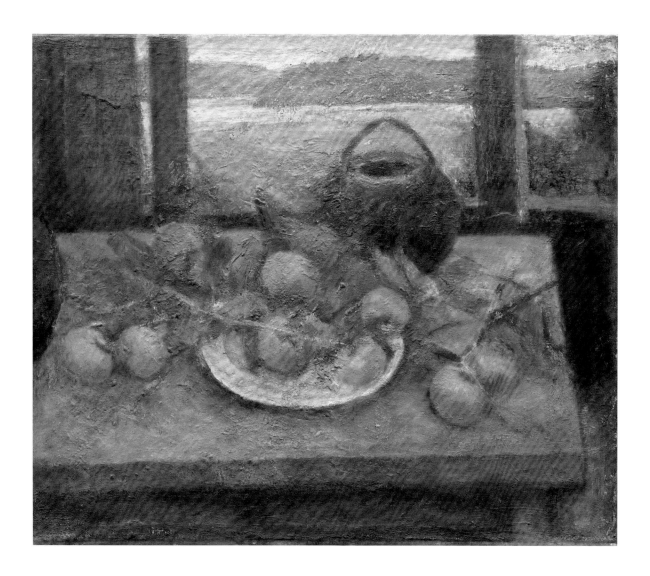

This painting depicts a rather simple theme: the fruit picked from the garden and a pottery jar. A few strings of persimmons with leaves and twigs spread across the rectangular desk tucked in a corner by the window. Under the golden light, the busy desk top captivates viewers' attention, making them peruse the image. The persimmons look fresh and full. Depicted as pairs, each persimmon is attached to another. The blurred green leaves and twigs creep around the table, surrounding the fruit like a haunting nightmare. Although the heavy-looking pottery jar connects the table top and the window, the bulky wooden post divides and separates the indoor and the outdoor spaces. The intersecting boundaries form a vivid sense of oppression, as if the artist were trapped in the crowded, narrow room as the landscape beyond the window remained distant and illusory. (YEN Chuan-Ying)

蕭如松 HSIAO Ju-Sung (1922-1992)
靜物（畫室一角） Still Life（Studio Corner）

水彩、紙 Watercolor on paper, 65.0 x 91.0 cm, 1966-1970
阿波羅畫廊收藏 Collection of Apollo Art Gallery

蕭如松於1922年生於臺北，其父親本籍為新竹州竹東郡北埔庄。查閱《臺灣總督府職員錄》與《臺灣人士鑑》可知，蕭如松的父親蕭祥安，曾任新竹新埔、北埔等公學校訓導。1918至1932年，蕭祥安皆於臺北地方法院任職通譯，後於1932年取得律師證，在臺北開業，為日治時期臺灣人出身之著名律師。曾任公學校訓導且成為律師的蕭祥安重視子女教育培養，蕭如松在父親的栽培下，於1942年自新竹師範演習科畢業後，1946年回到新竹定居並開始他終其一生的美術教師生涯。蕭如松常以生活周遭景色入畫，尤其以長年任教的竹東高中校園景致與學生群像為主題。因此雖然生長於臺北，然蕭如松更為人所知的身分，為新竹竹東畫家。

蕭如松喜愛使用冷色調的單色系作畫，呈現靜謐之感。如本幅作品中，以灰色系作為基底，深淺不同之線條與塊面表現出窗景與牆面的區別。而明暗不一的色塊，也暗示著光照的方向。右方以藍灰色描繪的色塊，與背景的灰色形成空間上的前後關係，又有如背光面所造成的陰暗效果。畫面中央至左方並列而立的玻璃盆栽，素雅簡潔，隨著光線照射表現出深淺不同的綠色，帶出畫面的韻律感；同時畫家刻意描繪出斜向葉脈，以及歪斜的玻璃杯，在充滿垂直與水平線的室內構圖中，增添活潑感。這些綠意滿盈的植物盆栽，既在冷色調的作品中，具有畫龍點睛之效，也暗示著植物是畫家在畫室中所使用的模特兒或裝飾，透露畫家的真實生活，並傳達蕭如松人如其名的樸實感。（郭懿萱）

Hsiao Ju-Sung was born in Taipei in 1922. His father was originally from Beipu Village in Hsinchu's Zhudong Township. From *Personnel Directory of Taiwan Governor-General's Office* and *Records of Taiwanese*, one could find that the artist's father Hsiao Hsiang-An had worked as a student affairs director in public schools in Hsinchu's Hsinpu and Beipu. From 1918 to 1932, he served as the interpreter office at Taipei District Court. He became a licensed attorney in 1932, started practicing in Taipei, and was a well-known Taiwanese attorney in the period of Japanese rule. Having worked as a student affairs director in public schools and then a lawyer, Hsiao Hsiang-An placed much importance on his children's education. Guided and nurtured by his father, Hsiao Ju-Sung graduated from Hsinchu Teacher's College (now National Hsinchu University of Education) in 1942, and returned to settle down in Hsinchu where he launched his career as an art teacher, a role he would come to play for his entire life. Hsiao often drew inspiration from his surrounding; in particular, he painted a lot of paintings featuring the campus Zhudong High School, where he was a teacher, and group portraits of students. Although grew up in Taipei, Hsiao was very much known as a Zhudong-based painter.

Hsiao preferred to use cold, monochromatic colors to paint and deliver a sense of tranquility. This work is a fine example. Using gray to form the foundation, the different shades of lines and planes create the distinction between the windows and the walls. Color blocks of different brightness also hint at the direction of light. The color block in blue-gray on the right and the gray area in the background form a contrast and a sense of depth; the former also looks like the dark side of an object sheltered from the light. From the center to the left of the painting, a row of plants in glasses look simple and elegant, showing different shades of green under the light and producing a sense of rhythm in the image. At the same time, the artist intentionally delineated the slant veins on the leaves and rendered the glasses askew as well, adding much liveliness to an indoor composition informed by vertical and horizontal lines. The presence of the lush plants enlivens this painting of cold-toned colors; it also suggests that these plants would have been props or decorations in the artist's studio, showing us a glimpse of Hsiao's real life while expressing his down-to-earth quality. (KUO Yi-Hsuan)

V

傳統的變革

REFORMING THE TRADITION

V

傳統的變革
REFORMING THE TRADITION

文／黃琪惠

國立臺北藝術大學美術學系兼任助理教授

Text / HUANG Chi-Hui

Adjunct Assistant Professor, Fine Arts Department, Taipei National University of the Arts

1895年臺灣從隸屬清朝的邊陲省份被迫成為日本的殖民地之後，臺灣由上而下快速地邁向現代化之路。承襲中國傳統的臺灣書畫也面臨移植的近代日本及西方美術的衝擊與影響。1927年官方舉辦臺灣美術展覽會提倡現代美術，設立的東洋畫部等同宣告寫生的東洋畫取代臨摹傳統的水墨畫，成為時代主流，傳統水墨畫承受變革與轉型的壓力。

在日本殖民政府並未設立專門美術學校的情況下，有志於繪畫者多靠自力救濟的主動方式學習。由於日本畫潮流湧入與中國來臺畫家的刺激，學習管道變得多元。除了很少數赴日進入美術學校學習者外，大多數人從臨摹畫譜開始，然後拜師請益，或前往日本、中國遊學，進入畫塾與短期學校進修，或是透過團體與展覽會方式觀摩吸收，參考美術出版物進行自我學習。臺展開辦後，他們將入選臺展東洋畫部視為創作目標，對傳統繪畫展開變革。

所謂的東洋畫，主要指日治時期移植到臺灣的近代日本畫（Nihonga），重視寫生技法與寫實的精神，又能表現細膩優雅的裝飾性特色。不過臺灣並無日本畫傳統的包袱，因此只要在寫生、寫實創作的前提下，畫家各自展現所學的背景與偏好，選擇工筆重彩或是筆墨寫意，表現臺灣的山水風景、人物與花鳥動物即可，也因此臺展的東洋畫作品具有多樣化的風格。誠如畫家林玉山回憶道：「寫生、寫實這種東西，只要你不固執，要畫到相當程度並不困難。如果你觀念固執，認為傳統的形式不可打破，繪畫在發展中就沒有新的轉變。那時候整個畫壇的風氣都偏向於寫生，不論繪畫的題材也好，畫風也好，甚至一幅畫的畫面也好，都比過去要活潑多了。」

有關臺灣東洋畫的發展，來臺日本畫家扮演關鍵性的角色，他們或傳承東洋畫或開創畫題，具有示範的作用。鄉原古統與木下靜涯長期擔任臺展東洋畫部審查員，並組織東洋畫團體，又各自指導臺灣人學習東洋畫並入選臺展。鄉原古統《藤花雙鳥》（1934，圖52）以輕柔淡雅的筆墨描寫藤花綻放、雙鳥齊鳴。《春之庭》（1937，圖53）、《夏之庭》（1937，圖54）同樣以水墨淡彩描繪庭院內花卉爭豔，細緻優雅、繽紛亮麗，流露退休後自在愉悅的心情。鄉原教導的高女學生幾乎都以花卉主題入選臺展。木下靜涯《淡水觀音山》（1930s，圖55）以水墨淡彩描繪居住地淡水的景色，沙洲人家與自然山水共生，呈現溫潤和諧、詩情畫意的氣氛。活躍於臺展的山岳畫家那須雅城，獻納給臺灣神社的《新高山之圖》（1930，圖56）則相當慎重的布局，畫面描繪主峰與東峰間初春融雪的陡峭岩壁與挺立的冷杉，

Previously a peripheral province of China's Qing dynasty, Taiwan was ceded to Japan and became a Japanese colony in 1895, and the entire island entered a rapid process of modernization in all aspects. During this process, the Taiwanese calligraphy and ink painting tradition inherited from China was challenged and influenced by the early modern Japanese and Western art that was brought to Taiwan. In 1927, the official Taiwan Fine Arts Exhibition (otherwise known as the Taiten) was launched to advocate modern art. It also established a Toyoga Division, which practically announced the replacement of Chinese ink painting that focused on the tradition of imitation with toyoga which emphasized on painting from life. As the latter became the mainstream of the time, traditional ink painting was put under tremendous pressure for reform and transformation.

Because the Japanese colonial government never founded any professional art schools, aspiring painters at the time mostly and actively relied on self-learning. As the trend of nihonga emerged and with the stimulation brought by immigrated painters from China, there were more and diverse learning channels. Apart from a handful of artists that could study in art schools in Japan, most artists began with imitating painting albums before finding teachers and mentors, travelling to Japan or China to study in private art studios and short-term schools, or observing and learning in art groups and exhibitions while teaching themselves from art publications. After the launch of the Taiten, their goal of art-making was to be selected into the Taiten's Toyoga Division, and started the reform of traditional painting.

The term "toyoga" refers to early modern nihonga (Japanese-style painting) introduced into Taiwan during the period of Japanese rule, which emphasized on the approach of painting from life and the spirit of realism while displaying delicate, elegant feature of decorativeness. However, Taiwan did not have a lineage, and therefore no burden, of traditional nihonga. Therefore, the artists only needed to conform to the prerequisite of creating realist painting from life, and could incorporate their individual background and preferences in their work. Whether colored fine brushwork or lyrical ink painting, they could freely portray Taiwanese landscapes, sceneries, figures, animals, or birds and flowers. Consequently, the toyoga paintings showcased in the Taiten demonstrated diversified style. As painter Lin Yu-Shan reminisced, "as long as one is not stubborn, it is not difficult to achieve a certain level of success in painting from life and realist painting. However, if one adhered to old concepts and insisted on following the traditional form, there will be no changes in developing painting. At that time, the entire art scene leaned towards painting from life. So, the subject, the style or even the image of a single painting has all become livelier."

Japanese expatriate painters in Taiwan played a crucial role in the development of toyoga in Taiwan. They had inherited the tradition of toyoga or reinvented the subjects of the genre, providing great examples for Taiwanese artists. Gobara Koto and Kinoshita Seigai were reviewers for Taiten's Toyoga Division for years. They also organized toyoga painting groups and instructed Taiwanese students, who were selected into the Taiten for their creations of toyoga. Koto's *Two Birds and Wisteria* (1934; fig. 52) depicts blooming wisterias and a pair of singing birds with soft, elegant ink brushwork. His *Garden of Spring* and *Garden of Summer* (both 1937; fig. 53 and fig. 54) are also painted with ink and light colors to portray beautiful blossoms in garden, which are exquisitely graceful and splendidly vibrant, expressing the artist's unfettered joy after retirement. Most of senior high school students instructed by Gobara were also selected into the Taiten with paintings of floral subjects. *Guanyin Mountain in Tamsui* (1930s; fig. 55) by Kinoshita Seigai delineates the scenery of Tamsui, where the artist once lived. The vista of co-existing sand bars, local households and natural landscape conveys a sense of warmth and harmony with a poetic, lyrical atmosphere. Mountain painter Nasu Masaki was an active figure in the Taiten. *Nitakayama* (1930; fig. 56) was his offering to the Taiwan Grand Shrine. The work shows a carefully pondered arrangement and portrays the steep cliffs

細膩的筆墨堆疊加上金、銀色點染，意圖形塑當時日本境內第一高山的雄偉壯麗與神聖莊嚴感。

臺展成立以前，尚未接受近代寫生觀念洗禮的臺灣畫家，經常在中日繪畫傳統之間折衝學習，既保留傳統的筆墨又吸收南畫與四條派的影響。世居臺南的呂璧松經營裱畫店，《赤壁夜遊圖》（1920s，圖57）這類傳統畫題在他的筆下，藉由深淺的筆墨強調景物的明暗與遠近的對比，增加臨場感與詩意氣氛。臺展開辦以後，取材眼中所見的臺灣景物寫實地表現，成為創作潮流。林玉山入選第二回臺展的《庭茂》（1928，圖58），描繪岳父家居後院的古井角落，花木繁盛、蟲鳴鳥叫，富有生活的氣息，表現其喜愛的鄉土情趣。

呂鐵州在首回臺展以傳統畫作遭挫敗後，赴京都拜日本畫家門下，從頭學習寫生技法與日本畫創作。1929年起他接連獲得臺展東洋畫特選及臺展賞，很快地成為有志於學習東洋畫者拜師的對象。《鹿圖》（c. 1933，圖59）是他指導呂孟津參選第七回臺展的示範作品。幾乎是等比例描繪梅花鹿一家三口於秋天的花木叢中，觀者宛如目睹鹿的活動生態，感受秋鹿一家出沒覓食的和樂氛圍，栩栩如生。呂鐵州與郭雪湖1934年結伴至中部北斗旅行寫生，記錄臺灣風土特色。1937年呂鐵州再次拜訪臺中家族，包括霧峰萊園林家、

神岡筱雲山莊呂家等地留下寫生稿。1939年郭雪湖更以《萊園春色》（圖60）獲得府展的推選。萊園即臺灣文化運動推動者也是其贊助人林獻堂的宅邸。郭雪湖寫實地描繪林家庭園入口、斑駁的磚牆與植栽花卉，色彩亮麗，構圖單純，整齊而氣派。隔年郭雪湖在臺陽展展出的花鳥畫作《秋江冷豔》（1940，圖61），主要描繪水柳與白腹錦雞，他回到傳統繪畫的手法，使用線條勾勒輪廓並施以色彩平塗塊面，帶有民間藝術的裝飾趣味，可見他的畫風相當寬廣多變。

戰後東洋畫家面臨國畫潮流衝擊的困境。隨著國民政府接收臺灣，中國畫家紛紛來臺，1950年代傳統水墨畫復興，臨摹風氣再起，重新定位國畫代表中華文化的典範。東洋畫家的創作卻遭指責為日本畫。擅長美人畫的陳進首當其衝，她在日本畫壇奮鬥多年的成就此時遭到無理的否定。於是她手持畫板，寫生戶外風景，參考寫生稿後，再以水墨用筆創作，回應國畫的潮流。《山中人物》（1950s，圖62）描繪家鄉新竹尖石鄉泰雅族人的生活風貌。山林以水墨皴擦點染，部落的傳統竹製建築中，有一埋首織布的泰雅族女性和守護家園的魁武勇士，描寫得仔細寫實，作為點景人物相當吸睛。同樣擅長美人畫的陳敬輝，也運用水墨淡彩描繪家鄉淡水的風景，而這幅繪寫宜蘭東澳灣的《東海邊色》（1957，圖63）中，他

and upright Taiwan white firs between Yushan's Main Peak and East Peak with melting snow in spring. With elaborately layered ink brushwork and the rendering of gold and silver dots, the artist aimed to convey the majestically sublime and austerely sacred mountain that was the highest in Japan's territory at the time.

Before the establishment of the Taiten, Taiwanese painters, who had not accepted the early modern concept of painting from life, often adopted an eclectic approach between Chinese and Japanese painting traditions, keeping characteristics of conventional ink brushwork while absorbing the influences of Nanga (Southern Painting) and the Shijo School. Growing up in Tainan, Lu Pi-Sung ran a local frame shop. When painting a traditional subject, such as *A Night Excursion in Chibi* (1920s; fig. 57), he used the contrast of ink to highlight brightness and darkness as well as the depth of the landscape, giving the image with a vivid presence and poetic atmosphere. After the launch the Taiten, painting Taiwanese landscape in a realistic way became the mainstream. Lin Yu-Shan's *Thriving Garden* (1928; fig. 58), which was selected into the 2nd Taiten, depicted an old well in a corner of his father-in-law's backyard. The lush flowers and plants, along with chirping insects and singing birds, displayed much vivacity as well as the artist's love for the local charm.

Lu Tieh-Chou was frustrated when his traditional painting did not make into the 1st Taiten. He later traveled to Kyoto and studied with a Japanese painter to learn techniques of painting from life and nihonga. In 1929, he was awarded Taiten's Special Selection Prize and the Taiten Prize in the category of toyoga, and soon became a teacher of many aspiring toyoga artists. *Deer* (c. 1933; fig. 59) was a demonstrative work when he instructed his pupil Lu Meng-Jin, who was preparing for the 7th Taiten. The almost life-size portrayal of a deer family of three in the autumn flowers and plants seems to present a lifelike image and the real ecology of deer, immersing the spectators in a joyful atmosphere when the deer family goes

out to seek for food on a crisp autumn day. In 1934, Lu Tieh-Chou and Kuo Hsueh-Hu traveled together to Beidou in central Taiwan to sketch and record Taiwanese landscape and customs. In 1937, Lu once again visited well-known families in Taichung, including the Lin family's Garden Lai in Wufeng and the Lu family's Xiaoyun Villa in Shangang; and the artist had created sketches in these places. In 1939, Kuo was selected into the Futen (Taiwan Governor-General's Office Art Exhibition) with *Spring in Garden Lai* (fig. 60). Garden Lai was the manor of Lin Hsien-Tang, who was the driving force behind Taiwan's cultural movement as well as Kuo's patron. Kuo truthfully depicted the garden's entrance, the time-worn brick walls and all the plants and flowers. With bright, vibrant colors and a simple composition, the painting looks well-ordered and impressive. Kuo Hsueh-Hu exhibited *Over the Cool Autumn Water* (1940; fig. 61) in the Tai-Yang Art Exhibition next year, which featured the subject of water willow and silver pheasant. The artist reverted back to traditional painting techniques, first delineating the outline before painting colors with the technique of flat application. The painting shows a decorative charm usually found in folk art, validating the artist's encompassive and versatile style.

After the war, toyoga painters found themselves in a conundrum caused by the wave and impact of the so-called national painting. Following the arrival of the Nationalist Government, many Chinese painters migrated to Taiwan. The 1950s witnessed the revival of traditional ink painting and the comeback of imitating masterpieces while Chinese ink painting was re-exalted to the position as the national painting that exemplified the Chinese culture. The creation of toyoga, on the other hand, was accused of being a Japanese tradition. Chen Ching, who excelled at bijinga (the Japanese tradition of paintings featuring beautiful women), found herself suffered the most impact of this change. Having endeavored in the Japanese art scene and achieved much success, her skills were incomprehensibly denied during this period. Therefore, she brought hand-held painting panels to sketch outdoors

選擇擅長的日本畫技法，再以墨色淡彩暈染，氤氳地表現出地景的特色與自然空靈的氛圍。東洋畫家即使運用水墨媒材，仍以寫生觀念創作，讓作品說話，正是回應傳統國畫臨摹潮流的最好作法。

林之助則堅持使用一貫的媒材創作，1977年提出以媒材命名的「膠彩畫」名稱，取代國族意識的畫類命名，解決省展長期的正統國畫論爭。他在題材與風格上不斷地突破創新，描繪寧靜平和的臺灣風景、活潑亮麗的花鳥畫。1950至1960年代更開拓膠彩畫表現的各種可能性，融入抽象繪畫與音樂理論，創作半抽象的《彩塘幻影》（1958，圖64）。這幅畫宛如一首韻律強烈、節奏豐富又和諧的交響曲，既是令人動容的視覺饗宴，也是臺灣畫家回應國畫潮流的另類作法。

and paint from life. Her sketches then became her references to create ink paintings. This was her response to the trend of national painting. *Figures in Mountains* (1950s; fig. 62) portrays the life of the Atayal people in Jianshi Township in the artist's hometown, Hsinchu. The painter applied the ink painting skills of wrinkling, rubbing, dotting and rendering to delineate the mountains and woods. In the traditional bamboo house in an indigenous village, an Atayal woman was weaving and a brawn warrior was guarding his family. The realistic and minute delineation indeed makes this figure and landscape rather appealing. Chen Ching-Hui was known for his bijinga as well, and he also used ink and light colors to delineate the landscape of his hometown, Tamsui. On view in this exhibition is his *Scenery of East Coast* (1957; fig. 63), which features the scenery of Yilan's Dongao Bay. He chose to paint this work with the techniques of nihonga, which he specialized in, and applied ink and light color rendering to highlight the characteristics of the landscape and its natural, ethereal ambiance. Even utilizing ink, toyoga painters could still employ the concept of painting from life to give a voice to their works, which is indeed the best way to respond to the trend of imitation underlining the tradition of national painting.

Lin Chih-Chu had insisted on using one medium to create his works. In 1977, he proposed the term "gouache painting," coined based on the creative medium, to replace naming painting genres based on national ideologies. This solved the lasting debate about the orthodox of national painting in Taiwan Provincial Fine Arts Exhibition. He had also consistently experimented with new subjects and style, creating landscapes depicting tranquil Taiwanese sceneries as well as vibrant, embellished bird-and-flower paintings. During the 1950s and the 1960s, he took a step further to expand the possibilities of gouache painting by incorporating abstract expression and music theory to create the semi-abstract *Illusions by the Pond* (1958; fig. 64). As if visualizing an intensely rhythmic, vividly melodious and superbly harmonious symphony, the painting is a moving feast for the eyes as well as an alternative response to the wave of national painting.

鄉原古統 GOBARA Koto (1887-1965)
藤花雙鳥 Two Birds and Wisteria

膠彩、絹 Gouache on silk, 133.7 x 41.6 cm, 1934
郭雪湖基金會收藏 Collection of Kuo Hsueh-Hu Foundation
題款：昭和甲戌歲春四月於臺北城東畫室寫之　原古統
Inscription: At Town's East Studio, Taipei in spring, April of 1934. Gobara Koto

明代癲狂才子畫家徐渭（1521-1593）喜歡用狂醉的筆勢畫墨筆葡萄藤；民初金石畫家吳昌碩（1844-1927）擅長用草書筆法寫出滿幅紫藤。紫藤枯乾的樹幹在紙面上左右纏繞，彎轉伸展，受文人畫家讚譽為蒼勁豪邁，富有個性。

鄉原古統的這幅絹本畫同樣以枯藤為主角，從畫面底部左半邊向上延伸，恣肆傾側左右，微風搖曳，如美人顧盼生姿。狹長畫幅刻意留下許多空白，中段冒出綠葉嫩芽，上段左側始見零星花苞，驀然間春花怒放，鳥鳴枝頭。

鄉原古統1917年抵臺，任職臺中中學校。1920年12月轉任於臺北女子高等普通學校（後改名第三高女）。創作這幅畫時，畫家與妻子及三位兒子定居在東門町，故稱工作室為城東畫室。四十七歲的他，正處於一生創作高峰期，精心構思巨幅「臺灣山海屏風」系列作（1931-1935）。這年完成的《木靈》（1934，臺北市立美術館藏，十二曲屏風），描寫臺灣高山原始森林，層疊蓊郁，震懾人心，如有靈氣。

如果說中國紫藤畫有若滄桑的老者，這幅畫中的紫藤則猶如清純少女。春寒料峭，鄉原閒靜地觀賞庭院的新氣象數日後，輕柔落筆描寫角落裡，藤花初綻，雙鳥齊鳴，設色清淡，惹人憐愛。（顏娟英）

The maverick genius painter Xu Wei (1521-1593) of China's Ming dynasty liked to paint grape vines with a style charged with wild, unbridled momentum. The bronze-and-stele style painter Wu Chang-Shuo (1844-1927) of the Republic Era exceled at drawing wisterias with cursive calligraphy. His dried-up wisteria branches twisted and turned on the paper, entangling as they bent and stretched, had earned the applause from literati painters, who praised Wu's painting as vigorous, striking and demonstrative of much individual character.

This silk painting of Gobara Koto also features dried wisteria branches of wisteria. Extending from the lower-left side from the bottom of the image and zigzagging their way upwards, gently swaying in the breeze, the wisteria looked like a beautiful woman throwing her charming glances around. The painter intentionally left a large portion of blankness in the long scroll. Green, tender sprouts appeared in the middle section, whereas a few floral buds could be seen in the upper-left section; and all of a sudden, the spring revealed itself with bursting blossoms and birds singing on the branch.

Gobara arrived in Taiwan in 1917, and taught at Taichung Middle School (now Taichung First Senior High School); in December 1920, he transferred to Taihoku Girls' High School (later renamed Taipei Third Girls' High School; now Zhongshan Girls High School). When he painted this work, the painter was living in Taipei's Dongmen (East Gate) with his wife and their three sons, for which he named his studio Town's East. At the age of forty-seven, Gobara was at the prime of his creative career, and had been conceiving the spectacular series of *Taiwanese Landscape Screen* (1931-1935). In this year, he completed *Taiwanese Landscape Screen – Spirit of the Forest* (1934; collection of Taipei Fine Arts Museum; twelve-fold screen), which portrayed Taiwan's primary forest in the high mountains and looked lush, impressive and ethereal.

If the Chinese wisteria ink paintings were like weather-beaten elders, the wisteria in this work would be a fresh and pure young maiden. In the chilly spring, Gobara leisurely admired the new atmosphere of the garden for a few days before applying his brush to gently delineate the first wisteria blossoms and the chirping couple of birds in the garden corner, creating this light-colored, endearing piece of work. (YEN Chuan-Ying)

鄉原古統 GOBARA Koto (1887-1965)
春之庭 Garden of Spring

彩墨、紙 Ink and color on paper, 170.0 x 93.0 cm (x2), 1937
臺北市立美術館典藏 Collection of Taipei Fine Arts Museum
鈐印：古統。Seal: Koto.

鄉原古統於1936年辭去臺灣的教職返日，隔年完成兩件二曲屏風《春之庭》、《夏之庭》。他長期任教臺北第三高等女學校，在課堂上教導女學生工筆寫生花卉，並發掘學生陳進，鼓勵她前往東京女子美術學校學習日本畫，是位嚴肅而溫和的美術教育者。他在第一回臺展展出《南薰綽約》，畫面布滿臺灣常見的花鳥，鳳凰木、夾竹桃、黃金雨、白鴿、臺灣藍鵲等，色彩豔麗活潑，強調南國的氣氛。他這類技法細膩寫實、色彩華麗的裝飾性畫風，啟發臺灣畫家郭雪湖等人的創作。

辭去教職的鄉原古統，回到日本福岡北部舅父家。卸下忙碌的教學與美術行政工作後，他終於可以專心創作，因此很快便開始繪製屏風畫。這時春天花草樹木開始綻放，他描繪百花齊放的花卉屏風，創作之餘也享受難得的天倫之樂。《春之庭》二曲屏風，不同於《南薰綽約》工筆重彩的寫實風格，而是以水墨淡彩描繪各種盛開的花卉，偏向寫意的筆墨韻味。迸發的木棉花、杜鵑、山茶花等花葉，前後左右交錯，布局密而不疏、雜而不亂，色彩亮麗又溫暖，觀者宛如呼吸到空氣中的花朵香氣，感受畫家生活的愉悅氣氛。（黃琪惠）

In 1936, Gobara Koto resigned his teaching position in Taiwan and returned to Japan. The next year, he completed two two-fold screens, *Garden of Spring* and *Garden of Summer*. Gobara had taught for years at Taipei Third Girls' High School. In the class, he instructed the students to paint fine-brushwork flowers and discovered Chen Chin, whom he later encouraged to study Japanese-style painting at Tokyo's Private Women's School of Fine Arts. He was a serious yet gentle art educator. In the 1st Taiten, he exhibited a triptych, titled *Graceful Blossoms from the South*. The work features common birds and flowers in Taiwan, including royal poinciana, oleander, golden shower, white pigeons and Formosan blue magpies, emphasizing the atmosphere of the southern country with vivacious, splendid colors. His exquisite, realistic techniques and extensively decorative style had inspired many Taiwanese artists, including Kuo Hsueh-Hu.

After he left the school, Gobara return to Japan and lived at his uncle's house in northern Fukuoka. Without the busy teaching and administrative work, he could finally concentrated on artistic creation and quickly began painting screens. It was the springtime when flowers were about to blossom. While painting the splendorous floral screens, he was also able to enjoy familial bliss. Different from the realist style characterized by the fine brushwork and vivid colors of *Graceful Blossoms from the South*, Gobara delineated the various blooming flowers on the two-fold screen, *Garden of Spring*, with light colors and ink, imbuing the work with the charm of lyrical ink painting. The interweaving bursts of cotton tree blossoms, azaleas and camellias are arranged in a tight but uncrowded, mixing but neat manner, whereas their colors are bright and warm. Viewers could almost smell their fragrance and perceive the joyful atmosphere of the painter's life. (HUANG Chi-Hui)

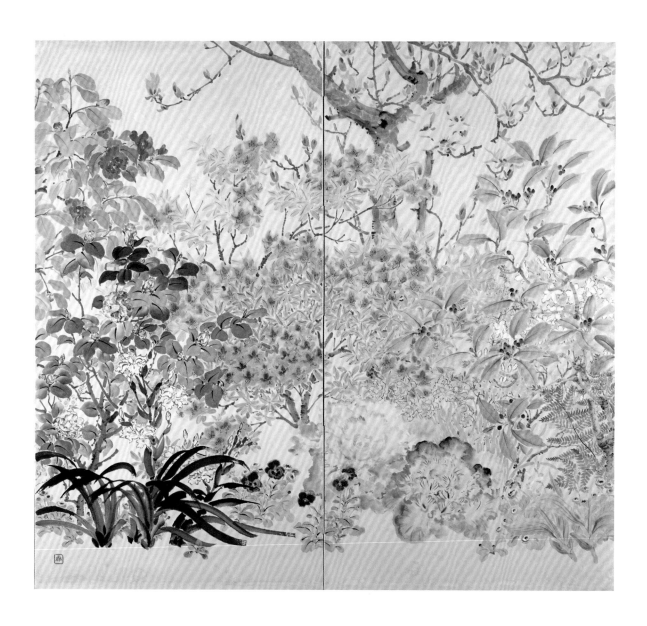

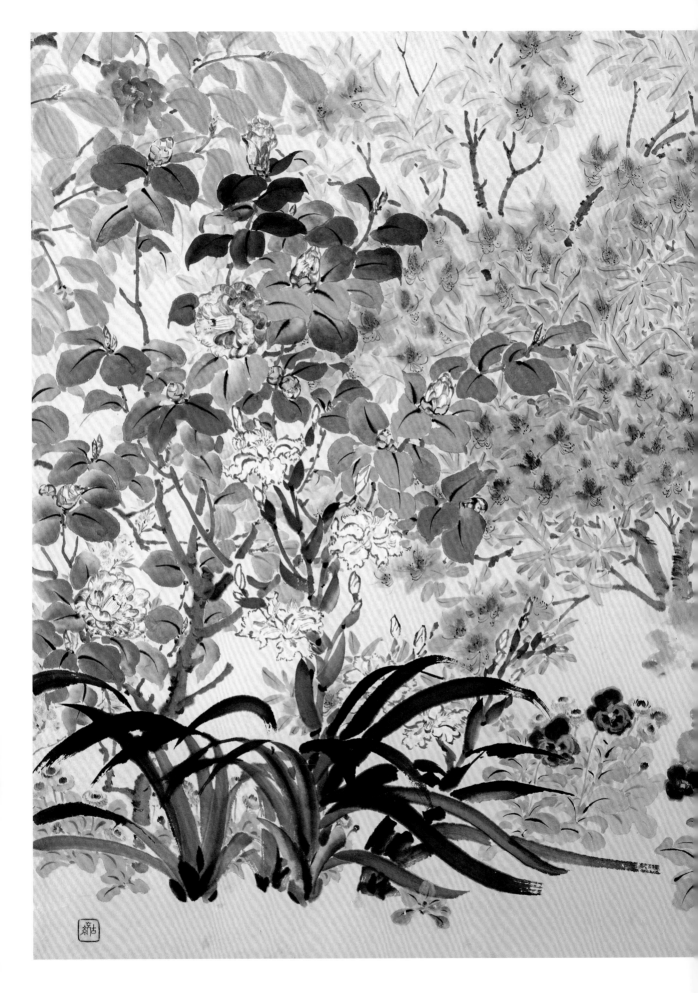

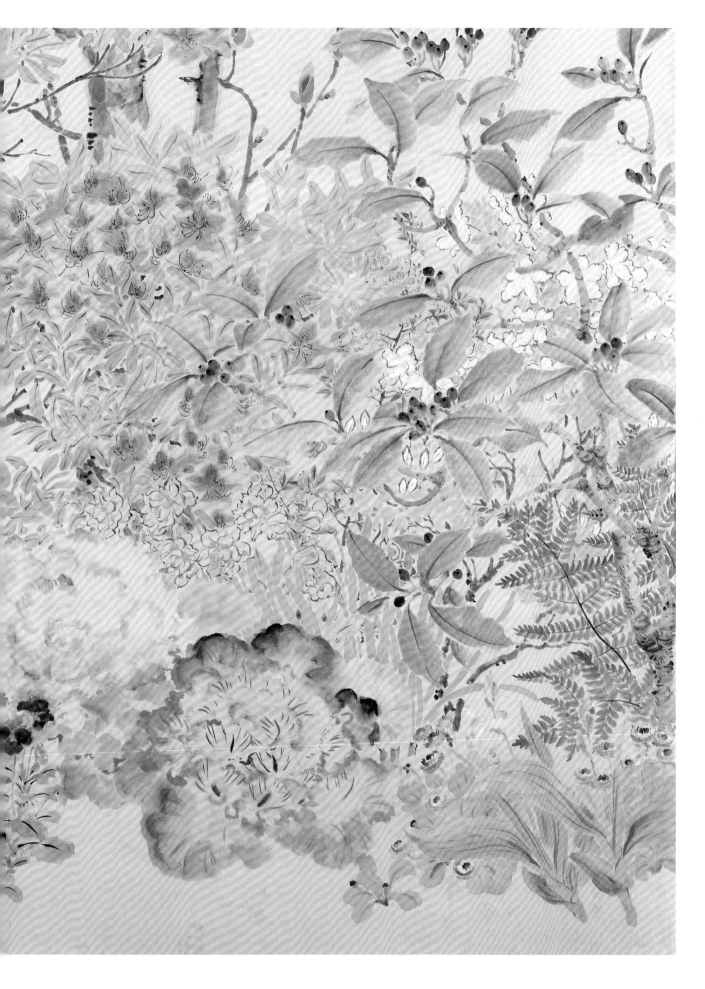

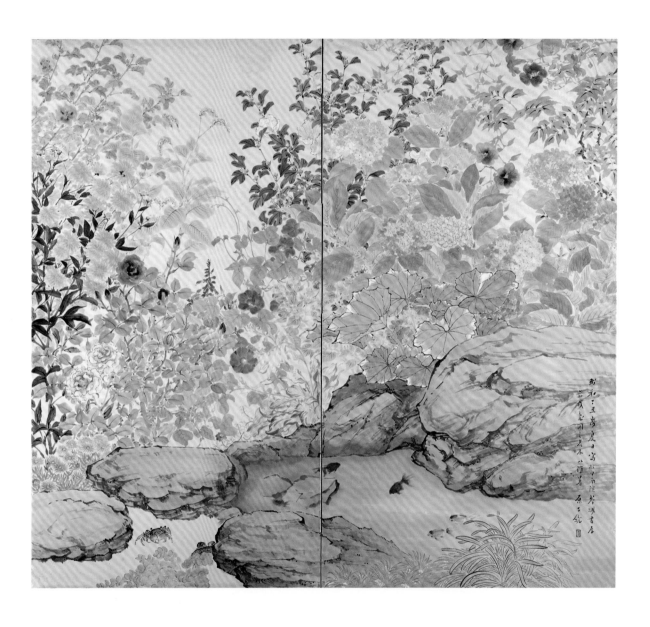

鄉原古統 GOBARA Koto (1887-1965)
夏之庭 Garden of Summer

彩墨、紙 Ink and color on paper, 170.0 x 93.0 cm (x2), 1937
臺北市立美術館典藏 Collection of Taipei Fine Arts Museum
款識：昭和丁丑歲夏日寫於甲南濱琴城書屋，前栽亂開之花木以消暑　原古統。鈐印：古統。
Inscription: At Kinjo Studio by the seaside of Kanan, the summer of 1937,
with cooling, natural flowers in the front garden. Gobara Koto. Seal: Koto.

鄉原古統完成《春之庭》後，夏天時接著畫《夏之庭》屏風，也是水墨淡彩作品，題款紀年為1937年。《夏之庭》無論畫中母題或空間層次都更為豐富，色彩淡雅繽紛。除了牽牛花、繡球花、扶桑花、菊花等植物外，前景還繪有岩石構成的水池。池中幾尾金魚悠游，甚至可見螃蟹橫走岸邊的有趣畫面，螃蟹母題或許代表著居住甲南海邊的常見景色。岩石的畫法，令人聯想到他在1935年《臺灣山海屏風》中描寫內太魯閣湍急水流中的岩石表現。

鄉原古統從1927年起共擔任九回的臺展審查員，作品除了裝飾性的花鳥畫外，最受矚目的是連續四次推出的「臺灣山海屏風」系列鉅作。他利用暑假期間作畫，以古雅的水墨技法及巨幅屏風形式，營造出天地磅礴壯闊的氣勢。秉持領導臺灣東洋畫壇的使命感，他對形塑臺灣特有的高山大海風景圖像，投注極大的熱誠。在退休返日後也將《臺灣山海屏風》帶回日本，目前已由家屬捐贈臺北市立美術館典藏。《夏之庭》屏風是在其返日後不久所繪，但題材和技法仍讓人想起畫家臺灣時期的繪畫風格。（黃琪惠）

After Gobara Koto completed *Garden of Spring*, he soon started working on *Garden of Summer* in the following summer. The screen is also a light color and ink painting, and the inscribed year is 1937. Both its motif and the layers of space in *Garden of Summer* were richer, and the work was painted with an elegant, light yet colorful palette. In addition to morning glories, hydrangeas, hibiscuses and chrysanthemums, the foreground showed a pond fringed with rocks. A few goldfishes were swimming in the pond, and a crab was walking amidst the rocks by the pond's edge. The motif of the crab perhaps indicated a common view of the Konan seaside, where the painter lived. The way Gobara delineated the rocks reminds us of the rocks in the rapid currents in *Taiwanese Landscape Screen-Taroko Gorge* painted in 1935.

Since 1927, Gobara served as a reviewer in the Taiten for nine times. Apart from the decorative bird-and-flower paintings, his most conspicusou works were the *Taiwanese Landscape Screen* series, which he presented in four different years. Using he summer vacations to paint the series, Gobara employed classical and elegant ink techniques, with the form of large-scale screen, to create the dynamic momentum of majestic, boundless nature. He had a sense of mission in heralding Taiwan's Japanese-style painting circle, and was devotedly invested in defining the image of Taiwan's distinctive landscape emblematic of high mountains and vast sea. After he retired and returned to Japan, he brought the *Taiwanese Landscape Screen* series with him. The series was later donated by the artist's family to the collection of Taipei Fine Arts Museum. *Garden of Summer* was painted shortly after Gobara settled down in Japan, and the subject matter as well as his techniques still remind us of his painting style formulated when he was in Taiwan. (HUANG Chi-Hui)

木下靜涯 KINOSHITA Seigai (1889-1988)
淡水觀音山 Guanyin Mountain in Tamsui

彩墨、紙 Ink and color on paper, 113.3 x 36.2 cm, 1930s
秋惠文庫收藏 Collection of Formosa Vintage Museum
款識：靜涯作。鈐印：靜涯子。Inscription: By Seigai. Seal: Seigai.

木下靜涯名為「世外莊」的淡水住處，位於三層厝二十六番地，現今的新北市淡水區三民街二巷二號，與當時文人洪以南（1871-1927）的住處達觀樓（今紅樓）比鄰而居。木下靜涯從這依山勢而建的洋樓，每日眺望淡水河面與觀音山，感受淡水風景陰晴雨霧的變化之美，成為他筆下創作的重要主題。

木下靜涯長期擔任臺展審查員，從第三回展出《雨後》，畫作便經常出現觀音山、帆影點點的河面、岸邊的相思樹或家屋，以水墨暈染變化表現雲霧瀰漫；溫潤、單純而甜美的理想化形象，成為他最為人熟知的淡水圖像。無論是雨過天晴的觀音山，或是從相思樹林間遠眺的淡水河，在他墨繪的畫筆下，洋溢著澹潤的詩意。

這幅《淡水觀音山》如同木下靜涯其他淡水景色作品，類似「之」字型的構圖和母題，充滿詩情畫意的氣氛。前景林投樹和佇立的鷺鷥，隔著淺沙洲與河面漁船望向前方更大的沙洲，上有花卉果樹包圍的幾戶人家；遠景則為航行水面的戎克船、煙雲繚繞的觀音山輪廓依稀可見。木下靜涯從四條派出發，寫生淡水的風景，將觀音山前常見的母題安排在山水畫的情境中，融合寫景與寫意的表現，使整幅畫面洋溢著寧靜悠閒、溫暖和諧的氛圍。（黃琪惠）

Kinoshita Seigai's residence in Tamsui, named Arcadia Villa, is located at Lot. 26 in San-Tseng-Tso, which is now the address of No. 2, Lane 2, Sanmin Street in Tamsui District, New Taipei City. Next to his residence was the mansion of the literatus, Hung I-Nan (1871-1927), and was known by the name, Da-Guan Mansion (now Red Castle). From this Western-style house built along the mountain's terrain, Kinoshita gazed at Tamsui River and Guanyin Mountain in the distance every day and observed the beauty of Tamsui's mist, rain and changeable weather, which all became important subjects in his work.

Kinoshita was a long-term reviewer in the Taiten. After he exhibited *After the Rain* in the 3rd Taiten, his painting had often depicted Guanyin Mountain, the river surface dotted with boats and Taiwan arcacia by the riverbank or houses, together with the use of ink rendering to express the enshrouding mist. Warm, pure and sweet idealized image became the most well-known image of Tamsui in his oeuvre. Whether it was Guanyin Mountain just washed by the rain or Tamsui River observed through the woods of Taiwan arcacia, the subject was always portrayed with misty, vapory poeticness in his ink painting.

Guanyin Mountain in Tamsui, like Kinoshita's other works featuring the landscape of Tamsui, shows a composition and motif in the form of the letter "Z," exuding a lyrical atmosphere. In the foreground stand screw pines and egrets, looking over some small sand bars and fishing boats and towards larger sand bars with flowers and fruit trees around a few households in the middleground. In the background, there is a junk sailing across the river, with the silhouette of Guanyin Mountain vaguely visible in mist. Kinoshita adopted the style of the Shijo School to sketch the landscape of Tamsui, incorporating common motifs around Guanyin Mountain into the landscape painting. By blending landscape delineation and freehand expression, the painting exudes a sense of leisure tranquility and a warm, harmonious atmosphere. (HUANG Chi-Hui)

那須雅城 NASU Masaki （1880s-卒年不詳）
新高山之圖 Nitakayama, the New Highest Mountain

彩墨、紙 Ink and color on paper, 183.5 x 84.0 cm, 1930
國立臺灣博物館典藏 Collection of National Taiwan Museum

那須雅城在日治初期以「豐慶」之名來臺進行環島寫生，因此對臺灣的山海地景具有實地踏查的經驗。1928年他再度來臺後即提出作品參選臺展，入選作品皆為山岳畫作。次年他在好友尾崎秀真（1874-1952）的介紹下加入臺灣山岳會，儼然成為畫壇知名的山岳畫家。來臺期間，那須雅城共奉納四幅畫給臺灣神社，其中包括這件《新高山之圖》，「新高山」即現在的玉山。戰後1950年，臺灣神社藏品移交至國立臺灣博物館典藏。

根據《臺灣神社誌》記載，1930年6月27日那須雅城以個人名義奉納《新高山之圖》給臺灣神社。《新高山之圖》尺寸相當巨大，畫中的新高山以迫近的構圖表現，氣勢極為逼人。崢嶸陡峭的深褐色岩壁，可能是主峰與東峰之間的山容，旁邊往下流動的灰白融雪，呈現新高山初春的景色，格外寫實逼真。前景濃墨勾勒出宛如金字塔狀的山岩，對照上方碎石雪坡的流動感，顯得十分穩重。不畏霜雪的臺灣冷杉挺立著，畫家以細膩的筆墨與金、銀色點染描繪，增加畫面的神聖莊嚴與神秘感，讓人產生敬畏。這幅作品與他1928至1930年入選臺展的新高山主題，無論構圖或聳立岩壁、臺灣冷杉、雲霧或融雪的描繪都非常類似。由於尚未發現那須雅城的臺展作品傳世，因此《新高山之圖》成為我們了解其山岳畫風格相當重要的作品，也是他珍貴的代表作。（黃琪惠）

At the beginning of the Japanese rule, Nasu Masaki toured around Taiwan to sketch under the name, "Toyokei." He therefore had the experience of personally visiting the mountains and coasts of Taiwan. In 1928, he once again came to Taiwan and submitted his paintings for the Taiten, which all featured mountains. The next year, his good friend Ozaki Hotsumi (1874-1952) introduced him to join the Taiwan Alpine Club, and the artist soon became a well-known painter of the mountains. During his time in Taiwan, Nasu offered four paintings to the Taiwan Grand Shrine, including *Nitakayama* on view in this exhibition. "Nitakayama" (literally the new highest mountain) is the name of Yushan during the Japanese rule. After the war, in 1950, the collection of the shrine was transferred to National Taiwan Museum.

According to *Record of Taiwan Grand Shrine*, Nasu offered *Nitakayama* to the shrine in his name on June 27, 1930. Enormous in size, the *New Highest Mountain* in the composition is depicted in an imminent way, making the mountain majestic and sublime. The steep, dark-brown cliffs are likely the view between the Main Peak and the East Peak. The gray melting snow flowing downward indicates that this is a rather realistic moment in the early spring on Nitakayama. The foreground reveals a pyramid-shaped rocky peak with thick ink, which looks stately and stable comparing to the fluidity expressed by the snow-covered debris slope. Snow-withstanding Taiwan white firs stand proudly and upright. The painter used delicate ink brushwork as well as gold and silver dots to add an austere sacredness and mysteriousness to the view, rendering the image awe-inspiring. This painting, whether its composition, the steep cliff, the Taiwan white firs, or the mist and melting snow, is very similar to Nasu's other paintings of the Nitakayama that were selected into the Taiten from 1928 to 1930. Because Nasu's other paintings showcased in the Taiten have not been found, *Nitakayama* becomes a key piece to understand the painter's mountain painting style as well as an incredibly precious masterpiece of his. (HUANG Chi-Hui)

57

呂璧松 LU Pi-Sung (1870-1931)
赤壁夜遊圖 A Night Excursion in Chibi

水墨、紙 Ink on paper, 136.5 x 53.5 cm, 1920s
寄暢園收藏 Collection of Chi Chang Yuan
款識：赤壁夜遊，呂璧松作。鈐印：呂璧松。
Inscription: A Night Excursion in Chibi, by LU Pi-Sung. Seal: LU Pi-Sung.

在臺南經營裱褙店的呂璧松，學畫歷程主要透過中日畫譜、畫冊或是圖片自我學習。他各類題材都畫，人物畫較遵循民間傳統題材，帶有民俗性的趣味描繪；花鳥畫學習日本四條派，山水畫也吸收南畫或四條派的表現。

本幅取材的典故為北宋文人蘇軾（1037-1101）被貶至黃州時，與來訪好友黃庭堅、佛印一起登舟遊江。他們行過赤壁，皓月當空，共同舉杯吟詩，談論赤壁之戰乃至於天地人生；蘇軾感慨寫下〈前赤壁賦〉，後來重遊時再撰〈後赤壁賦〉。「赤壁賦圖」從北宋喬仲常的敘事畫手卷，到明代丁玉川的舟行赤壁一景立軸，歷代畫家以赤壁賦為題作畫不乏其人，甚至流傳到日本，浮世繪畫家月岡芳年（1839-1892）也描繪此主題。

呂璧松《赤壁夜遊圖》的母題與構圖，類似月岡芳年繪製《赤壁月》的版畫，如巨大陡峭山石構成的赤壁、江面舟行的點景人物，以及天空的圓月。在描繪前景船隻行走於低水平面的湖泊，還有蘇軾與二客對坐、搖槳的船夫時，呂璧松的筆墨表現簡潔有力。左側突出的壁面與樹木，筆法勾勒直率，墨色濃淡分明，遠景則為留白的弧狀山形，對照淡墨的天空與一輪圓月，氣氛相當詩意。他以深淺對比的墨色描繪岩石、樹木，再以淡墨暈染湖面，造成類似光影的效果，加深景物深入畫面空間的錯覺。呂璧松從傳統題材出發，風格上加強明暗、遠近的對比，使景物更具真實感。（黃琪惠）

Lu Pi-Sung ran a frame shop in Tainan, and taught himself painting through learning from Chinese and Japanese painting albums, catalogues and pictures. His painted a wide range of subject matters, ranging from figurative paintings featuring traditional topics with intriguing delineation characterized by its folkness, to bird-and-flower paintings followed the style of Japan's Shijo School, to landscapes showing the influence of the Nanga (Southern Painting) or Shijo School.

This painting was inspired by the story of the North Sung literatus, Su Shi (1037-1101). When Su was relegated to Huangzhou, his good friends Huang Ting-Jian and Master Foyin visited him; together, they sailed on a barge. When the group traveled through Chibi (literally, "Red Cliff") at night, with the moon high in the sky, they toasted each other and wrote poems on the spot to discuss the battle of Chibi, life and the world. Inspired by his sentiments, Su wrote "Former Ode to the Red Cliff," and later "Latter Ode to the Red Cliff" when revisiting the place. From the narrative handscroll painting by Ciao Zhong-Chang of North Sung dynasty to the single-view vertical scroll depicting the barge sailing through Chibi by Ding Yu-Chuan of Ming dynasty, "Odes to the Red Cliff" have served as a popular topic for generations of painters. Even in Japan, ukiyo-e painter Tsukioka Yoshitoshi (1839-1892) had painted this topic.

The motif and composition of Lu Pi-Sung's *A Night Excursion in Chibi* is reminiscent of Tsukioka's print, titled *Moon of the Red Cliffs*, featuring the gigantic, steep cliff, the figures on a barge sailing through the river and the full moon in the sky. Lu's brushwork expression is succinct and powerful in terms of his depiction of the barge sailing across the low-level lake, with the figures of Su Shi, his two guests sitting across the barge and the rowing boatman in the foreground. The cliff and trees protruding from the left are delineated in a straightforward manner, with a vivid contrast of ink shades. In the distance, the mountain-shaped blankness with the backdrop of the sky rendered with light ink and a full, bright moon delivers a vividly poetic scene. Lu portrayed the rocky cliff and trees with a contrast of ink colors, and painted the lake surface with light ink to produce the effect of glistening moonlight and deepen the perception of depth in the image. The painter took a traditional subject and added stylized contrast of light and shadow as well as a clear sense of depth to bring the depicted scene to life. (HUANG Chi-Hui)

赤壁夜遊 呂應和作

林玉山 LIN Yu-Shan (1907-2004)
庭茂 Thriving Garden

膠彩、紙 Gouache on paper, 144.0 x 88.0 cm, 1928
私人收藏 Private Collection
鈐印：林英貴印。玉山。Seal: Lin Ying-Gui; Yu-Shan

19 27年林玉山以《水牛》、《大南門》入選第一回臺展東洋畫部，在畫壇嶄露頭角，隔年成家後並不斷構想準備參選第二回臺展的題材。林玉山經常到嘉義市南郊的岳父家走動，他觀察到籬笆院子內花木繁盛，有口古井，婦女在古井旁洗刷餐具後留下的剩米殘粒，總會吸引麻雀飛來啄食。他覺得這樣的生活場景富有親切的鄉土情趣，而決定構思此畫，作為參選臺展的主題。結果這幅《庭茂》順利入選第二回臺展，作品再次受到審查員的肯定，證明自己的繪畫實力。

畫中古井上置放繫繩的汲水桶，兩隻麻雀佇立覓食，與從樹木上方往下望的麻雀互相對視。麻雀、古井、水桶、繩索構成畫面的中軸線，使構圖十分穩定，又具動態的生命氣息。右邊竹叢前的挺拔樹木向左伸展至上方邊緣，與左邊古井周遭的美人蕉等花卉連成一氣。花木扶疏、枝葉茂密，充滿綠意盎然的生機。林玉山意圖表現庭院蔥鬱的花木，景物或許稍嫌繁雜，但他對物象的前後關係處理，層次分明，也相當自然生動。鑿井取水，是在近代自來水設施普遍供應以前，最常使用的民生設備，畫中水桶與旁邊地面的濕潤水漬，顯示打水使用過的痕跡。林玉山以畫家之眼，取材日常生活的角落，整體以褐、綠色調為主，洋溢著古樸溫暖的氣氛，引人共鳴。（黃琪惠）

In 1927, Lin Yu-Shan's *Water Buffalo* and *South Gate* were selected by the Toyoga (Japanese-style painting) Division of the 1st Taiten, and the artist became known in the art scene. The next year, after he got married, he continued searching for topics to participate in the 2nd Taiten. The artist had often visited his father-in-law who lived in the southern outskirt of Chiayi City. There, he observed the fenced yard with thriving plants and flowers. In the yard was an old well, where women would wash and scrub eating utensils, and residue of rice could be found by the well. So, there were often sparrows looking for food in the yard. For the artist, such an everyday scene brimmed with relatable local charm, and he decided to paint the scene as his next work for the Taiten. *Thriving Garden* was indeed accepted by the 2nd Taiten as the artist had hoped. Having his work acknowledged by the reviewers, the painter had once again proven his skills and talents.

In this painting, a bucket tied with rope for fetching water was placed on the well. Two sparrows perched on it, seeking food and looking at another sparrow in the tree that was gazing downward. The sparrows, well, bucket and rope formed the central axis of the image, making the composition stable and displaying a dynamic liveliness. The tall tree on the right and in front of the bamboos stretched towards the upper-left side of the painting, and connected to the canna lilies next to the well on the left. The flourishing flowers and plants with lush leaves filled the garden with overflowing vitality. Lin aimed to portray the luxuriant greenery of the garden. Although the scene might be a bit disorderly, but the way he handled the relative distance of the objects in the painting showed clear layers in a very natural manner. Fetching water from a well was a common practice before tap water became available in the early modern period; and well was a frequently used everyday facility. In this painting, the bucket and the wet ground indicated that someone had just fetched water here. With a painter's eye, Lin drew his material from a corner in the everyday life. The painting is predominantly in brown and green tones, which gives the overall image a down-to-earth, warm atmosphere that resonates with the viewer. (HUANG Chi-Hui)

呂鐵州 LU Tieh-Chou (1899-1942)
鹿圖 Deer

膠彩、紙 Gouache on paper, 145.0 x 231.0cm, c. 1933
私人收藏 Private Collection
鈐印：鐵州。款識：深州修補。鈐印：深州
Seal: Tieh-Chou. Inscription: Repaired by Shen-Chou. Seal: Shen-Chou

呂鐵州於1930年自日本京都學畫返臺後，作品接連在臺展東洋畫部榮獲特選及臺展賞，顯示他從傳統水墨畫家轉型為現代東洋畫家的身分。1932年他開始向登門求教者傳授東洋畫，1935年更成立南溟繪畫研究所正式授課，入室弟子來自中北部，包括入選臺展的呂汝濤、呂孟津、余德煌、林雪州、許深州、陳宜讓、游本鄂、黃華州、廖立芳、羅訪梅、蘇淇祥等人。其中許深州（1918-2005）持續創作，活躍於戰後畫壇。呂鐵州的臺展畫作皆為花鳥與風景畫，其弟子也以花鳥畫創作為主。他取材臺灣常見的鳥類和花木，細緻寫實地描繪，色彩鮮麗，呈現華麗而優雅的風格。

呂鐵州現存作品中描繪動物題材者相當少見，這件《鹿圖》的再發現，有助於我們認識他多元的創作題材與風格。畫中梅花鹿一家置身花草叢中，周遭蓖麻、芒草、楓葉、月桃及蕨類植物相互交錯，紛雜而不亂，空間的處理層次分明。公鹿注視前方，眼神警覺明亮，低頭吃草的母鹿哺育著小鹿，體態神情同樣自然生動，充滿生命力。一家三鹿也象徵家庭和樂的意味。背景中墨色暈染的霧氣，交錯的淺赭色楓葉與芒草，散發秋天時節的氛圍。

呂孟津・《鹿》・1933年・第七回臺展入選作品

這件作品曾由其弟子許深州進行修補，包括再著色與添加金箔，讓畫面展現出原本亮麗的生機。許深州留下題款，並認為此應為老師指導呂孟津參選臺展時的示範之作。呂孟津於1933年以《鹿》入選第七回臺展，該畫即摹仿其師呂鐵州的作品。從臺展黑白圖版看來，呂孟津如實地模寫，僅減省花卉植物的母題，鹿的姿態也稍有不同，略顯僵硬。相較之下，呂鐵州更能掌握寫實描繪的技法，並表現日本畫特有的詩意氣氛。本件作品一直為豐原神岡三角仔呂家收藏，後來輾轉入臺中私人收藏至今，可謂十分珍貴。（黃琪惠）

Lu Tieh-Chou returned to Taiwan after finishing his learning of painting in Kyoto, Japan in 1930. His works were then subsequently awarded the Special Selection Prize and the Taiten Prize in Taiten's Toyoga (Japanese-style painting) Division, indicating his transitioning from a traditional ink painter to a modern toyoga painter. In 1932, he began accepting pupils that wanted to learn toyoga, and in 1935, founded Nanming Painting Studio and began officially giving painting lessons. Lu's protégés mainly came from central and northern Taiwan. Those who had been featured in the Taiten exhibitions included Lu Ju-Tau, Lu Meng-Jin, Yu De-Huang, Lin Hsueh-Chou, Hsu Shen-Chou, Chen Yi-Jang, You Pen-E, Huang Hua-Chou, Liao Li-Fang, Luo Fang-Mei and Su Chi-Hsiang. Among them, Hsu Shen-Chou (1918-2005) had continued a career as an artist, and had been active in the post-war art scene. Lu's paintings featured in the Taiten were all bird-and-flower paintings and landscapes, and his

pupils also mainly painted bird-and-flower paintings. He drew his material from common avian species and flora in Taiwan, delineating them with minute details and vibrant colors, creating a distinctively luxurious and elegant style.

Lu's existing works depicting the topic of animals are very few. The rediscovery of *Deer* helps us to grasp his diverse subject and style. In the painting, the family of sika deer was surrounded by flowers and plants. The castor oil plant, reed, maple, shell ginger and ferns were mixed, making the scene rich but not busy; the layer of space was handled rather clearly. The buck stared at the front with bright, vigilant eyes, whereas the doe nursing a fawn was feeding on grass. All of them were depicted in a natural, vivid way that gave the image a sense of vitality. The family of three also symbolized familial joy and harmony. Mist painted with rendered ink, intermixed with light brown maple leaves and reeds in the background, conveyed the crispness of autumn.

This painting was repaired by Hsu Shen-Chou, who re-colored the painting and added gold leaf to restore the liveliness of the painting. Hsu also inscribed on the painting, and believed that this work was created by his teacher for instructing Lu Meng-Jin, who was preparing to join the Taiten. The latter was indeed selected into the 7th Taiten later with his work, *Deer*, which imitated his teacher's painting. Judging from the black-and-white plate of the Taiten, the student had followed his teacher's work truthfully, leaving out only the flowers and plants while changing the poses of the deer, which were somehow depicted with slight stiffness. In comparison, Lu Tieh-Chou had mastered the realist techniques and conveyed the unique poeticness of nihonga. This work had been in the collection of the well-known Lu family in Shangang's Sanjiaozai in Fengyuan, and was later acquired by a private collector in Taichung and has remained in the same collection. It is indeed a precious work. (HUANG Chi-Hui)

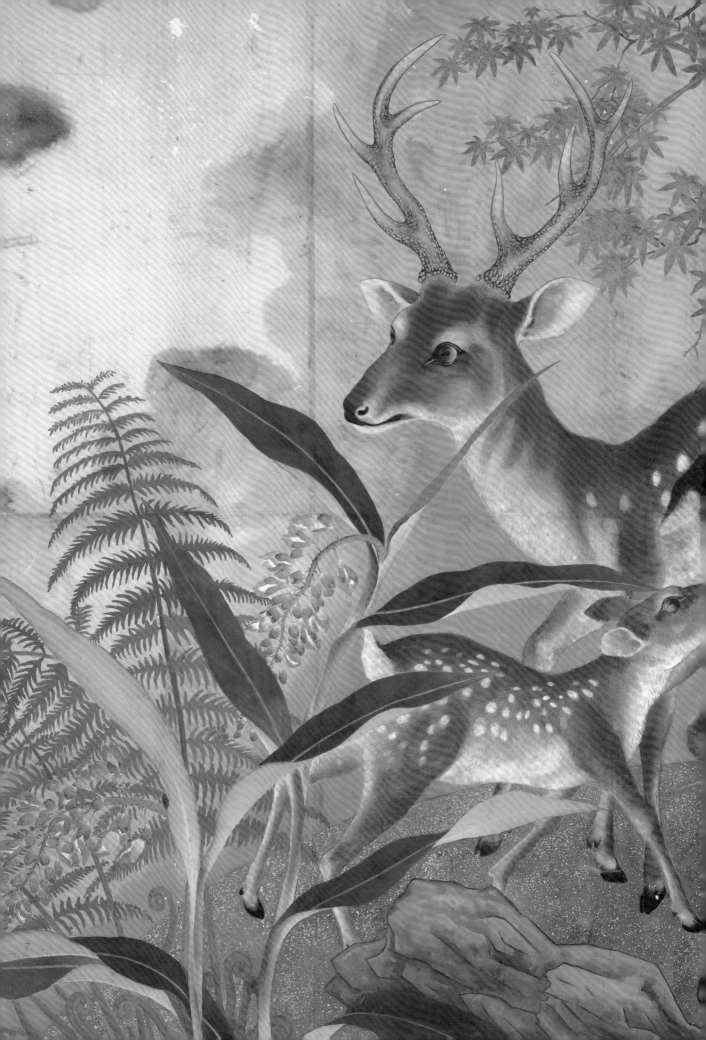

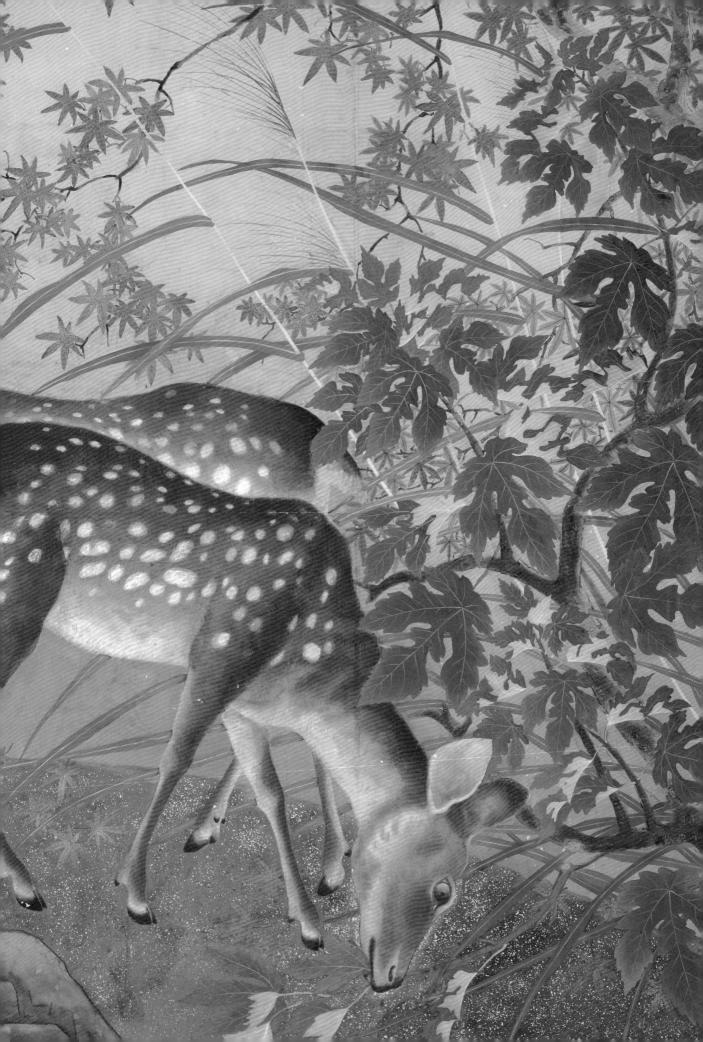

郭雪湖 KUO Hsueh-Hu (1908-2012)
莱園春色 Spring in the Garden Lai

膠彩、紙 Gouache on paper, 220.5 x 147.0 cm, 1939
國立臺灣美術館典藏 Collection of National Taiwan Museum of Fine Arts

這幅作品色彩亮麗，構圖單純，整齊而氣派；從標題可知是霧峰林家的庭園入口。近景一片花團錦簇，花圃栽植金黃色的美人蕉，方形池塘漂浮著睡蓮，水仙花沿牆盛開，左側牆邊還有一叢仙人掌。藍天綠地的背景中，不規則的石板路引導觀眾來到重層屋頂下緊閉的黑木門與紅磚牆。畫家在厚質地的紙上，皴擦出圍牆斑駁的歲月痕跡。紅色磚牆散發出熱情洋溢的效果；黑色門板上裝飾著藍色蟠龍鋪首，格外活潑。圍牆後方盛開的白梅樹老幹盤曲交錯，生氣昂揚；高聳天際的棕櫚樹象徵主人家崇高無比的地位。

宅邸主人林獻堂是日治時期民間的精神領袖，也是臺灣文化運動的推動者；他愛護後輩，資助年輕人留學費用，也贊助過許多藝術家。根據林獻堂日記，1934年郭雪湖在臺中市圖書館舉行個展時，曾特地邀請他前往參觀。林獻堂不但履約，更購藏一幅作品。隔年畫家再次造訪林家，盤桓多日，在附近農村寫生（文獻，頁278-283）。

郭雪湖十九歲入選臺展，多次獲得特選；他奮力投入創作，在圖書館、展覽會場臨摹研究，同時到處旅行寫生，記錄臺灣風土特色。《莱園春色》獲得府展該年度「推選」最高榮譽。畫家創作需要贊助者的支持，可惜戰爭後期的局勢艱難，莱園主人已無心力收藏畫作，改為資助畫家旅行廣東。畫家及其家屬長期用心保存此畫，為我們見證了在此艱困的年代，贊助者與創作人之間無私的共同努力。（顏娟英）

With bright colors and a simple composition, this painting looks rather orderly and grand. From the title, it is clear that the painting depicts the garden entrance of the Lin family mansion and garden in Wufeng. In the splendid foreground is a patch of golden canna lilies, and waterlilies are blooming in the rectangular pond, whereas daffodils along the wall are in blossom. Under the wall to the left, there is a cactus. Against the background of blue sky and green meadow, an irregular path paved with stone slabs leads the spectator's line of vision to the closed black wooden doors and redbrick walls under the multilayered roof. On the thick paper, the artist painted the time-honored traces of the walls with the technique of wrinkling and rubbing. The redbrick walls create a feeling of liveliness. The black door panels are joined with a blue dragon head applique, displaying a rather vivacious air. Behind the walls, the ancient trunks of white plum trees dotted with blossoms intertwine, exuding great vitality. The sky-reaching palm tree symbolizes the mansion owner's esteemed social status.

The mansion belonged to Lin Hsien-Tang, who was a civil leader during the period of Japanese rule as well as the driving force behind Taiwan's cultural movement. Lin supported young intellectuals greatly. He had financed many youths' expenses for studying abroad and many artists. According to Lin's diary, when Kuo Hsueh-Hu held his solo exhibition at the Taichung Municipal Library, the artist had especially invited him. Lin not only went to the exhibition, but also acquired a painting. The next year, Kuo revisited the Lin family mansion, where he stayed for days and painted from life in the nearby village (Documents, pp. 278-283).

Kuo was selected into the Taiten for the first time at the age of nineteen, and had won the Special Selection Prize multiple times. He devoted himself to painting, imitating and studying other artists' works in library and exhibitions while travelling to different places to paint and record Taiwanese landscape. *Spring in the Garden Lai* was awarded the Recommendation Prize, the highest honor in the year's Futen (Taiwan Governor-General's Office Art Exhibition). Artists need support of patrons. Sadly, the owner of Garden Lai was not able to collect paintings anymore due to the difficult situation in the late period of the war. Instead, he financed the artist to travel through Guangdong. The artist and his family have endeavored in preserving this painting, which provided us a remarkable piece of evidence to prove the selfless and collaborative efforts between a patron and an artist during the trying time. (YEN Chuan-Ying)

郭雪湖 KUO Hsueh-Hu (1908-2012)
秋江冷豔 Over the Cool Autumn Water

彩墨、紙 Ink and color on paper, 152.0 x 225.0 cm, 1940
國立臺灣美術館典藏 Collection of National Taiwan Museum of Fine Arts

郭雪湖出身大稻埕裱畫店，學畫熱情強烈且虛心求教，又善用各種藝術資源，因而轉益多師，不斷地精進。他先後學習中國、西洋與日本的繪畫風格，然後自由地融會貫通。1940年臺陽美術協會增設東洋畫部，郭雪湖提出《秋江冷豔》參展，此作與他去年入選府展的《萊園春色》著重鮮麗重彩的細密寫實風格，迥然不同。《秋江冷豔》是由四連屏組成整幅的花鳥畫，主要描繪水柳、銀雞、雞屎藤及牡丹花等母題，以深褐、墨綠與赭紅色調為主，顯得古樸典雅。畫風採線條勾勒輪廓並施以色彩平塗塊面，富有民間傳統繪畫的裝飾性趣味，可見他的畫風相當寬廣多變。

此畫主要由水柳枝幹呈弧形跨越四幅立軸構成。水柳生長在水邊，為臺灣原生種，落葉性中喬木，樹皮呈灰褐色，枝幹有明顯的縱裂紋，葉面綠色有光澤，葉背為粉白色。畫家如實地描繪，掌握水柳的特徵並加以誇大，強調枝幹戲劇性折曲的張力。樹葉隨風吹動的翻飛，與附生的雞屎藤花交錯纏繞，右下方盛開的牡丹花，與銀雞位置相互呼應。郭雪湖寫實地描繪水柳與錦雞，不過並非傳達其生長的自然生態，而是因應創作意念與畫面的需要而安排。雞屎藤、白腹錦雞與牡丹花的搭配，是畫家刻意的組合，使畫面增添富貴與喜氣。《秋江冷豔》四連屏長期懸掛於郭雪湖的畫室，陪伴他度過漫長的創作時光，可見這是畫家相當鍾愛的作品。（黃琪惠）

Kuo Hsueh-Hu grew up in a frame shop in Dadaocheng. He was fiercely passionate about painting and was humble in learning. He was also good at using various art resource that enabled him to learn from different artists to consistently improve himself. He had mastered Chinese, Western and Japanese painting styles and could freely combine them to create one that was his own. In 1940, the Tai-Yang Art Association established its toyoga division, and Kuo submitted *Over the Cool Autumn Water* to participate in the exhibition. This painting was completely different from *Spring in the Garden Lai*, which was selected into the Futen the year before and displayed vibrant colors and a refined, realistic style. *Over the Cool Autumn Water* is a bird-and-flower quadriptych and features the motifs of water willow, silver pheasant, Chinese fever vine and peony painted in a palette predominantly constituting of dark brown, dark green and vermillion, giving the painting an archaic and elegant feel. The artist first outlined the contour of the objects and used flat application to color the planes, which produced a decorative charm often found in traditional folk painting. From this painting, it is clear that Kuo's painting style is indeed versatile.

This work comprises four vertical scrolls connected by an overarching water willow branch. Water willow, an endemic tree species in Taiwan, grows by the water and is a type of deciduous tree with taupe bark and rather noticeable cracks along its branches. The leaves are green and shiny, with a powder white back. The artist truthfully delineated these details, fully capturing the features of water willow and exaggerating them to emphasize the dramatic force of twist displayed by the branch. The swaying leaves in the wind entangled with the Chinese fever vines, whereas the blooming peonies at the lower-right corner echoed the silver pheasant. Kuo portrayed the water willow and the silver pheasant in a realistic manner not to show the natural environment of the flora and fauna but to convey his artistic concept and the need of the composition. The combination of the Chinese fever vines, the silver pheasant and the peonies is a design to enrich the painting with a sense of prosperity and happiness. The quadriptych of *Over the Cool Autumn Water* had been mounted on the wall of Kuo's art studio and accompanied him throughout years of creative work, indicating that the work was much cherished by the artist. (HUANG Chi-Hui)

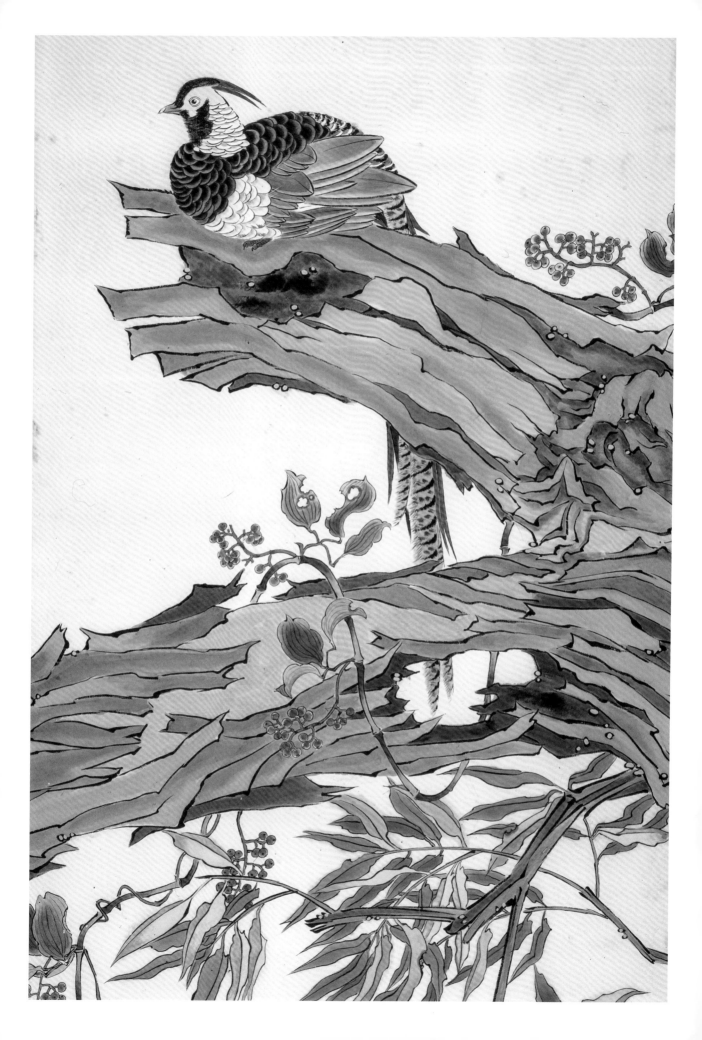

陳進 CHEN Chin (1907-1998)
山中人物 Figures in Mountains

彩墨、紙 Ink and color on paper, 44.0 x 51.0 cm, 1950s
私人收藏 Private Collection

畫家未滿十八歲便前往東京，留學女子美術學校，學習日本畫將近二十年，她不但大量吸收、臨摹老師傳授的新舊美人畫傳統畫法，更積極汲取西方現代美術典範，絕不落人後，故而多次入選重要日本官方展覽，並曾榮膺臺灣展覽審查員。

1945年日本戰敗，她意識到護持她多年的雙親年華老去，遂決定返鄉定居。戰後政局快速變化，隨著國民政府來臺，五〇年代傳統水墨畫復興，重新定位為「國畫」，代表中華文化的典範。陳進在日本畫壇辛苦經營的成果，此時面臨無情的挑戰、否定，甚至羞辱，被指為殖民地奴化政策的表現。正式展覽會上，陳進擅長的美人畫風已然銷聲匿跡，但是她並沒有放棄創作，改為手持畫板戶外風景寫生，回家後參考畫稿，以水墨用筆在紙上揮灑皴擦。

這幅畫是五〇年代畫家用心製作的水墨作品，描寫故居附近新竹尖石鄉的山地風貌，同時也是泰雅族人生活的忠實觀察。山坳裡簡單俐落的傳統部落建築，取自竹林，形成自然的生態景觀。清晨寒氣中，老樹光禿的枝幹在風中飄搖，屋內女人埋頭織布；織布讓家人溫暖，高超的技巧還能贏得族人尊敬。一旁側面的屋內，男人站立在窗邊露出魁梧的上半身，有如守護家園的勇士。這幅畫記錄原住民部落文化與自然的和諧，也描寫家庭安全的可貴，更流露出畫家內心堅持創作價值的深刻感觸。（顏娟英）

The artist went to Japan before she was eighteen years old, and studied at Private Women's School of Fine Arts. Throughout nearly twenty years of studying nihonga in Japan, Chen Chin not only extensively absorbed and imitated the traditional and new painting techniques of bijinga (painting of beautiful women), but also actively studied exemplars of Western modern art, working more diligently than others. She had been featured in prestigious Japanese official art exhibitions multiple times, and was appointed a reviewer for art exhibitions in Taiwan.

After Japan surrendered in the war in 1945, she realized that her aging parents required her care and decided to return to Taiwan. The post-war political scene changed drastically after the Nationalist Government arrived in Taiwan, and traditional ink painting was revived in the 50s and was valued and re-positioned as "national painting" that embodied the Chinese culture. Chen's achievements in nihonga, which she had strived to attain, were cruelly challenged, denied, even humiliated and accused as the result of enslavement policy implemented in the colonies. In official art exhibitions, the genre of bijinga that Chen specialized in had disappeared completely. Nevertheless, the artist did not give up on painting, and shifted her focus to making sketches outdoors by drawing on handheld panels, which would later become her drafts for creating ink paintings on paper back home.

This ink painting was painstakingly created by the artist in the 50s, which depicted the mountain landscape in Hsinchu's Jianshi Township near the artist's home; it also reflected the artist's truthful observation of the life of the Atayal people. The simple, clean-cut traditional architecture in the village located in the col was made of bamboo, forming a natural landscape. In the morning coldness, branches of bare trees quivered in the wind. Inside the house, a woman was weaving, making cloth that could keep the family warm while earning the community's respect for her superb skills. In another part of the house, a man showing his naked upper body was standing by the window, guarding his home like a warrior. The painting recorded the harmony between the indigenous culture and nature as well as portrayed the valuableness of a safe home. Moreover, it spoke the artist's feeling of insisting on the value of artistic creation. (YEN Chuan-Ying)

陳敬輝 CHEN Jing-Hui (1911-1968)
東海邊色 Scenery of East Coast

膠彩、絹 Gouache on silk, 54.3 x 76.1 cm, 1957
長流美術館收藏 Collection of Chan Liu Art Museum
款識：丁酉十一月，敬輝。鈐印：敬輝。
Inscription: Jing-Hui, November 1957. Seal: Jing-Hui

陳敬輝1957年創作此幅宛如仙境、夢幻般的山水，描繪的其實是宜蘭東澳灣。東澳灣北起烏巖角，南至烏石鼻，全長約兩公里，沿途崖岸險隘。海灣狀似凹形港澳，如新月般弧線優美，為沙灘與礁岩互相組合而成的海岸。東澳灣最南端的粉鳥林漁港，風光明媚，宛如遺世獨立的「天涯海角」，充滿寧靜與純樸之美。若要觀賞整個壯麗的東澳灣，最佳地點是烏巖角上方的蘇花公路轉彎處，面向海洋，鳥瞰海灣，蔚藍海水與青翠山脈，構成一幅山連水、水連天的美景。此外，東澳灣的腹地是由東澳溪沖積而成的三角洲，夾於兩座青山之間，原本是原住民泰雅族的小村落。參差不齊的住屋散布在山坳裡，與山花野草、碧水藍天、青巒疊嶂，交織成一幅天然的畫面。陳敬輝也站在類似的觀看角度寫生。

陳敬輝1932年從京都市立繪畫專門學校畢業返臺後，擔任淡水女學校及淡水中學教師，活躍於臺展而成為知名的東洋畫家。戰後他長期擔任省展國畫部審查員，在正統國畫論爭之下學習中國畫傳統，臨摹唐寅（明代唐寅）等人的山水畫作，也運用水墨描繪淡水風景。而這幅《東海邊色》，他回到擅長的日本畫技法描繪。畫幅以赭黃為基調，運用墨色濃淡暈染表現山體與稜線，山間隱約可見村舍聚落。青綠色彩描繪湛藍的海灣以及點綴的白色浪花，表現地景特色與自然空靈的氛圍。這幅畫可能是他擔任第十二屆省展審查員時參展的作品。（黃琪惠）

This ethereal, dream-like landscape was created by Chen Jing-Hui in 1957. The painting depicted Yilan's Dongao Bay, which begins from Wuyenjiao in the north and extends to Wushibi in the south for about two kilometers, with steep cliffs along the coast. The bay looks like a beautiful crescent-shaped harbor and has a mixture of sandy beaches and reef rocks. In its southernmost point lies Fenniaolin Fishing Harbor, which is known for its enchanting scenery – a natural, serene, untainted gem isolated from the rest of the world. The best place to see the magnificent Dongao Bay is from a turn on Suhua Highway above Wuyenjiao, which faces towards the ocean and overlooks the bay. The azure water and emerald mountains constitute an impressive vista of interconnecting mountains, ocean and sky. In addition, the land of Dongao Bay is an alluvial delta formed by Dongao River. In between two mountains was an Atayal village. Various houses scattered in the valley, the blue water and sky as well as the rolling mountain ranges produce a natural landscape decorated with mountain flowers. When painting this work, the artist had adopted a similar perspective.

Chen graduated from Kyoto City Technical School of Painting in 1932 and returned to Taiwan. He began teaching at Tamsui Girls' High School and Tamsui High School. He was also active in the Taiten and became a well-known toyoga painter. After the war, he had served as a reviewer for the National Painting Division in the Taiwan Provincial Fine Arts Exhibition. During the debate about orthodox national painting, he had studied traditional Chinese painting, imitating ink landscape by art masters, such as Tang Yin (1470-1524) while creating ink painting depicting the landscape of Tamsui. To paint *Scenery of East Coast*, the artist used the techniques of nihonga that he had mastered. The artist used ochre as the base of the work, and applied the technique of ink rendering to delineate the mountains and the ridge lines. Amidst the mountains were clusters of houses. The azure bay was painted with green and dotted with white waves, expressing the features of the landscape and its ethereal ambience. It is likely that this work was showcased in the 12th Taiwan Provincial Fine Arts Exhibition, in which Chen served as a reviewer. (HUANG Chi-Hui)

林之助 LIN Chih-Chu (1917-2008)
彩塘幻影 Illusions by the Pond

膠彩、紙 Gouache on paper, 118.0 x 78.0 cm, 1958
國立臺灣美術館典藏 Collection of National Taiwan Museum of Fine Arts

林之助戰後任教於臺中師範學校並長期擔任省展的審查員，他與其他省展國畫部的臺灣畫家一樣，面臨作品被質疑是否為國畫的壓力；1977年他提出膠彩畫名稱，解決省展長期的正統國畫論爭問題。創作方面則堅持膠彩畫媒材，並在題材與風格上勇於變革創新，企圖結合膠彩素材與西方繪畫理念及流派，因而創作出介於寫實與抽象之間的作品。其實林之助的興趣相當廣泛，除了繪畫外也喜愛文學、音樂與舞蹈，其中音樂對其繪畫創作的影響相當深刻，踢踏舞的才華甚至能登上舞臺表演。他曾說：「繪畫是造形、色彩、線條的排列，而音樂是聲音的高低、強弱、長短的節奏，兩者的道理是相通的，因此我作畫時常聆聽古典音樂，從音樂的旋律、節奏、和聲的安排上，來思考畫面的構圖、色彩的濃淡強弱與造形上的變化，從音樂上，我獲得許多創作靈感。」

《彩塘幻影》曾在1958年第十三屆省展展出，是充分展現畫家創作深受音樂啟發的一件作品。畫面水塘由近及遠的移動視點所構成，水面以塊面分割方式表現深淺色彩的光影變化，莖葉垂直簡化的造形、倒垂的枯荷與倒影，皆以幾何形體的塊面組成。加上黑白、藍灰、灰綠、淺黃的色彩交織，猶如一首韻律強烈、節奏豐富又和諧的交響曲。左下角飛行的翠鳥，像是見證了這場秋塘幻影的樂章。荷花與翠鳥的組合，是國畫常見的創作題材，林之助不同於寫意的水墨或是工筆描繪的技法，而是運用幾何塊面組合物象，呈現色彩的視覺躍動、造形的變化節奏，令人感受到自然之美與音樂性的表現。（黃琪惠）

Lin Chih-Chu taught at Taichu (Taichung) Normal School and served as a reviewer in the Taiwan Provincial Fine Arts exhibition for a long time. Like other Taiwanese artists showcased in the National Painting Division of the art exhibition, his work was questioned whether it fitted the genre of national painting. In 1977, he finally came up with the term "gouache painting" that resolved the long-term debate about authentic national painting. Lin insisted on gouache painting and was rather innovative and revolutionary in terms of subject and style. He hoped to combine concept and style of gouache and Western painting, and consequently created a body of semi-realistic and semi-abstract works. In reality, Lin had quite a few interests. Apart from painting, he also liked literature, music and dance. Music had a profound influence on his painting. A skilled tap dancer, he had even performed on stage. He once stated, "painting is the arrangement of forms, colors and lines, whereas music is the combination of high and low notes, power and softness, long and short rhythm. They have the same logic. So, when I paint, I often listen to classical music, and contemplate on my composition, shade and contrast of colors as well as variations of form based on the arrangement of melody, rhythm and harmony. I have indeed gained much creative inspiration from music."

©林之助基金會

Illusions by the Pond was showcased in the 13th Taiwan Provincial Fine Arts Exhibition in 1958, and fully visualized how the artist had drawn inspiration from music. The pond in the image is composed with a shifting viewpoint moving from the near to the far. The water surface is divided into various blocks to express the changing light with different shades of colors. The vertical and simplified forms of the stems and leaves as well as the withered, bent lotuses and their reflections are constituted of geometric blocks. Together with the use of varying colors, such as black and white, blue gray, gray green and light yellow, the painting looks like a vibrantly melodious, richly rhythmic and highly harmonious symphony. The common kingfisher in flight at the lower left corner seems to be the audience of this incredible piece of music on the illusory autumn pond. The combination of lotus and common kingfisher is common in Chinese ink painting. However, Lin did not employ the techniques of lyrical ink painting or fine brushwork painting to portray this image. Instead, he used an ensemble of geometric blocks and planes to present the visual pulsation of colors and the moving rhythm of forms, enabling the spectator to see the beauty of nature and its musicality. (HUANG Chi-Hui)

VI

旅人之眼

THE TRAVELER'S EYE

VI

旅人之眼
THE TRAVELER'S EYE

文／蔡家丘

國立臺灣師範大學藝術史研究所副教授

Text / TSAI Chia-Chiu

Associate Professor, Graduate Institute of Art History, National Taiwan Normal University

旅行，不但是一種休閒娛樂，也是增廣見聞、獲取新知的機會，更是進行文化交流、對話，形成一趟自我觀照、重新定位的旅程。旅人受惠於社會、經濟、交通、觀光等的發展配合，卻也同時受這些因素左右目光。二十世紀初的臺灣，海上商船、陸上鐵路等交通發展，日本政府徵選「臺灣新八景」、宣傳國立公園候選地，使觀光活動逐漸興盛，旅遊路線形成，同時也影響了臺灣人對土地的觀察認識。更廣域來看，許多臺灣人因求學或工作的關係，前往東京、上海、廈門、巴黎等地，也是一種跨文化的移動、肩負任務的旅行，從異地懷鄉的方位，確立臺灣在世界上的座標。

在美術史上，旅行是畫家探索題材的契機，刺激創作的力量。在日本，室町時代畫僧雪舟（1420-1506）隨使節前往中國，學習明代山水畫風格。江戶時代浮世繪畫家描繪驛路風情，創作如《東海道五十三次》等作品，反映大眾旅遊文化。在歐洲，畫家走入田野或探訪古蹟，調和自然與人文元素，描繪有如田園牧歌，或如畫廢墟（picturesque ruins)般的風景畫。日本在明治維新積極西化的過程中，畫家便吸收這樣的概念，隨著國家勢力擴張，前往東亞各地遊歷時，投射到眼前風景，取材創作。有的畫家則是參照傳統，在腦海中喚起過去所學的漢學典故、繪畫風格，望向所遊之處一一印證，再重新演繹創作。遊歷創作便是如此回溯記憶與傳統，不斷學習與轉化，進而折射和創造的過程。

二十世紀初的臺灣，可以看到許多日本畫家延續這樣旅行的歷史與潮流來訪，遊歷創作，形成臺灣美術圖像的一部分。本展挑選了數位在近代日本美術史上具代表性的畫家，來臺遊歷創作的作品。例如與橫山大觀（1868-1958）等人創立日本美術院的西鄉孤月浪跡來臺，遠眺儼然坐落於山林間的糖廠，像是在窺盼尋找清淨的桃花源。富田溪仙看似簡筆描繪臺灣風景人物，其實是藉此呼應日本新南畫創作的潮流。河合新藏雖是水彩畫家，也創作傳統形式的彩墨立軸，描繪臺南舊城門與自然風景交融的古今遞嬗。小澤秋成肩負宣傳高雄的任務，描繪明亮繽紛的港口風光。同樣為擔任臺展審查而來臺的還有藤島武二、梅原龍三郎，藤島運用近代西洋繪畫幾何構圖概念，描繪臺南古建築特色；梅原受到雷諾瓦（Pierre-Auguste Renoir，1841-1919）影響，呈現臺灣藝旦美艷又不失個性的一面。山崎省三則秉持日本春陽會對風土的觀察，仔細凝望淡水戎克船與觀音山風景。川島理一郎曾著有《旅人之眼》一書，集結其遍歷歐美、東亞各地的遊記，包括來臺所見。他曾仔細觀察原住民生活，不亞於曾學習古希臘文化時的體會，深感震撼。由這些「旅人之眼」所描繪的作品，如此具體而微地傳達了臺灣美術中遊歷創作的一個視界。

traveling is not merely a form of leisure entertainment; it also brings opportunities to broaden one's horizon and acquire new knowledge. It is even a form of cultural exchange and dialogue, a chance to embark on a journey of self-introspection and re-position oneself. Travelers have benefited from social, economic, transportation and tourism development; at the same time, however, their attention is also dictated by these factors. In the early 20th-century Taiwan, along with the development of seafaring and railway as well as Japanese government's selection of the "New Eight Views of Taiwan" and promotion of candidate sites for national parks, tourist activities began increasing and tourist routes started forming, which had in turn influenced how Taiwanese people observed and perceived the land. From a wider perspective, many Taiwanese had traveled to Tokyo, Shanghai, Xiamen, Paris and other places for education or work, which was a form of intercultural and task-oriented journeys, allowing them to nostalgically review Taiwan from the foreign land while establishing Taiwan's position on the global map.

In art history, travel has offered painters opportunities to find new topics and boosted their creative energies. During Japan's Muromachi period, artist monk Sesshū Tōyō (1420-1506) travelled with Japanese envoys to China, where he learned the ink landscape style of Ming dynasty. During the Edo period (1603-1867), ukiyo-e painters portrayed scenes of road stations and reflected the mass tourist culture in works such as *Fifty-three Stations on the Tokaido*. In Europe, painters ventured into the field or visited historical sites, and integrated natural and cultural elements to create landscape paintings that were reminiscent of pastoral scenes or picturesque ruins. Throughout Japan's active process of Westernization in the Meiji Restoration, painters had travelled in East Asia as the national power expanded, and had brought and projected these concepts onto the sceneries and landscapes in front of their eyes, from which they drew inspiration to create new works. Some painters, on the other hand, referred to the tradition, evoking allusions of Chinese literature and painting style they had learned while looking for validation in places they travelled to before reinterpreting them with their works. Travel, in short, indicates a process of retracing

memory and tradition as well as continuous learning and transformation for further refraction and creation.

At the beginning of the 20th century, many Japanese painters had continued this tradition and wave by visiting and traveling in Taiwan, where they had created works that became an integral part of Taiwanese art. Included in this exhibition are several representative painters from the early modern history of Japanese art, along with their works created based on their tours in Taiwan. Saigo Kogetsu, who co-founded Nihon Bijutsuin (Japan Visual Arts Academy) with Yokoyama Taikan (1868-1958) and other artists, had drifted to Taiwan. His painting depicting the distant view of a sugar factory amidst the mountains seemed to manifest the artist's quest of the Shangri-la. Tomita Keisen created works of Taiwanese landscape and figures with simple brushwork, which in fact echoed the trend of the new Nanga (southern painting) in the Japanese art scene. Although a watercolorist, Kawai Shinzo also painted color ink paintings in the form of traditional vertical scroll, illustrating the vicissitudes of time through portraying Tainan's old city gate blended with natural landscape. Ozawa Shusei shouldered the mission of promoting Kaohsiung and produced a luminous, bright-colored harbor scene. Fujishima Takeji and Umehara Ryuzaburo both visited Taiwan for serving as reviewers in the Taiten. Fujishima employed the concept of geometric composition in early modern Western painting to delineate Tainan's historical architecture. Umehara was influenced by Pierre Auguste Renoir (1841-1919) and represented the Taiwanese geisha in a way that was attractive but not without individual personality. Yamazaki Shozo upheld the objective of Shunyokai (Shunyo Association) that emphasized on landscape and customs and depicted his gaze of the landscape with a junk and Guanyin Mountain in Tamsui. In His *Traveler's Eye*, Kawashima Rüchiro collected his travelogues in Europe, the US and East Asia, including what he saw in Taiwan. He had closely observed the indigenous people and their life, which made a profound impression on him that was no less than the impact he experienced when learning ancient Greek culture. These works included in "The Traveler's Eye" have epitomized the vision of travel paintings in Taiwanese art.

西鄉孤月 SAIGO Kogetsu (1873-1912)
臺灣風景 Landscape in Taiwan

膠彩、絹 Gouache on silk, 42.0 x 118.0 cm, 1912
松本市美術館典藏 Collection of Matsumoto City Museum of Art

1911年，浪跡天涯的西鄉孤月來到臺灣，料想不到這一趟將會是他人生旅途的終站。他原本被視為橋本雅邦（1835-1908）的接班人、日本畫畫壇的後起新秀，然而離婚後便遠走他鄉，鬻畫遊歷。包括《高砂文雅集》中有二張水墨簡筆的女性幽靈圖等，後來鄉原古統曾批評他在臺的作品呈現著荒涼的心境。相較之下，《臺灣風景》用筆細膩，布局審慎，讓廣角的視野穿越椰林田野，渡過河與橋，抵達安座於畫面中心的糖廠，並遙望遠方無盡的山脈。畫家留有另一張相同尺寸與構圖的作品（現藏山種美術館），約略調整色調、山形，與樹林位置，不無可能都是為復出畫壇所作的準備。

臺灣於日治初期便開始發展新式製糖工業，設立如臺灣、明治、鹽水港等製糖會社，各社的製糖所逐漸遍布全臺。畫中約略可見糖廠煙囪上的三角形標記，可能為鹽水港製糖會社的商標。配合西鄉孤月來臺的時間點推測，當時隸屬於該社的有位於臺南岸內、新營，或是高雄旗尾的製糖所。若是後者，作品取景便是從旗山望向楠梓仙溪、製糖所的方向，以及背景的三地門鄉、中央山脈南段的北大武山等等。孤獨的西鄉，當年如此穿越椰林盡處後，眼前應該是豁然開朗，土地平曠、廠舍儼然。猶如在南國邊境看見新天地的氣象，覓得心中的桃花源。

西鄉孤月創作的山水與花鳥畫，大多數是將畫稿或畫譜等融會貫通後製作，不具特定的地點或對象。《臺灣風景》不但是畫家病逝前的絕筆作，也是少數實地取景的作品。同時可說是臺灣在日治初期，膠彩畫還未被推廣之前，很早已出現的一件完整而技巧成熟的風景畫，無論對畫家自身或臺灣美術史而言，都是相當重要的作品。（蔡家丘）

In 1911, roaming artist Saigo Kogetsu arrived in Taiwan, not knowing this trip would be his last. The artist had been deemed the next Hashimoto Geho (1835-1908) and a rising star in the field of nihonga (Japanese-style painting); however, after divorcing his wife, he left home and started traveling, supporting himself by selling his paintings. He had created two works featuring female ghosts drawn with ink and simple brushwork, which were included in *Takasago Bungashu*. Gobara Koto had commented on his works created in Taiwan, asserting that they had visualized the painter's desolated state of mind. In comparison, *Landscape in Taiwan* was painted in a refined way. The careful arrangement shows an expansive view that traverses coconut trees, the field,

river and bridge to reach the sugar factory at the center of painting and overlooks the endless mountains in the distance. There is another painting by Saigo, which is the same in size and composition (now in the collection of Yamatane Museum of Art), with slight adjustments of colors, the shape of mountains and the position of the woods. It is likely that both paintings were create for the artist's comeback to the art circle.

Taiwan started developing the new industry of sugar production at the beginning of Japanese rule. Taiwan Sugar Company, Meiji Sugar Company and Ensuiko Sugar Refining Company were established, and had sugar refineries throughout Taiwan. In this painting, there

seems to be a triangular logo on the chimney of the sugar factory, which might be the trademark of Ensuiko Sugar Refining Company. Based on the timing of Saigo's trip to Taiwan, the company had sugar plants in Tainan's Annei and Xinying as well as Kaohsiung's Chiwei. If it was the latter, this landscape would be the view of Nanzixian River and the sugar plant from Chishan, where one could see Sandimen Township, the southern section of the Central Mountain Range and Mount Kavulungan in the background. The lonely artist, after traversing the coconut trees, probably found the view opening up to a vast, unobstructed flat land, with the sugar factory standing in the distance. It would be like a new vista found in the southern border, an ideal Shangri-la for the artist.

Saigo's landscapes and bird-and-flower paintings were mostly created based on different sketches or drafts and did not depict specific locations or subjects. *Landscape in Taiwan* was not only the final work before the painter died of an illness, but also one of his few works that was painted in the field. Meanwhile, this painting was a complete gouache landscape demonstrating mature skills at the early period of Japanese rule, long before gouache painting was taught and became popular. For both the artist as well as Taiwanese art history, it is an indispensable work. (TSAI Chia-Chiu)

富田溪仙 TOMITA Keisen (1879-1936)
臺灣秋色圖 Autumn in Taiwan

彩墨、紙 Ink and color on paper, 133.5 x 30.5 cm, 1909-1910
寄暢園收藏 Collection of Chi Chang Yuan

富田溪仙為臺灣日治初期自日本前來遊歷的代表畫家之一，1909年來臺時，與臺灣書畫會交流，5月底舉辦展覽拍賣作品，創作題材包括臺灣風俗人物，另有作品收入於臺灣書畫集《高砂文雅集》、《東寧墨跡》等。富田溪仙遊歷臺灣、中國，隨之創作不少寫生帖與畫集，如《南船北馬》、《支那山海經》、《樊籠帖》、《南泉山船往來》、《臺清漫畫紀行》等等。此時期富田溪仙一方面研究日本南畫，一方面遊歷臺灣、中國等地，尋找畫題，畫風從傳統四條派轉為南畫筆調的水墨風格。

事實上富田停留臺灣的時間較長，取材不少臺灣風俗入畫。本作即為其中之一，描繪臺灣婦女於芭蕉樹下，似是在搗衣或從事農作的模樣。可以看到這位尚值青壯年的畫家，好奇地觀察記錄臺灣風俗，以活潑大方的水墨線條生動地勾勒人物與樹葉等特徵。不但如此，作品也呼應著日本畫壇重拾南畫風格的潮流，探索線條發揮與題材選擇的可能性，促使畫家成功地確立日後的風格。（蔡家丘）

Tomita Keisen was a representative figure among the Japanese painters that toured in Taiwan during the early period of Japanese rule. He came to Taiwan in 1909, and during his visit, he exchanged ideas with members of Taiwan Calligraphy and Painting Society, and held an exhibition to sell his works at the end of May. His subject matter included Taiwanese customs and figures, and his works were included in Taiwanese calligraphy and painting albums, such as *Takasago Bungashu* and *Ink Paintings from Tunging*. Tomita had toured Taiwan and China, and created many sketches and painting albums based on his travels, including *Nansen Hokuba, Shina Sengaikyo, Hanro Gacho, Boats in Nanchuan, Taishinmanga-kiko*, etc. During this period, Tomita was studying the Nanga (southern painting) while travelling in Taiwan and China to look for subjects. His painting style had gradually shifted from the Shijo School to the ink style characteristic of the southern painting.

In fact, Tomita had stayed a longer period in Taiwan and painted quite a few works featuring Taiwanese customs. This painting was one of them, which foregrounded a Taiwanese woman washing clothes or doing farming chores under a banana tree. From this painting, it is clear that the painter, who was at the prime of his life, had a curious mind and was eager to record the customs of Taiwan. He delineated the figure and the features of the tree leaves with lively and bold ink lines. Moreover, this work also echoed the revival of the southern painting style in the Japanese art scene at the time. The artist had explored the possibility of ink line and new subject matter, which contributed to his formulation of a personal style later. (TSAI Chia-Chiu)

河合新藏 KAWAI Shinzo (1867-1936)
臺灣所見（對幅）Records of Taiwan (Paired Hanging Scrolls)

膠彩、絹 Gouache on silk, 125.5 x 42.5 (x2) cm, 1917
台灣50美術館收藏 Collection of Museum 50 of Taiwan

本作為雙幅形式，左幅近景描繪一群在溪邊洗衣的婦女，沿溪流蜿蜒至上游處，可見小橋與民舍。右幅中景描繪半頹圮的城門，向前方蜿蜒的道路兩旁可見羊群徘徊。兩幅構圖各以溪流與道路導引觀者視線，左右相對，可見經營上的巧思。同時，帶有透視感的構圖，也顯示畫家受到近代西洋寫實技巧的影響，與傳統繪畫的構圖視點不同。右幅著重古城門與自然地景、動植物的搭配，呈現如畫廢墟般的景象。許多畫家經常觀察並取材古城門，融入風景畫創作。例如石川欽一郎曾反覆描繪臺北的小南門，搭配周遭的相思樹、古橋構成畫面。取材臺南大南門的作品，可見於遊歷來臺畫家石川寅治（1875-1964）創作的繪葉書，以及如楢原益太（1888-1963）在臺灣報紙上發表的插繪。林玉山1927年於第一回臺展的入選作品《大南門》，描繪城門的角度便與河合新藏此幅十分相近。本作為較早所見的一例。

河合新藏於1916年來臺，於鐵道旅館舉辦個展，展出作品六十餘件，包含水彩畫、油畫、與絹本淡彩畫。對當時日本的畫家來說，水彩畫雖為西洋繪畫，但水溶性的媒材特色，與傳統繪畫有相通之處，因此也很常見水彩畫家創作如本作般的彩墨立軸作品。同時，留學歐洲的畫家創作風景畫時，學習到融合自然與人文風景的概念，作品常呈現浪漫如田園牧歌，或如畫廢墟（picturesque ruins）般的情境。本作便可說明上述日本水彩畫家創作的特色，由箱書所記可知為返日後隔年所作。（蔡家丘）

This work is a paired hanging scrolls. In the left one, a group of women was washing clothes by the creek in the foreground, and near the upstream of the meandering creek was a small bridge and a common house. In the right scroll, there was a somewhat time-worn city gate, and a small herd of goats was lingering by the sides of the winding road. The compositions of the two scrolls guide the spectator's line of vision with the creek and the road, forming an opposition that indicates the artist's clever design. Meanwhile, both compositions reveal a sense of perspective, implying that the artist was influenced by early modern techniques of Western realist painting; hence, the compositional viewpoint dissimilar to that of traditional painting. The right scroll focused on the combination of an ancient city gate, natural landscape, animals and plants, displaying an image of picturesque ruins. Many artist often observed and drew inspiration from historical city gate, incorporating the element into their works. For example, Ishikawa Kinichiro had repeatedly painted Taipei's Little South Gate together with Taiwan acacias and ancient bridges. Works featuring Tainan's Great South Gate could be found in Ehagaki postcards created by Ishikawa Toraji (1875-1964) and Taiwan's newspaper illustrations by Narahara Masuta (1888-1963); both artists had toured in Taiwan. Lin Yu-Shan's *South Gate*, which was selected into the 1st Taiten, portrayed the city gate in an angle quite similar to this work by Kawai, which was created earlier.

Kawai came to Taiwan in 1916 and held his solo exhibition at Taiwan Railway Hotel. The exhibition featured more than sixty works, ranging from watercolors, oils to color ink paintings on silk. For Japanese artists at that time, although watercolor was a Western-style painting genre, the water-soluble characteristics of the medium were similar to that of traditional painting. Therefore, it was not rare to see vertical color ink scrolls by watercolorists like this work. Also, when artists trained in Europe painted landscape paintings, they had acquired the concept of intermixing natural and cultural landscape. Consequently, their works were often romantic and reminiscent of pastoral scenes or picturesque ruins. This work is a fine example of these features in works by Japanese watercolor painters discussed above. From the note on the artwork box, one can tell that this work was created the year after Kawai returned to Japan. (TSAI Chia-Chiu)

丸山晚霞 MARUYAMA Banka（1867-1942）
臺灣高山花卉圖 Mountain Flowers in Taiwan

彩墨、紙 Ink and color on paper, 34.5 x 138.0 cm, 年代不詳 Year unknown
寄暢園收藏 Collection of Chi Chang Yuan

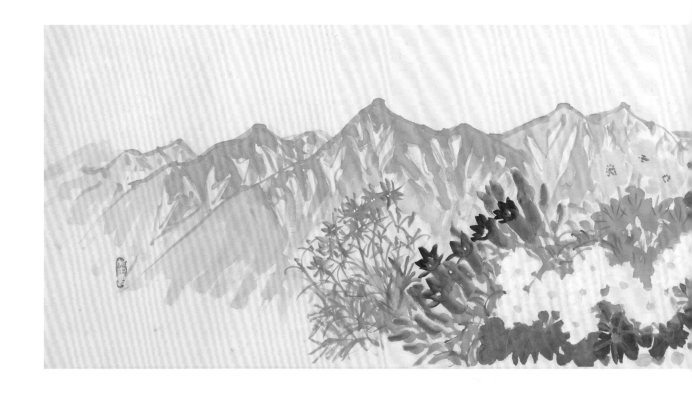

丸山晚霞喜愛登山與高山植物，曾經旅行印度、臺灣等的山岳地帶取材創作，他特別鍾愛石楠花，也將其種植在自己家的庭院。創作時經常將山岳與植物兩者相互搭配，尤其常見將石楠花置於前景的構圖。例如取景自歐陸山岳的《ヒマラヤ山と石楠花》（喜馬拉雅山與石楠花，1924，東京國立近代美術館藏），或來臺遊歷創作的《新高連峯》（1934，圖版刊於雜誌《新高阿里山》2號，1934年10月）。同時也有不取材特定地點，而將這樣的構圖逐漸定型化的作品，如《霧と石楠花》

（霧與石楠花，丸山晚霞記念館藏）、《山巔麗花》（1940，丸山晚霞記念館藏）等，形成他晚年的風格之一。

本作構圖雖然並不複雜，但正好具有這樣的代表特色。筆觸簡率，色調乾淨明亮，同時凸顯位於畫面中央的紅色石楠花。可以說是熱愛登山與花卉的畫家，在下筆時胸有成竹，於信手拈來之際，明心見性的作品，猶如是對鍾愛事物的一個縮影。（蔡家丘）

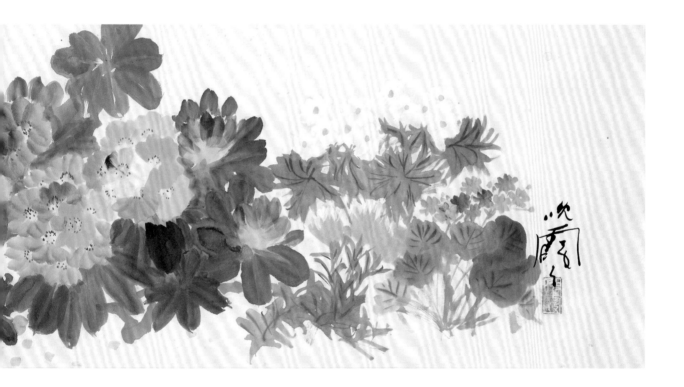

Maruyama Banka loved mountain climbing and mountain plants. He had travelled to India and Taiwan, touring the mountainous regions to look for creative materials. He especially adored alpine roses, which could be found in his garden as well. His painting often combined mountains and plants, particularly the composition with alpine roses set in the foreground; for instance, *The Himalayas and Alpine Roses* (1924; collection of the National Museum of Modern Art, Tokyo), which was inspired by European mountains, and *Rolling Peaks of Nitaka* (1934; the plate was published on the magazine, *Nitaka Arisan*, vol. 2, October 1934). He also created paintings featuring typical compositions without basing on any specific locations, such as *Alpine Roses in Mist* (collection of Maruyama Banka Museum) and *Splendid Flowers on Mountain Peaks* (1940; collection of Maruyama Banka Museum), which formed his style in his later career.

The composition of this painting is uncomplicated and precisely characteristic of his later style. The artist used simple, straightforward brushstrokes and clear, bright colors while highlighting the red alpine roses at the center of the painting. It is obvious that the artist who loved mountain climbing and flowers was confident and much inspired in painting the work, making this piece an epitome of things he adored and a revelation of his inner world. (TSAI Chia-Chiu)

小澤秋成 OZAWA Shusei (1886-1954)
臺北風景 Scenery of Taipei

油彩、畫布 Oil on canvas, 65.0 x 91.0 cm, 1931
國立臺灣博物館典藏 Collection of National Taiwan Museum

小澤秋成是日本西畫家，1927年赴法習畫，1930年返回日本，1931年受邀來臺擔任第五回臺展的審查員，本件作品即展出於該展覽會中。雖然本作長年收藏於國立臺灣博物館中，但直到最近才被重新發現。

1931年10月，小澤來到臺灣不過數日，就以兩件描繪臺北林蔭道的作品參展。在大澤貞吉的展覽評論中提到其中一件是描繪三線道路，一件是看得見塔的市街風景，也就是本作品。大澤特別欣賞後者，認為構圖雖然類似喜愛描繪巴黎郊外風景的尤特里羅（Maurice Utrillo，1883-1955），然而筆觸中有著東洋畫家的技法，具有優異的精神性內涵（文獻，頁298-299）。作品採單點透視的構圖，行道樹、電線桿與有塔的白色建築沿著兩條斜線布列。小澤以快速的運筆來描繪樹幹與樹葉、電線桿等。路面上Z字型連續彎曲的線條，則表現出天雨路濕的水面倒影與天光返照。這些看起來有些隨性、甚至凌亂的筆觸，類似毛筆所形成的書法性線條，或許就是大澤貞吉在畫面中所感受到的東洋畫家的技法。

1920年代活躍於巴黎的日本畫家如佐伯祐三（1898-1928）與藤田嗣治（1886-1968），都試圖在油畫中融入東方繪畫的特色，來樹立自我風格。在本件作品中也可見到小澤秋成的類似嘗試。和小澤在巴黎相識的臺灣畫家陳清汾曾提到：「眾所周知，小澤秋成的畫，在日本不用說，在遙遠的歐洲也博得好評。巴黎人讚嘆其獨具魅力的線條。我們應特別留意小澤的畫風，他大膽採擷都會風景，使用於他人畫作中所看不到的獨特色彩及線條，創造出一個小小的世界，具有在不知不覺中呼喚觀者的偉大力量。」（文獻，頁300-301）臺北三線道在當時被稱為「東洋的小巴黎」，甫到臺北的小澤，也在城市中尋找具有歐風摩登氣息的林蔭道來作為繪畫題材。他在同年舉辦的美術演講中提到，臺北市民對於城市的美化，不應迷惑於眼前的利益，而應著眼於保護大自然與歷史建築物。在本件作品中可見到小澤試圖以藝術的手法，來引領觀者欣賞都市風景之美。（邱函妮）

In 1927, Japanese Western-style painter Ozawa Shusei began studying painting in France and returned to Japan in 1930. Later in 1931, he was invited to visit Taiwan and serve as a reviewer in the 5th Taiten. This painting was showcased in the same exhibition. Although it has been in the collection of National Taiwan Museum, it has only been rediscovered recently.

In October 1931, only a few days after Ozawa arrived in Taiwan, he had already submitted two paintings featuring Taipei's wooded boulevard. Oosawa Sadakichi's comments on the exhibition mentioned a painting depicting the Sam-suànn-lōo (literally, the three-lane road) and another one portraying the cityscape with a tower, which is the painting on view in the exhibition. Oosawa particularly admired the latter and stated that its composition brought to mind the works of Maurice Utrillo (1883-1955), who loved to paint the Parisian suburban landscape, but Ozawa's brushstrokes were reminiscent of the painting techniques used by Japanese painters, showing remarkable spiritual implication (Documents, pp. 298-299). The painting is composed of a single perspective. The roadside trees, electricity poles and the white building with a tower align along the sides of the road. With rapid brushwork, the artist depicted the tree trunks, leaves and electricity poles while delineating the reflection and daylight on the wet surface of the road in the raining day with zigzagging lines. The spontaneous, or even disorderly, brushstrokes were similar to the lines of calligraphic writing, which was probably the Japanese painting technique observed by Oosawa.

Japanese painters that were active in the Parisian art scene during the 1920s, such as Saeki Yuzo (1898-1928) and Foujita Tsuguharu (1886-1968), had incorporated characteristics of Eastern painting into their oil paintings to formulate their individual style. Ozawa made a similar attempt in this work. Chen Ching-Fen, who made Ozawa's acquaintance in Paris, once said, "it is a known fact that Ozawa's painting is not only acclaimed in Japan but also very well-received in distant Europe. The audience in Paris have been amazed by his unique and charming lines. We should all pay attention to his style. He boldly captures the urban scenes, and uses unique colors and lines that cannot be found in other painters' works, creating a small world that has the great power to call out to the audience without their knowledge of it." (Documents, pp. 300-301) Taipei's Sam-suànn-lōo was nicknamed "the Little Paris of the East." Having just arrived in Taipei, Ozawa captured the city's wooded boulevard that exuded a European modern feel with his painting. In an art speech held in the same year, he mentioned that the citizens in Taipei should not be beguiled by the advantage at hand when thinking about the city's beautification. Instead, they should put the emphasis on preserving nature and historical architecture. In this work, it is telling that Ozawa has used the means of art to guide his audience to appreciate the beauty of urban landscape. (CHIU Han-Ni)

小澤秋成 OZAWA Shusei (1886-1954)
高雄風景 Scenery of Kaohsiung

油彩、畫布 Oil on canvas, 49.0 x 58.5 cm, 1933
台灣50美術館收藏 Collection of Museum 50 of Taiwan

小澤秋成於1931至1933年間為擔任臺展審查員來臺，期間除了描繪臺北街景外，也接受委託前往花蓮、高雄遊歷創作。1931年與另一名審查員和田三造（1883-1967），前往當時成為國立公園候補地之一的花蓮太魯閣旅行，小澤此行創作的《外太魯閣峽》，隔年參加國立公園洋畫展覽會，巡迴日本數城市。

1933年小澤秋成接受高雄市役所委託，作為宣傳，繪製三十多幅高雄風景畫，於州廳展出。部分作品印製成一套的風景繪葉書（文獻，頁292-297），並將其中兩件作品命名為《高雄の春》（高雄之春）、《高雄の夏》（高雄之夏），與另一件《高雄風景》於第七回臺展展出。同年也另以兩件《高雄風景》參加日本二科會展。本作品應為此系列創作中的一件，以鮮明的色彩描繪碼頭邊的風景，以線條勾勒人物、船隻，與電線杆等。相較於表現臺北街景時的奔放風格，此作在形象的描繪上較為收斂，更著重在展現高雄具有的耀眼氣候、色彩，以及港區新興而繽紛的生活情調。（蔡家丘）

From 1931 to 1933, Ozawa Shusei served as a reviewer in the Taiten. During this period, he not only painted Taipei's streetscape, he was also commissioned to tour Hualien and Kaohsiung, where he also created paintings. In 1931, he and another reviewer Wada Sanzo (1883-1967) visited Hualien's Taroko, a candidate site for a national park at the time. During this trip, Ozawa painted *Outside the Taroko Gorge*, which was exhibited in The Exhibition of Western-style Paintings of National Parks that toured in various cities in Japan.

In 1933, Ozawa was commissioned by Kaohsiung City Hall to create more than thirty landscapes featuring Kaohsiung's sceneries to promote the city, which were exhibited at Takao (Kaohsiung) Prefectural Hall. Some of the paintings were made into a set of ehagaki postcards (Documents, pp. 292-297), among which two of them were respectively titled *Spring of Kaohsiung* and *Summer of Kaohsiung*, while another one, *Scenery of Kaohsiung*, was showcased in the 7th Taiten. In the same year, two other paintings also titled *Scenery of Kaohsiung* were showcased in the Nika Association Exhibition in Japan. This work belonged to this series. The artist portrayed the harbor with vibrant colors, and delineated the figures, boats and electricity poles with lines. Comparing to the free style when depicting Taipei's streetscape, this work demonstrated a more reserved style in terms of portraying the image. Instead, the artist had placed his emphasis on the characteristic sunny weather and colors of Kaohsiung as well as the new and colorful lifestyle and milieu of the harbor area. (TSAI Chia-Chiu)

山崎省三 YAMAZAKI Shozo (1896-1945)
戎克船之朝 A Junk in the Morning

油彩、畫布 Oil on canvas, 58.5 x 71.5 cm, 1933
國立臺灣博物館典藏 Collection of National Taiwan Museum
畫框：平川知道第9回臺展作品畫框，1935年

作品畫面左下角的簽名「shozo. y」，是山崎省三姓名拼音Yamazaki Shozo的縮寫，為山崎常用的簽名方式之一。這件作品目前鑲嵌的畫框，是總督府文教局學務科職員平川知道，於1935年入選臺展第九回作品《靜物》的畫框，原作目前僅見於臺展圖錄中。兩件作品可能先後被收藏到臺灣教育會館，而後被誤裝在一起。

1933年11月18至20日，山崎省三來臺於教育會館舉辦個展，展出作品約三十件，包括此作《ジャンクの朝》（戎克船之朝）。當時展覽消息與作品的黑白圖版刊登於《臺灣日日新報》（文獻，頁302-305）、《大阪每日新聞》。畫家細膩並多彩地描繪淡水風景，特別是佔據畫面大半、被稱為「戎克船」的臺灣船隻。前景駐足的人物凝望著船隻，和淡水河對岸的觀音山。人物以和簽名同樣的黑色來描寫，既是作為點景人物，或許也是觀望山水的畫家對自身的寫照。

山崎省三加入的繪畫團體「春陽會」，有許多從歐洲回歸的畫家，藉由旅行東亞尋找題材，或汲取東洋美術古典風格，如小杉放庵（1881-1964）、萬鐵五郎（1885-1927）等人。他們在官展傳統的展覽會藝術，與逐漸興起的前衛藝術之間，追求日本油畫創作的深化。如此可以理解，山崎的作品反映了春陽會創作的旨趣，通過旅行東亞凝望風土，進行東洋回歸的實踐。（蔡家丘）

Signed on the lower-left corner is a signature that reads "shozo. y," which is short for Yamazaki Shozo, one of the common signatures used by the painter. The current frame of this painting was originally used for *Still Life*, another painting featured in the 9th Taiten in 1935, created by Hirakawa Chido, a clerk in the Student Affairs Division of the Bureau of Culture and Education under the Office of Taiwan Governor-General. The latter now can only be found in Taiten's catalogue. The two paintings were probably packaged together by mistake after being stored at Taiwan Education Hall.

From November 18 to 20, 1933, Yamazaki visited Taiwan and presented his solo exhibition in Taiwan Education Hall; the exhibition showcased about thirty works, including *A Junk in the Morning*. The news of the exhibition and black-and-white plates of the exhibited paintings were published on *Taiwan Nichinichi Shinpo* (official daily newspaper in colonial Taiwan; Documents, pp. 302-305) and *Osaka Mainichi Shimbun* (*Osaka Daily News*). The artist minutely and colorfully portrayed the landscape of Tamsui, foregrounding Taiwan's "junk" that occupied a large portion of the image. In the foreground stood a figure looking at the vessel and Guanyin Mountain across Tamsui River. The figure was delineated in black, which was the same color as the signature. While being a figure in landscape, it perhaps symbolized the artist himself who was looking at the landscape as well.

Yamazaki was a member of Shunyokai (Shunyo Association), a painting group joined by many painters returned from Europe and had searched for subjects through traveling in East Asia or absorbing the classical style of Japanese art, for instance, Kosugi Hoan (1881-1964) and Yorozu Testugoro (1885-1927). In between the exhibition art characterized by the tradition of official art exhibitions and the emerging avant-garde art, they had embarked on their own quest to deepen the tradition of Japanese oil painting. From this perspective, it is understandable that Yamazaki's work reflected the objective of Shunyokai, which was to revisit Japanese artistic tradition through gazing at East Asian landscape and customs. (TSAI Chia-Chiu)

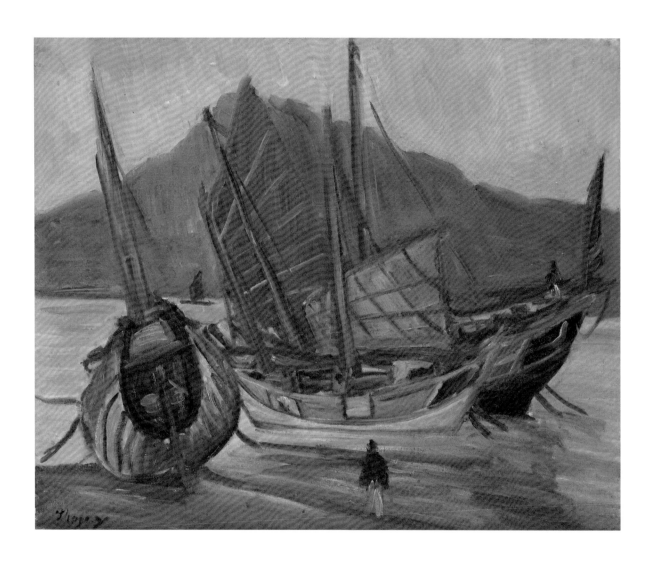

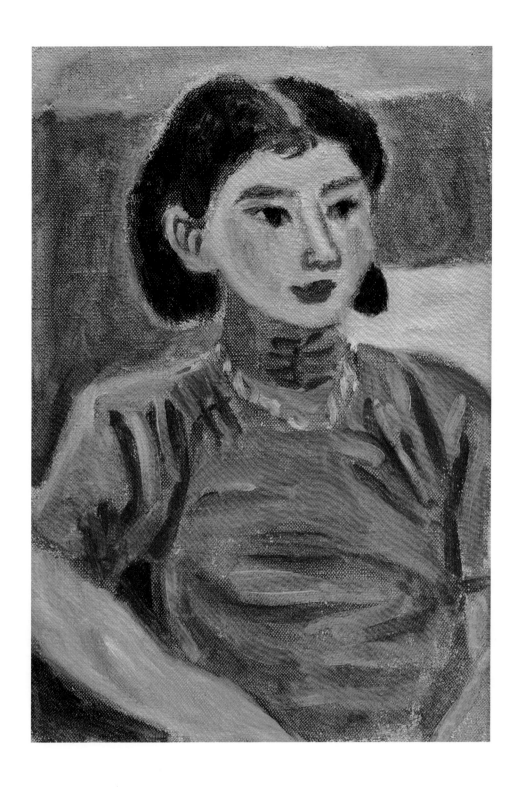

梅原龍三郎 UMEHARA Ryuzaburo (1888-1986)
臺灣少女 Taiwanese Maiden

油彩、畫布 Oil on canvas, 39.5 x 27.5 cm, 1933
寄暢園收藏 Collection of Chi Chang Yuan

梅原龍三郎相當傾慕法國畫家雷諾瓦（Pierre-Auguste Renoir），留法期間曾多次拜訪，也曾收藏其作品。雷諾瓦經常以較為薄塗的筆觸，描繪女性人物豐腴的面容和肢體，並喜好柔美如薔薇般的色調。梅原來臺時可能以藝旦為模特兒創作的這件作品，便可以看到吸收運用了雷諾瓦的風格，表現在女子較為圓潤與帶腮紅的臉頰，以及充滿紅色調的服飾與背景。不過此時期梅原也在思考屬於東洋油畫的風格，除了實地遊歷取材外，描繪女性人物時也藉由表情、髮式、服裝，與身體姿態，呈現更具東方人物個性的一面。這樣的轉化，也延續到日後他前往北京，描繪許多女性人物畫的風格中。

梅原龍三郎於1933年10月31日首次來臺，11月4日與較早來臺擔任臺展審查員的藤島武二，於蓬萊閣舉辦懇親會。1935年10月18日，與藤島等其他畫家一同為擔任臺展審查再次來臺，11月3日返日，期間梅原與藤島曾和李梅樹、陳澄波、顏水龍等人用餐合影。1936年再度來臺擔任臺展審查員。梅原龍三郎來臺期間曾遊歷臺灣南部，取材臺南孔廟創作。《臺灣少女》應為1933年來臺時取材的作品，1934年10月曾展於銀座三昧堂畫廊，作品圖版刊登於美術雜誌《みづゑ》1934年12月第358期。（蔡家丘）

Umehara Ryuzaburo was a great admirer of the French master, Pierre-Auguste Renoir, and had visited him several times when he was studying in France; moreover, he was a collector of Renoir's works. Renoir often used thin application of oil paint to depict the chubby cheeks and plump figure of females in his paintings, and preferred a rosy palette for such portrayal. It is likely that Umehara used a gē-tuànn (Taiwanese geisha) as his model to create this painting, which showed his assimilation of Renoir's style that manifested through the rounded, blushed cheeks of the woman as well as the red-toned attire and background. However, Umehara was also contemplating on finding Japanese oil painting style during this period. Apart from painting a topic found in his travel, his depiction of the woman also demonstrated characteristics and personality of Asian figures through the facial expression, hairstyle, clothing and posture. Such transformation would continue in many of his other paintings featuring female figures created after he arrived in Beijing.

Umehara first visited Taiwan on October 31, 1933, and co-hosted a reception at Penglai Pavilion with Fujishima Takeji, who had arrived in Taiwan earlier to serve as a reviewer in the Taiten. On October 18, 1935, he and Fujishima came to Taiwan and served as the Taiten's reviewers again, and returned to Japan on November 3. During their second visit, Umehara and Fujishima dined and took photographs with Li Mei-Shu, Chen Cheng-Po, Yen Shui-Long and others. Umehara served as a reviewer in the Taiten and visited Taiwan for the third time in 1936. During these visits, he toured southern Taiwan and painted Tainan's Confucius Temple. *Taiwanese Maiden* was presumably a painting based on the materials collected in his first visit in 1933, and had been shown in Sanmido, a gallery in Ginza, and the plate of the painting was published on issue 358 of the art magazine, *Mizue,* that came out in December 1934. (TSAI Chia-Chiu)

藤島武二 FUJISHIMA Takeji (1867-1943)
臺灣風景 Scenery of Taiwan

油彩、畫布 Oil on canvas, 37.6 x 55.5 cm, 1935
寄暢園收藏 Collection of Chi Chang Yuan

藤島武二於1933年10月19日首次造訪臺灣，擔任第七回臺展西洋畫部審查員，結束工作後曾至南部旅行。1934年10月16日再次為擔任臺展審查員來臺，並遊歷臺南，攀登阿里山，描繪玉山日出風景，創作如第十五回帝展出品作《山上の日の出》（山上的日出）、《旭光》（新高山，Aritzon Museum 藏）。同年12月底曾再次來臺前往南部旅行至隔年初，曾以臺南為題創作油畫三十餘件，粉彩數十件。1935年10月，與梅原龍三郎等其他畫家一同為擔任臺展審查員來臺，並曾前往日月潭。

藤島武二創作時經常思考東西方文化的融合，設計具造型性和裝飾感的畫面。例如1902年以西洋繪畫人體表現描繪日本古代人物的《天平の面影》（天平的面貌），或是1924年藉文藝復興風格創作穿中國服飾的橫向女性人物《東洋振り》（東洋模樣），以及1938年以幾何色面來描繪構成信州風土的《耕到天》等等。藤島至臺灣南部旅行，有不少取材孔廟的創作，特別是取景建築空間的一角，如迴廊的牆面或屋簷下的通道。或是如本作般，以遠距離描繪臺灣建築和自然如橫切面般的風景，與神奈川縣立近代美術館藏《臺南風景》有相似的風格。以清晰迅速的筆觸呈現建築、道路，與樹木的幾何輪廓和色塊對比，可見畫家一路以來追求的風格，在晚年漸趨成熟與單純化的傾向。（蔡家丘）

Fujishima Takeji visited Taiwan for the first time on October 19, 1933, to serve as a reviewer in the Western-style Painting Division of the 7th Taiten, and toured southern Taiwan after finishing his work. On October 16, 1934, he came to Taiwan for serving as a reviewer again. This time, his visited Tainan and climbed Alishan to paint the sunrise from Yushan, creating works like *Sunrise on the Mountain* and *Sunrise (Nitakayama)* (collection of Artizon Museum) that were showcased in the 15th Teiten (Imperial Art Exhibition). At the end of December in the same year, Fujishima visited Taiwan again and toured in the south until early next year. The trip resulted in more than thirty oil paintings and several dozens of pastel works featuring Tainan. In October 1935, he visited Taiwan with Umehara and other painters to serve as reviewers in the Taiten and traveled to Sun Moon Lake.

Fujishima often took into consideration of integrating Eastern and Western culture when creating his work, designing images informed by plasticity and decorativeness. For instance, his *Reminiscence of the Tempyo Era* of 1902 employed the expression of human body in Western-style painting to delineate a Japanese ancient figure; in 1924, he adopted the Renaissance style and created *Orientalism* that featured the silhouette of a woman in Chinese garment; and in 1938, he utilized geometric planes to compose *Highly Cultivated Hills* that portrayed the landscape of Nagano. When Fujishima travelled in southern Taiwan, he created many works featuring the Confucius Temple, in which he would especially focused on a corner of the architecture, such as the walls of a corridor or the passageway under the eaves. Or, like in this painting, he would delineate Taiwanese architecture and landscape like a cross-section of nature from a distance. *Landscape of Tainan* in the collection of the Museum of Modern Art, Kamakura and Hayama showed a style similar to this painting. The artist used clear, swift brushstrokes to portray the geometric contour and contrasting color blocks that constituted the architecture, road and trees, indicating that the style the artist had consistently pursued was maturing and more simplified in his late years. (TSAI Chia-Chiu)

特別展示

SPECIAL EXHIBIT

顏水龍 YEN Shui-Long (1903-1997)
熱帶魚 Tropical Fish

磁磚馬賽克 Mosaic tiles, 220.0 x 300.0 x D10.0 cm, 1973
國立臺灣工藝研究發展中心典藏 Collection of National Taiwan Craft Research and Development Institute

1961年，將步入六十歲的顏水龍因緣際會踏入馬賽克鑲嵌藝術的公共領域。他以在歐洲教堂常見的馬賽克鑲嵌壁畫為靈感，利用打碎的陶瓷片與磁磚製作鑲嵌壁畫；此後三十多年，帶領美術相關科系師生陸續於臺灣各地完成一系列馬賽克與浮雕壁畫。作品表現題材大致可分為宣揚公眾生活美學、宗教民俗文化、臺灣農業與產業發展、禮讚大自然，以及臺灣風景與在地植物紀錄圖像。

顏水龍曾擔任電光牌衛浴公司美術顧問，1973年接受委託為公司臺北門市壁面製作《熱帶魚》馬賽克壁畫。此作品磁磚本體重達約四百多公斤，比較同為室內作品的臺中太陽堂餅店馬賽克壁畫《向日葵》（1965），或長期展示於臺南美術館一館的《熱帶植物》（1972），在尺寸規模上都要大些。由於作品配合衛浴設備展示，畫面以海底珊瑚與熱帶魚為主角，橫向平貼的馬賽克構築出平靜宜人的海底世界；色彩鮮豔、紋樣斑斕的熱帶魚穿梭在姿態橫生，疏若有致的珊瑚海草間，自在悠游，饒富動感；深淺不一的波紋線條，水清粼粼，瑰麗多彩。顏水龍以海洋為題材的馬賽克壁畫僅有此幅，其珊瑚水草的造形表現，令人想起另一幅油畫《仙人掌》（1962-1964）；以山海樸素的植物主題，描繪的是臺灣珍貴的生命力。

壁畫於電光牌武昌街門市拆遷時，毀損斷裂，2007年電光企業委託顏水龍學生林俊成與李億勳修復，並裝上金屬外框。為使臺灣國寶級文化財都能獲得妥善維護並永傳後世，2019年電光企業慨然將此珍貴作品捐贈國立臺灣工藝研究發展中心收藏。

顏水龍的馬賽克壁畫風格造型簡練而生動，意境典雅且樸實，畫面結構講求理性；油畫的設色技巧運用在馬賽克的排剪拼貼上，以釉色不均與瓷片不平烘托出獨特的肌理質地，如同油彩混色般呈現豐富的立體層次效果。經過粹練的主題內容簡潔質樸，反映出他素樸生活與實事求真的美學觀。顏水龍的馬賽克，是陪伴無數市民成長的共同歷史記憶。（雷逸婷）

In 1961, Yen Shui-Long was about to turn sixty, and serendipitously began engaging in making mosaic public art. Drawing inspiration from mosaic murals common in European churches, Yen made use of shattered ceramics and tiles to create murals. For over three decades since then, the artist had led art teachers and students to create a series of mosaic and relief murals in various places in Taiwan. The subjects of these works could mainly be divided into the following subjects: promoting public living aesthetics, religious and folk culture, agricultural and industrial development in Taiwan, celebration of nature, and images of Taiwanese landscape and local plants.

Yen was the art consultant to Tien Kuang Enterprise, a company specializes in sanitary ware. In 1973, he was commissioned by the company to produce the mosaic mural, entitled *Tropical Fish*, for the company's store in Taipei. The tiles used to create this piece alone weighed four hundred kilograms, making the entire work larger than Yen's other indoor mosaic murals, including *Sunflower* (1965), made for Taichung's Taiyang Bakery, and *Tropical Plants* (1972), which has been exhibited in Building 1 of Tainan Art Museum. Because the work was to be shown with sanitary ware, the mural's image features coral reefs and tropical fish, using horizontal mosaic design to construct a peaceful, pleasant world under the sea. The vibrantly colorful tropical fish with splendid patterns relaxingly swim amidst naturally grown, well-proportioned placed coral reefs and sea grass, showing a

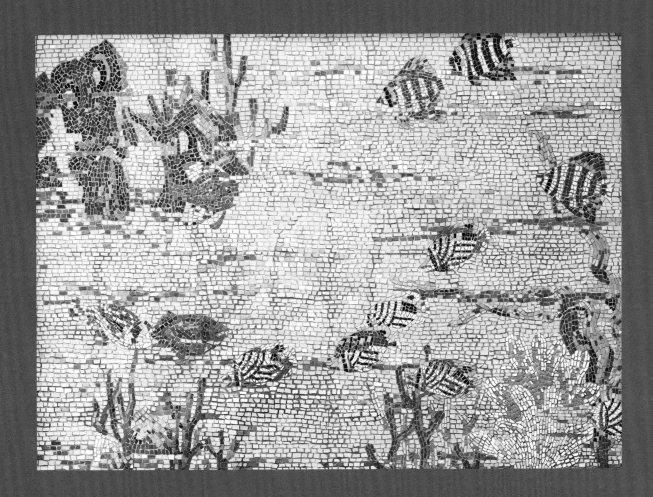

dynamic sense of movement. The rippling lines of various shades of blue depict glistening light under water, producing a gleaming, multicolored picture. This work is the only mosaic mural portraying the ocean among all of Yen's works. The forms of reefs and sea grass are reminiscent of his oil painting, *Cactus* (1962-1964). Through portraying simple plants in mountains and under the sea, the artist expressed the precious vitality of Taiwan.

This mural was broken and damaged when the company's store on Wuchang Street was closed and torn down. In 2007, Tien Kuang Enterprise commissioned Yen's students, Lin Chun-Cheng and Li Yi-Hsun, to restore the work and add the metal frame. To ensure that this national cultural property of Taiwan could be permanently and properly preserved for future generations, the company generously donated this work to the National Taiwan Craft Research and Development Institute in 2019.

Yen's mosaic mural style is refined and lively, its artistic conception is elegant and simple, and the composition rational. He applied the technique of oil painting on the mural's arrangement and mosaic collage, using different glaze colors and uneven ceramic pieces to craft the work's unique texture, producing a rich, three-dimensional effect like that of mixing and layering oil paint. Yen's well-thought-out themes are uncomplicated and down-to-earth, reflecting the artist's simple life and candid, truthful aesthetics. His mosaic works have become part of many citizens' shared memory growing up. (LEI Yi-Ting)

臺灣に生れて

彫刻家　黃土水

世間の人はよく、藝術家は變人だと云つて批難する。私も藝術家の一少分子なので、人に變り者だと云はれないやうにと、いつも氣を附けては居るものゝ、それでも時々友達などに、君は少々變物だ、人との交際が下手で困ると注意されることがある。何分彫刻は造形藝術中でも一番遣りにくい仕事で（同一程度のものを仕上げるに日本畫が一日かゝれば洋畫が一週間、彫刻は一月と云ふやうな工合）

一箇の製作に一二ヶ月乃至五六ヶ月もかゝり、少し面倒なものになると一二ヶ年から三四年もかゝる。稀には十數年或は一生涯を通じて一箇の製作に終始した人さへある。昔から七十を古稀と云つてゐるが、マア人間の壽命は長く見ても七十が程度であらう。僅かに七十年たてば大事な此のからだも淋しい墓場に運ばれ、其處で芬々たる臭氣と蠢めく蛆になつてしまふ。人間の壽命は實に短いものである。いや七十なら未だしも、實際は人生五十と云ふのが通り相場で、佛敎にも鹽より鹽に歸る五十年と云つてゐるやうに、實際人間の平均年齢は五十にも足りないのである。自分が幾つでこの世を去るかは分らないが、假に人間の定命で死ぬとすれば、もう既に半分以上を過してしまつた。殘りの年で果してどれ丈けの仕事が出來るか、それは分らないが、

の内一囘でも過つて指一本でも取り過ぎやうものなら、それこそ變て、今迄の努力も殆んど水の泡になつてしまふ。努力の方は宜いとして、石材の費用や運貨やモデル代、道具代、其他種々雜多な費用が並大抵ではない。貧しい私達にはそれが一番恐ろしい。今日は黃金萬能の時代であるから、いくら良い作をしやうと思つても、費用がなければどうすることも出來ない。只手を束ねて冥たる天に向つて溜息する外はないのである。一寸した不注意の寫に、貴重な多くの時間と、多大な費用が皆フイになつてしまふことを思へば私達は寸刻も氣を許すことが出來ないのである。かやうに、毎日彫刻の事ばかりに心を取られてゐるから、人との交際も自然頓着になり勝である。之は私達丈けではなく、一般に藝術家と云ものは大抵昔からしたものである。それ故藝術家は多く變人だと云ふ、有難くない評を受けるのである。

彫刻家の眞の使命は良い作をして、此の人間生活をより以上に美化するに在る。此の尊い使命を果すべく一箇の作と難も容易な業……

文獻

DOCUMENTS

第一位入選帝展的臺灣藝術家──黃土水

The First Taiwanese Artist Featured in the Teiten – Huang Tu-Shui

◉ 黃土水入選帝展剪報

1920年10月黃土水第一次入選日本帝國美術院展覽會,作為第一位入選帝展的臺灣人,《臺灣日日新報》連續登載黃土水相關之報導。此長篇採訪中,黃氏提到入選作品《蕃童》及同時出品卻落選的《凶蕃之馘首》製作過程,且因東京美術學校老師曾說發揮個性之重要,黃土水身為臺灣人,便思及「臺灣獨特之藝術」。黃土水未留下日記、信件等一手資料,由此報導可呈現黃氏創作的具體內容,以及他對臺灣與藝術有著特別的意念。

(鈴木惠可)

〈第二回帝國美術院展覽會出品 蕃童 黃土水氏作〉,日治時期相紙繪葉書,發行單位與年份不詳,葉柏強收藏

彫刻「蕃童」が
帝展入選する迄
黃土水君の奮闘と
其苦心談（上）

彫刻「蕃童」が
帝展入選する迄
黃土水君の奮闘と
其苦心談（下）

黃土水首度入選帝展報導（上），
引自《臺灣日日新報》，1920年10月17日，第7版

黃土水首度入選帝展報導（下），
引自《臺灣日日新報》，1920年10月19日，第7版

黃土水首度入選帝展報導，引自《臺灣日日新報》，1920年10月18日，漢文第4版

◉久邇宮邦彦王參訪報導

1920年《臺灣日日新報》報導10月29日下午，日本皇族久邇宮
邦彦王參訪大稻埕第一公學校，參訪時看到黃土水製作的大理
石《少女半身像》（圖1），遂可推測黃土水於1920年3月東美
校畢業後，同年這件作品就被學校收藏著。（鈴木惠可）

日本皇族久邇宮邦彥王參訪臺灣報導，引自《臺灣日日新報》，1920年10月30日，第7版

各種原型ノ部

三六　臺灣風景　石…

三七　鳩　石膏　昭和二年作　甄德太子奉讚展入選

三八　鹿　石膏　大正十五年作

三九　鹿　石膏　大正十五年作

四〇　水牛　石膏　大正十五年作

四一　兔　石膏　昭和五年作

四二　鯉　石膏　大正十五年作

四三　明石總督　銅　昭和四年作

四四　橫哲氏　ブロンズ　昭和四年作

四五　婦人牛身　銅　大正十五年作

各種原型ノ部

四六　御大典臺北州獻上品原型水牛群像　昭和三年作

四七　櫻姬　石膏　大正十二年作

四八　常娥　昭和二年作

四九　子供　美術學校生徒時代作

五〇　琵琶　昭和四年作

五一　大レリーフ製作用水牛原型　昭和四年作

五二　同　昭和五年作

五三　同　子　同

五四　獅子　同

五五　狐　同

五六　雞　鳥（附木彫）　昭和三年作

五七　同　同

五八　鳶　昭和三年作

即賣品ノ部

五九　龍　置物（辰年作品七點）　ブロンズ　昭和五年作　二五圓

六〇　山　羊（未年作品）　昭和五年作　二五圓

六一　綿　羊（同）　同

ブロンズ製作依頼ニ應ズル作品ノ部

六二　觀音像　木彫　大正三年國語學校生徒時代　第一師範藏

六三　猿　木彫　同　同

六四　猿　木彫　昭和二年作　林柏壽氏藏

六五　水牛　ブロンズ　昭和五年東伏見妃殿下ヘ獻上品複製　井手氏藏

六六　鹿　木彫　昭和五年總督ヨリ劇製　石塚氏藏

六七　仙人　木彫　大正四年美術學校入學ノ際　黃氏藏

六八　習作　木彫五種　大正四年美術學校生徒時代　同

六九　兔　銅　大正十五年　同

諸家所藏品ノ部

七〇　馬　銅　昭和三年　同

七一　琵琶　銅　昭和四年　龍山寺藏

七二　少女　大理石　昭和二年作　太平公學校藏

七三　釋迦如來　ブロンズ　臺灣日日新報社藏

七四　皿　木彫レリーフ　河村氏藏

七五　灰　木彫レリーフ　三好氏藏

七六　馬　木彫　土性氏藏

七七　鹿　木彫　立花氏藏

七八　狐　同　顏氏藏

七九　常娥　木彫　志保田氏藏

八〇　獅子　子　木彫レリーフ

黃土水遺作展目錄，1931年，莊永明舊藏

故黃土水君 遺作品展覽會陳列品目錄

彫刻家

日時　昭和六年五月九日、十日　午前九時ヨリ午後五時マデ
場所　舊廳舍

光榮記念品
久邇宮家御下賜銀盃　（肖像製作ニツキ）　昭和四年
總裁宮御下賜聖德太子奉讚展入選賞　昭和四年

製作品
臺灣教育會館所藏品ノ部

立像ノ部

番號	名稱	材料	備考
一	みかど雛子	木彫	宮中獻上品複製
二	雙鹿	木彫	同
三	番童	石膏	第二回帝展出品　大正七年作
四	甘露水	大理石	第三回帝展出品　大正八年作
五	ボーズせる女	石膏	第四回帝展出品　大正九年作
六	釋迦如來	石膏	昭和二年龍山寺木彫ノ原型
七	尼	石膏	美術學校生徒時代作
八	子供	石膏	大正十五年作
九	子供放尿	石膏	大正十一年作
一〇	同上未完成	大理石	大正十二年作
一一	顏國年氏	石膏	

坐像ノ部

番號	名稱	材料	備考
一五	裸婦（結髮）	石膏	昭和四年作
一六	歡田氏母堂	木彫	昭和四年作
一七	張清港氏母堂	石膏	昭和四年作
一八	郭春秧氏	石膏	昭和三年作
一九	許丙氏母堂	石膏	昭和四年作
二〇	黃純青氏	石膏	昭和四年作
二一	後藤氏令孃	石膏	昭和四年作

胸像ノ部

番號	名稱	材料	備考
二二	蔡法平氏	石膏	美術學校生徒時代作
二三	志保田氏	石膏	昭和四年作
二四	孫文氏	ブロンズ	大正十五年作
二五	高木友枝氏	石膏	昭和四年作
二六	安部幸兵衞氏	石膏	昭和五年作　昭和五年聖德太子奉讚展入選
二七	立花氏母堂	石膏	昭和四年作
二八	永野榮太郎氏	石膏	大正十五年作
二九	永田隼之助氏	石膏	大正十五年作
三〇	横哲氏	石膏	昭和五年作
三一	益子氏戚父	石膏	昭和五年作

李梅樹，黃土水葬禮速寫，1930年，李梅樹紀念館收藏

◉ 黃土水的葬禮

1930年12月下旬，長年工作過勞的雕塑家黃土水罹患盲腸炎，延誤就醫而轉為腹膜炎；住院數天後21日凌晨病歿。黃土水身邊缺少有社會經驗的家屬；李梅樹率領東京美術學校多位學弟趕赴醫院，義不容辭地處理學長的身後事。次日下午，他們護送遺體至火葬場，再由李梅樹將骨灰送回位於池袋的黃家。這一年春天李梅樹才經歷一場生死別離，愛護他的長兄劉清港醫師突然病危，他趕回臺北見最後一面並處理諸多後事，因而遲至9月才返回東京。黃土水是大家最尊敬的前輩，感情上也像是一齊獻身創作臺灣現代美術的革命同志。在火葬場等待時，李梅樹忍不住拿出口袋裡的筆記本，記錄下哀傷的時刻。（顏娟英）

李梅樹，黃土水葬禮速寫，1930年，李梅樹紀念館收藏

北師學潮：畫家的青春

The Taihoku Normal School Student Movement: The Youth of the Artists

◉ 陳植棋的學籍簿

陳植棋是臺灣畫壇中如流星般早逝的青年畫家。1906年出生於臺北橫科，1931年因病逝世。在他短短二十五年的人生中，曾兩度入選日本帝國美術院展覽會，在當時是頗受矚目的畫家。不過，陳植棋踏上藝術之道，卻與人生中的一段挫折有關。這裏所展示的陳植棋學籍簿，是他就讀臺北師範學校時的在學紀錄，學籍簿中除了記載基本資料與成績之外，也有與操行相關的文字紀錄。此處可見到以紅筆寫下陳植棋於大正十三年（1924）11月28日因「騷擾事件」而被退學的紀錄。另外也可見到以鉛筆寫著「美術學校希望（有志於美術學校）」的文字。

此處所謂的「騷擾事件」，是指發生於1924年11月的臺北師範學校的學潮。學潮爆發的原因在於校方長久以來對臺日人學生的差別待遇所累積的不滿情緒，而這樣的情緒在1924年三年級學生的修學旅行時引爆。由於校方的偏頗立場與對學生的不當處分，引發學生的抗議。陳植棋等四年級的學生，作為請願代表向校長陳情斡旋，卻不被接受，因而又引發了更進一步的罷課行動。11月28日，包含陳植棋等三十位學生，遭到學校的退學處分。陳植棋在被退學後，受到美術老師石川欽一郎的鼓勵，轉向美術之道，並且在隔年的1925年，如願考上東京美術學校西洋畫科，開始他的繪畫生涯。（邱函妮）

《自大正六至十四年度退學生徒學籍簿》封面，國立臺北教育大學校友中心暨校史館典藏

陳植棋學籍簿，引自《自大正六至十四年度退學生徒學籍簿》

《自大正六至十四年度退學生徒學籍簿》索引

生徒明細簿

生徒姓名 陳植棋　明治三九年一月一六日生

戶主姓名 陳彬琳　續柄 孫

保證人姓名 同前　續柄 同

族別 福建

原籍 現住所 台北州七星郡汐止街字橫科四八一番地

職業 農業　職業 同

資産 粟六百石

身體檢查表

下：《自大正六至十四年度退學生徒學籍簿》第二卷封面

左：《自大正六至十四年度退學生徒學籍簿》第二卷陳植棋頁

◉ 李梅樹、李澤藩、李石樵的學籍簿

陳植棋因1924年發生的「騷擾事件」而被退學。但其實不只陳植棋曾經參與學潮，與陳植棋前後期在北師就讀的美術家，如李梅樹、李澤藩、李石樵等人都曾經被捲入學潮當中。北師有兩次較大的學潮事件，較早的一次是發生在1922年2月的學潮，此次起因於北師的學生在校外因交通規則而和警察起衝突。臺北南警署長率特務警察到校壓制，有四十五名學生遭到逮補。陳植棋、李梅樹和李澤藩的學籍簿中都記載了他們因參與此次學潮而被學校處分的紀錄。李石樵比陳植棋晚入學，從他的學籍簿中也可看到他在第一學年快結束時，參與了1924年發生的學潮。（邱函妮）

昭和四年（1929）三月第二回演習科，引自《臺北第二師範學校卒業紀念寫真帖》，國立臺北教育大學典藏

《大正十五年三月卒業各部生徒學籍簿》第二十四卷李澤藩頁，國立臺北教育大學校友中心暨校史館典藏

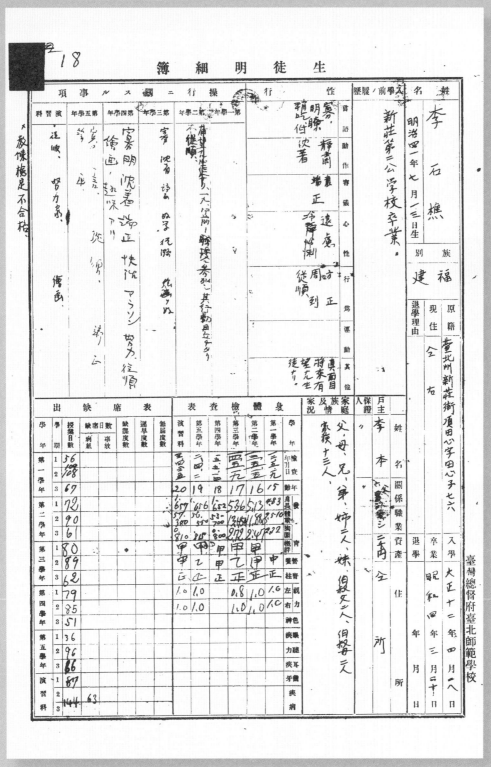

《昭和三年度卒業生徒名簿》第二卷李石樵頁，國立臺北教育大學校友中心暨校史館典藏

陳植棋相關書信

Chen Chih-Chi's Correspondence and Other Letters Related to Him

陳植棋和潘鶼鶼結婚合照，中央研究院臺灣史研究所提供

陳植棋致潘鶼鶼信件，中央研究院臺灣史研究所提供
（典藏號：T1076_03_0003）
信封正面：台灣 七星郡汐止街橫科 陳鶼々樣 親展 郵戳 〔不明〕3.11.5
信封背面：東京府下 巢鴨町上駒込二七四 高橋方 陳 十一月四日

◉ 陳植棋致妻子潘鶼鶼信件（1928年11月4日）

在異鄉求學的陳植棋經常與妻子魚雁往返，字裡行間往往流露出他的不安、苦惱、
抱負以及對未來的期望。從這些書信可以體會到一個遭遇人生挫折，背負著家人與
鄉人期待前往東京，立志有所成就的年輕人的真實心情。這封信的書寫背景是陳植
棋首次入選日本帝展後給妻子的回信。雖然在當時入選帝展是十分光榮的事，然而
在信中卻可見到陳植棋對於入選一事抱持著戒慎恐懼的心情，以及想要以藝術改造
社會的熱忱與決心。（邱函妮）

信件內文

1.
昨日久し振り親しい貴女からの便りに接せられて愉快で
した。
自分のねってゐる所は未来の社会を支配する芸術であり
ますから、これから一大馬力を掛けて猛烈に奮闘する覚
悟であります。
入選後、僅かの日にちで自分大作を三点仕上げました。
兎角帝展、台展へは毎年力作（大作）を出したいもので
あります。
自分の考へは益々大きくなり、熱は益々

翻譯

1.
昨天久違地接到親愛的你寄來的信，十分開心。
我一心鑽研的是支配未來社會的藝術，所以覺悟今
後要傾盡全力，猛烈奮鬥。
入選後，只過了幾天我便完成三件大作。
總之希望每年向帝展、臺展提出力作（大作）。
我有越來越多的想法，熱情也

2

MARUZEN (3)

3>

2.
　湧いて来ます。唯、体の健康と物質の力が根底である事は忘れてはなりません事です。
　近頃は世の中の人々がうるさくてたまりません。
　祝ひの便りの返事だけでも中々時間がかゝります。世の中の俗人は人をうん〔と〕ほめ上げて油断させ、そして突き落す悪者が多いやうであります。自分は祝便をもらってさほど喜びません。
　自重してねっちり、根気よくやる事にかぎります。
　体も出来るだけ大事にしてゐますから安心して

2.
　不斷地湧現。然而，不可忘記身體健康與物質力量才是基礎。
　最近不堪世人的喧擾。
　光是回覆祝賀信便花費許多時間。世間的俗人拼命稱讚使人輕忽大意，然後接著落井下石的壞人很多。自己收到許多祝賀信反而高興不起來。
　只能夠自重執著，努力堅持地工作。
　會盡可能地照顧身體，敬請

翻譯／蔡家丘
校對／顏娟英
日文釋讀／鈴木惠可

33.

3.
下さいませ。
人間は楽の世界を求めるなら苦の忍耐せねばならないも
のだ。
「凡人欲求楽者必忍於苦」為則
奥田さんから宜しくの便りが来られました。
共に大事に暮らしませう。
台展は如何でありませう。
自分の作は小林見たやうな古い人には分らないでせう。
自分は自分為に画くべき事である。
　　　　　　　　　　　　　　　　十一月四日
　　　　　　　　　　　　　　　　　陳植棋

阿鶼さまへ

3.
安心。
人若想要追求安樂的世界，就非忍耐痛苦不可。
以「凡人欲求樂者必忍於苦」為原則。
奧田寄來問候的信件。
彼此保重，好好地過日子吧。
臺展的事情如何了？
自己的作品，像小林那樣看來古板的人是不會理解
的吧。我是為了自己而畫。
　　　　　　　　　　　　　　　　十一月四日
　　　　　　　　　　　　　　　　　陳植棋

給阿鶼

李梅樹、李石樵致潘鶼鶼信件，中央研究院臺灣史研究所提供（典藏號: T1076_03_0011）

● 李石樵、李梅樹致陳植棋妻子潘鶼鶼書信（1930年10月9日）

李石樵與李梅樹曾就讀臺北師範學校，與陳植棋都受到石川欽一郎的影響而對美術產生興趣。他們後來也跟隨著陳植棋的腳步，先後進入東京美術學校，立志成為畫家。先來到東京的陳植棋，對於李梅樹與李石樵等人都十分照顧，也是志同道合的好友。1930年年底，已畢業返鄉的陳植棋為了參加帝展，抱病勉強赴日，雖然如願入選，卻一病不起。此時在東京代替家人照顧陳植棋的就是好友李石樵與李梅樹等人。這封信是由李石樵執筆，報告陳植棋入院中的病情與近況，信末和李梅樹共同署名。從信中可以感受他們對陳植棋病情的擔心，並且費心照顧病人的詳細情形。（邱函妮）

信件內文

1
前略
陳様のお病気の経過を知せ申上げます。それ以後別にこれといふことがなく順調に恢復しつゝあるのですが吾等が思ったのよりも時間がかゝったのでその全快の日の来るのが待ち遠しくてたまりません。御本人にとっても何となく病院がいやで仕様がないと言って居られました。現在では元気は随分あるし、大して瘠せては居ないし、意識がはっきりして、平常と何ら変りがございません。熱は平熱を保ってゐますが時々発寒して微熱を見るばかりです。今ではその微熱が気になるだけで絶対に危険がございません。若しその熱がなかったらと希った末、昨夜梅樹兄と一緒に先生と詳しくその真実の経過、病状、及び以後の療養法を相談し、聞かせてもらいました。先生は
「このやうに行けば大へん経過がよいといはれる。た

翻譯

1
前略
謹以此信向您說明陳先生的病情進展。後來沒有什麼特殊狀況，身體逐漸恢復健康，但比我們預料地更花時間，急切盼望早日痊癒，實在感到煎熬。他本人也說總覺得不想待在醫院中。現在他的精神相當不錯，並沒有太過消瘦，意識清楚，與平常沒什麼兩樣。體溫保持正常，但有時發冷且持續微燒。現在只擔心微燒的症狀，但是病情絕非危急。由於我們希望發燒的症狀能夠改善，昨晚和梅樹兄一起拜訪醫師，請教他病情的實際進展、病況以及後續的療養方式。醫生說：「按照目前的狀況，病情算是恢復得不錯。不過

2

最初（入院前）無理なことをした為め時間がかゝった分けで、肺の方へは絶対に移ってゐませんから、間違ひなく治ります。一般に肋膜炎は治りにくい病気で治ったやうであってなかなか治りません。治ったと言って事実すっかり治ってゐなければ百人に八十人以上は三年乃至五年で肺病で倒れます。私は肋膜に対してはやかましいもので、治ってゐないものを治ったといったら親切なやうで甚だ不親切であります。して今が大事で、完全に治ったら以前よりも肋膜が強くなり却って肺病に罹る心配がないやうになります。早く帰りたいと言ってゐるやうですが今の所では決してそのやうなことを考へてはならない。汽車や汽船で必ず悪くしますからこの方面の病気はゆっくりした気持で当地で療養して暖くなってから帰った方がよいでせう」と。

だが私等の方では経済関係から、お家の絶え

2

由於起初（入院前）太過勉強，因此恢復需要些時間。並沒有傳染到肺部，所以一定可以治好。一般而言，肋膜炎是很難治療的疾病，看起來像是好了，但卻很難完全康復。看似痊癒，卻沒有徹底治好的話，一百個人裡面有八十人以上會在三五年內因肺病而倒下。所以我在肋膜炎的治療上會特別地仔細。還沒痊癒卻說治好了，看似親切，實際上卻是非常地不負責任。因此現在正是關鍵時期，完全治好的話，肋膜會比生病前更加強健，也不必擔心會罹患肺病。雖然好像病人說想要早點回家，但是現在絕對不可以考慮這樣的事情。搭火車跟搭汽船都會讓病情惡化，這個疾病必須平心靜氣慢慢地在當地療養，等天氣暖和以後再回去會比較好。」不過，我們向醫師說明由於經濟狀況，並且家裡非常的擔心，

3

ざる御心配から、といふやうなことを言って何時頃退院が許されますかと聞いたら「これからの経過も考慮して若し平熱を保って行けば本月二十日あたりに下宿の方へお帰りになって往診でもしたらよいでせう。そして一応針を刺してみて水の有無を確かめませう」

今日も注射器で背中の方から百瓦ばかりの水を取り出しました。水の質がよくて血がなく余り濁ってゐませんでした。明後日も一度取ってみるさうです。二十日あたりに私等の方でも学校は休みであるから都合がようございます。下宿に居ても今の病勢から考へてやはり経験のある附添婦が必要でせう。

尚御承知の通り陳様は殊に御病気になってから、さうだ何々の支那料理を食べたい、あゝ、あっさりした何々の日本料理を食べたいといふやうに気持ちが

3

想知道到底何時才允許出院。醫生回答說：「也要看後續的恢復狀況，若是體溫保持正常，預計在這個月的二十號左右可以先回去租屋處，然後再由醫生出診會比較好。總之我先針刺檢查，看看是否有積水的現象。」

今天也用注射針從背部取出大約一百毫升的水。水質不錯，沒有帶血，不太混濁。後天會再取一次水。二十日左右學校也休息，對我們來說也較方便。但是即使返回租屋處，按照現在的病情來考慮的話，還是需要有經驗的看護來幫忙吧。

我想您們已經知道，陳先生在生病以後會隨著心情而突然想吃這吃那的，例如他會說：對了，現在想吃某某中華料理；又會說，啊！我想吃某某清淡的日本料理。

4
変わりますから現在の所、何とかして間に合わせてゐます。尤もそのやうなことは病人に取っては当然のことですから。先に御手紙でお家の方御一人いらっしゃるさうですが陳様では御自分では早く治ると思って、又御父上様でも余り御丈夫ではないし、お家の仕事が多ふございますから、そんなにしなくてもよいといふことにして置いたのです。尚奥様がいらっしゃるとしたら、寒い時節だし昭陽ちゃんが困りますからと言ふこともありました。若しお出になると仮定したら看護婦の一月七十円位のお金がいらないし、お食事も好きなものが食べられますから、大へん結構でございます。でも色々なその事情の為め御本人でも口に出せません。尚現在では幾分か親切な看護婦さんをやとっていますから、吾等も出来るだけ尽して不自由ないやうにして上げてゐますから御安心下さいませ。そして追々よくなれば看護

4
現在還可以想辦法滿足他的需求。當然，這是病人應有的權利。在先前的信中提到家裡會派一個人過來，不過陳先生自己認為可以很快治好，父親的身體也不太好，家裡的事情也多，所以有交代不需要有人過來。並且若夫人過來的話，現在也是寒冷的季節，也不知如何照顧昭陽。不過，若能過來的話，一個月可以節省七十圓左右的護士費用，也可以隨時吃愛吃的東西，將會十分理想。然而由於種種緣故，因此本人也不好意思說出口。現在倩請了一位還算親切的護士，我們也盡量不要讓他覺得不如意，敬請安心。病情逐漸好轉的話，

翻譯／邱函妮
日文釋讀、校對／
鈴木惠可

5
婦もいらなくなるし、気持ちもやはらげられて行くでせう。
尚以前には直ぐ治るといふやうなことを何回も差上げてお家の方々をだましたやうな形になってゐましたが不経験な私等はそのやうに信じてゐたからです。
陳様は起きられない（先生からそのやうにさせてゐるから）から御手紙を書く時は仰向けになって書き、興奮してしまひますから、発熱の原因を引き起します。その点御了承を願ひます。
先づは御通知まで。

<div align="right">

皆様の御壮健を祈る。
乱筆を謝す。
十月九日夜　　　李梅樹
李石樵

</div>

陳鶲々様

5
也就不需要護士，心情也會慢慢地變輕鬆吧。另外，以前我們好幾次在信上說馬上就會治好，看起來好像在欺騙您們的樣子，然而這是由於我們缺乏經驗，一直相信馬上就會痊癒的緣故。
陳先生還無法起身（醫生囑咐不可起床），因此寫信時得躺著寫，這會讓他過於激動而發燒。這一點也請諒解。
謹此通知。

<div align="right">

祝福各位健朗
匆忙寫就，敬請見諒
十月九日夜　　　李梅樹
李石樵

</div>

陳鶲々女士

◉ 李石樵致陳植棋妹妹陳鶴書信（1931年12月30日）

李石樵致陳鶴信件，中央研究院臺灣史研究所提供（典藏號：T1076_03_0019）

信件內文

拜啓

昨日珍しい御土産を頂戴しまして恐縮に堪へません。
美味しく戴きました。御礼申上げます。
次ぎにお兄さまの遺作品は先日岡田先生を訪問した際
に見て頂きましてその中、五点受付けて下さることに
なりました。
淡水風景、静物、自像、花、真人廟。
例年ならば春台展は何もそんな大した展覧会ではないが
来年から色々な小団体の展覧会がなくなるものですか
ら、現在では各方面から人気が集って相当盛会になるも
のと予想されてゐます。出来るだけ多く出したかったけ
れど会の性質から、作品の上から考へて五点受付けて下
されば結構なものと感謝しなければなりません。

翻譯

敬啓者

昨天收到您送來的珍奇特產，實在過意不去。非常
地美味，謹致上感謝之意。
其次，前幾日我去拜訪岡田老師時讓他看了您大哥
的遺作，他收下其中五件作品如下。
淡水風景、静物、自畫像、花、真人廟。
往年春臺展不是什麼太了不起的展覽會，但是從明
年起，將會有許多小團體的展覽會停辦，預料會受
到各界的歡迎，而成為一大盛會。雖然想盡可能地
多展出一些作品，但考慮到展覽會的性質，以及作
品本身，能收下這五件作品，已經是很好的結果

翻譯／邱函妮
日文釋讀、校對／
鈴木惠可

念の為め出品目録を同封しましたから御覧下さいませ。
それから額縁のことですが、静物と自像の方は風景幅の
ものですから友人の間では誰でも持ってゐません。（現
在風景幅の絵は殆ど誰も描きません）それで額縁屋から
借りることになりました。外の三点は私の持合せのもの
を使用しました。何卒御休神下さいませ。
先づは通知並びに厚く御礼申上げます。
年の始めに当り皆々様の御健康を祈り申上げます。
乱筆にて失礼。

<div style="text-align:right">

十二月三十日
石樵
李梅樹先生からも御礼申上げます
</div>

陳様

了，不感謝不行。
慎重起見，隨信附上展出目錄，請過目。
關於畫框一事，由於靜物和自畫像為風景型的尺
寸，朋友之間沒有人有這種尺寸的畫框（現在幾乎
沒有人畫風景型尺寸的畫了）。因此向畫框店借
用。另外三件作品就使用我現有的畫框，請安心。
在此先通知此事並致上深深的感謝之意。
新年恭祝各位身體健康。
字跡潦草請見諒。

<div style="text-align:right">

十二月三十日
石樵
李梅樹先生亦致上感謝之意
</div>

陳女士

川島理一郎《旅人之眼》

Traveler's Eye by Kawashima Riichiro

川島理一郎，《旅人の眼》，東京：龍星閣，1936

川島理一郎於1929年第二次造訪臺灣，期間前往烏來泰雅族部落，由警察安排陪同，搭乘臺車與轎子，經過迂迴的崖道後抵達。他觀察原住民的農穫活動、穀倉建築，聽到原住民婦女持杵搗米的音律，猶如千古傳響，深受感動。川島的遊記〈烏來から淡水へ　台湾風物記の一〉發表在雜誌《中央美術》上：

「男人背著大綑的稻子回來，或者正忙著將稻子收入稱作カホ（kaho）的穀倉內。此稱為kaho的穀倉很像日本古代建築，竹子作成柱子，屋頂上覆蓋著茅草，地板架高，柱子上附加防止老鼠爬上去的圓形木板套子。此外，也看到三、四位女人拿著長杵來回搗米的情景。在稱為ロホン（rohon）的鼓形臼上，拿著叫做カセジュ（kasejiu）的長杵輪流搗擊，那樣的聲音令人回想到千古以前的往昔，正是臺灣有名的特色，據說也有人特定來此聆聽。像這樣依然生活在神話時代似的蕃人生活是如此的和平，這樣的美麗，令人不由得感動。」

兩件描繪原住民的插畫，原本是作為該遊記的插圖，分別標為〈鐵砲を持つ蕃人〉（持槍的蕃人）與〈はた織る蕃女〉（機織的蕃女），此遊記後來收於畫家文集《旅人之眼》中。圖左下為妻子飯田李花子的落款「李花子」。

兩件插畫看似簡單勾勒人物輪廓，但都恰如其分地表現出人物與器物造型的特徵，以及原住民生活的剪影。無論是遊記的內容或插畫的表現方式，都可見到畫家對遠古文明生活有著濃厚的興趣。事實上，川島於1910年代初到巴黎遊學，就十分嚮往古典文明，曾經與藤田嗣治（1886-1968）一起模仿古希臘式的生活和舞蹈，1930年代也曾從中發想設計馬賽克壁畫。由此可知，川島在遊歷臺灣的過程中，再次對古典文明產生了共鳴，將這樣的關注從歐洲轉移到對臺灣原民文化的觀察與描繪。（蔡家丘）

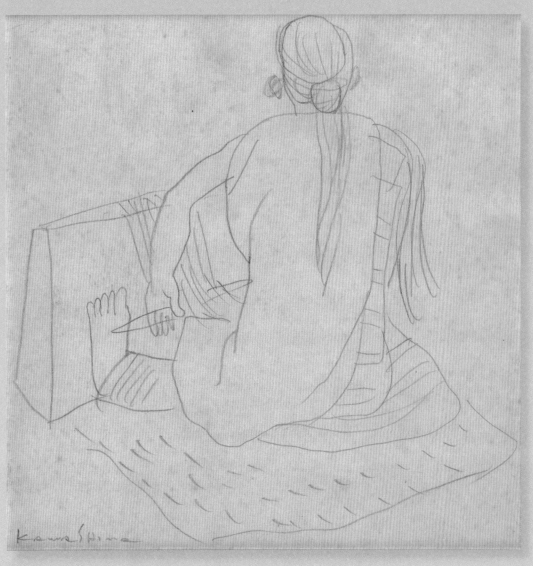

川島理一郎，《旅人之眼
——臺灣風物記（女）》，
1929年，鉛筆、紙，寄暢園
收藏

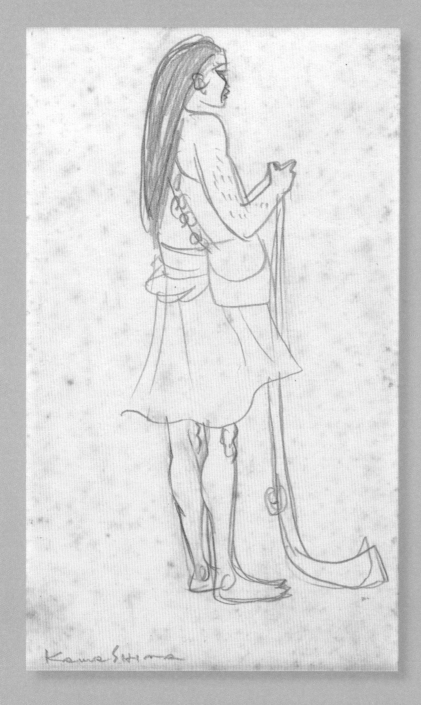

川島理一郎，《旅人之眼——臺灣風
物記（男）》，1929年，鉛筆、紙，
寄暢園收藏

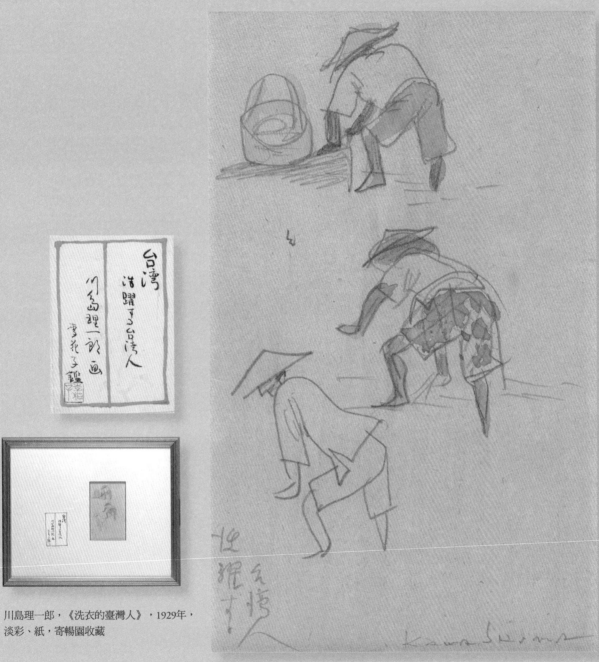

川島理一郎，《洗衣的臺灣人》，1929年，
淡彩、紙，寄暢園收藏

石川欽一郎於《臺灣日日新報》的旅行隨筆專欄

Ishikawa Kinichiro's Column of Travelogues on *Taiwan NichiNichi Shinpo*

石川欽一郎於1930年10月第四回臺展展出《驛路初夏（郊野）》前，7月曾於《臺灣日日新報》發表關於苗栗街景的圖文，其中如7月26日夕刊版三的插繪，取景角度與樹木房舍的配置便與《驛路初夏》頗有雷同。石川並記述此處為苗栗南部大湖街道的入口，可見牛車、臺車、汽車、與旅人往來，「有著難捨的驛路風情」。由此推測《驛路初夏（郊野）》可能是石川在夏天行旅至此後進一步的創作。（蔡家丘）

石川欽一郎（欽一廬），〈光風青山（三）苗栗の街〉，《臺灣日日新報》，1930年7月26日，夕刊第3版

陳澄波《東臺灣臨海道路》相關資料

Documents related to Chen Cheng-Po's *East Taiwan Seaside Road*

陳澄波的《東臺灣臨海道路》（圖27）長年下落不明，僅從報紙及畫家的相簿中得知其存在。2015年由撰寫上山滿之進傳記的兒玉識先生，發現收藏於日本山口縣防府市立防府圖書館的一件風景畫，即是陳澄波繪製於1930年的作品。防府圖書館的前身是防府市立三哲文庫，是上山滿之進晚年為了回饋故鄉所捐贈建立的圖書館。1941年開館，上山滿之進的相關文獻與遺物也一起捐贈與寄存。陳澄波的畫作很可能在此時一起入藏。在1930年的報紙中記載了這件畫作的創作經緯。曾擔任第十一任臺灣總督的上山滿之進在卸任之際，委託陳澄波製作繪畫以作為紀念。（邱函妮）

掛著陳澄波《東臺灣臨海道路》之舊防府圖書館閱覽室風景，防府市立防府圖書館典藏，栖來光拍攝

臺南州下縱貫道路

社會事業係員

大屯郡庄長會

【臺中電話】大屯州大屯郡では十

年度自治記念體育會を開催す
その費用、方法、期日等について
各公學校長郡に集まり十一日打合

久保田顧問官
訪伊東伯

平沼副議長
訪伊東伯

罷學高等校生
依然蹲居學寮
教授會對高等科生
停學兩日間促其反省

兩視學官
與校長協議

一百二十日
全國平穩

共匪軍敗中央軍
迫近花園六華里

中央軍準備北進
軍需品續々到漢
轉送平漢線方面

太魯閣峽　臨海道路　為山上薰庵前督憲囑筆　嘉義陳澄波氏作

漢文 臺灣日日新報

昭和五年九月十二日

政府堅持強硬態度
內閣運命置諸度外
樞府不諒解則附期限奏請
若否決條約案則為反對上奏，
以國民多數支持為盾斷然與鬪

十一日東電。樞府側之態度硬化中。又財源上之數字。將如何配村于補充計畫與國民負擔輕減。在今且實不能說明。非決故意為回避。政府對于補充計畫。可以不要。此置混同其諸詢機關之職分與其言。而樞府稱為此若企。用則樞府審查。思以責任為實現。是以現在望為信用政治的見解也。有大權輔弼重責之政府。其言明不能置信。非為審議之前提條件也。而樞府猶不諒解政府計畫。須于條約御批准後乃為立案。最早不可不為附期限審論之言之。如補充計畫。在政府側見解。以補充計畫之具體案。目下在海軍當局作成中。又財源約五億三千萬圓。議之奏請。若停止委員會。于本會議否決條約案時。不外取反對附期限審議之途耳。政府受國民多數支持。而縮結條約。有反對者。斷然與鬪。諸度外也。觀此。十二日之第十四委員會將全在于是矣。政府安危之岐路。此際全置全國 天氣平穩。農作物無事。（電通東京十一日發）

〈太魯閣峽 臨海道路 為上山
蔗庵前督憲囑筆 嘉義陳澄波
氏作〉，《臺灣日日新報》，
1930年9月12日，第4版

閣氏赴德州督戰
待張氏態度決定

十一日北平電。閻錫山氏之赴德州。以奉天會議。形勢明白。俞要四五日。故于此間欲出戰線督戰。又十五日。張學良氏態度若明。閻鴻兩氏代表。將為復命。茲與閣氏復歸相候。時局將見轉回也。

閣錫山氏向德州
將歸京樹立政府
云　最短期間內

十一日北平電。閻錫山氏。十一日午前零時四十分。發平漢驛。向德州。臨行語云。今後行動。因軍事期間中。遠慮不能竟表。但最短期間內。當歸京以當政府之樹立。余不在中。汪兆銘氏望徒速無事解決之也。又擴大會議委員趙戴文氏等。亦同赴德州云。

市內學童　齲齒診查
囑託齒科醫　歷訪父兄
以求諒解

小公學校兒童之保健衛生。當局亦甚苦心。注意于向上發達。最近因口腔衛生思想普及。家庭間亦漸致愛惜。甚為鳩首協議。而學生二名訪問本社。陳述如左之部立於主動的地位。而被退學之人。又適寫運動部員。文科三年乙。時有代表者十五名。十一日午前十一

文科三年乙組
提出反對意見
反對盟休

高校照休。自最初立於反對之怫位者。有文科三年乙。就中約有四五十名。於十一日。提出盟休反對意見。於學校當局。同時委員二名回事件之醸成。運動此回事件之醸成。康診斷。既報因山基隆署。命令健結束業之基隆時。十一日午前十一

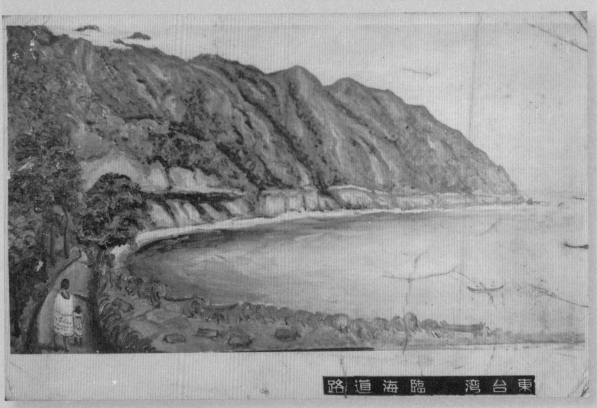

陳澄波《東臺灣臨海道路》之明信片，出自陳澄波相簿，中央研究院臺灣史研究所典藏

〈上山記念金 高砂族研究の為め　全部提供に決定〉，《臺灣日日新報》，1930年10月16日，第2版

〈上山前總督紀念金為研究高砂族決定全部提供〉，《臺灣日日新報》，1930年10月16日，第4版

郭雪湖《萊園春色》草稿相關寫生本
Kuo Hsueh-Hu's Sketch Book with Sketches of *Spring in the Garden Lai*

郭雪湖素描簿，1937-1975年，郭雪湖基金會收藏，中央研究院臺灣史研究所提供

這本寫生稿在封面寫著「霧峰、三角仔卷」；霧峰指林家萊園、三角仔即神岡呂家筱雲山莊兩處寫生地點；時間從1937年8月到1939年2月。林家花園從清末到日治時期不斷地擴建整治，融合閩式、江南庭園與西式建築元素，花木扶疏，景致優美；代表臺灣中部地區仕紳的精緻文化。出身臺北大稻埕商街的畫家郭雪湖，頗為著迷於林家花園曲徑通幽，整齊華麗的景象，早在1934、1935年就多次到此地盤桓寫生，尋求創作的靈感。（顏娟英）

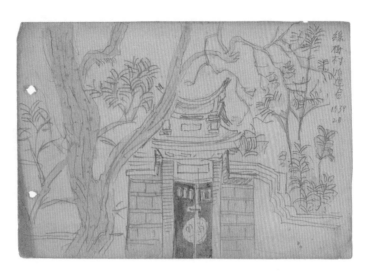

劉啟祥目前僅存的親筆書信（1961年10月4日）
The Only Existing Letter Written by Liu Chi-Hsiang

2010年秋天，劉家接到一通來自日本的陌生電話，一對年邁的雙胞胎——富貴子、紀久子女士，希望將保管多年的劉啟祥作品物歸原主：數幅戰前的油畫，多幀紀錄生活剪影的老照片，及劉啟祥和長子耿一於1961年寄出的書信。本次首度展陳的畫作《有樹幹的景物》（圖9）、相本與親筆信，皆來自這場跨越半世紀情誼的尋人與歸還故事。

1935年，結束三年多歐遊生活的劉啟祥，回到東京目黑區柿之木坂306號購屋定居，隔年與笹本雪子（1918-1950）結婚成家。當時的鄰居即富貴子、紀久子的父親——海軍少將坂上富平（1895-1980）。從相本可知，這幢毀於戰爭的家屋，曾見證兩家庭共同製作新年麻糬、拍攝全家福等溫馨融洽的互動場景。坂上從事機械技術的研究，曾任海軍學校校長，參與航空母艦的建造，在日本海軍史上佔有一席之地。不難想像，此一敏感身分，在戰後戒嚴與通訊網絡不甚發達的年代，或許曾多少增添了聯繫的困難度。

告別日本十六年後，劉啟祥終於在1961年10月4日提筆寫信給交情深厚的鄰居。如此長的親筆文書，是內斂的畫家目前僅見的一封。信中提及遷居的過程、妻子逝世與孩子的成長，並附兩張相片交代近況。其一為1954年於高雄縣大樹鄉小坪頂，毗鄰果園和給水廠的山坡地興建的家屋畫室，此處是劉啟祥招待畫友與創作的靈感地。其二是1961年4月於高雄市自宅開設的「啟祥畫廊」內首次舉辦的個展。當年的劉啟祥以精神領袖之姿，擘劃著未來高雄美術發展的藍圖，與此信同月正式成立的「臺灣南部美術協會」，成為往後數十年培育地方

劉啟祥寫給坂上富平的書信，1961年，劉耿一收藏，中央研究院臺灣史研究所提供

美術人才的重要舞臺。相片中的他神態自信而愉悅，彷彿向好友述說著自己的抱負與理想正逐步實現。信末表達了相見的期待，並請坂上的兒女「寫信給我家的孩子」。可惜畫家生前未再前往日本，寄放的畫作因而由坂上的後代接手保存。

2011年夏天，年逾古稀的劉耿一偕夫人回到出生地，拜訪幼年對自己照顧有加的坂上姊妹並取回父親的物品。坂上富平在1946年2月1日的日記中寫道：「住在隔壁的臺灣劉先生，今日要搭永川丸出發航行。」、「要和夫人離別，心裡感到難過，不過一定還能再見面。」遲來六十五年的會面不僅圓了長輩的夢，一幅幅新出土的珍貴畫作，勢必也將為臺灣美術史再添寶貴的一頁。（日記引自劉耿一〈倒流的時光〉，《文學臺灣》第108期，2018年10月15日，頁13。全文記述作者取回畫作的完整過程。）（張閔俞）

十五歳になった男子伯熙が出生 その後また子が高雄市に住み

たいとふのひ日本式の住家一棟を買取ってそこに十二歳になる

女子小学六年級の季嫻が生れました又女子からの時分病を得

やっと今月です産もした為また無事でしたが四身は弱却

てこの世を去りました今また十二年前の事です

皆様に今を御知らせ出来て敷へて手紙を書く気にはな

れませんでした子が色々と御世話になってる皆様に対して申

訳なくお詫び申します今後も唯子供達の教育

に力を注いでいる次第であります

耿一は今年三十四歳尚弘は二十歳潤子は十八歳今後とも

がひらして東京へ行かし皆様にお目にかかる日があると念願

しって居ります 同封の寶眞は八年前高雄郊外團りは

龍眠の木蔚支樹オレンヂとネーブルの小山に池を前にして建

これは教室です　後隣りは高雄市水源地になってます　子供達
はここから学校へ通ってます
別一枚は今年四月中高雄市の自宅で個人展を開いて撮ったもの
です　まづい粗ですが　一つ御覧になって下さつ　子供達の宝貝と
は後程　差し上ますれば　つれに若いか出来ますれば
皆様の御写真を記念に戴けば　全幸に存じます
中島様　中村様　辻村様　西村様の皆様　お元気にせらるか？
宜しく御傳へ下さませ　中島さん　中村さん　お住居の市坂に
住んびつらしゃいますか　一つ御住所を御知らせ下さつ
粉錫び姓名　創生容以前平町に住んでましむトモ工学園に
通ってた頃よ、横の市坂の家へ遊びに来たのです　今度東
京へ行くことに成りまして　長い間御世話に頼つたお荷物
もい様にかたづけました　本よらませ　長い間お
長い間か邪魔して申し

訳申座ります　本当に有り難う御礼つまました

明年東京へ行く機会があると思ます　遠くより皆様に

お目にかゝる事もたのしく待っています

ひばるか南の空び皆様の健康を祈りつゝ

　　　　　　　　　　敬具

一九六一年　十月四日

　　　台湾省高雄県大樹郷小坪村

　　　六十六号

　　　　劉啓祥拝

トシちゃん
キクちゃん
トミちゃん
フミちゃん
家の子れに御便り下さいませ

劉啟祥書信附寄照片（左：高雄縣小坪頂劉啟祥家居，右：劉啟祥1961年於啟祥畫廊個展前留影），劉耿一收藏，中央研究院臺灣史研究所提供

坂上先生同夫人鈞鑑：

年月如矢般地流逝，大家平安否？別後諒必益加健壯，為您感到欣慰。回首十六年的歲月如一日，昔日東京居的記憶如今依然清晰地浮現腦海。你們大家親切深厚的友情，至今難以忘懷，不勝感激，在此鞠躬致謝。別後令郎令嬡均有成就，致上恭賀之意。聽說日本日益進步，邁入繁榮之路，這是全日本國民偉大之處，真正值得慶賀。臺灣也向日新繁榮的道路前進。

我們回到臺灣，住在臺南縣的故鄉柳營，過了二年和在日本無異的歡樂歲月，期間雪子生下兒子伯熙，現已十五歲。之後雪子想住高雄，所以買了一棟日式住宅，在那裡生下現在十二歲，唸讀小學六年級的女兒季娥。雪子當時因病勉強支持到八個月分娩，孩子平安，但母體衰弱於翌日去世。距今已經十二年前的事，一直不能告知大家，也無法寫信表達心情。對昔日曾多方照顧雪子的您們，深感抱歉，請多諒解。今後也只有對孩子們的教育來盡力而已。

耿一今年二十四歲，尚弘二十歲，潤朱十八歲，日後會讓他們到東京，希望跟大家見面的日子到來。附寄的照片是八年前在高雄市郊附近有龍眼樹、荔枝、柳橙、蓮霧的小山上，面對水池而建的畫室。後臨高雄市水源地，小孩們由此通學。另一張是今

年四月中於高雄市自宅舉行個展時拍攝的，效果不是很好，但請您欣賞一下。孩子們的照片，以後再送給您。順便一提，如果方便的話，請寄大家的照片當做紀念，即感榮幸。

中島先生、中村先生、辻村先生、西村先生是否無恙，想必大家平安，拜託轉達問候之意。中島和中村先生是否還住在柿之木坂？請告知住所。

我甥兒劉生容以前住在平町，通學到「トモエ學園」之時，常去我們柿之木坂的家玩。他這次決定要去東京，長期受您照顧的行李（物品），拜託他幫忙處理。長時期打擾，很抱歉，不知如何道謝，真的非常感謝。

我想明年有去東京的機會，不久的將來可以見到你們，雀躍地等待那一天的到來。就在此遙遠的南方天空，祈禱大家身體健康。

劉啟祥上 1961年10月4日
臺灣省高雄縣大樹鄉小坪村六十六號

トシ子、紀久子、トミ子、富美子，
請寫信給我家的孩子。

陳進《三地門社之女》畫稿

Drafts of *Women of Sandimen* by Chen Chin

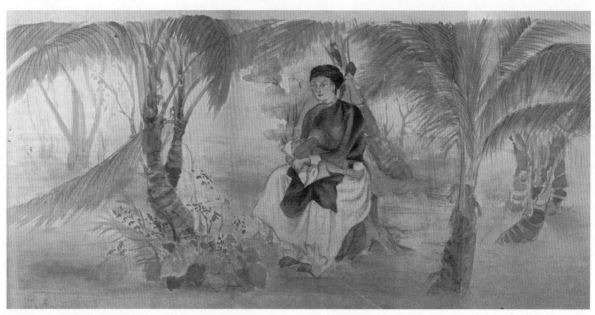

陳進，《三地門社之女寫生稿》，1936年，水彩、紙，31.0 x 73.0 公分，私人收藏

陳進1934年以《合奏》入選第十五回帝展，不久被聘至屏東高女擔任圖畫科教師，至1937年
前往東京定居為止。她任教屏東高女期間取材臺灣原住民主題的作品，再度獲得帝展的肯
定，即此件入選1936年文展的《サンティモン社の女》（三地門社之女，圖5）。本幅創作過
程頗費周章，畫家不但前往三地門社排灣族部落進行水彩寫生，還速寫模特兒並拍攝照片，
作為構思主題的靈感來源。完成小幅試作後，接著製作大底稿，然後在東京借用東京上野寬
永寺大廣間完成此件大作。換句話說，陳進從寫生、製作草圖、試作、線描底稿到完成品的
繪製過程，費盡心思琢磨如何以日本美人畫技法詮釋排灣族婦孺的家居生活，意圖呈現原住
民的文化特質，又能保有美人畫優雅的特色。（黃琪惠）

陳進，《三地門社之女底稿》，1936年，墨彩、紙，134.5 x 196.5 公分，私人收藏

小澤秋成 《高雄介紹》 明信片

Postcards from *Introduction to Kaohsiung* by Ozawa Shusei

1933年小澤秋成接受高雄市役所委託，作為宣傳，繪製三十多幅高雄風景畫，於州廳展出，並選取部分作品印製成風景繪葉書。（蔡家丘）

小澤秋成，《高雄介紹》明信片一套，1934年，高雄市役所發行，郭双富先生收藏

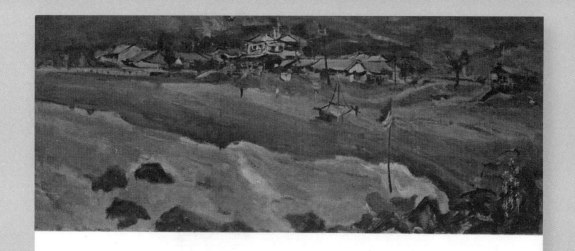

西·子灣海水浴場　　高雄市役所選　　小澤秋成筆

《西子灣海水浴場》

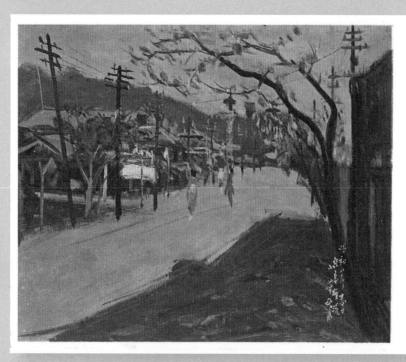

春
の
湊
町

高雄市役所選

小澤秋成筆

《春の湊町》（春之湊町）

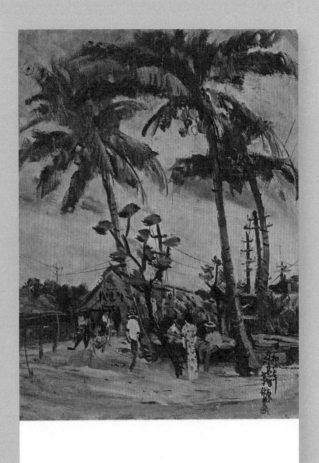

高雄驛前　　高雄市役所選　　小澤秋成筆

《高雄驛前》（高雄車站前）

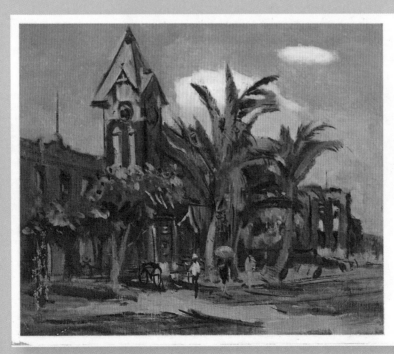

埠頭の建物　　高雄市役所選　　小澤秋成筆

《埠頭の建物》（港口的建築）

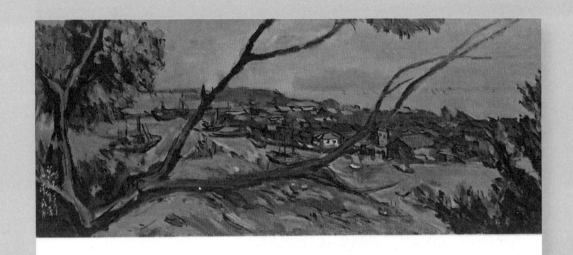

高雄市濫觴の旗後　　　高雄市役所選　　小澤秋成筆

《高雄市濫觴の旗後》（高雄市的發源地旗後）

棧　　橋　　高雄市役所選　　小澤秋成筆

《棧橋》

《渡船場の花》（渡船場之花）

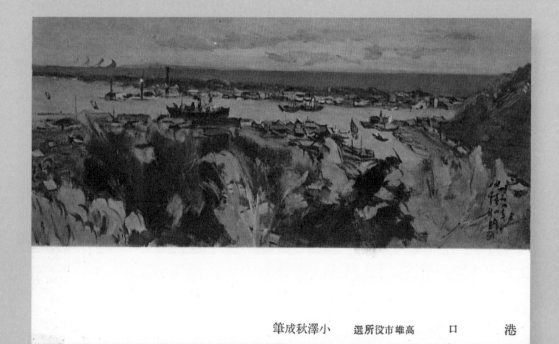

《港口》

壽山の散歩道　高雄市役所選　小澤秋成筆

《壽山の散歩道》（壽山的散步道）

觀測所より港內を望む　高雄市役所選　小澤秋成筆

《觀測所より港內を望む》（從觀測所望向港內）

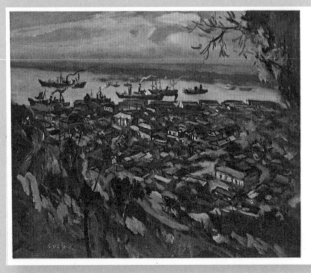

岸壁の遠望　髙雄市役所選　小澤秋成筆

《岸壁の遠望》（眺望碼頭）

小澤秋成《臺北風景》相關報導

Newspaper Reports about *Scenery of Taipei* by Ozawa Shusei

1931年小澤秋成受邀來臺擔任第五回臺展的審查員，才來不過數日，就以兩件描繪臺北林蔭
道的作品參展。在大澤貞吉（鷗亭生）的展覽評論中提到《臺北風景》（圖69）這件作品，
認為構圖類似擅長描繪巴黎郊外風景的尤特里羅（Maurice Utrillo）。小澤秋成曾擔任第五、
六、七回的臺展西洋畫部審查員，1932年在臺北舉辦個展時，由同時期在巴黎習畫的陳清汾
為其撰寫展覽評論，他提到小澤所描繪的都會風景，在歐洲也頗受好評。（邱函妮）

小澤秋成《臺北風景》（上方照片右二）陳列於第五回臺展會場，引自《臺灣日日新報》，1931年10月26日，第7版

鷗亭生（大澤貞吉），〈臺展洋畫部に投げられた爆彈—小澤審查員の作を評す〉，《臺灣日日新報》，1931年10月26日，第3版

陳清汾，〈小澤秋成氏の個展に就いての雜感（1）─吾々は氏の何を学ぶべきか〉，《臺灣日日新報》，1932年7月21日，第3版

陳清汾，〈小澤秋成氏の個展に就いての雑感（2）－臺展と都市美〉，《臺灣日日新報》，1932年7月22日，第3版

山崎省三《戎克船之朝》與「畫框」

Yamazaki Shozo's *A Junk in the Morning* and Its "Frame"

這件作品目前鑲嵌的畫框，是總督府文教局學務科職員平川知道，於1935年入選臺展第九回作品《靜物》的畫框，原作目前僅見於臺展圖錄中。兩件作品可能先後被收藏到臺灣教育會館，而後被誤裝在一起。

1933年11月18至20日，山崎省三來臺於教育會館舉辦個展，展出作品約三十件，當時展覽消息與作品的黑白圖版刊登於《臺灣日日新報》、《大阪每日新聞》，包括此作，故可確知此作為山崎省三《戎克船之朝（ジャンクの朝）》（圖71）。又，作品畫面左下角的簽名「shozo. y」，是山崎省三姓名拼音Yamazaki Shozo的縮寫，為山崎常用的簽名方式之一。（蔡家丘）

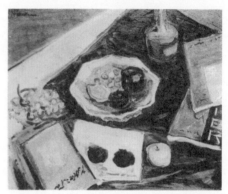

平川知道，《靜物》，1935年，引自中央研究院歷史語言研究所臺展資料庫

〈春陽會員山崎氏の個展　教育會館で〉，《臺灣日日新報》，1933年11月18日，第6版

山崎省三，《戎克船之朝（ジャンクの朝）》，1933年，油彩、畫布，58.5 x 71.5 公分，國立臺灣博物館典藏

平川知道第九回臺展（1935年）作品畫框細部

平川知道第九回臺展（1935年）作品畫框背面

立石鐵臣《風景》描繪地點與創作年代考證

Research about the Location and Year of *Landscape* by Tateishi Tetsuomi

最初見到《風景》（圖32）這件畫作時，還不知道創作年代與描繪地點。從作品背面所貼的標籤可知作者是立石鐵臣，標籤上也寫著畫家當時在臺北大安的地址。立石從1940年起居住於此地，因此推測作品的創作年代應該是在1940-48年之間。進一步查閱這段時期的資料，可以找到關於此畫作的更多訊息。由於立石鐵臣曾經在臺灣發行的雜誌上刊登許多插畫與文章，在比對《民俗臺灣》的插畫後，可知作品中所描繪的建築是臺灣基督長老教臺南神學校。進而翻閱1941年的《文藝臺灣》，發現了立石所寫的〈臺南通信〉。在這篇文章中，他提到了在1941年元旦到臺南旅行，以及在臺南神學校校園中寫生的經過。（邱函妮）

立石鐵臣，〈台南　旧長老教会神学校〉，《民俗台灣》，第2卷第7號，1942年7月

臺南神學校照片，引自臺南長老大會編，《南部臺灣基督長老教會設教七十週年紀念》，臺南市：教會公報，2004

信通南臺

立石鐵臣

立石鐵臣，〈臺南通信〉，《文藝台灣》，
第2卷第1號，1941年3月

て、悠々と𢌞つてゐるのは、銀閣の
子より、よほど旅雨の掬ひだよ。（註
―数の下のバケツに、小川の時も休
まず聞けるためである。牛のそれは永
いからな。）

八信

富蠹の窩が来た。（註―福田放雄君
のことである。池田君は、臺北市萬華
の民俗研究の發表家で、「瓦葺の窩」とい
ふ貴重な研究の發表がある。萬華厚選の委
斗である。―この正月の旅雨には、

色々の學派の蓑斗が集散した。勿論、
ものは一ツも無い―何か、羅句迴しな
せなら、この喫茶店の主人は、私の知
リナガとでも云つて、コーヒーを主に
した豆の研究をする）―臺北の街の縁の
繪の大部分は、見ると不眠症になる。

台南の牛は鈴をつけてゐる

九信

正月だといふのに、臺南の姿が青さ
から誰も肯はないらしい。少し前
覗いたら、大きなカレンダーがあつて、

九月二十六日の日曜が出てゐた。
ラファエル前派の繪を見てゐたら、
ラファエル前派の眼母子の繪に
入つてゐるシーンとしてゐた。
この庭園内の建物はなかなか面白い。
樹木との關係をもつて、淡水より繪に
は面白いと思ふ。崙男善女のために、
印度崇拜が寂かと匂つてゐる。

十信

旅雨は毎日快晴だ。狀態といふ字を
十も崩れたぐらい奧邪な日が續く。
旅南好日、頭日旅雨、驕潺古墓、―そ
れを黄鴬と云ふ字で綴りもかへる。浪
れを写實にも写眞にも頷いてもへる表
現かと思ふ。
安平には何度も出かけてゐる。いま

十一信

安平の夕方は淋しい。何となく氣味
わるい。堡壘の古城の歌は、決
して尖はれてはゐない。モヤモヤと身
を包む。
安平には何度も出かけてゐる。

十二信

十三信

正面には、五色の天女みたやうな繪が
あつたり、故人の背陰提が陶板に描
てあつたりする。背陰提の中にはソフ
をかぶつてあるどの墓碑で、
きまつて最後に立石の大きな影でてあ
る。何百取ひは何干といふ數の立石と
云ふ字が夕陽を受けてゐた。妙な氣が
する。

十四信

毎日、夜は平晝蒂に早く窒てゐる。

顏水龍的書信
Yen Shui-Long's Letters

◉ 顏水龍回答謝里法問題之書信底稿（1975年）

1975年居住在紐約的謝里法透過在臺北的中國時報藝文記者林馨琴協助，廣發問卷給前輩畫家，調查有關日治時期臺灣美術發展的各種情況。當時任教於實踐家專的顏水龍可能是老畫家中極少數親筆回信的。謝里法1976年3月在《藝術家》雜誌發表〈為什麼身為畫家而又兼事工藝美術——顏水龍的自白〉，直接引用畫家的親筆長篇自述；這說明顏水龍確實是一位具有歷史觀，不斷地檢討並堅定創作目標的人。不過，這封郵簡從內容上來看，是進一步回答其他相關細節以及美術團體活動，並不是他們的第一次通信。（顏娟英）

顏水龍回答謝里法問題之書信影本，1975年，中央研究院臺灣史研究所提供

謝里法先生：5月26日接着您的信、未能迅速回信非常抱歉。因為雜事繁多，而且今年度的台陽美展年值處理會務並參加展出作品多幅，繁忙彼此。請寬諒。

關於您所問幾個問題、茲記略答於後。

1. 在第三屆"台陽美展"以就退出。因為我常住在東京，有時失了連絡、或來不及出品、寄作品也不方便、致以中斷。

2. 陳德旺君等人退出"台陽美協"的理由，差不多是藝術上的主張有不同之處。本人記不了。

3. 藍蔭鼎先生一直沒有進"台陽美協"其原因很難說，總是每一個作家、不論作品不論性格都有不同的地方、我想任何人不好意思地評人家的作法。可是他開拓他的境地、獲保今天的成就。

4. 我被推薦為第三屆"台展"審查委員是誰推荐？我本人都不知道。因為那時我在東京、聘書在東京接到的。本來想不再去當審查工作（為自己沒有力量來審查人家的作品）、經與老師 藤島武二 商量、他說自己也被聘、希望我一齊來台灣。因此使我決心回台、其與藤島武二老師同行。我對公共關係較為不善長因此我完全不知道是誰推荐我為審查委員。而且這項審查工作、我想不想去第二次、剛好——第次屆就不聘我了。

5. 台展初期的刊物等資料是有的、最近我們要求"藝術家"雜誌社招集老一輩畫家聚會、把各位所有資料供出、請一位負責人來整理或影印送給您。請您寫信給何政廣先規進。

6. 關於 黃清埕 的資料不太清草學等他的牢名簽領，他是澎湖縣人。1941年3月畢業於 東京美術專科學校彫塑科（現在藝大）。帝展入選兩次、日本彫塑作家協會會友。戰爭末期、自日本返台時、因所搭船隻被炸沉、夫婦一起喪生。據陳德旺君所說清埕是彫塑科畢業第一名、他的作品優越 但不太願意發表作品、經朋友游說 本岳於日本彫

● 顏水龍寫給顏娟英的書信（1993年3月26日）

顏水龍八十一歲（1984）從學校退休，七年後，搬離臺北大直的家，回到情如義父的已故林獻堂（1881-1956）的故鄉霧峰定居。這封信是畫家九十歲時，在霧峰家中用心地執筆回覆顏娟英的一封信。信中回憶1930年，搭乘火車穿越西伯利亞遠赴法國，生動宛如在目的情節。一名日本警察雖然不知有何目的，也坐上同一班長途火車，但最終對他的照顧讓畫家永銘於心。（顏娟英）

顏水龍寫給顏娟英的書信影本，1993年3月26日，中央研究院臺灣史研究所提供

2 NO. ___

一位日本人、警官的樣子、臨我令面、告訴转西伯

刘乘的藪包皆是黑色不好、我拜托他買幾条給我、経過

半個小時、他帶了好幾条給我顾、我即付他錢、他說送給我

初見面的對手非常好意。

其他犯和18年在工藝ニユース七月号（南ユ省工藝指導

所出版）台灣の工藝産業に就いて。在民俗台灣之寫

「染廠」有関台灣的植物染料。其他所有資料都措失了

還有種々發表的資料放在台北大道街之家。如有機会

請続学習面談。現在住在霧峰專門作画、請続来遊

取り敢へず乱筆を以て　御返事まで　草々　顥　來巔陰

25×12

紀錄片

DOCUMENTARIES

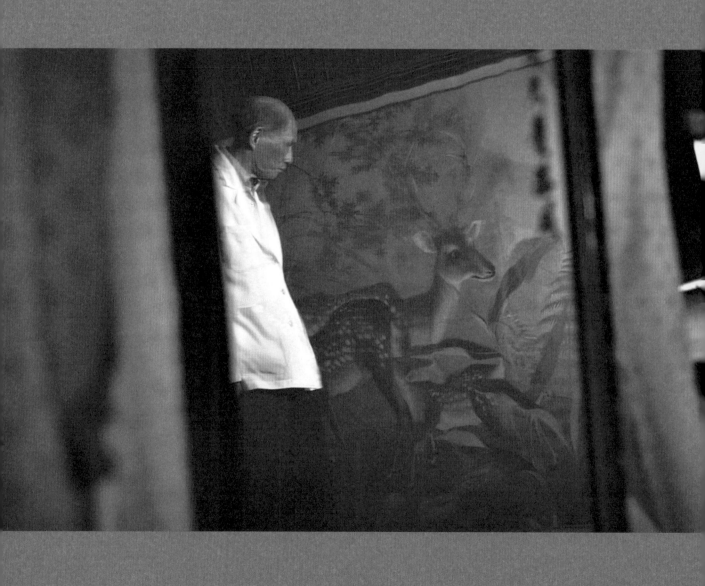

追尋不朽的青春
A Quest for the Everlasting Bloom

探尋未竟的山水
Exploring the Unfinished Landscape

紀錄片Documentary, 2019-2020, 60 mins
藝術很有事 Inside the Arts

「為」什麼有這麼多年輕的學生，或是二、三十歲的人這樣投入創作，然後認為美術創作可以改變臺灣社會，而且犧牲他的生命都沒有關係？」在一次訪問中，顏娟英老師道出1920、30年代，藝術家們的心魂。

百年前，黃土水、陳植棋、陳澄波……等藝術家燃燒生命創作，揭開臺灣現代美術的序幕；百年後，以中央研究院顏娟英老師為首的研究群，費心考掘這些年代久遠且散落在藝術家後代、民間、非美術館的公立機關、甚至海外的作品，並與北師美術館的策展團隊共同尋找作品。「藝術很有事」節目從2019年8月開始側拍，將這一年多來匯聚各方心力的找尋過程，製作成兩支影片：《追尋不朽的青春》及《探尋未竟的山水》。前者著重時代精神，了解藝術家當年追求現代美術的艱苦，卻也義無反顧的堅定；後者側重團隊的考掘，這些美術作品如何曲折「出土」的過程，而藝術家後代又如何珍重地保存先人作品，使我們理解，美術史的挖掘、認識和保存工作從來未竟……

藝術很有事

「藝術很有事」為有觀點、多單元、無主持的全外景藝文節目，以藝術和藝術家為主體，策展為導向，每周以一個主題為核心推出一至三個單元，跨界探索視覺藝術、表演藝術、文學、建築、設計與大眾文化等各領域的創作內涵，重視藝術與時代、社會的關係，觸及歷史、環境、趨勢、城市、文化資產、國際重要展演等諸多面向。以當代機動部隊的形式，即時紀錄藝術發生的現場，並以精準的影像敘事呈現，為臺灣留下珍貴的藝文影像資產。

曾入圍第53屆金鐘獎「節目創新獎」與「人文紀實節目獎」，並獲頒第54屆金鐘獎「人文紀實節目獎」與美國紐約電視獎「娛樂類生活風格節目」銅獎（2019）。

主創：
徐蘊康／製作人、編劇
吳佳明／導演、剪輯
黃培理／攝影指導

"Why so many young students or young people in their twenties or thirties were willing to devote themselves to art-making, believing that artistic creation could change the society of Taiwan to the extent that it would be acceptable to sacrifice their lives?" In an interview, Yen Chuan-Ying revealed the ideal of the artists in the 1920s and the 1930s.

Over a century ago, Huang Tu-Shui, Chen Chih-Chi, Chen Cheng-Po and many other artists dedicated their life to artistic creation, ushering in the overture of Taiwanese modern art. One century later, the research group led by Yen Chuan-Ying of Academia Sinica has strived to unearth and study the artworks created a long time ago and in the possession of the artists' families, private collectors, governmental institutions that are not art museums, and even in foreign countries. Together, they have embarked on a journey of searching

for these works with the curatorial team of the Museum of National Taipei University of Education (MoNTUE). In August 2019, "Inside the Arts" started filming their journey that many people have endeavored for over a year, and produced two films, respectively entitled *A Quest for the Everlasting Bloom* and *Exploring the Unfinished Landscape*. The former focuses on the zeitgeist and foregrounds the hardship in these artists' adamant and relentless pursuit of modern art education and creation. The latter emphasizes on the discoveries of the research team, revealing the twists and turns behind the "unearthing" of these artworks as well as how the artists' families have wholeheartedly cherished and preserved the artworks created by their predecessors. Their efforts enable the audience to understand the work of excavation, study and preservation of art history is never finished.

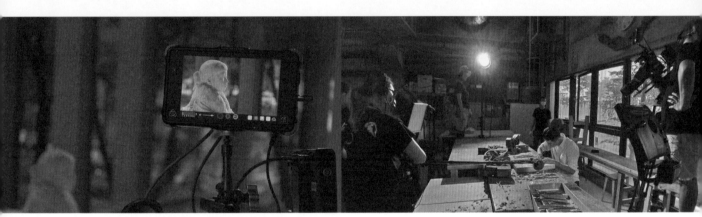

Inside the Arts

"Inside the Arts" is a perspective-based arts and culture program with multiple units filmed in the real-world setting without a host. The curatorial program revolves around art and artists, and presents one to three units under one theme to explore the creative work of different disciplines, including visual arts, performing arts, literature, architecture, design and popular culture. The program places an emphasis on the relationship between art, our time and society while engaging in various dimensions, such as history, environment, trends, cities, cultural heritage, major international exhibitions and performances. With much mobility like a contemporary tactical unit, the production team produces immediate documentation of artistic sites and presents it with precise cinematic narrative to preserve Taiwan's precious filmic assets of arts and culture.

The program has been nominated for "Best Humanities Documentary Category" in the 53th Golden Bell Awards, and is the recipient of "Humanities Documentary Category" in the 54th Golden Bell Awards and the "Entertainment -Lifestyle Program—Bronze Prize" in New York Festivals TV and Film Awards (2019).

Main Content Creators
HSU Yun-Kang / Producer, Script Writer
WU Jia-Ming / Director, Video Editor
HUANG Pei-Li / Director of Photography

青春不朽

Hisako

紀錄片 Documentary, 2020, 14 mins
木漏類比 Komorebi

「永劫不死的方法只有一個，就是精神上的不朽。……以大自然的黑土捏塑出天真無邪的小孩，以紅木刻出朝氣活潑的男子，用白石雕出細緻柔軟的美女。同時又可以成為永恆不朽，不衰老不死的人類。」

——黃土水〈出生於臺灣〉

本片紀錄黃土水《少女》胸像之修復過程，以八釐米攝影機拍攝，試圖呈現當時藝術家所處的時代氛圍，透過細膩的聲音處理，放大修復過程中的各種細微聲響：化學粉末在水裡化開、軟膏彼此沾黏、柔軟的布匹輕拂過大理石表面等，引人走進藝術家透過物質企圖塑造的不朽世界，將一瞬封存於作品之中。影片的敘述者是主持此次《少女》胸像修復的日本修復師森純一，畢業自東京藝術大學，是黃土水的學弟，也是一名雕刻家。經由修復，森純一與黃土水開啟了百年的對話，黃土水的文字與大理石表面刀刀刻鑿的裂痕相互呼應，散發著屬於那個時代的精神。拂去了歷史的塵埃、歲月的沉積，《少女》白皙通透的肌膚照映出臺灣初代藝術家的群像，召喚著當代的我們。

木漏類比

名稱取自團隊四人在2020年臺北電影節合作的作品「南光，木漏れ日」，日語的「木漏れ日（Komorebi）」指的是透過枝葉縫隙灑落的陽光，「れ日」音同「類比」，也代表創作團隊對類比時代的嚮往。

林君昵、黃邦銓／導演
王榆鈞／音樂
周震／聲音設計

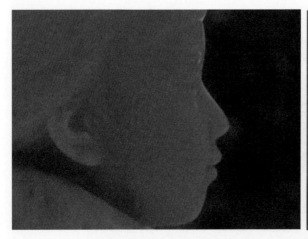

"There is only one method to become immortal, and that is through spiritual immortality… to sculpt an innocent, sweet child with natural dark clay, a spirited, energetic man with redwood, and a delicate, tender belle with white marble, making them immortal humans with everlasting youth."
—HUANG Tu-Shui, "Born in Taiwan"

The film documents the restoration of Huang Tu-Shui's *Bust of a Girl*. Shot with an 8mm camera, the film aims to reflect the artist's social milieu, and employs exquisite sound processing to amplify various subtle sounds captured during the restoration process, such as the dissolution of chemical powder in water, the adhesion of ointment, the soft caress of fabric on the marble surface, etc., leading the audience into the everlasting world that the artist has crafted with matter and the moment he has forever preserved. The film is narrated by Japanese conservator-restorer Mori Junichi, who chairs the restoration project of the sculpture. Graduated from Tokyo University of the Arts, the alma mater of Huang Tu-Shui, Mori is also a sculptor himself. Through this restoration project, Mori and Huang begin a dialogue spanning a century of time. Huang's writing has echoed every individual carving mark on the marble surface, exuding the spirit of his era. Removing the historical dust and the veil of time, the alabaster *Bust of a Girl* reflects the collective image of Taiwan's first-generation artists and seizes the attention of contemporary audience.

Komorebi

The name of the art group is derived from the four artists' collaborative work, entitled *Nanguang, Komorebi*, featured in the 2020 Taipei Film Festival. In Japanese, the term "komorebi" refers to the sunshine trickling down through crevices between tree branches and leaves. Phonetically, "rebi" (れ日) sounds like "analog" (類比) in Mandarin, and points to the art group's longing for the analog era.

LIN Chunni / Director, Cinematographer
HUANG Pang-Chuan / Director, Cinematographer
WANG Yujun / Music
CHOU Cheng / Sound Design

附錄

藝術家小傳

ARTISTS' PROFILES

丸山晚霞
MARUYAMA
BANKA
1867-1942

出生於長野縣，本名健作。因結識水彩畫家吉田博、三宅克己，引發興趣投入水彩畫創作。1901年歐遊返國後參與創立太平洋畫會，1906年與大下藤次郎等人於東京開設水彩畫講習所，1913年參與發起日本水彩畫會。丸山晚霞除往來於故鄉與東京，並至日本各地旅行寫生，也積極至海外旅行登山。1917年與畫家河合新藏旅行朝鮮半島，描繪金剛山。於1931年與1934年兩度來臺，前往各地及中部山岳遊歷創作，舉辦展覽和座談會，描繪臺灣山岳的作品也刊印於雜誌《新高阿里山》。1936年與足立源一郎等人創立日本山岳畫協會。

Maruyama Banka, born Maruyama Kensaku, was from Nagano Prefecture, Japan. Yoshida Hiroshi and Miyaki Katsumi inspired him to explore watercolor painting. In 1901, after returning from his European trip, Maruyama cofounded the Taiheiyo European Art Society. In 1906, alongside individuals like Oshita Tojiro, Maruyama opened an atelier focused on watercolor painting in Tokyo. In 1913, he co-founded the Nihon-Suisai Gakai (Japan Watercolor Society). Besides traveling between his hometown and Tokyo, Maruyama also visited many places in Japan to paint en plein air, and actively went hiking overseas. In 1917, he traveled with artist Kawai Shinzo to the Korean Peninsula to portray Mount Kumgang. During his two visits to Taiwan in 1931 and 1934, Maruyama went to see multiple locations as well as mountains in central Taiwan. Meanwhile, as he held exhibitions and symposiums, the magazine *Nitaka Arisan* published his works of the Taiwanese mountain ridges. In 1936, Maruyama co-founded the Nihon Sangakuga Kyokai (Japan Mountain Painting Association) with others including Adachi Genichiro.

河合新藏
KAWAI SHINZO
1867-1936

出生於日本大阪，師事五姓田芳柳、小山正太郎。1901年前往巴黎留學，1904年返回京都。與大下藤次郎等人創立日本水彩畫研究所，1913年參與創設日本水彩畫會。第一回文展入選作品《森》，第二回文展入選《綠蔭》等作，為官展中活躍的水彩畫家，也是日本於二十世紀初期水彩畫隆盛時期的代表畫家之一。

Kawai Shinzo, born in Osaka, Japan. Kawai was a student of Goseda Horyu and Koyama Shotarou. In 1901, Kawai traveled abroad to study in Paris, and then returned to Kyoto in 1904. He co-founded the Japan Watercolor Research Institute with Oshita Tojiro and others. In 1913, he co-founded the Nihon-Suisai Gakai (Japan Watercolor Society). Kawai exhibited his work *Forest* in the first Ministry of Education Art Exhibition (Bunten), and later *Green Shade* and others in the second Bunten exhibition. He was very active in the official exhibitions, and also one of the representative watercolor painters in Japan in the early 20th century.

藤島武二
FUJISHIMA TAKEJI
1867-1943

出生於鹿兒島，先至東京向川端玉章學習日本
畫，後入曾山幸彥、山本芳翠畫塾學習油畫。
1896年得黑田清輝推薦，擔任東京美術學校西洋
畫科助教授，參與其創立的洋畫團體白馬會。此
時期創作受外光派風格影響，呈現文學性、浪漫
與裝飾性畫風，成為明治浪漫主義繪畫的代表畫
家。1906年作為文部省留學生留學巴黎，1908年
轉往羅馬。1910年返日擔任東京美術學校教授。
1912年與岡田三郎助設立本鄉洋畫研究所，隔年
設立川端繪畫研究所洋畫部。1920年代中期起，
參考義大利文藝復興風格，創作許多著中國服飾
的女性人物橫顏像。1930年代後期，接受皇居學
問所委託等工作，於日本各地、蒙古，與臺灣等
地，創作不少以日出為題的作品。曾擔任帝國美
術院會員、帝室技藝員，獲頒文化勳章。1943年
逝於東京。

Fujishima Takeji, born in Kagoshima, Japan. Fujishima initially studied
Nihonga (Japanese painting) with Kawabata Gyokusho. He later studied
oil painting in the painting schools of Soyama Sachihiko and Yamamoto
Housui relatively. In 1896, recommended by Kuroda Seiki, he taught at
the Tokyo Fine Arts School Assistant Professor of Western Painting and
participated in the Hakuba-kai, a western painting art group founded by
Kuroda. His practice during this period was influenced by Pleinairism,
showing literary, romantic, and decorative painting qualities—a style makes
him a representative Romanticism painter during the Meiji era. In 1906, he
studied abroad in Paris as a foreign student under a program of the Ministry
of Education. Later on, he moved to Rome in 1908. In 1910, Fujishima
went back to Japan and taught at the Tokyo Fine Arts School. In 1912, he
co-founded the Hongo Western Painting Research Institute with Okada
Saburosuke and founded the Western Painting Department of Kawabata
Painting School in the following year. Since the mid-1920s, referencing
the Italian Renaissance style, he produced many side portraits of female
characters in Chinese costumes. In the late 1930s, he was commissioned by
the Imperial Palace's Institute of Learning to create works with the subject
matter of sunrise in Japan, Mongolia, Taiwan, etc. Fujishima once served
as a member of the Imperial Art Academy, Imperial Court Artist, and was
awarded the Cultural Medal. He died in Tokyo in 1943.

呂璧松
LU PI-SUNG
1870-1931

臺南人，單名林，貢生呂陽泰之孫，活躍於清末
至日治前期的畫家。1913年他已在臺南市經營裱
褙店，擅長山水、人物、花鳥等畫類，求畫者絡
繹不絕。呂璧松除了作為一位職業畫師外，也與
詩人胡殿鵬交流，談論詩書畫論，頗受其推崇，
也藉由入選展覽會而成為社會眼中的畫家。1910
至1920年代他除了參加臺灣日日新報社主辦的全
島書畫展、嘉義勸業共進會書畫展外，作品還入
選日本熊本美術展、富山市美術博覽會等。他指
導在地的「酉山吟社書畫會」，並率同會員參選
全島書畫展，屢獲佳績。1923年一篇介紹臺灣的
書畫家文章中，指出呂璧松為知名的山水人物畫
家，作品頗帶有日本畫風。1928年他獲得善化商
工協會主辦的全島書畫展首獎，1929年於新竹書
畫益精會主辦的全島書畫展獲得特選。1929年他
在高雄州勸業課長李贊生及當地商人的後援下，
於愛國婦人會館舉辦畫展。1931年初因病去世。

Lu Pi-Sung, from Tainan, first name Lin, pseudonym Pi-Sung. He was an
active painter from the late Qing Dynasty to the early Japanese colonial
period, and the grandson of Lu Yang-Tai, an Imperial Examination
Candidate. In 1913, Lu already has a picture mounting studio in Tainan.
He was skilled in landscapes, figures, flowers, and birds, with many
customers visiting the studio to seek his works. In addition to working as
a painter, Lu also frequented himself with poet Hu Dianpeng, conversing
on poetry, literature, painting, and art theories, and was well respected
by Hu Dianpeng. He also became a publicly celebrated painter by being
selected into various exhibitions. From the 1910s to 1920s in addition
to participating in the Island-Wide Calligraphy and Painting Exhibition
organized by the Taiwan Nichi Nichi Shimpo, the Chiayi Industrial Mutual-
Progress Fair Calligraphy and Painting Exhibition, his works were further
selected to feature in the Japan Kumamoto Art Exhibition, Toyama City
Art Fair among others. Under Lu's teachings, members of the local Youshan
Yinshe Painting and Calligraphy Association participated in the Island-Wide
Calligraphy and Painting Exhibition, frequently achieving positive results.
In 1923, Lu Pi-Sung was mentioned in an article introducing Taiwanese
calligraphers and painters as, a well-known painter of landscape and figures,
whose works were influenced by the Japanese style. In 1928, he received the
first prize of the Island-Wide Calligraphy and Painting Exhibition organized
by the Shanhua Chamber of Commerce and Industry. In 1929, Lu received
the prize in the Island-Wide Painting and Calligraphy Exhibition which was
organized by the Hsinchu City Painting and Calligraphy Club. In the same
year, he held a painting exhibition at the Patriotic Women's Association
with the support of the director of the Education Department of Kaohsiung
State, Li Zang-Sheng, and local businessmen. He died of illness in early
1931.

石川欽一郎
ISHIKAWA
KINICHIRO
1871-1945

西鄉孤月
SAIGO KOGETSU
1873-1912

日本靜岡縣人，就讀東京電信學校時隨小代為重習畫並學習英文。1889年入大藏省印刷局工作，1900年轉任陸軍參謀本部通譯官。先後加入明治美術會、巴會，師事川村清雄、淺井忠，私淑英國水彩畫家阿爾弗雷德・伊斯特（Alfred East）。1904年日俄戰爭時從軍。1907至1916年首度來臺，擔任陸軍通譯官，兼任國語學校教師。活躍臺北、東京畫壇，曾多次入選文展與新文展。1922年赴歐考察、寫生，1924至1932年再度來臺，任教臺北師範學校、推動臺展，成立「臺灣水彩畫會」，培育眾多臺灣第一代西畫家，奠定其畫壇導師的地位。一生積極推廣水彩風景寫生，曾出版《最新水彩畫法》、《山紫水明》等諸多著作，並於《臺灣日日新報》、《臺灣教育》等報刊大量發表作品。退休返日後持續創作，1945年逝世。

Ishikawa Kinichiro, born in Shizuoka Prefecture, Japan. He studied painting under the tutelage of Shodai Tameshige as well as English in the Tokyo Telecommunications School. In 1889, Ishikawa worked at the Ministry of Finance Printing Bureau. In 1900, he was transferred to the position of Interpreter Officer in the Imperial Japanese Army General Staff Office. He joined Meiji Bijutsu-kai (Meiji Art Society) and Tomoe-kai successively, and then studied under the tutelage of Kawamura Kiyoo and Asai Chu. Ishikawa also privately studied works of the British watercolorist Alfred East. In 1904, he joined the army during the Russo-Japanese War. From 1907 to 1916, Ishikawa traveled to Taiwan for the first time, serving as an army interpreter and lecturer in the Taiwan Governor-General's National Language School. Active in Taipei and Tokyo painting circles, Ishikawa was selected multiple times for the Ministry of Education Art Exhibitions (Bunten) and New Ministry of Education Art Exhibitions (Shin Bunten). In 1922, he traveled to Europe to study and painted en plein air. From 1924 to 1932, Ishikawa visited Taiwan again. He taught at the Taipei Normal School, facilitated the Taiwan Fine Arts Exhibition (Taiten), founded the Taiwan Watercolor Painting Society, guided many first-generation Western-style painters in Taiwan, and established his position as a mentor in the painting circle. He has actively promoted watercolor landscape painting throughout his life, publishing many books such as *Latest Watercolor Painting Method, Purple Mountains, Clear Waters*, and published many works in newspapers such as *Taiwan Nichi Nichi Shimpo* and *Taiwan Education*. After retiring and returning to Japan, he continued painting until he died in 1945.

出生於松本，進入東京美術學校繪畫科、研究科就讀，與同期生橫山大觀等人並稱為橋本雅邦門下之四天王。畢業後原擔任該校助教授，1898年東京美術學校紛亂事件時，岡倉天心辭任校長，創立日本美術院，西鄉孤月一同離校轉任該院評議員，並與老師橋本雅邦的四女結婚，不久離婚。1903年起巡遊日本東北、四國、九州等地。1911年年初輾轉來臺，10月遊歷阿里山與中南部，11月於嘉義俱樂部舉辦畫會。隔年4月，於臺南公館舉辦畫會，由於罹患腸胃炎，返回東京家去世。作品描繪自然風物又帶有纖細而幻想的氣氛，屢次入選日本繪畫協會共進會並獲獎，代表作如《春暖》（1897，東京藝術大學大學美術館藏）。

Saigo Kogetsu was born in Matsumoto, Japan. When Saigo enrolled in the program of Painting and Research at the Tokyo Fine Arts School, he was one of the so-called "the Four Devas of Hashimoto Gaho", in alignment with students in the same grade like Yokoyama Taikan. After graduation, he worked as an assistant professor in school until 1898 when the Tokyo Fine Arts School Disturbance made the then principal Okakura Tenshin resign. Saigo left the school with Okakura, and became a council member at the Nihon Bijutsuin (Japan Visual Arts Academy), an Academy established by Okakura after his resignment. Meanwhile, Saigo married the fourth daughter of his teacher Hashimoto Gaho, but the two divorced soon after marriage. Since 1903, Saigo toured around Tohoku, Shikoku, Kyushu, and other places in Japan. In early 1911, Saigo arrived in Taiwan—visiting the central and southern Taiwan like Alishan in October and holding an exhibition at the Chiayi Club in November. In the following year in April, he held another exhibition in the Tainan Public Hall but died from gastroenteritis when he returned home at Tokyo. Saigo's works demonstrate natural scenery with an elegant and fantasy-like atmosphere. His works were selected into the Japan Painting Association Fair multiple times, especially known for his *Spring Warmth* (1897, Tokyo University of the Arts Museum Collection).

富田溪仙
TOMITA KEISEN
1879-1936

福岡市出生，師事京都畫家都路華香，學習四條派畫風，1903年作品於第五回內國勸業博覽會獲獎。1909年春來臺停留三個多月後，轉往遊歷廈門、香港、廣東，再從福州到蘇州、杭州，為期約一個月。1912年第六回文展展出取材中國水鄉風景的《鵜船》，獲得好評，確立水墨畫風。獲橫山大觀推薦加入日本美術院，晚年曾任帝國美術院會員。

Tomita Keisen was born in Fukuoka City, Japan. Tomita studied the Shijo painting style under the tutelage of Kyoto painter Tsuji Kako. In 1903, his work won the award at the fifth National Industrial Exposition. In the spring of 1909, after staying in Taiwan for more than three months, for about a month, he traveled to Xiamen, Hong Kong, and Guangdong, following with Fuzhou, to Suzhou, and Hangzhou. In 1912 at the sixth Ministry of Education Art Exhibition (Bunten), Tomita exhibited *The Pelican Boat*, inspired by the scenery of Chinese riverside villages—earned him a good reputation for his ink wash painting style. Recommended by Yokoyama Taikan, Tomita joined the Nihon Bijutsuin (Japan Visual Arts Academy) as a member of the Imperial Art Academy in his later years.

那須雅城
NASU MASAKI
1880s-卒年不詳

出身讚岐高松藩神社主祭之家。從小向父親那須賢直習畫，1902年前往東京進入橋本雅邦畫塾學習，1906年起畫作入選日本畫新派團體「二葉會」及「美術研精會」展。日本統治時期二度來臺：第一次為1909至1914年，第二次約1928至1940年代初，主要從事寫生旅行、創作及參與展覽會活動。擅長繪畫與文字，習慣將旅行所見的山川風土速寫在寫生帖中，也常在報章雜誌發表寫生稿與紀行文。來臺期間總共奉納兩幅歷史畫、兩幅山岳畫給臺灣神社，目前為國立臺灣博物館典藏。那須氏第一次來臺時以「豐慶」為名，主要進行寫生旅行，接受官方委託繪製畫作，並在理蕃前進部隊的保護下進行環島寫生。第二次是在旅行日本、滿州、朝鮮並描繪各地山岳後，攜帶子女來臺居住，並更名「雅城」。第二回臺展起，皆以新高山（玉山）等山岳畫入選，包括遠赴法國描繪阿爾卑斯山的畫作。除了受到臺展肯定外，也成為臺灣山岳會認可的山岳畫家。

Nasu Masaki was born into a Shinja Shrine family in Sanuki Takamatsu. Nasu studied painting from his father Nasu Yoshinao since childhood. In 1902, he moved to Tokyo to study at the Hashimoto Gaho tutorial classes. Since 1906, his paintings have been selected into exhibitions by new Japanese painting groups like Futaba-kwai and Kenseikwai. Nasu visited Taiwan twice during the Japanese colonial period: the first time was from 1909 to 1914, and the second time was from 1928 to the early 1940s; mainly traveled to paint en plein air, worked on paintings, and participated in exhibitions. Nasu was eloquent in both drawing and writing, constantly sketched the scenes of his travels in sketchbooks, and frequently published sketches and travel articles in newspapers and magazines. During his stay in Taiwan, he offered a total of two historical paintings and two mountain paintings to the Taiwan Grand Shrine, and these are currently in the National Taiwan Museum collection. When Nasu came to Taiwan for the first time, he used the name "Hokei." His main goal for this trip was to create landscape paintings, commissioned by the government. He traveled around the island to make landscape drawings under the local advancing troop's protection. Later on, Nasu went to Taiwan again after he traveled around Japan, Manchuria, and Korea under Japanese rule to make mountain paintings. This time, he relocated to Taiwan with his children and changed his name to "Masaki". Since the second Taiwan Fine Arts Exhibition (Taiten), his mountain paintings including those of Yu-Shan (Mount Jade) and the French Alps, were frequently selected and shown in the exhibition. Besides, the Taiwan Mountain Association also recognized his status as a landscape painter.

小澤秋成
OZAWA Shusei
1886-1954

日本長野縣出生。1911年自東京美術學校圖畫師範科畢業，曾任中學校教員，1927年赴法留學，一邊於二科會展出作品，1930年返日並舉辦滯歐洋畫展覽會。1935年創立東京漆工藝社，擔任社長。

Ozawa Shusei was born in Nagano Prefecture, Japan. In 1911, he graduated from the normal school curriculum of the Tokyo Fine Arts School and worked as a middle school teacher. In 1927, Ozawa went to France to study while at the same time exhibited his works in the Nika Association. In 1930, he returned to Japan and held an exhibition featuring overseas Japanese painters in Europe. In 1935, he founded the Tokyo Lacquer Crafts Company and served as the company's president.

川島理一郎
KAWASHIMA RIICHIRO
1886-1971

出生於足利，於1905年前往美國、1911年前往巴黎學畫，並認識資生堂經營者福原信三，提供資生堂來自歐美的流行訊息，也曾於資生堂藝廊舉辦個展。1926年和梅原龍三郎一同創立國畫創作協會第二部（西洋畫）。此外並受委託擔任聖德太子奉讚美術展與新文展的評審。1935年，發表退出帝展改組活動的聲明，並退出國畫會。川島從1924年初訪中國，到太平洋戰爭爆發前的1940年之間，他至少到訪臺灣四次、朝鮮兩次、中國與滿洲五次。他不僅取材東亞各地的風景及人物創作作品，同時積極地在臺灣舉辦個展，受到矚目，也參與日本於中國及朝鮮舉辦的官方展覽。

Kawashima Riichiro was born in Ashikaga, Japan. In 1905, Kawashima went to the United States. In 1911, he went to Paris to study painting, where he met Shiseido's owner, Fukuhara Shinzo. He provided Shiseido with fashion information from Europe and the United States, and he once held a solo exhibition at the Shiseido Art Gallery. In 1926, he co-founded the Second Division (focused on Western paintings) of the Kokuga Sosaku Kyokai (Kokugakai, Society for the Creation of a National Painting Style) with Umehara Ryuzaburo. In addition, Kawashima served as a selection committee member of the Prince Shōtoku Commemorative Art Exhibition and the New Ministry of Education Art Exhibitions (Shin Bunten). In 1935, he issued a statement to withdraw from the reorganization of the Imperial Art Exhibition (Teiten) and withdraw from the Kokugakai. Between 1924 when he visited China for the first time and 1940 right before the Pacific War started, he traveled frequently—including four times to Taiwan, two times to Japanese Korea, and five times to China and Manchuria. Not only did he draw inspiration from landscapes and figurative paintings from all over East Asia, but also he held solo exhibitions in Taiwan actively, attracting widespread attention. He also participated in official exhibitions held by the Japanese government in China and Japanese Korea.

鹽月桃甫
SHIOTSUKI TOHO
1886-1954

日本宮崎縣人，本名永野善吉，因入贅而改姓，桃甫為其號。1909年入東京美術學校圖畫師範科，後於大阪、愛媛等地任教職，曾以油畫《石槌山之風》（1916）入選文展，也擅長水墨南畫。1921年抵臺，陸續擔任臺北第一中學、臺北高等學校美術老師，課餘指導京町畫塾、黑壺會等民間美術活動，是首位將油畫技巧引入臺灣的美術教育家。1927年又與石川欽一郎、鄉原古統等人設立官辦的臺灣美術展覽會，擔任西畫部審查員，引領臺灣畫壇的發展。鹽月的作品具備強烈的野獸派色彩，創作上大力鼓吹自由表現的藝術觀，強調個人的思考與創造力，尤其關注臺灣的地域特色及原住民文化，不只曾為《生番傳說集》製作插繪裝幀，也多次在臺展提出原住民圖像作品，影響深遠。1943年起兼任臺北帝大預科講師。1946年終戰遣返日本後，全心投入宮崎縣的文藝活動。

Shiotsuki Toho, born Nagano Zenkichi, was from Miyazaki Prefecture, Japan. His last name was changed when he married into the Shiotsuki family, but he was better known by his pseudonym Toho. In 1909, he started the normal school curriculum at the Tokyo Fine Arts School. Later, he taught in Osaka and Ehime, among other places. His oil painting, *The Wind of Shizuchi Mountain* (1916), was included in the first Ministry of Education Art Exhibition (Bunten). He was also skilled in Nanga. In 1921, Shiotsuki arrived in Taiwan and served as an art teacher at No. 1 Taihoku High School and Taihoku High School. In his spare time, he participated in local cultural communities such as the Jingding Painting School and the Heihuhui group. Shiotsuki was the first art educator to introduce oil painting techniques to Taiwan. In 1927, he co-organized the official Taiwan Fine Arts Exhibition (Taiten) with Ishikawa Kinichiro, Gobara Koto and others, and served as a selection committee member of its Western Painting Division, leading the development of the Taiwanese art world. Shiotsuki's works featured strong Fauvist color and vigorously advocated freedom of expression, emphasizing personal thinking and creativity. He paid particular attention to regional characteristics and the aboriginal cultures of Taiwan, not only contributing to the illustrations and bindings for the publication *Aboriginal Tales Collection*, but also exhibiting works on multiple occasions at Taiten that featured aboriginal imageries, something that had far-reaching influence. From 1943, he also served as a lecturer at Taihoku Imperial University. At the end of 1946, Shiotuski was repatriated to Japan where he devoted himself to cultural activities in Miyazaki Prefecture.

鄉原古統
GOBARA KOTO
1887-1965

日本長野縣人，本名堀江藤一郎，幼年過繼給舅父鄉原保三郎為子，因而改姓。1910年從東京美術學校師範科畢業，隔年前往中國南部旅行寫生，1917年來臺任教臺中中學，1920年轉任臺北第三高女，並兼任臺北第二中學。1927年起擔任臺展東洋畫部審查員，至1935年第九回為止，1936年辭職返日。鄉原個性嚴謹而溫和，許多高女學生在其指導下相繼入選臺展，陳進更受到他的鼓勵邁向專業畫家之路，郭雪湖的創作風格亦受其啟發，可說在臺灣的東洋畫教學與推展中扮演舉足輕重的角色，影響深遠。擅長山水與花卉，重視寫生，無論工筆重彩或寫意墨繪，皆能掌握自然景物的神采。1930至1935年間在臺展推出「臺灣山海屏風」系列鉅作，包括連峰迭起的能高山脈、驚濤拍岸的北關怒濤、水流湍急的太魯閣峽谷，以及參天的阿里山神木，運用多連屏的水墨形式，呈現臺灣山海宏偉壯闊的氣勢，是其畢生的代表作。

Gobara Koto, born Horie Touichirou, was from Nagano Prefecture, Japan, and took on the Gobara surname when he was adopted by his uncle, Gobara Yasusaburou. In 1910, Gobara graduated from the normal school curriculum of the Tokyo Fine Arts School, and, in the following year, traveled to the southern regions of China to paint en plein air. In 1917, he traveled to Taiwan and started teaching at Taichung Middle School. In 1920, Gobara then transferred to a simultaneous teaching position at the Third Taipei Municipal Girl's High School and the Second Taipei Municipal Middle School. From 1927 to 1935, he served as a selection committee member of the Japanese Painting Division of the Taiwan Fine Arts Exhibition (Taiten). In 1936, Gobara resigned from the position to return to Japan. He had a serious but gentle personality. Many female high school students participated in the Taiten exhibition under his guidance. His encouragement led Chen Chin to pursue a professional painting career and inspired Kuo Hsueh-Hu's painting style. Gobara played a pivotal and influential role in the teaching and development of Nihonga (Japanese painting). Skilled at painting landscapes and flowers, he emphasized the importance of painting en plein air, whether it was his meticulous brushwork or xieyi (literally "depicting the spirit"), he captured the essence of beauty in nature. From 1930 to 1935, he showcased the "Taiwanese Landscape Screens" series at the Taiten exhibitions. Included in the series are the rising peaks of the Neng-Gao Mountains, the raging tides of the Tempestuous Waves in Beiguan, the turbulent waters of the Taroko Gorge, as well as the towering Sacred Tree in Alishan. His use of multiple panels and ink wash in the series conveys the magnificent momentum of Taiwan's natural scenery, helping to make it the most significant masterpiece of his career.

木下靜涯
KINOSHITA
SEIGAI
1887-1988

梅原龍三郎
UMEHARA
RYUZABURO
1888-1986

日本長野縣人,本名源重郎,靜涯是其號。師事四條派村瀨玉田等畫家,後進入京都日本畫大家竹內栖鳳的畫塾學習。1918年與畫友在前往印度的旅途中,路經臺灣舉辦畫展,後因照顧生病的友人而停留臺灣,最後定居淡水「世外莊」至1946年戰爭結束返日為止。1927至1943年,擔任十回臺展、六回府展的東洋畫部審查委員,並參與創立「臺灣日本畫協會」、「栴檀社」團體,與鄉原古統同為臺灣東洋畫壇的領導人物。木下為職業畫家,雖未在學校任教,也從未正式設帳授徒,但私下求教的人很多,其中蔡雲巖與他較為親近,在返日時託付其畫稿與書籍。畫作多以山水、花鳥為題材,工筆與墨繪皆擅長,也重視寫生的創作。由於身居淡水,時常感受其節氣變化之美,因此畫作主題最常見到氤氳的淡水風景表現。

出生於日本京都,於關西美術院接受淺井忠指導。1908年留學巴黎,拜訪雷諾瓦(Pierre-Auguste Renoir)並向其請益。1914年參與二科會創立,1922年參與春陽會創立,1926年和川島理一郎一同創立國畫創作協會第二部(西洋畫),1928年改組為國畫會。擔任帝國美術院會員、東京美術學校教授、帝室技藝員。1930年代到訪臺灣、鹿兒島,1939至1943年間到訪北京五回,在國畫會展展出取材櫻島、北京等的代表作品。1952年辭任東京美術學校教職,同年獲頒文化勳章。1950年代,創作融合琳派與南畫,呈現裝飾性與自由絢爛、顏料濃厚的風格。並曾屢次渡歐,描繪威尼斯、坎城風景。1960年代舉辦回顧展多次,1986年逝於東京。

Kinoshita Seigai, from Nagano Prefecture, Japan, used the pseudonym Seigai instead of his real name, Genjuro. Kinoshita learned under the tutelage of Murase Gyokuden and other artists of the Shijo school. He later enrolled in the private painting school of Takeuchi Seiho, one of the great masters of Nihonga (Japanese painting). In 1918, while on a journey to India with his artist friends, Kinoshita passed through Taiwan, where he had an exhibition. Afterwards, Kinoshita stayed to take care of his sick friend, and then finally settled in "Shiwaizhuang" in Tamsui, where he stayed until he returned to Japan at the end of the war in 1946. From 1927 to 1943, he served as a selection committee member of the Japanese Painting Division for ten editions of the Taiwan Fine Arts Exhibition (Taiten) and six editions of the Taiwan Governor-General's Office Art Exhibition (Futen), and participated in the establishment of the "Taiwan Nihonga Association" and "Sendan-sha". Together with Gobara Koto, the two artists were the leading figures in the Nihonga artists' community in Taiwan. Kinoshita was a professional painter; he did not teach in any schools, nor did he officially accept any apprenticeships. However, many artists came to him for advice in private. Of these artists, he was particularly close to Tsai Yun-yen, to whom he entrusted his paintings and books when he returned to Japan. Many of his paintings feature landscapes, flowers, and birds as subjects. He was skilled at both meticulous brushwork and ink washes, but also emphasized the importance of sketching from life. Due to living in Tamsui, he often felt the changes in seasons, hence one of the most common themes of his paintings was the drenched Tamsui landscape.

Umehara Ryuzaburo was born in Kyoto, Japan. Umehara was under the tutelage of Asai Chu during his time at the Kansai Bijutsu-in (Kansai Arts Institute). In 1908, he studied in Paris and visited Pierre-Auguste Renoir for advice. In 1914, Umehara participated in founding the Nika Association, and in 1922, he founded the Shunyo-kai. In 1926, with Kawashima Riichiro, he co-founded the Kokuga Sosaku Kyokai Second Division (Western Painting), which was reformed into Kokugakai in 1928. Umehara served as a member of the Imperial Art Academy, professor of the Tokyo Fine Arts School, and an Imperial court artist. In the 1930s, he visited Taiwan and Kagoshima, and from 1939 to 1943, he visited Beijing five times and exhibited works that depicted scenes from Sakurajima and Beijing in the Kokugakai exhibition. In 1952, he resigned from his teaching position at Tokyo Fine Arts School, and, in the same year, he received the Cultural Medal. In the 1950s, his works incorporated the styles of Rinpa and Nanga, demonstrating a decorative style that was vibrant and unrestricted. Umehara traveled to Europe on multiple occasions to depict the scenery of Venice and Cannes. He held several retrospectives in the 1960s and died in Tokyo in 1986.

小原整
OHARA HITOSHI
1891-1974

陳澄波
CHEN CHENG-PO
1895-1947

日本埼玉縣人。1917至1918年就讀東京美術學校西洋畫科時，即以《秋之庭園》、《睡蓮之池》入選第十二、十三回文展，1919年從該校畢業。1926年任教山梨縣都留高女。1932年在石川欽一郎的推薦下來臺任教臺北師範學校，一直到戰後1946年返日為止。不同於石川欽一郎專攻水彩畫，小原以油畫創作為主，畫風介於印象派、後印象派之間。來臺後專注於美術教育，不再參選任何美展。任教臺北師範學校期間，啟發臺灣學生對繪畫的興趣，使其獻身創作或學校的美術教育，也擔任新竹州圖畫講習會講師及學校美術展覽會審查員，對新竹的美術發展貢獻良多。畫家鄭世璠、陳在南就讀北師期間向其學習油畫，戰後仍保持聯繫。1969年來臺與學生相聚，重遊舊地寫生。1974年過世後，鄭世璠等人為他在哥雅畫廊舉辦遺作展，並號召臺北第二師範學校畢業同學成立「芳蘭美術會」，1975年舉辦第一回芳蘭美展，每年必定展出石川欽一郎與小原整的畫作，藉此懷念兩位恩師。

Ohara Hitoshi hailed from Saitama Prefecture, Japan. In 1917 and 1918, whilst enrolled in the Western Painting Department at the Tokyo Fine Arts School, Ohara was selected for the twelfth and thirteenth Ministry of Education Art Exhibitions (Bunten) with his works *Autumn Garden* and *Lotus Pond*. He graduated in 1919. In 1926, he taught at Tsuru Senior High School, and in 1932, at the recommendation of Ishikawa Kinichiro, he came to Taiwan and started teaching at the Taipei Normal School, where he worked until he returned to Japan in 1946. In contrast to Ishikawa Kinichiro, who specialized in watercolor, Ohara painted mainly with oil. Ohara's painting style was somewhere between impressionism and postimpressionism. After coming to Taiwan, he no longer participated in exhibitions. Instead, he dedicated himself to painting and art education, and while teaching at Taipei Normal School he inspired many Taiwanese students to take up painting. Ohara also served as a lecturer at the Hsinchu Drawing Workshop and as a judge for the school art exhibitions, contributing to art development in the Hsinchu region. Artists Cheng Shih-Fan and Chen Tsai-Nan studied oil painting from Ohara during their time at the Taipei Normal School and maintained correspondence after the war. In 1969, he returned to Taiwan to meet his students and to sketch at familiar locations. After he died in 1974, Cheng Shih-Fan and others organized an exhibition of Ohara's work at Goya Gallery and gathered together alumni from the Taipei Second Normal School to form the Fang Lan Art Society. The first annual Fang Lan Art Exhibition was held in 1975, with the works of Ishikawa Kinichiro and Ohara Hitoshi exhibited in memory of the two mentors.

嘉義人，1913年入國語學校師範部乙科，受石川欽一郎影響，對美術產生興趣。1917年返鄉任教、成家。1924年赴日，考取東京美術學校圖畫師範科，師事田邊至，奮力朝油畫家志向前進。1926年以《嘉義街外》成為臺灣首位入選帝展的西畫家。留日期間，曾前往中國旅行寫生，1929年起任教上海新華藝專等校。此時創作出一系列描繪江南風景的油畫，透過線條、點景人物營造動態感，逐步建立個人風格。1933年結束旅居生涯返臺。隔年以《西湖春色》四度入選帝展，並與畫友組織臺陽美術協會。自此創作題材轉向嘉義、淡水等臺灣風景，以專業畫家身分持續活躍官展、臺陽展及日本光風會展。1946年任第一屆嘉義市參議員、省展評審，隔年受難於二二八事件。

Chen Cheng-Po was born in Chiayi, and in 1913 he entered the Taiwan Governor-General's National Language School. Inspired by Ishikawa Kinichiro, Chen became interested in art. In 1917, he returned to his hometown to teach and raise his family. In 1924, Chen traveled to Japan where he passed the examination for the normal school curriculum of the Tokyo Fine Arts School, studied under Tanabe Itaru, and aspired to become an oil painter. In 1926, Chen became the first Taiwanese Western-style painter to be selected for the Imperial Art Exhibition (Teiten) with his painting *Outside Chiayi Street*. During his stay in Japan, he traveled to China to paint en plein air. From 1929, he taught at Shanghai Xinhua Art College and other schools, and, during this time, he created a series of oil paintings depicting scenes from the Jiangnan region, introducing dynamic movements into his figures through his use of lines, gradually establishing his personal style. In 1933, he ended his years of travel and returned to Taiwan. The next year he was selected for the Teiten exhibition for the fourth time with the work *Spring in the West Lake*, and co-founded the "Tai-Yang Art Association" with other artists. Since then, the subject of Chen's works shifted to Taiwanese landscapes such as Chiayi and Tamsui. He continued to be active as a professional painter in official exhibitions, Tai-Yang Exhibitions, and Japan Kofu-kai Exhibitions. In 1946, he served as Chiayi City Councilor and a selection committee member at the first Taiwan Provincial Art Exhibition. Tragically, he died the following year as a victim of the February 28 Incident.

黃土水
HUANG TU-SHUI
1895-1930

臺北艋舺人，1915年國語學校畢業後，同年
進入東京美術學校雕刻科木雕部選科，是第
一位入學該校的臺灣人。1920年以《蕃童》
入選第二回帝展後，第三至五回帝展也接連
入選，成為第一位入選日本官展的臺灣人。
除了木雕，亦學會西式塑造及大理石技法，
擅長寫實動物、女性裸體等題材，發揮多方
面的雕塑才華。1923年左右開始以臺灣水牛
為主要創作主題，包括1924年《郊外》（第
五回帝展）、1926年《南國之風情》（第
一回聖德太子奉贊美術展）、1928年《水
牛群像（歸途）》（日本三之丸尚藏館收
藏）等，最後發展至浮雕大作《水牛群像》
（1930，臺北中山堂）。此外，1920年代後
半開始大量接受委託創作，在獻給臺北龍山
寺的《釋迦出山像》（1927）像之外，尚有
如日本皇族久邇宮邦彥王夫妻的肖像等，製
作了臺日重要人士的肖像雕塑。

Huang Tu-Shui was born in Bangka, Taipei. After graduating from
the National Language School, Huang entered the Woodcarving
Department of the Tokyo Fine Arts School, becoming the first
Taiwanese student at the school. In 1920, his work *Aboriginal Child*
was selected to appear at the second Imperial Art Exhibition (Teiten).
Huang featured consecutively at the Teiten exhibition from the third
to the fifth editions, becoming the first Taiwanese to be selected for
an official Japanese exhibition. In addition to wood sculpture, he also
studied Western-style modeling and marble sculpting techniques.
He was an expert in sculpting realistic animals, female nudes, and
other themes, exerting his sculptural talents in a wide variety of
subjects. Around 1923, Huang began to use Taiwan water buffalo as
the main creative theme in his works. These included, among many
others, *In the Country* (1924), which was selected for the fifth Teiten
exhibition, *In the South* (1926), which was selected for the 1st Prince
Shōtoku Commemorative Art Exhibition, and *The Water Buffalo
(Returning)* (1928), which is currently part of The Museum of the
Imperial Collections. His masterpiece, *The Water Buffalo* (1930),
was the culmination of this creativity, a painting which is currently
displayed in the Taipei Zhongshan Hall. In addition, apart from the
Shakyamuni Descending the Mountain (1927), which was donated
to Taipei's Lungshan Temple, Huang began accepting large volumes
of commissioned works during the latter half of the 1920s. Busts of
important figures in Taiwan and Japan were requested, including the
Japanese imperial family, Kuni no miya Kuniyoshi and his wife.

山崎省三
YAMAZAKI
SHOZO
1896-1945

師事小杉放庵、山本鼎，1920年代投入農民
美術與自由畫運動，加入春陽會。1929年短
暫遊學巴黎、義大利後，1930年代頻繁旅行
沖繩、臺灣，1934年於第十二回春陽會展出
《臺湾婦人の横向図》等作，同時在《臺灣
日日新報》發表評論其中楊三郎留歐的特別
陳列作品。1938年8月他並與山本鼎前來探
察臺灣美術工藝現狀，對原住民工藝十分讚
賞，9月於臺北公會堂舉辦座談會進行交流，
並於臺灣日日新報社講堂舉辦洋畫小品展。
戰爭期間山崎作為從軍畫家前往華南、大同
石窟、南洋等地。1940年與楊三郎等參與在
廈門舉辦之日華合同美術展，並於鐵道旅館
舉辦個展。1945年因腦溢血病逝於越南陸軍
病院。

Yamazaki Shozo studied under Kosugi Hoan and Yamamoto Kanae.
In 1920 he participated in the Peasant Art and the Free Drawing
Education Movement and joined the Shunyo-kai. In 1929, after a
brief study tour to Paris and Italy, he began traveling frequently to
Okinawa and Taiwan in the 1930s. In 1934, Yamazaki showcased the
painting, *Side view of Taiwanese lady*, among other works. At the same
time, he published a critique of Yang San-Lang's exhibited works in
Taiwan Nichi Nichi Shimpo. In August 1938, he traveled to Taiwan
with Yamamoto Kanae to explore the arts and craftsmanship of the
island, and praised indigenous technique above all. September of the
same year, Yamazaki organized an exchange seminar at the Taipei City
Public Auditorium (now renamed Zhongshan Hall), and showcased
an exhibition consisting of smaller works at the Taiwan Nichi Nichi
Shimpo Auditorium. During the war, Yamazaki traveled to Southern
China, the Yungang Grottoes, Nanyang, and other places as a military
painter. In 1940, he participated in the Japan-China Art Exhibition,
held in Xiamen, with Yang San-Lang and others, and presented a
solo exhibition at the Railway Hotel. In 1945, he died of a cerebral
hemorrhage in the Vietnamese Army Hospital.

藝術家小傳 ARTISTS' PROFILES

鮫島台器
SAMEJIMA TAIKI
1898-卒年不詳

日本鹿兒島人，本名盛清。居住基隆並於鐵道部工作時，開始製作雕塑作品，1929年於基隆、臺北舉辦個展。後來受到在臺日本人士的支援，及黃土水的介紹，赴東京拜日本著名雕塑家北村西望為師。北村一般不收徒弟，但因鮫島再三拜訪，一年後終成其門下弟子。1932年初次入選第十三回帝展，次年以臺灣原住民男性像《山之男》再度入選，1934、1939年又相繼入選第十五回帝展和第三回新文展，1941年獲無鑑查資格，出品1941、1943年的新文展及1944年的戰時特別展。與北村西望一樣，鮫島擅長塑造健康活力的男性裸體像，後期亦追求男性老人像之創作。鮫島除在日本參加官展外，也保持與臺灣的關係，1934年將《女神像》捐給基隆公會堂，1935年製作《北白川宮能久親王像》、《陳中和像》等，從事不少銅像製作。1933及1935年在臺灣舉辦個展，1941年臺陽美術協會設立雕刻部時，鮫島也與臺籍雕塑家陳夏雨、蒲添生一起成為會員。

Samejima Taiki, from Kagoshima, Japan, and whose real name was Morikiyo, started making sculptures when he lived in Keelung, Taipei and worked at the Railway Department. In 1929, he held a solo exhibition in Keelung. Later, with the support of Japanese nationals in Taiwan and the introduction of Huang Tu-Shui, he went to Tokyo to meet with the renowned Japanese sculptor Kitamura Seibo, and hoped to become Kitamura's student. Kitamura did not usually take on students. Nevertheless, Samejima continued to visit, and, a year later, Kitamura eventually agreed. In 1932, Samejima was selected for the first time for the thirteenth Imperial Art Exhibition (Teiten). The year after, he was selected again, and exhibited the Taiwanese aboriginal male sculpture, *Man of Mountains*. In 1934 and 1939, he was selected for the fifteenth Teiten exhibition and the third New Ministry of Education Art Exhibition (Shin Bunten). His success meant he later received selection exemption status for the 1941 Shin Bunten Exhibition, exhibited in the 1941 and 1943 Shin Bunten Exhibitions, and the Wartime Special Exhibition in 1944. Similar to Kitamura Seibo, Samejima was skilled at sculpting strong energetic male nudes, and, in his later years, he also pursued elderly male forms. As well as participating in official exhibitions in Japan, Samejima also maintained his relationship with Taiwan and produced many bronze statues. In 1934, he donated the *Goddess Statue* to the Keelung City Public Auditorium, and in 1935, he created the *Statue of Prince Kitashirakawa Yoshihisa* and the *Statute of Chen Jhong-He*. In 1933 and 1935, he held solo exhibitions in Taiwan, and in 1941, when the Sculpture Division of the Tai-Yang Art Association was founded, Samejima and Taiwanese sculptors Chen Hsia-Yu and Pu Tien-Sheng joined as members.

呂鐵州
LU TIEH-CHOU
1899-1942

出生於桃園大溪，本名鼎鑄，從小喜愛傳統藝術。父親呂鷹揚是當地擅長漢詩的知名紳商。1923年至大稻埕經營繡莊，為顧客描繪繡花圖樣，並以臨摹畫譜與畫冊的方式學習繪畫。1927年首回臺展以傳統題材《百雀圖》落選後，隔年赴日從頭學習近代日本畫。他進入京都市立繪畫專門學校福田平八郎的畫室學習，也與日本畫家小林觀爾在京都各地寫生。1929年轉型有成，以《梅》獲得第三回臺展東洋畫部特選。次年卻因家中經濟遭逢鉅變而返臺。作品《後庭》（1931）、《蓖麻與軍雞》（1932）及《南國》（1933）陸續獲得臺展賞榮耀，儼然成為畫壇著名的花鳥畫家。他細緻地描繪臺灣常見的花卉植物與鳥類，以精準而略帶簡化的造型、華麗典雅的色彩，充分展現對象的外觀與內在的生命力。1935年設立南溟繪畫研究所，指導的學生相繼入選臺展。他並參加團體持續研究與推廣東洋畫，包括栴檀社、麗光會、六硯會及臺陽美術協會。1942年不幸因病去世。呂鐵州的繪畫人生起伏轉折，天分加上不服輸的個性，追求完美與嚴謹的創作態度，讓他崛起於畫壇而成為臺灣人創作東洋畫的先驅之一。

Lu Tieh-Chou, born in Daxi, Taoyuan, and whose real name was Ding-Chu, had loved traditional art since childhood. His father, Lu Ying-Yang, was a well known local merchant also talented in poetry. In 1923, Lu Tieh-Chou operated an embroidery shop in Dadaocheng, drew embroidery patterns for customers, and learned to paint by imitating painting manuals. After Lu failed to enter the first Taiwan Fine Arts Exhibition (Taiten) in 1927 with the traditionally themed *Hundred Sparrow*, he went to Japan the following year to study modern Nihonga (Japanese painting) from scratch. He studied at the Kyoto City Technical School of Painting in Fukuda Heihachiro's class, and painted en plein air with Kobayashi Kanji. In 1929, he successfully transitioned from a traditional Chinese artist to a Nihonga artist and was selected to showcase in the Japanese Painting Division at the Third Taiten Exhibition with the work *Plum Flower*. In the following year, he returned to Taiwan due to the decline in his family's fortune. His works *Backyard* (1931), *Castor and Army Rooster* (1932), and *Southern Country* (1933) won awards and honors at successive Taiten exhibitions. As a result, Lu became a celebrated flower and bird painter. He meticulously depicted flowers, plants, and birds commonly found in Taiwan with precise and slightly simplified forms, and gorgeous and elegant colors that fully presented their appearance and vitality. In 1935, Lu established the Nan-Ming Painting Institute, where the students under his guidance were frequently selected for the Taiten exhibitions. He also participated in the continuous research and promotion of Japanese paintings in art groups, including the Sendan Sha, Li-Guang Hui, Liu Yan Hui, and Tai-Yang Art Association. Lu died of illness in 1942. Lu Tieh-Chou's painting career had its ups and downs. His talent, coupled with an unyielding personality, his pursuit of perfection, and a serious attitude toward his artistic practice, allowed him to rise in the art world to become one of the pioneers of Taiwanese Japanese painting.

林克恭
LIN KO-KUNG
1901-1992

出生於板橋林本源富商之家，在父親林爾嘉於廈門鼓浪嶼的「菽莊花園」成長，從小受西式菁英教育與傳統文化浸染。1920年入劍橋大學攻讀法律與經濟，畢業後轉向美術，於倫敦大學斯雷德美術學院及巴黎裘里安、日內瓦美術學校等就讀深造，是臺灣近代唯一接受歐洲完整學院美術訓練的前輩畫家。1925年便入選英國皇家學院展。1931年以《裸女》入選臺展並於臺北舉辦個展，活躍於廈港臺三地畫壇，曾任廈門美專校長，入會臺陽美術協會。二戰時避居香港、澳洲。1949年返臺後受邀任教於政治作戰學校及文化大學美術系，亦曾擔任全國美展評委，並參與「自由中國美展」及中國畫學會。畫風清新簡鍊，重視透視與結構，擅長表現形、色、線的互動關係。1950年代末改以人體組合等抽象語彙，發展出富含東西文化象徵意涵的作品。1973年任巴西聖保羅雙年展評委後退休定居紐約。

Lin Ko-Kung was born into a wealthy merchant family in Banqiao. Lin spend his childhood in his father Lin Erjia's estate, "Shuzhuang Garden", on Gulangyu Island, Xiamen, where he was raised with an elitist western education while surrounded by traditional Chinese culture. In 1920, he entered Cambridge University to study law and economics. After graduation, he turned to fine arts and studied at the Slade School of Fine Arts in London, the Académie Julian in Paris, and École des Beaux-Arts in Geneva, becoming the only Taiwanese painter of his time to receive complete European art training. In 1925, Lin was selected to exhibit at the Royal Academy in London. In 1931, his work *Female Nude* was selected to participate in the Taiwan Art Exhibition (Taiten) and Lin held a solo exhibition in Taipei. Active in the painting circles of Xiamen, Hong Kong, and Taiwan, Lin also served as the Principal of Xiamen Art College and joined the Tai-Yang Art Association. Lin took refuge in Hong Kong and Australia during World War II. In 1949, after returning to Taiwan, Lin was invited to teach at the Fine Arts Department of Fu Hsing Kang College and the Chinese Cultural University. He also served as a selection committee member at the National Art Exhibition, participated in the "Free China Art Exhibition", and in the Chinese Painting Society. His painting style was refreshing and simple, paying attention to perspective and structure, and skilled at juxtaposing form, color, and line. In the late 1950s, his works shifted into investigating human body composition and abstract vocabulary, which led to the development of works that are rich in both Eastern and Western cultural symbols. In 1973, after serving on the judging committee of the São Paulo Biennale in Brazil, Lin retired and settled in New York.

郭柏川
KUO PO-CHUAN
1901-1974

臺南市人。幼時曾入私塾研習漢文，1921年國語學校師範畢業後返鄉任教公學校。1926年赴日於川端畫學校學畫，1928年考入東京美術學校西洋畫科，師事岡田三郎助。1937年他從日本轉赴中國東北旅行寫生，然後在北平落地生根。他任教於國立北平師範大學、北平藝專、私立京華藝術學校，同時舉辦多次的個展，1941年成立「新興美術會」，並與水墨畫家黃賓虹、齊白石往來，也陪同六度造訪北平的日本畫家梅原龍三郎旅行寫生，建立亦師亦友的情誼。他受到梅原龍三郎的創作啟發，以松節油稀釋的油彩在宣紙上作畫，並吸收水墨畫構圖與書法線條的美感或青花、五彩的釉色，意圖以油畫建立具有東方精神的繪畫風格。1948年他攜家返臺，於臺北中山堂舉辦個展。1950年他應邀至成功大學建築系任教，直到1970年退休為止。1952年他創設臺南美術研究會，奠定南部美術發展的重要根基。

Kuo Po-Chuan, born in Tainan, studied the Chinese language with private tutors from a young age. In 1921, after graduating from the National Language School, he returned to his hometown and taught in a public school. In 1926, Kuo traveled to Japan to study at the Kawabata Painting School. Then he studied in the Western Painting Department at the Tokyo Fine Arts School and under the guidance of Okada Saburosuke. In 1937, he traveled from Japan to northeast China to paint en plein air and then settled down in Beijing. He taught at National Beijing Normal University, National School of Fine Arts in Beijing, and Private Jinghua Art School, and showcased many solo exhibitions at the same time. In 1941, Kuo founded the "Emerging Art Association", and befriended ink painters Huang Binhong and Qi Baishi. He also accompanied the Japanese painter Umehara Ryuzaburo, who visited Beijing six times to travel and paint from life, establishing a relationship that was between mentorship and friendship. Inspired by Umehara Ryuzaburo's paintings, Kuo began painting on rice paper with oil paints that were diluted with turpentine. Kuo wanted to incorporate the beauty of ink painting compositions, calligraphy lines, and colorful glazes, to create a painting style with an eastern spirit in the form of an oil painting. In 1948, he returned to Taiwan with his family and held his solo exhibition in Taiwan at the Zhongshan Hall in Taipei. In 1950, Kuo was invited to teach in the Architecture Department of National Cheng Kung University until his retirement in 1970. In 1952, he founded the Tainan Fine Arts Association, laying down the critical foundation for the development of art in southern Taiwan.

廖繼春
LIAO CHI-CHUN
1902-1976

李梅樹
LI MEI-SHU
1902-1983

臺中豐原人，就讀國語學校時開始自學油畫，1924年與陳澄波同船赴日考取東京美術學校圖畫師範科，師事田邊至。返臺後任教於臺南長老教會中學及女學校，首屆臺展即以《靜物》獲得特選，隔年再以《有香蕉樹的院子》入選帝展。此後連續入選帝展、臺展，與陳進一同成為臺展首聘的臺籍審查員，並與畫友共組赤陽洋畫會、赤島社與臺陽美術協會。戰後持續擔任教職及省展審查員，先後任教於臺南一中、臺中師範學校、臺灣師範學院等校，在文化藝術界享有盛名，可謂桃李滿天下。1962年應美國國務院之邀赴美考察，回國後以絢麗的色彩組合，開創出帶有抽象筆意的具象畫風，將觀音山等自然風景簡化為形色的變奏。此種對不同繪畫風格加以嘗試的開明作風，是其備受學生愛戴的主因，著名的現代繪畫運動團體「五月畫會」即在其影響下成立。1973年自教職退休，1976年病逝。

Liao Chi-Chun, born in Fengyuan, Taichung, studied and taught himself oil painting during his days at the National Language School. In 1924, Liao embarked on the same boat as Chen Cheng-Po to take part in the entrance exam for the normal school curriculum of the Tokyo Fine Arts School, where he studied under Tanabe Itaru. After returning to Taiwan, he taught at Tainan Presbyterian Middle School and Girls' School. He was selected for the first Taiwan Fine Arts Exhibition (Taiten) with the work *Still Life*, and the following year was selected for the Imperial Art Exhibition (Teiten) with the work *Courtyard with Banana Trees*. Since then, he was selected each year for the Teiten and Taiten exhibitions, and, together with Chen Chin, he became the first Taiwanese selection committee member of Taiten. Liao co-founded the Chi-Yang (Red Sun) Western Painting Society, Chidao (Red Island) Group, and Tai-Yang Art Association. After the war, he continued to serve as a faculty member and on the selection committee for Provincial Fine Art Exhibitions. He taught at Tainan First High School, Taichung Normal School, Taiwan Normal University, and various other schools. Liao nurtured many talents and was widely respected in cultural circles. In 1962, he was invited by the US State Department to visit the United States. After returning, he began painting with abstract brushwork and brilliant color combinations, simplifying natural scenery such as Guanyin Mountain into a variety of forms and colors. This enlightened style and experimentation with different painting techniques are the main reasons why Liao is loved by students. The prominent modern painting group "Fifth Moon Group" was also founded under his influence. In 1973, Liao retired from teaching, and in 1976 he died from illness.

新北市三峽人，兄劉清港為三峽第一位臺籍公醫。1918年入國語學校，畢業後返鄉任教公學校。1924年參加石川欽一郎暑期美術講習會，臺展開辦後連續入選。1929年考取東京美術學校西洋畫科，師從岡田三郎助等人。1934年學成返鄉，與畫友組織臺陽美術協會；畫風寫實嚴謹，持續參加臺、府展。《紅衣》（1939）、《花與女》（1940）入選日本新文展。戰前曾任三峽協議員、茶葉組合長等公職。戰後擔任臺北縣縣議員、三峽農會理事長、省展審查委員等多項職務，更親自投入三十六年主持三峽清水祖師廟的重建工作。該廟未完工已博得「東方藝術殿堂」美譽，並於2018年成為市定古蹟。1960年代起任教文化大學、國立藝專，創立藝專雕塑科，邀請多位前輩畫家至該校任校。李梅樹一生堅持鄉土寫實畫風，作品滿溢對土地與人情的關愛，除了描繪家鄉風景外，也常以身邊親友入畫，留下許多古典優雅的臺灣婦女肖像。1983年逝世後葬於三峽。

Li Mei-Shu was born in Sanxia, New Taipei City. Li's brother, Liu Ching-Kan, was the first Taiwanese public doctor in Sanxia. In 1918, Li entered the Taiwan National Language School, and, upon graduation, Li returned to his hometown and taught at a public school. In 1924, Li participated in Ishikawa Kinichiro's summer art seminar and was selected for the Taiwan Fine Arts Exhibition (Taiten) every year since its inauguration. In 1929, he passed the entrance examination for the Western Painting Department at the Tokyo Fine Arts School, studying under Okada Saburosuke and others. In 1934, Li graduated and returned to Taiwan to co-found the Tai-Yang Art Society with other artist friends. He continued to paint in realist styles and participate in the Taiten and Futen exhibitions. His works, Girl in *The Red Dress* (1939) and *Girl with Flowers* (1940), were selected for the Ministry of Education Art Exhibition (Shin Bunten). Before the war, Li served as a Sanxia township councilor, the chairman of the Taipei Tea Merchants Association, and other public sector roles. After the war, he served as Taipei County Councilor, chairman of the Sanxia Farmers Association, and committee member of the Provincial Fine Art Exhibitions, among other roles. Li also devoted 36 years to the rebuilding of the Sanxia Zushi Temple. The temple had already earned its reputation as a "Palace of Oriental Art" while under construction, and in 2018 it became a city designated historic site. From the 1960s, Li taught at the Chinese Culture University, and the National Taiwan University of Arts, where he founded their Sculpture Department, inviting many senior artists to teach at the University. Li committed himself to painting the local landscape and figurative works with a realist style throughout his life, and his paintings demonstrated strong local sentiments for the land and people. In addition to depicting the scenery of his hometown, he often painted friends and relatives, leaving many classic yet elegant Taiwanese female portraits. Li died in 1983 and was buried in Sanxia.

顏水龍
YEN SHUI-LONG
1903-1997

藍蔭鼎
LAN YIN-DING
1903-1979

出生於臺南下營，六歲時父母親雙亡。臺南教員養成所畢業，任教公學校兩年後前往東京打工留學。1929年東京美術學校西洋畫研究科畢業。次年前往巴黎留學。他到羅浮宮臨摹提香（Titian）、安格爾（Jean-Auguste-Dominique Ingres）等的古典人物畫，以便帶回臺灣公開展示；此外，世界殖民地展覽（The Paris International Colonial Exhibition）刺激他思考原始藝術與現代生活藝術的連結。1931年入選法國秋季沙龍展，1932年底返回日本。次年從事廣告設計，同時經常返臺，於北中南舉辦三場留歐作品展；為臺灣新民報繪製連載小說插圖。1934年任臺展審查員並參與創設臺陽美術協會。1937年受聘總督府殖產局，調查全臺手工藝產業。1941年加入造型美術協會；創立南亞工藝社等，致力於產品外銷，帶給農民福利。

戰後參與成立南投縣工藝研究班等研習所；1971年創立臺北實踐家專美術工藝科。他相信，推動實用美術工藝品的製作與使用，將美感融入生活，更能全面提昇臺灣社會的文化價值觀。他投入製作工程繁瑣的馬賽克公共藝術，希望藝術走入街頭，深入民眾。他亦長期關注原住民，在畫作中描繪他們的藝術與文化，更反映弱勢族群的生命尊嚴。

宜蘭羅東人，羅東公學校畢業，從師石川欽一郎門下習水彩畫，曾獲臺灣總督府推薦赴日進修水彩畫。返臺後任教於第一高女、第二高女、第三中學。作品多次入選臺展、帝展、府展等。1929由石川欽一郎推薦為英國皇家水彩協會會員，亦加入日本水彩畫會、中央美術會，也是臺灣繪畫團體七星畫壇、赤島社成員。1939年在羅馬舉行個展，受邀成為義大利美術協會會員。戰後積極參與公共事務，曾任臺灣畫報社、豐年半月刊社之社長兼總編輯。1954年應美國國務院邀請，成為第一位赴美訪問的臺灣藝術家，也是首位在美國新聞處舉辦畫展的華人藝術家。多次奉派出國訪問，進行藝術外交。曾入選世界十大水彩畫家。1973年出任華視董事長。早期承襲石川的輕快畫風，但色彩更為明亮繽紛；後期以水墨畫的皴、擦、染等技法結合水彩畫效果，擅於描繪氣勢磅礴的風景與集體人群的動態，如《春江水暖》（1971），給人宛如電影場景般的深刻印象。另著有散文集《鼎廬小語》等，圖文合輯《畫我故鄉》為其遺作。

Yen Shui-Long was born in Xiaying, Tainan. Yen's parents passed away when he was six years' old. After graduating from the Tainan Teachers' Training School, Yen taught in public schools for two years before traveling to Tokyo to work and study. In 1929, Yen graduated from the Graduate School of the Western Painting Department of the Tokyo Fine Arts School, and in the following year traveled to Paris to study. He imitated Titian, Jean-Auguste-Dominique Ingres, and other classical figurative painters in the Louvre in order to exhibit them back in Taiwan. In addition, the Paris International Colonial Exhibition stimulated him to contemplate the connection between primitive art and the art of modern living. In 1931, his work was selected for the Salon d'Automne, and in 1932, he returned to Japan. In the following year, Yen became engaged in advertising design, but, at the same time, he often returned to Taiwan where he held three exhibitions in the north, centre, and south of the country showcasing works created during his time in Europe. He also produced illustrations for serial novels printed in the newspaper Taiwan Shin Min Pao. In 1934, he became a selection committee member for the Taiwan Fine Arts Exhibition (Taiten) and co-founded the Tai-Yang Art Association. In 1937, Yen was employed by the Bureau of Economy to investigate the crafts industry in Taiwan. In 1941, he participated in the Plastic Arts Association, founded the South-Asia Arts and Crafts Society, and participated in other activities committed to promoting product exports and better welfare for farmers.

After the war, Yen organized the Nantou Craft Seminars and other institutes, and in 1971, he founded the Shih Chien College of Home Economics, Art and Craft Department. He believed in the promotion of practical arts and the integration of aesthetics into life to comprehensively strengthen the cultural values of Taiwanese society. Yen poured himself into the laborious production of mosaic public art, hoping that art could enter the streets and into people's lives. He was also concerned with aboriginal culture, depicting their art and culture in his paintings to highlight respect towards ethnic minorities.

Lan Yin-Ding, born in Luodong, Yilan, studied watercolor under Ishikawa Kinichiro and was recommended by the Governor-General of Taiwan to study watercolor painting in Japan. After returning to Taiwan, he taught at Taipei First Girls High School, Taipei Second Girls High School, and Taipei Third Middle School. His works were selected for, among others, the Taiwan Fine Arts Exhibition (Taiten), Imperial Art Exhibition (Teiten), and Taiwan Governor-General's Office Art Exhibition (Futen). In 1929, Lan become a member of the Royal Watercolour Society through Ishikawa Kinichiro's recommendation, a member of the Nihon-Suisai Gakai (Japan Watercolor Society), Central Fine Arts Association, Chi-Hsing (Seven Stars) Painting Group, and Chidao (Red Island) Group. In 1939, he held a solo exhibition in Rome and was invited to become a member of the Italian Fine Arts Association. Lan actively participated in public affairs after the war, serving as the president and editor-in-chief of Taiwan Pictorial and Harvest Semi-monthly. In 1954, he became the first Taiwanese artist to visit the United States with an invitation from the US State Department, as well as the first Chinese artist to hold an exhibition at the U.S. Information Service. He was sent abroad on many occasions to conduct cultural diplomacy, and was named as one of the top ten watercolor painters in the world. In 1973, he was appointed chairman of the Chinese Television Service (CTS). In the early parts of his career, Lan took on Ishikawa's brisk painting style, but with lighter and more vibrant colors; later in his career, he used ink painting techniques, such as rubbing and dyeing, combined with watercolor effects, and was particularly skilled at depicting majestic landscapes and dynamics in the crowd, such as The Warm Glow of Spring Time (1971). This style would leave a lasting impression in viewers' minds, almost like a scene taken from a movie. Before his death, Lan also wrote literary works, such as Ding Lu Xiao Yu, and produced the illustrated literary compilation Draw My Hometown.

何德來
HO TE-LAI
1904-1986

立石鐵臣
TATEISHI
TETSUOMI
1905-1980

苗栗人，地主何宅五養子，幼時於東京求學。就讀臺中一中期間學習油畫，1927年考取東京美術學校西洋畫科，師事和田英作，曾組織赤陽洋畫會，參與七星畫壇、赤島社展出。1932至1934年是何德來與臺灣畫壇關係最密切的時刻，他與李澤藩等人成立「新竹美術研究會」，致力推動家鄉的現代美術研究風氣。後因胃疾等因素，1934年於新竹公會堂舉辦個展後即赴東京定居，此後活躍於多個日本在野畫會，尤以1942年起參與的「新構造社」最為重要。返日後苦於疾病和戰亂，使其戰後創作出《今日仍在描繪和平之夢》（1951）等充滿象徵寓意及人道關懷的群像作品。形式上則開創出如《五十五首歌》（1964）等以和歌入畫，極具特色又帶有自傳性質，充滿哲思的文字畫。1956年由同鄉畫家鄭世璠協助於臺北中山堂舉行個展。1974年出版詩歌集《吾之道》。畢生不售畫，過世後由家族將遺作捐贈臺北市立美術館。

出生於臺北，父為總督府職員，1913年隨父返日。1921年起向跡部直治習日本畫，1926年轉學西洋畫，先後拜岸田劉生、梅原龍三郎為師。1928年起固定參與國畫會展。1934年遷居臺灣，為同年成立之臺陽美術協會發起人中唯一日籍畫家。隔年退會，與西川滿等人另創立「創作版畫會」。1936年返日，1939年再度來臺任職臺北帝國大學理農學部，繪製動植物標本畫。經常於《文藝臺灣》、《民俗臺灣》發表文章，亦負責諸多書籍與雜誌的裝幀、插繪工作。戰前作品多次獲臺展獎項。戰後以日僑身分留用，任職省立編譯館、臺灣大學等單位，1948年遣返回到東京。返日後繪畫風格轉向超現實主義，並將細密畫導入油畫創作。1962年完成《臺灣畫冊》，追憶中流露對臺灣的思念之情。1978年出版《細密畫描法》。1980年因肺癌逝世。

Ho Te-Lai, born in Miaoli, was the adopted son of wealthy landowner Ho Zhai-Wu. He studied in Tokyo as a child. He learned oil painting while studying at Taichung First Senior High School, and in 1927 he passed the entrance examination for the Western Painting Department at the Tokyo Fine Arts School, studying under Wada Eisaku. Ho co-founded the Chi-Yang (Red Sun) Western Painting Society, participated in the Chi-Hsing (Seven Stars) Painting Group, and Chidao (Red Island) Group exhibitions. 1932 to 1934 marked the period where Ho was closest to the painting circle in Taiwan. Ho, Lee Tze-Fan and others co-founded the Hsinchu Art Research Association to promote modern art research in his hometown. In 1934, after holding a solo exhibition at the Hsinchu Public Hall, he relocated to Tokyo due to abdominal illness and other reasons. After moving to Tokyo, he was active in many Japanese painting societies. The most important of which was the Shinkozo, in which he participated since 1942. After returning to Japan, Ho had to endure disease and war, inspiring him to create the work *The Dream of Peace Still Depicted Today* (1951) and other works filled with symbolic meanings of humanitarian sentiment. In terms of form, he pioneered the incorporation of waka (Japanese poetry) into his work. The philosophical words in *Fifty-Five Waka Poems* (1964) are distinctive and autobiographical. In 1956, with assistance from artist Cheng Shih-Fan, who was from the same hometown as Ho, he was able to present a solo exhibition at Zhongshan Hall in Taipei. In 1974, he published a collection of poems called *My Way*. Throughout his life, he never sold any of his paintings, and, after his death, his family donated his works to the Taipei Fine Arts Museum.

Tateishi Tetsuomi was born in Taipei and his father worked at the Governor-General's office. In 1913, he returned to Japan with his father. In 1921, he studied Nihonga (Japanese painting) with Atobe Naoharu. In 1926, Tateishi switched over to study western painting with Kishida Ruisei and then Umehara Ryuzaburo. From 1928 onwards, he regularly participated in the Kokugakai exhibitions. In 1934 he moved to Taiwan, and became the only Japanese artist in the Tai-Yang Art Association that was founded in the same year. Tateishi withdrew from the association the following year and founded the Printmaking Association. In 1936, Tateishi moved to Japan, but he returned to Taiwan again in 1939 to teach at the Faculty of Science and Agriculture, Taihoku Imperial University, producing animal and botanical illustrations. He frequently published essays in magazines such as *Bungei Taiwan* and *Minzoku Taiwan*, and was responsible for the bindings and illustrations of many books and magazines. Before the war, Tateishi had won various awards at the Taiwan Fine Arts Exhibitions (Taiten). After the war, he stayed as a Japanese overseas national and worked in organizations such as National Taiwan University and the Provincial Institute for Compilation and Translation. In 1948, he was repatriated to Tokyo. After returning to Japan, his painting style shifted to surrealism and he introduced botanical illustrations into oil painting. In 1962, Tateishi completed the *Taiwan Gasatsu* where he revealed the fond memories and nostalgic feelings he had for Taiwan. In 1978, he published *Detailed Drawing Methods*. He died from lung cancer in 1980.

陳植棋
CHEN CHIH-CHI
1906-1931

出生於汐止橫科，1920年進入臺北師範學校。1924年年底因參與該校學潮遭退學，在美術教師石川欽一郎的鼓勵下，隔年赴日考取東京美術學校西洋畫科，並入吉村芳松畫塾。1926年成立美術團體「七星畫壇」。課餘亦關心臺灣民族運動。1927年臺展開辦後連續四年入選，獲特選或無鑑查資格。1928年以《臺灣風景》入選帝展。1929年參與成立西畫團體「赤島社」。同年協助倪蔣懷成立「臺灣繪畫研究所」，以青年領袖之姿積極提攜後進。作品善用大膽創新的色調及筆觸營造臺灣圖像，展現奔放而強烈的個人色彩。1930年抱病攜《淡水風景》赴日參加帝展，雖順利入選卻病倒，隔年逝世，年僅二十六。

Chen Chih-Chi was born in Hengke, Xizhi. In 1920, he entered Taipei Normal School, but was expelled after participating in student protests in late 1924. The following year, with encouragement from his teacher, Ishikawa Kinichiro, Chen was accepted into the Western Painting Department at Tokyo Fine Arts School, where he also studied at Yoshimura Yoshimatsu's painting school. In 1926, Chen founded Chi-Hsing (Seven Stars) Painting Group. He was also actively involved in the Taiwan nationalist movement in his own time. In 1927, after the first Taiwan Fine Arts Exhibition (Taiten) commenced, his works were selected consecutively for four years, where he either won the grand prize or received selection exemption status. In 1928, his painting *Taiwan Landscape* was selected for the Imperial Art Exhibition (Teiten). In 1929, he founded the Chidao (Red Island) Group. In the same year, Chen assisted Ni Chiang Huai and co-founded the Taiwan Institute of Painting, with Chen actively supporting up and coming artists as a youth leader. His works make use of bold and innovative colors and brushstrokes to create images of Taiwan, showing strong personal styles. In 1930, while suffering from illness, Chen submitted the work *Tamsui Landscape* to the Teiten Exhibition. Although the work was selected, Chen's illness worsened and he died at the age of twenty-six.

藝術家小傳 ARTISTS' PROFILES

陳進
CHEN CHIN
1907-1998

新竹香山人，父親陳雲如為地方上的名望士紳。1925年在臺北第三高女美術老師鄉原古統的鼓勵下，前往東京女子美術學校就讀。第一回臺展以在學的三幅畫作《姿》、《罌粟花》、《朝》入選。1929年經松林桂月介紹進入鏑木清方門下研究，跟隨山川秀峰、伊東深水學習。1932年受邀擔任臺展東洋畫部審查員，1934年《合奏》首度入選日本帝展。1934至1937年期間任教屏東高女，之後定居日本專心創作與參展，1946年返臺。陳進從學習日本美人畫，轉變至描繪臺灣傳統與現代兼備的女性人物，精緻細膩的風格，塑造出高貴典雅、柔中帶剛的女性形象。對創作的堅持，使其在男性主導的畫壇中脫穎而出，成為臺灣第一位女性畫家。戰後走出嚴謹理想的人物畫風，呈現較自由的自我面貌。創作題材涵蓋家庭圖像、花卉、風景與佛畫，並在原有的日本畫基礎上，融合水墨與西洋繪畫技法，呈現多樣化的作品風格。

Chen Chin was born in Xiangshan, Hsinchu, and Chen's father, Chen Yun-Ru, was a well-respected local figure. In 1925, encouraged by her art teacher Gobara Koto at Third Taipei Municipal Girl's High School, Chen attended Tokyo Girls College of Art. For the first Taiwan Fine Arts Exhibition (Taiten), Chen submitted three works from college: *Pose*, *Poppy Flower*, and *Morning*, and all three were selected. In 1929, with an introduction from Matsubayashi Keigetsu, Chen began research under the supervision of Kaburaki Kiyokata and studied alongside Yamakawa Shuho and Ito Shinsui. In 1932, she was invited to become a selection committee member of the Japanese painting division of the Taiten exhibition. Then, in 1934, she participated for the first time at the Imperial Art Exhibition (Teiten) with her work *Ensemble*. From 1934 to 1937, she taught at Pingtung Girl's Senior High School, and later moved to Japan to concentrate on her practice and exhibitions, returning to Taiwan in 1946. After starting out studying Japanese Bijin-ga (Japanese style female portraiture), Chen shifted to depicting Taiwanese female figures that demonstrated both traditional and modern qualities. Her exquisite and delicate style created female images that are noble and elegant, gentle but determined. Perseverance in Chen's painting practice made her stand out in the male-dominated art scene and allowed Chen to become the first professional female painter in Taiwan. After the war, she stepped away from painting stereotypical and idealized characters and started to show a more liberal side to her works. The subject matter of Chen's works crosses from family scenes to flowers, landscapes, and Buddhist paintings. Building on her training in Nihonga (Japanese painting), Chen combined ink and western painting techniques to present a diversified painting style.

楊三郎
YANG SAN-LANG
1907-1995

臺北人,家族為地方富商。1923年赴日就讀京都美術工藝學校,一年後轉入關西美術院學習油畫,師承非官展系統的黑田重太郎,田中善之助,作品入選臺展,日本春陽會展。因第五回臺展意外落選,遂於1932年遠赴巴黎遊學進修,期間入選法國秋季沙龍展,隨後再度於臺展大放異彩。1934年發起創設臺陽美術協會,隔年受薦為日本春陽會友,至此奠定畫壇地位,被公認為推動臺灣畫會與美術運動的領頭羊。戰後應邀籌辦省展並擔任審查委員,此後專注於創作與畫會活動,成為臺陽美展歷久不衰的靈魂人物。畫風受法國畫家柯洛(Jean-Baptiste-Camille Corot,1796-1875)影響,以風景畫為主,晚年定期前往日本、歐美等地進行寫生創作。1991年成立楊三郎美術館,1995年病逝。

Yang San-Lang came from an upper-class merchant family in Taipei. In 1923, Yang attended the Kyoto School of Arts and Crafts, but a year later he transferred to the Kansai Bijutsu-in (Kansai Arts Institute), studying under Kuroda Jutaro and Tanaka Zennosuke, both of whom were outside the official exhibition system. Yang's work was selected for the Taiwan Fine Arts Exhibition (Taiten) and the Shunyo Art exhibition. Due to his unexpected failure to enter the fifth Taiten exhibition, he went to Paris in 1932 to do his further studies. Whilst in Paris, he was selected for the Salon d'Automne, and, upon his return, Yang excelled once again at the Taiten exhibitions. In 1934, he called for the founding of the Tai-Yang Art Association. The following year Yang was recommended as a member of the Shunyo-kai. From this point on Yang established his status in the art scene, and was recognized as a leading figure in promoting Taiwanese art groups and movements. After the war, Yang was invited to organize the Provincial Fine Art Exhibition and served on the review committee. He then concentrated on his painting practice and art group activities, becoming the permanent central figure of the Tai-Yang Art Exhibition. Yang's style of painting was influenced by French painter Jean-Baptiste-Camille Corot (1796-1875). Focused primarily on landscapes, Yang traveled regularly to Japan, Europe, the United States, and other countries to paint en plein air in his later years. In 1991, the Yang San-Lang Art Museum was established. Yang died from illness in 1995.

李澤藩
LEE TZE-FAN
1907-1989

新竹人,諾貝爾獎得主李遠哲之父。1921年入臺北師範學校,受石川欽一郎啟蒙習畫,畢業後返回新竹任教。1928年以《夏日的午後》入選臺展,並活躍於臺灣水彩畫會與日本水彩畫會。戰後任教新竹師範學校,1956年起又陸續兼任於臺灣師範大學美術系、國立藝專及全省教師研習會授課,終生奉獻杏壇。參與臺陽美術協會及省展活動,1960年代起任省展審查員。創作多為臺灣風景寫生,尤其新竹一帶風景名勝是其一生繪寫不輟的核心主題,技法上開創出洗畫、厚疊等別具一格的個人水彩技法。1971年創立新竹縣美術協會並任會長,1976年罹患血栓症,病癒後重拾畫筆,晚年以憶想方式完成《社教館懷古》(1982)、《孔子廟》(1986)等重要大作。

Lee Tze-Fan, born in Hsinchu, was the father of Nobel Prize laureate Lee Yuan-Tseh. In 1921, he entered the Taipei Normal School where he was inspired to paint by Ishikawa Kinichiro. After graduation, Lee returned to teach in his hometown. In 1928, he was selected for the Taiwan Fine Arts Exhibition (Taiten) with the work *Summer Afternoon*. He also participated in the Taiwan Watercolor Painting Society, and Nihon-Suisai Gakai (Japan Watercolor Society). After the war, he taught at Hsinchu Normal School. From 1956 he dedicated his life to teaching, and taught at the Fine Arts Department of Taiwan Normal University and the National Taiwan University of Arts, and lectured at provincial teachers' seminars. Lee also participated in Tai-Yang Art Association activities and the Provincial Fine Art Exhibition. From the 1960s he also served on the Provincial Fine Art Exhibition selection committee. Most of his works are plein air paintings of Taiwanese landscapes, especially the scenic sites around the Hsinchu area, a subject he constantly returned to throughout his life. Lee developed a distinct personal style of painting where he washed drawings or stacked paint thickly among other techniques. In 1971, Lee founded the Hsinchu County Art Association and served as its chairman. In 1976, he suffered from thrombosis, and, after treatment and recovery, returned to painting. In his later years, he completed important masterpieces such as *Reminiscing Social Education Center* (1982) and *Confucius Temple* (1986).

林玉山
LIN YU-SHAN
1907-2004

郭雪湖
KUO HSUEH-HU
1908-2012

嘉義市人,從小跟隨家中風雅軒裱畫店的畫師學習,嫻熟神像民俗畫與裱褙技術。後來向南畫家伊坂旭江請益,也隨陳澄波學習水彩畫寫生,並赴東京川端畫學校日本畫科就讀。1927年首屆臺展以《水牛》、《大南門》入選東洋畫部,1930年寫生家鄉景物的細密重彩畫《蓮池》獲臺展的特選首獎,畫藝深受肯定。除了重彩作品外也常有水墨之作,並參加詩社學習詩文,增進創作的文化內涵。筆下的水牛敦厚樸實,表達人與土地間的緊密關係與溫暖情感。他號召嘉南畫友成立「春萌畫會」,使嘉義畫家入選臺展的比例增高。1950年代任教師大美術系時,畫壇又興起傳統水墨畫與臨摹的風氣,他力倡寫生創作並發展彩、墨並重的風格。創作題材遍及各類花鳥動物,皆栩栩如生;晚年描繪山岳海景,融合東西方繪畫的筆墨、光影與色彩表現。

Lin Yu-Shan was born in Chiayi. Lin learned to paint from the painters who worked in his family's framing store. He was also familiar with folk paintings and mounting techniques. Later on, Lin studied with Nanga artist Isaka Sikou, and also studied watercolor and painting en plein air with Chen Cheng-Po. Lin traveled to Tokyo to study at the Japanese Painting Department of Kawabata Painting School. In 1927, he was selected for the Japanese Painting Division of First Taiwan Fine Arts Exhibition (Taiten), with his works *Water Buffalo* and *Southern Gate*. In 1930, the *Lotus Pound*, a detailed, heavy color plein air painting of scenes from his hometown won the first prize at the Taiten Exhibition, and his painting skills were recognized by all. In addition to heavy color painting, he frequently produced ink paintings and participated in poetry clubs with the aim of studying poetry and literature to enhance the cultural undertone within his works. The water buffalos that came from his brush are modest and truthful, expressing the close relationship and emotion between man and land. Lin called upon other southern Taiwanese artists to start the Chun-Meng Painting Society, and this increased the proportion of Chiayi painters selected for the Taiten Exhibitions. In the 1950s, while teaching at the Fine Arts Department of Taiwan Normal University, the art scene experienced a renaissance of traditional ink paintings and imitation paintings. Lin advocated for painting en plein air and for the development of both color and ink. Lin's creative themes cover all kinds of true to life flowers, birds, and animals. In his later years, he depicted mountains and seascapes, combining light and color expressions from Eastern and Western painting.

臺北大稻埕人。就讀太平公學校時向導師陳英聲學習水彩畫寫生,後跟隨蔡雪溪學習神像畫與裱褙技術,並利用總督府圖書館藏的美術書籍自學。1927年以《松壑飛泉》入選第一回臺展,與陳進、林玉山合稱「臺展三少年」。1928年以寫生的重彩細密畫《圓山附近》獲臺展特選。1930年《南街殷賑》更獲得臺展特選首獎,主題描繪迪化街中元節時的熱鬧景象,相當符合臺展當局提倡的地方色。臺展前幾回中皆以細密重彩的華麗風格,引領許多畫家跟進學習。曾參與創立「梅檀社」、「六硯會」團體,研究與推廣東洋畫。1931年前往日本見學,開始簡化構圖並使用水墨畫法,在單純形象中追求清晰可讀的效果。1940年《農家之朝》以簡潔筆觸勾勒,施以平塗色彩,帶有平面裝飾性與通俗的趣味。戰後1946年與楊三郎籌辦省展,1954年赴日舉行個展,重新開啟日本畫創作,以鮮麗重彩描繪靜物與風景畫。1964年在鄉原古統的協助下移居日本,後定居美國,繼續各地旅行寫生與辦展的創作生活。

Kuo Hsueh-Hu was born in Dadaocheng, Taipei. When studying at Taiping Public School, Kuo learned watercolor painting from his teacher Chen Ying-Sheng. He then learned idol paintings and mounting techniques from Tsai Shiue-Shi, and taught himself through the art books in the Governor-General's library. In 1927, he was selected for the first Taiwan Fine Arts Exhibition (Taiten) with the work *Stream Through a Pine Ravine*. Together with Chen Chin and Lin Yu-Shan, Kuo was named one of the "Three Youths of Taiten." In 1928, his work *Scenery Near Yuan Shan* received the special prize at the Taiten Exhibition. In 1930, his work *Festival on South Street*, which depicts the energetic scene of Dihua Street during the Zhongyuan Festival, received the first prize in the Taiten Exhibition - the subject of the painting was in keeping with the local qualities Taiten wanted. Lin's participation with works featuring meticulous brushwork and vibrant colors in the first few editions of the Taiten Exhibition has led many painters to study his work and follow suit. He participated in the co-founding of Sendan Sha and Liu Yan Hui in order to research and promote Nihonga (Japanese painting). In 1931, he traveled to Japan to study. There he began to deconstruct compositions and use ink painting techniques to pursue a simple and easy-to-read effect in an image. In 1940, in *Farmhouse Morning* the image was outlined with simple brushstrokes, painted in decorative and popular flat colors. After the war in 1946, he organized the provincial exhibition with Yang San-Lang. In 1954, he traveled to Japan, where he held a solo exhibition, and returned to painting in the Nihonga style once again, depicting still life and landscapes using a heavy color technique. In 1964, with assistance from Gobara Koto, Kuo moved to Japan and later to the United States, continuing his life of travel, painting, and exhibiting.

李石樵
LI SHIH-CHIAO
1908-1995

出生於臺北泰山，1923年入臺北師範學校，1927年入選首回臺展。隔年赴日，由陳植棋介紹向吉村芳松學習，三年後考取東京美術學校西洋畫科，師事岡田三郎助。1933年以《林本源庭園》首次入選帝展，1936年畢業後留在東京繼續創作，並往返臺中為仕紳、地主製作肖像畫；同年二百號鉅作《楊肇嘉氏家族》入選帝展，取得在臺灣藝文界的崇高地位。此後多以女性圖像為主題參加官展，1943年獲得新文展無鑑查資格。戰爭末期定居臺中，1946年遷居臺北。戰後發表《市場口》（1946）、《建設》（1947）、《田家樂》（1949）等大作反映現實社會問題。其後畫風轉向立體主義表現手法，更深入追求多色彩的平衡與空間結構分析。1963年始任教師大。1992年李石樵美術館開幕。

Li Shih-Chiao was born in Taishan District, Taipei. In 1923, Li entered the Taipei Normal School, and in 1927 he was selected for the first Taiwan Fine Arts Exhibition (Taiten). The following year, Li traveled to Japan and, through the introduction of Chen Chih-Chi, he studied under Yoshimura Yoshimatsu. Three years later, Li passed the entrance examination for the Western Painting Department at the Tokyo Fine Arts School, studying under Okada Saburosuke. In 1933, Li's work *Garden of Lin Ben-Yuan* was selected for the Imperial Art Exhibition (Teiten) for the first time. In 1936, he remained in Tokyo after graduating. During this period Li traveled between Taiwan and Japan to paint portraits for wealthy and influential families. In the same year, his large scale masterpiece, *The Family of Yang Zhaojia*, was selected for the Teiten exhibition, and Li became a celebrated figure in the Taiwanese art scene. From then, Li often participated in official exhibitions with female figures as his theme. In 1943, Li received selection exemption status for the Ministry of Education Art Exhibition (Shin Bunten). Toward the end of the war, Li moved to Taichung, and in 1946 he moved to Taipei. After the war, he unveiled the works *Market* (1946), *Construction* (1947), *Harvest* (1949), and other important works that reflected on social issues. After this period, Li's painting style shifted toward cubism, with the in-depth pursuit of color balance and spatial structural analysis. In 1963, Li began teaching at National Taiwan Normal University. In 1992, the Li Shih-Chiao Art Gallery was opened.

張萬傳
CHANG WAN-CHUAN
1909-2003

出生於淡水，1929年入臺灣繪畫研究所向石川欽一郎習畫，結識洪瑞麟、陳德旺。1931年考取東京帝國美術學校西洋畫科，因興趣不合退學，改至川端畫學校進修。遊學時受鹽月桃甫及旅法畫家的影響，偏好帶有個人主義色彩的野獸派、巴黎畫派風格。1936年加入臺陽美術協會，後與畫友另立「MOUVE洋畫集團」，主張自由研究。因老家位於廈門而與當地畫壇連結，曾和呂基正等人組織「青天畫會」，亦受林克恭之邀任教廈門美專，此時也以描繪鼓浪嶼的風景畫屢次入選府展。戰後任教臺北大同中學、國立藝專等校。1950年代曾二度加入臺陽美協、組織「紀元美術會」，往後遠離主流畫壇，成為代表性的在野畫家。其創作不以參展為目的，重視主觀形體與色彩的表達，用色筆觸皆奔放而情感強烈。出生地淡水、餐桌魚蝦等日常生活景物，皆是其熱愛的主題。退休後旅居歐美等地寫生，以九十五歲高齡辭世。

Chang Wan-Chuan was born in Tamsui. In 1929, Chang attended the Taiwan Institute of Painting, where he studied painting with Ishikawa Kinichiro and met Hung Rui-Lin and Chen Te-Wang. In 1931, he passed the entrance examination and entered the Western Painting Department at Teikoku Art School in Tokyo, but dropped out due to a difference in interest, and transferred to the Kawabata Painting School. He was influenced by Shiotsuki Toho and other French-educated artists, preferring Fauvism and the School of Paris' painting styles. In 1936, Chang joined the Tai-Yang Art Association and later founded the "MOUVE Artists' Society" with other artists. Since his hometown was in Xiamen, Chang connected with the local painting circle, and with Lu Chi-Cheng and others founded the "Qingtian Painting Society". He also received an invitation from Lin Ko-Kung to teach at Xiamen Art College. During this period, his landscape paintings depicting scenes from Gulangyu Island were repeatedly selected for the Taiwan Governor-General's Office Art Exhibition (Futen). After the war, he taught at Taipei Datong High School, National Taiwan University of Arts, and other schools. In 1950s, he joined Tai-Yang Art Association for the second time, founded the "Era Art Association", moved away from the mainstream painting scenes, and became a representative figure of those who opposed them. His works were not created to participate in exhibitions. Instead, with his dynamic and emotional use of color and brush strokes, he focused on expressing the forms and color of the subject. Growing up in Tamsui, fish and shrimps found on the dining table, and other everyday objects and scenes, were all themes he enjoyed. After retirement, Chang traveled and painted around Europe and the United States. Chang died at the grand old age of 95.

陳德旺
CHEN TE-WANG
1910-1984

臺北人，臺北第一中學畢業後師從石川欽一郎，進入臺灣繪畫研究所。1929年赴日習畫，受日本畫壇1930年代新興美術團體「獨立美術協會」精神影響，未進入正規美術學校。旅日十幾年間，因家境殷實得以自由地拜師學藝，曾於川端畫學校、本鄉繪畫研究所學習，也師從二科會名家熊谷守一、安井曾太郎等，並入吉村芳松畫塾。作品多次入選臺、府展，1936年與張萬傳、洪瑞麟一同加入臺陽美術協會，不久退出，另組標榜自由研究與創作的「MOUVE洋畫集團」。1941年返臺定居。戰後與畫友再組「紀元美術會」，於臺北大同中學任教直至退休。陳德旺埋首鑽研繪畫原理，甚少舉行畫展。他習慣在單純的主題中反覆實驗色彩與形體的調和法則，因而創作出一系列色調清新，具有和諧韻律感及獨特空間感的風景畫、自畫像等。生前留下的研究筆記和訪談在其病逝後，經整理出版為《陳德旺畫談》。

Chen Te-Wang was born in Taipei. After graduating from the No. 1 Taihoku High School, Chen entered the Taiwan Institute of Painting, where he studied under Ishikawa Kinichiro. In 1929, Chen traveled to Japan to study painting, and was influenced by the spirit of the Dokuritsu Fine Arts Society, an up and coming art group in the 1930s. Chen, therefore, did not enter any formal art schools. Coming from an affluent background, Chen was able to freely study from different artists in the ten years he spent in Japan. Chen studied at the Kawabata Painting School, Hongo Painting Institute, and under the tutelage of Nika Association artists Kumagai Morikazu and Yasui Sotaro, and joined the painting school of Yoshimura Yoshimatsu. His works were selected on multiple occasions for the Taiwan Fine Arts Exhibition (Taiten), and Taiwan Governor-General's Office Art Exhibition (Futen). In 1936, together with Chang Wan-Chuan and Hung Rui-Lin, Chen joined the Tai-Yang Art Association. However, they left the association soon after to form the Mouve Artists' Society, which emphasized freedom in research and creativity. In 1941, Chen returned to Taiwan. After the war, he formed the Era Art Association with other artists and taught at Taipei Datong High School until retirement. Chen dedicated himself to researching theories in painting, and rarely participated in exhibitions. He was used to repeatedly experimenting with laws of harmony in color and forms with a simple subject matter. As a result, he created a series of landscapes and self-portraits with refreshing colors, harmonious rhythm, and unique spatial compositions. The notes and interviews left behind during his lifetime were compiled and published in the book *The Art of Chen Te-Wang*.

劉啟祥
LIU CHI-HSIANG
1910-1998

出身臺南府城世家，1923年公學校畢業後即赴東京就讀青山學院中學部、文化學院美術部；除了美術創作，亦有深厚之文學及音樂素養。1931年畢業前後，作品入選日本二科會及臺灣美術展覽會。1932-1935年歐遊期間，長期在羅浮宮臨摹印象派畫家的人物畫鉅作。1933年，以《紅衣少女》入選巴黎秋季沙龍。1937年3月，在東京銀座舉行滯歐作品展，稍後移至臺北教育會館展出；一時被譽為「臺灣畫壇的彗星」。1941年成為臺陽美術協會會員，兩年後成為二科會會友。戰後定居高雄，擔任省展審查委員，深耕南臺灣美術發展，先後組成「劉啟祥美術研究會」、「高雄美術研究會」、「南部畫會」等團體；並致力美術教育，任教東方工專、臺南家專與高雄醫學院。劉啟祥的畫風簡潔沉靜，其所繪女性畫像風采翩翩，溫潤明亮，流露出健康生命的自信；而他筆下的太魯閣與南臺灣風景則是壯闊無垠，瀟脫自在，煥發著真實自然的生命力。

Liu Chi-Hsiang, born in Tainan, came from an affluent family. In 1923, Liu finished his public school education and headed to Japan to study at Aoyama Gakuin middle school and the Art Department of the Bunka Gakuin. In addition to his talent for art, he had a profound literary and musical aptitude. Around the time of his graduation in 1931, his work was selected for the Nika Association Exhibition and the Taiwan Art Exhibition (Taiten). From 1932 to 1935, Liu traveled to Europe, spending a large amount of his time imitating portraits by impressionist painters in the Louvre. In 1933, his work *Girl in Red Dress* was selected for the Salon d'Automne in Paris. In March 1937, he held an exhibition in Ginza, Tokyo, showcasing the works he had painted in Europe; the exhibition was later shown at the Taipei Education Hall. Liu was once called "the shooting star of the Taiwanese art scene". In 1941, he became a member of the Tai-Yang Art Association, and two years later a member of the Nika Association. After the war, he settled in Kaohsiung and served as a member of the Provincial Exhibition selection committee, and was committed to the development of art in southern Taiwan. Liu founded the "Liu Chi-Hsiang Art Research Association", "Kaohsiung Art Research Association", "Southern Painting Association", and other groups. He dedicated himself to art education teaching at Tung Fang Design Institute, Tainan School of Home Economics, and Kaohsiung Medical University. Liu's painting style is simple and quiet. His female portraits are graceful and dynamic, the subjects revealing a sense of confidence and vitality, while his depictions of Taroko and landscapes of southern Taiwan display the magnificent and unrestrained forces of nature.

陳清汾
CHEN CHING-FEN
1910-1987

出生於臺北大稻埕，為日治時期著名茶商—錦記茶行陳天來的四子。太平公學校畢業後，1925年赴日，進入私立美術學校學習，並師事有島生馬。1928年年初與老師有島一同渡歐至巴黎習畫，描繪巴黎凱旋門與近郊的風景畫，旋即於年底入選日本二科會與巴黎秋季沙龍展，自此至1930年代中期，作品屢屢入選日本二科會。1931年經西伯利亞返日後回臺，隔年於總督府舊廳舍舉辦滯歐作品展，1933年起參加臺、府展並多次獲得特選。

陳清汾也經常為美術界奔走，1929年曾聲援臺灣畫家創立西洋畫團體「赤島社」，1934年參與創立「臺陽美術協會」，參加展覽。常於北投別墅招待畫友，也曾做為臺灣人畫家代表與總督府文教局等官方單位溝通。經中日戰爭至第二次世界大戰後，陳清汾接手家業，漸少創作，擔任茶業公會理事長、臺灣省政府委員、泰北中學董事長等職。

Chen Ching-fen was born in Dadaocheng, Taipei, and was the fourth child of Chen Tian-Lai, owner of the Jinji Tea Company and a prominent tea merchant during the Japanese colonial period. After graduating from Taiping Public School, Chen went on to study in Japan at a private art school under Arishima Ikuma. At the beginning of 1928, Chen traveled with Arishima to paint in Paris, depicting the Arc de Triomphe and the landscapes in the suburbs of Paris. By the end of the year, Chen was immediately selected for the Nika Association and Salon d'Automne Exhibition. From then until the mid-1930s, his works were repeatedly selected for the Nika Association exhibitions. In 1931, he returned to Japan via Siberia, and then back to Taiwan. In the following year, Chen held an exhibition of the works he had created in Europe at the Governor-General's old building. From 1933 onward, he participated and won prizes regularly at the Taiwan Fine Arts Exhibition (Taiten) and Taiwan Governor-General's Office Art Exhibition (Futen).

Chen often assisted in the art scene through various methods. In 1929, he voiced his support for Taiwanese artists to form the Western painting group Chidao (Red Island) Group. In 1934, he participated in co-founding the Tai-Yang Art Association and participated in exhibitions. He often entertained painters at his estate in Beitou, and also acted as a representative for Taiwanese painters to communicate with officials such as the Culture and Education Department of the Governor-General's Office. After the Sino-Japanese War and the Second World War, Chen took over the family business, spending less time on his artistic practice. He served as the chairman of the Tea Association, a council member of the Taiwan Provincial Government, and the chairman of Taibei High School, among other roles.

陳敬輝
CHEN JING-HUI
1911-1968

生於新北市新店，傳教士郭水龍六子。強褓中即過繼給舅父陳清義牧師與偕瑪連夫婦為養子，因此成為馬偕的外孫。自幼被送往日本京都，寄養在中村先生家，及長與其女春子結為連理。從小對美術興趣濃厚，陸續就讀京都市立美術工藝學校、京都市立繪畫專門學校，接受學院完整的日本畫訓練。1932年學成返鄉，任教淡水高女及淡江中學，直到戰後1968年過世為止。他一生奉獻美術教育，啟蒙許多學生走向藝術創作道路，如徐藍松、吳炫三。自1930年入選臺展後，一直是臺、府展的常勝軍，畫作主要描繪學生活動、淡水風土民情，呈現清新秀麗與淡雅的風格。戰後擔任省展審查員，持續提出作品展出，也參加臺陽展。作品或融入水墨韻味或西畫技法，也參與淡江中學大禮堂外觀設計及禮堂內兩幅壁畫的繪製。

Chen Jing-Hui, born in Xindian, New Taipei City, was the sixth son of the missionary Kuo Shui-Long. While still an infant, he was entrusted to his uncle, Reverend Tan Cheng Gi, and his wife, Mary Ellen Mackay, as their adopted son, becoming the grandson of Canadian missionary George Leslie Mackay. Chen was sent to Kyoto, Japan, and grew up in the Nakamura family's house and married their daughter, Haruko. Chen was interested in art since childhood and went on to study at the Kyoto School of Arts and Crafts and the Kyoto City Technical School of Painting, where he received the complete Nihonga (Japanese painting) training. In 1932, he finished his studies and returned to his hometown, where he taught at the Tamsui Girl's High School and Tamkang Senior High School until his death after the war in 1968. He dedicated his life to art education and inspired many of his students, such as Hsu Ran-Sung, and Wu Syuan-San, to follow the path of artistic practice. From 1930, when Chen was first selected for the Taiwan Fine Arts Exhibition (Taiten), he became a frequent exhibitor in the Taiten and Taiwan Governor-General's Office Art Exhibition (Futen). His paintings mainly depict student activities and the lifestyles of Tamsui in an invigorating yet elegant style. After the war, Chen served as a selection committee member for the Provincial Exhibitions, continued to submit his own works for exhibitions, and participated in Tai-Yang Art Exhibitions. His works may incorporate ink wash or western painting techniques. He also participated in the exterior design and painting of two murals inside Tamkang Senior High School's auditorium.

洪瑞麟
HUNG RUI-LIN
1912-1996

張義雄
CHANG YI-
HSIUNG
1914-2016

臺北大稻埕人，父親擅傳統書畫。幼時就讀稻垣藤兵衛創設的稻江義塾，受其人道主義精神啟發，影響日後的創作之路。1929年入臺灣繪畫研究所隨石川欽一郎習畫，隔年赴日進修即以《微光》入選臺展。1931年入東京帝國美術學校西洋畫科，師事海老原喜之助、清水多嘉示。留學期間傾心普羅美術運動而謳歌勞動者，作品曾多次入選春陽會、臺展等，畢業後停留日本近兩年繪寫雪地農民。1936年入臺陽美術協會，1938年另與張萬傳、陳德旺等組織「MOUVE洋畫集團」，同年至瑞芳煤礦任職，開啟三十餘年紀錄礦工的繪畫生涯。礦坑的限制使其作品多以水墨、淡彩速寫而成，卻能捕捉勞動者在黑暗中最真實的生命光輝，世人譽為「礦工畫家」。1954年與畫友組織「紀元美術會」，1964年應李梅樹邀請至國立藝專指導素描。晚年定居洛杉磯，繪畫主題轉向明亮的陽光與雲海，畢生創作及手稿於2020年由後代捐贈回臺。

成長於嘉義書香門第，幼時仰慕陳澄波而向其學習油畫。1932年入東京帝國美術學校，因生計困難休學後輾轉於關西美術院、東京川端畫學校等處進修。1940年與畫友組織嘉義「青辰美術協會」。1944年赴北京工作，戰後返臺。1950年代斬獲多項美展大獎，獲得省展免審查資格。其後短暫任教於臺灣師範學院、國立藝專等校，最終因與主流畫壇不合，轉而經營鳥店及私人畫室維生，但仍參與青雲畫會、紀元美術會活動。1964年移居東京，1980年起定居巴黎，成為首位獲得法國藝術家年金及入會法國秋季沙龍的臺灣畫家。張義雄的一生流浪漂泊，使其作品多聚焦於日常生活的況味，以風景和靜物畫為主，亦有小丑等主題獨特的人像作品，猶如畫家孤寂心境的投射與自語。早期創作多使用粗重的黑色線條，旅居巴黎後畫風轉趨明亮。晚年再度返日居住，享壽一〇二歲。

Hung Rui-Lin was born in Dadaocheng. Hung's father was skilled at traditional calligraphy and painting. Hung studied at the Daojiang School established by Inagaki Tobei for poor children, where he was inspired by its humanitarian spirit - something which influenced his future creative path. In 1929, Hung entered the Taiwan Institute of Painting, where he learned to paint with Ishikawa Kinichiro. The following year, he traveled to Japan to study and was selected for the Taiwan Fine Arts Exhibition (Taiten) with the work *Glimmer*. In 1931, he studied at the Western Painting Department of Teikoku Art School in Tokyo, with Ebihara Kinosuke and Shimizu Takashi as his teachers. During his time studying overseas he followed the Proletarian Art Movement and praised manual workers. His works were selected on multiple occasions for the Shunyo-kai and Taiten exhibitions. After graduation, Hung stayed in Japan for a further two more years to paint farmers in the snow. In 1936, Hung joined the Tai-Yang Art Association, and in 1938 he co-founded the Mouve Artists' Society with Chang Wan-Chuan, Chen Te-Wang, and other artists. In the same year, he began working in the Rui Fang coal mines, beginning a career painting miners that lasted for over thirty years. Limitations on working in mines meant most of Hung's works were quick sketches made with ink and light colors, but this allowed him to accurately capture the essences of life that shone in the dark mines. The world knows him as the "miner painter". In 1954, he co-founded the Era Art Association with other artists, and, in 1964, he was invited by Li Mei-Shu to teach drawing at the National Taiwan University of Arts. He moved to Los Angeles in his later years, and the theme of his paintings became bright sunshine and a sea of clouds. In 2020, a life-long collection of paintings and sketches by Hung was donated back to Taiwan by his children.

Chang Yi-Hsiung, born in Chiayi, grew up in a family of scholars. As a child he admired Chen Cheng-Po and studied with him. In 1932, he entered the Teikoku Art School in Tokyo, but dropped out due to financial difficulties and later attended the Kansai Bijutsu-in (Kansai Arts Institute), Kawabata Painting School, and other schools. In 1940, Chang co-founded the Chiayi "Qing-Chen Art Association" with other artists. In 1944, he traveled to work in Beijing, but returned to Taiwan after the end of the war. In the 1950s, Chang won several awards at exhibitions and received selection exemption status for the Provincial Fine Art Exhibition. After this, he briefly taught at Taiwan Normal University, National Taiwan University of Arts, and other schools. He eventually left these positions because of disagreements with the mainstream art circles, and opened a bird store and taught painting privately to make a living. Despite this, Chang still participated in the Blue Cloud Fine Arts Association and Era Art Association activities. In 1964, Chang moved to Tokyo, and in 1980 he relocated to Paris. He became the first Taiwanese painter to receive a French artist's pension, and became a member of the Salon d'Automne in France. Chang lived a nomadic and wandering life, which resulted in many of his paintings focusing on subjects in his everyday life, with the majority being landscapes and still life paintings, with some figurative works and some with clowns as the subject - almost like a projection and monologue on the artist's solitary state of mind. Chang's early works were often outlined with thick black lines, but after moving to Paris his colors shifted to a brighter pallet. He returned to live in Japan again in his later years where he died at the age of 102.

呂基正
LU CHI-CHENG
1914-1990

出生於臺北大稻埕商家,初名許聲基,戰後改名基正。早年於廈門旭瀛書院、廈門繪畫學院師從王逸雲。1931年赴神戶打工習畫,1935年再赴東京,先後於今井朝路創設的神港洋畫研究所,東京的獨立美術研究所、クロッキー(速寫)研究所等畫塾磨練繪畫技巧。除了參與日本獨立協會畫展,接觸藝術大眾化的理念外,也師事「獨立美術協會」的林重義、伊藤廉,展現不同於其它留日畫家的學習路徑。作品曾多次入選全關西洋畫展、兵庫縣美展及臺展等。1937年與畫友組織「青天畫會」、「MOUVE洋畫集團」。戰後定居臺北,長年任職省立博物館,並參與省展、臺陽展。他全心投入美術推廣工作,於1948年創辦戰後第一個民間畫會「青雲美術會」,展出長達四十屆,規模與影響力僅次於臺陽美協。戰前以人體、女性像為主,戰後熱衷推廣登山寫生,能精準地捕捉並呈現臺灣山脈宏偉的氣魄與精神性內涵,為臺灣山岳繪畫的代表性畫家。1990年病逝臺北。

Lu Chi-Cheng was born into a merchant family in Dadaocheng. Lu was originally named Hsu Shen-Chi, but he changed his name to Chi-Cheng after the war. In Lu's early years he attended the Xuying College in Xiamen and the Xiamen Painting College, where he studied with his teacher Wang Yi-Yun. In 1931, he traveled to Kobe where he worked and studied painting simultaneously, and then to Tokyo in 1935, where he studied at Imai Asaji's Shinko Western Painting Institute, the Tokyo Independent Art Institute, Croquis Institute, and other painting schools to refine his painting skills. In addition to participating in exhibitions held by the Nippon Independent Kyokai, he also studied with Hayashi Shigeyoshi and Ito Ren from the Independent Art Association, taking on a different education path to other Japan educated Taiwanese painters. His works were selected on multiple occasions for, among others, the Kansai Area Western Painting Exhibition, Hyogo Prefecture Art Exhibition, and Taiwan Fine Arts Exhibition (Taiten). With other artists he co-founded the "Qingtian Painting Society" and "Mouve Artists' Society" in 1937. After the war, Lu settled in Taipei and worked for many years at the National Taiwan Museum while also continuing to participate in the Provincial Fine Art Exhibitions and Tai-Yang Art Exhibitions. Lu devoted all his efforts to promoting art, and he participated in the first postwar civilian art group, the "Qing Yun Fine Art Association", showcasing at forty of its annual exhibitions. The group's influence was second only to the Tai-Yang Art Association. Prior to the war, he focused on figurative paintings and female portraits, but after the war he was passionate about the promotion of mountaineering and plein air painting. Lu accurately captured the magnificent presence and spiritual essences of Taiwan's mountains, and he was considered to be a prominent figure of Taiwanese mountain landscape paintings. In 1990, Lu died from illness in Taipei.

鄭世璠
CHENG SHIH-FAN
1915-2006

新竹人,小學時受李澤藩啟蒙美術。就讀臺北第二師範學校時,追隨教師石川欽一郎、小原整習畫。1936年返鄉任教。日文與漢文造詣俱佳,1942年遂轉任《臺灣日日新報》記者。畫筆仍與文筆並重,不僅全勤出品臺陽展,更以《後街》、《麗日》等作入選五屆府展。戰後短暫發行《新新》月刊雜誌。1948年任職彰化銀行,擔任研究員三十餘年。工作之餘熱心創作,以省展、臺陽展和青雲美展為主要舞臺。作品多為都會風景畫,風格求變,1960年代起嘗試抽象主題,晚年發展噴彩技法。1975年與北師校友創立「芳蘭美術會」。1980年退休後持續創作參展,以畫會友。

Cheng Shih-Fan was born in Hsinchu. His interest in art was inspired by Lee Tze-Fan while he was in elementary school. During his time at the Taipei Second Normal School, he studied under Ishikawa Kinichiro and Ohara Hitoshi. In 1936, he returned to teach in his hometown. Eloquent in both Japanese and Chinese, Cheng worked as a reporter at the *Taiwan Nichi Nichi Shimpo* in 1942. While he produced articles with his pen, he was working on paintings with his brush. Not only did he participate at every edition of the Tai-Yang Art Exhibitions, but his works *Back Street* and *A Fine Day* were selected for the fifth Taiwan Governor-General's Office Art Exhibition (Futen). After the war, he briefly published the *Xin Xin* monthly magazine. In 1948, Cheng began working at the Chang Hwa Bank as a researcher, a position he kept for over 30 years. Aside from his day job, he kept painting enthusiastically, showcasing his works at Provincial Fine Art Exhibitions, the Tai-Yang Art Exhibition, and Qing Yun Art Exhibitions. His works mainly consist of landscape paintings, varying in style. From the 1960s, Cheng began to experiment with abstract subjects, and in his later years he developed the spraying technique. In 1975, Cheng co-founded the "Fang Lan Art Society" with other alumni from the Normal School. In 1980, after retirement, Cheng continued his painting practice and participated in exhibitions, meeting new friends through painting.

林之助
LIN CHIH-CHU
1917-2008

出生於臺中大雅富紳家庭，幼時赴東京求學，1934年入東京帝國美術學校日本畫科，畢業後師事兒玉希望，以《朝涼》（1940）入選「紀元二千六百年奉祝展」，《母子》、《好日》蟬聯第五、六屆府展特選第一名。戰後全心投入美術教育，持續參與省展、臺陽美展。1945年遷居臺中市後受聘於臺中師範學校直至退休，1954年創設「臺灣中部美術協會」，成為中臺灣畫壇的領導人物，同時投入美術教科書設計與咖啡廳經營，實踐藝術大眾化、生活化的理念。1977年提出「膠彩畫」名稱取代「東洋畫」，解決戰後臺灣畫壇圍繞「國畫」定義的紛擾，並於1981年創立「臺灣省膠彩畫協會」，隨後於東海大學首開膠彩畫課程，對臺灣膠彩畫的發展具有不可磨滅的貢獻。早期以人物畫為代表，後期多以生活周遭的花鳥風景入畫，作品皆提煉於寫生與嚴謹的構思，力求最精純的造型與賦彩，畫面純淨優雅且布局獨到，自成一家。1988年起旅居美國，定期返臺參與美術活動。

Lin Chih-Chu was born into an affluent family in Taya, Taichung, and studied in Tokyo from an early age. In 1934, he entered the Department of Japanese Painting at the Teikoku Art School, and after graduation he studied under the tutelage of Kodama Kibo. His work, *Bathing in the Morning* (1940), was selected for the "2600th Kōki Anniversary Art Exhibition", and the works *Mother and Child* and *Nice Day* were awarded first prize at the fifth and sixth Taiwan Governor-General's Office Art Exhibitions (Futen). After the war, Lin devoted himself to art education and simultaneously continued to participate in the Provincial Fine Art Exhibitions and Tai-Yang Art Exhibitions. In 1945, Lin moved to Taichung City where he taught at Taichung Normal School, a post he held until his retirement. In 1954, Lin founded the "Central Taiwan Fine Arts Association" and became a leading figure in the painting circle of central Taiwan. At the same time, he edited art textbooks and managed a coffee shop, putting into practice the concept of introducing art to the majority and into people's daily lives. In 1977, he proposed to replace the term "Toyoga" with "Gouache Painting", and, in doing so, Lin cleared the turmoil surrounding the postwar definition of "National Painting" that had troubled the Taiwanese painting circle. In 1981, he founded the "Taiwan Gouache Painting Association", and then founded the first gouache painting course at Tunghai University, delivering unquestionable contributions toward the development of gouache painting in Taiwan. In his early practices, Lin was known for his figurative paintings, but in his later periods, various scenes of everyday life, flowers, and birds made their way into his paintings. Lin's works were developed through a process of detailed studies from life. He strived for the purest form and color, resulting in an image that is simple and elegant, with a unique composition - becoming a style of his own. From 1988, Lin lived in the United States, returning to Taiwan regularly to participate in art activities.

廖德政
LIAO TE-CHENG
1920-2015

出生臺中豐原仕紳望族，父親進平為臺灣民主運動人士。臺中一中畢業後赴日，1940年考取東京美術學校西洋畫科，先後入南薰造、安井曾太郎門下。終戰後任教臺北師範學校。1947年父親於二二八事變蒙難失蹤；遂於隔年辭職，1949年轉任開南商工。戰後初期參與省展、青雲美展，以《花卉試作》、《清秋》先後獲省展特選。1954年後專注於「紀元畫會」同仁活動。1960年代兼任實踐家專、國立藝專。他以長時間構思創作，經常反覆實驗來表現臺灣風景裡的溼度與綠色。1970年代遷居天母後風格逐漸確立，以窗邊靜物及觀音山風景為兩個代表性題材。1989年退休。晚年曾任二二八基金會董事。

Liao Te-Cheng was born in Feng-Yuan, Taichung. Liao came from a distinguished and noble family, and his father was a Taiwanese democracy activist. After graduating from Taichung First Senior High School, Liao traveled to Japan. In 1940, he passed the entrance examination for the Western Painting Department at the Tokyo Fine Arts School, where he studied successively under Minami Kunzo and Yasui Sotaro. After the war, Liao started a teaching position at Taipei Normal School. In 1947, his father became a victim of the February 28 Incident and was never found again. The following year he left his position and transferred to teach at Taipei KaiNan High School in 1949. In the first few years after the war, Liao participated in the Provincial Fine Art Exhibitions and Qing Yun Art Exhibitions, winning prizes at the Provincial Fine Art Exhibitions with the works *Flower Practice* and *Autumn*. From 1954 onward, Liao concentrated on "Era Art Association" activities. In the 1960s, he also taught at Shih Chien College of Home Economics and the National Taiwan University of Arts. He spent long periods contemplating his works, and often experimented repeatedly to achieve the humidity and greenness that is present in Taiwanese landscapes. In the 1970s, after moving to Tianmu, his painting style became gradually established. The two representative themes by Liao were still life paintings set by his windows and the view of Guanyin Mountain outside. He retired in 1989, and, in his later years, served on the board of directors of the 228 Memorial Foundation.

蕭如松
HSIAO JU-SUNG
1922-1992

新竹北埔客家人，父親蕭祥安為日治時代第一位臺籍律師。1935年入臺北第一中學受鹽月桃甫啟迪美術，以《太湖之山》入選第五屆臺陽美展。1940年考取臺北第二師範學校，不久轉入新竹師範，曾受有川武夫、李澤藩指導繪畫。畢業後至高雄任教，又隨書道家鄆廷憲習書法。1945年遷返竹東鎮後終生定居於此，先後任教於竹東國小、竹東高中等校，並多次獲頒優良教師獎。創作上刻苦自學，雖少有機會接觸正規美術訓練，卻能在長年自修中開創出獨到的繪畫風格。其水彩畫重視光線的分析處理，及線性、塊面等形式表現，無論人物、風景或靜物畫，都蘊含詩意而沉穩的氛圍，晚年作品更加簡練。1960至1970年代，也曾以別具一格的膠彩畫屢獲省展優選。蕭如松長年參與省展、臺陽美展，並於1954年成為青雲畫會會員。1988年自教職退休，1992年心肌梗塞逝世。

Hsiao Ju-Sung was from Beipu. His father, Hsiao Hsiang An, was the first Taiwanese lawyer during the Japanese colonial period. In 1935, Hsiao entered No. 1 Taihoku High School where he was inspired by Shiotsuki Toho. Hsiao was selected for the fifth Tai-Yang Art Exhibition with the work *Mountain of Taihu*. In 1940, he was accepted into Taipei Second Normal School but transferred to Hsinchu Normal School soon after, where he was taught by Arikawa Takeo and Lee Tze-Fan. After graduation, Hsiao taught in Kaohsiung and studied calligraphy with Yin Te-Chun. In 1945, Hsiao returned to Zhudong township where he resided for the rest of his life, teaching at Zhudong Elementary School and National Chutung Senior High School. He received the Outstanding Teaching Award multiple times. Although he did not have much opportunity to access formal art training, unbeaten by the hardship, he learned by himself and was able to develop a unique painting style through years of self-study. His watercolor paintings focus on analyzing and handling light, and the expression of the lines and shapes he used. There is always a poetic and calming atmosphere present in his works, whether it is his landscapes, still life, or figurative paintings. In his later life, the images became simplified even further. From the 1960s to 1970s, Hsiao also won prizes at multiple Provincial Fine Art Exhibitions with his unique gouache paintings, and participated in the Provincial Fine Art Exhibition and Tai-Yang Art Exhibitions for many years. In 1954, he became a member of the Blue Cloud Fine Arts Association. In 1988, Hsiao retired from teaching, and in 1992 he died from a heart attack.

作品清單
List of Artworks

1.
黃土水 HUANG Tu-Shui
少女 *Bust of a Girl*
1920
大理石雕 Marble
28.0 x 35.0 x H50.0 cm
臺北市太平國小典藏 Collection of Taipei
Municipal Taiping Elementary School

2.
鹽月桃甫 SHIOTSUKI Toho
萌芽 *Budding*
1927
油彩、畫布 Oil on canvas
65.5 x 80.5 cm
私人收藏 Private Collection

3.
石川欽一郎 ISHIKAWA Kinichiro
河畔 *Riverside*
1927
油彩、畫布 Oil on canvas
116.5 x 90.5 cm
阿波羅畫廊收藏 Collection of Apollo Art
Gallery

4.
陳植棋 CHEN Chih-Chi
淡水風景 *Tamsui Landscape*
1925-30
油彩、畫布 Oil on canvas
73.0 x 91.0 cm
家屬收藏 Collection of Artist's Family

5.
陳進 CHEN Chin
三地門社之女 *Women of Sandimen*
1936
膠彩、絹 Gouache on silk
147.7 x 199.9 cm
福岡亞洲美術館典藏 Collection of
Fukuoka Asian Art Museum

6.
林之助 LIN Chih-Chu
好日 *Nice Day*
1943
膠彩、紙 Gouache on paper
165.0 x 135.0 cm
私人收藏 Private Collection

7.
顏水龍 YEN Shui-Long
港風影 *Harbor Winds and Shadows*
1932
油彩、畫布 Oil on canvas
65.0 x 80.0 cm
國立臺灣博物館典藏 Collection of National
Taiwan Museum

8.
顏水龍 YEN Shui-Long
明妮莉小姐 *Mlle Minelli*
1932
油彩、紙板 Oil on paper
35.0 x 27.0 cm
私人收藏 Private Collection

9.
劉啟祥 LIU Chi-Hsiang
有樹幹的景物 *Landscape with Tree
Trunks*
1930
油彩、畫布 Oil on canvas
52.6 x 72.5 cm
家屬收藏 Collection of Artist's Family

10.
立石鐵臣 TATEISHI Tetsuomi
稻村崎 *Inamuragasaki*
1930s
油彩、畫布 Oil on canvas
72.0 x 91.0 cm
寄暢園收藏 Collection of Chi Chang Yuan

11.
李石樵 LI Shih-Chiao
四弟像 *Younger Brother*
1931
油彩、畫布 Oil on canvas
116.5 x 91.0 cm
李石樵美術館收藏 Collection of Li Shih-
Chiao Art Gallery

12.
李澤藩 LEE Tze-Fan
病房 *Hospital Room*
1940
水彩、紙 Watercolor on paper
78.0 x 58.0 cm
李澤藩美術館收藏 Collection of Lee Tze-Fan
Memorial Art Gallery

13.
劉啟祥 LIU Chi-Hsiang
肉店 *Butcher's Shop*
1938
油彩、畫布 Oil on canvas
117.0 x 91.0 cm
家屬收藏 Collection of Artist's Family

14.
顏水龍 YEN Shui-Long
妻子（顏夫人）*Artist's Wife (Mrs. Yen)*
1942
油彩、畫布 Oil on canvas
60.5 x 50.0 cm
家屬收藏 Collection of Artist's Family

15.
何德來 HO Te-Lai
背影 *Rear View (Playing a Three-stringed
Lute)*
1973
油彩、畫布 Oil on canvas
38.0 x 45.0 cm
家屬收藏 Collection of Artist's Family

16.
林之助 LIN Chih-Chu
少女 *Young Lady*
1951
膠彩、紙 Gouache on paper
43.0 x 46.0 cm
私人收藏 Private Collection

17.
呂基正 LU Chi-Cheng
少女小玫 *Little Vivian*
1964
畫布、油彩 Oil on canvas
45.5 x 37.9 cm
私人收藏 Private Collection

18.
陳敬輝 CHEN Jing-Hui
舞者 *Dancer*
1958
膠彩、紙 Gouache on paper
36.7 x 51.7 cm
長流美術館收藏 Collection of Chan Liu Art
Museum

19.
洪瑞麟 HUNG Rui-Lin
等發工資 *Payday*
1959
水墨淡彩、紙 Ink and watercolor on paper
38.0 x 52.5 cm
私人收藏 Private Collection

20.
洪瑞麟 HUNG Rui-Lin
礦工 *Miners*
1956
油彩、木板 Oil on panel
53.0 x 33.0 cm
私人收藏 Private Collection

21.
鹽月桃甫 SHIOTSUKI Toho
刺繡 *Embroidery*
1930s
油彩、三夾板 Oil on plywood
35.0 x 24.0 cm
顏水龍舊藏 Previous Collection of YEN Shui-Long

22.
鮫島台器 SAMEJIMA Taiki
山之男 *Man of Mountains*
1935
銅 Bronze
15.5 x 10.0 x H36.0 cm
台灣50美術館收藏 Collection of Museum 50 of Taiwan

23.
林玉山 LIN Yu-Shan
蘭嶼少女 *Girl on Orchid Island*
1963
彩墨、絹 Ink and color on silk
56.0 x 43.0 cm
私人收藏 Private Collection

24.
藍蔭鼎 LAN Yin-Ding
永樂市場（市場風景）*Yongle Market (Market Scenes)*
1950
彩墨、紙 Ink and color on paper
18.5 x 142.0 cm
台陽畫廊收藏 Collection of Taiyang Gallery

25.
石川欽一郎 ISHIKAWA Kinichiro
驛路初夏（郊野）*Ancient Road in Early Summer (Countryside)*
1930
水彩、絹 Watercolor on silk
62.0 x 77.0 cm
屏東縣政府典藏 Collection of Pingtung County Government

26.
楊三郎 YANG San-Lang
村之入口 *Entrance of a Village*
1929
油彩、畫布 Oil on canvas
60.0 x 73.0 cm
河上洲美術文物收藏 Collection of Heshangzhou Arts & Antiques

27.
陳澄波 CHEN Cheng-Po
東臺灣臨海道路 *East Taiwan Seaside Road*
1930
油彩、畫布 Oil on canvas
69.5 x 130.5 cm
山口縣防府市收藏 Collection of Hofu City, Yamaguchi Prefecture

28.
陳澄波 CHEN Cheng-Po
南郭洋樓 *A Western-style House in Nanguo*
1938
油彩、畫布 Oil on canvas
53.0 x 65.0 cm,
私人收藏 Private Collection

29.
何德來 HO Te-Lai
農村風景（臺灣，新竹）*Countryside Landscape (Hsinchu, Taiwan)*
1933
油彩、畫布 Oil on canvas
61.0 x 50.5 cm
家屬收藏 Collection of Artist's Family

30.
李澤藩 LEE Tze-Fan
新竹國小所見 *Hsinchu Elementary School*
1939
水彩、紙 Watercolor on paper
54.0 x 78.0 cm
李澤藩美術館收藏 Collection of Lee Tze-Fan Memorial Art Gallery

31.
鄭世璠 CHENG Shih-Fan
山村 *Mountain Village*
1941
油彩、畫布 Oil on canvas
50.5 x 65.0 cm
家屬收藏 Collection of Artist's Family

32.
立石鐵臣 TATEISHI Tetsuomi
風景 *Landscape*
c. 1941
油彩、木板 Oil on panel
24.0 x 33.0 cm
鄭世璠舊藏 Previous Collection of CHENG Shih-Fan

33.
郭柏川 KUO Po-Chuan
淡水 *Tamsui*
1953
油彩、紙 Oil on paper
34.1 x 45.0 cm
私人收藏 Private Collection

34.
陳清汾 CHEN Ching-fen
淡水河邊 *Tamsui Riverside*
年代不詳 Year unknown
油彩、畫布 Oil on canvas
52.7 x 65.0 cm
呂雲麟紀念美術館收藏 Collection of the Lu Yun-Lin Memorial Art Museum

35.
張萬傳 CHANG Wan-Chuan
淡水 *Tamsui*
c. 1980
油彩、畫布 Oil on canvas
91.0 x 72.5cm
私人收藏 Private Collection

36.
陳德旺 CHEN Te-Wang
觀音山遠眺 *A Distant View of Guanyin Mountain*
1980
油彩、畫布 Oil on canvas
53.0 x 65.5 cm
南畫廊收藏 Collection of Nan Gallery

作品清單
List of Artworks

37.
廖繼春 LIAO Chi-Chun
野柳 *Yehliu*
1965
油彩、畫布 Oil on canvas
45.5 x 53.0 cm
私人收藏 Private Collection

38.
林克恭 LIN Ko-Kung
風景 *Landscape*
1960s
油彩、木板 Oil on panel
38.0 x 45.0 cm
私人收藏 Private Collection

39.
小原整 OHARA Hitoshi
臺灣農家 *A Farm House in Taiwan*
1967
油彩、畫布 Oil on canvas
45.5 x 53.3 cm
鄭世璠舊藏 Previous Collection of Cheng
Shih-Fan

40.
鄭世璠 CHENG Shih-Fan
西門街大圓環 *Roundabout on Ximen Street*
1961
油彩、木板 Oil on panel
43.0 x 121.0 cm
家屬收藏 Collection of Artist's Family

41.
呂基正 LU Chi-Cheng
雲湧高峰 *Mountain Peaks with Surging Clouds*
1962
油彩、木板 Oil on panel
91.0 x 73.0 cm
國立臺中教育大學典藏 Collection of
National Taichung University of Education

42.
呂基正 LU Chi-Cheng
冰天雪地 *Snowfield*
1976
油彩、畫布 Oil on canvas
91.0 x 116.5 cm
私人收藏 Private Collection

43.
呂基正 LU Chi-Cheng
奇萊雪景 *Snow-covered Qilai*
1982
油彩、畫布 Oil on canvas
80.0 x 116.5 cm
私人收藏 Private Collection

44.
陳植棋 CHEN Chih-Chi
桌上靜物 *Table Top Still Life*
1928
油彩、畫布 Oil on canvas
60.0 x 73.0 cm
家屬收藏 Collection of Artist's Family

45.
李梅樹 LI Mei-Shu
靜物 *Still Life*
1932
油彩、畫布 Oil on canvas
72.0 x 91.0 cm
李梅樹紀念館收藏 Collection of Li Mei-Shu
Memorial Gallery

46.
何德來 HO Te-Lai
冰塊 *Ice Cube*
1933
油彩、木板 Oil on panel
27.2 x 27.2 cm
鄭世璠舊藏 Previous Collection of CHENG
Shih-Fan

47.
何德來 HO Te-Lai
豆腐 *Tofu*
1971
油彩、畫布 Oil on canvas
46.0 x 53.0 cm
家屬收藏 Collection of Artist's Family

48.
張萬傳 CHANG Wan-Chuan
魚・酒・水果・茶 *Fish, Wine, Fruit, Tea*
1981
油彩、畫布 Oil on canvas
45.5 x 53.0 cm
私人收藏 Private Collection

49.
張義雄 CHANG Yi-Hsiung
蘭嶼紀念 *Scenery in Orchid Island*
1978
油彩、畫布 Oil on canvas
80.0 x 116.5 cm
私人收藏 Private Collection

50.
廖德政 LIAO Te-Cheng
紅柿 *Persimmon*
1973-1976
油彩、畫布 Oil on canvas
50.0 x 60.5 cm
南畫廊收藏 Collection of Nan Gallery

51.
蕭如松 HSIAO Ju-Sung
靜物（畫室一角） *Still Life (Studio Corner)*
1966-1970
水彩、紙 Watercolor on paper
65.0 x 91.0 cm
阿波羅畫廊收藏 Collection of Apollo Art
Gallery

52.
鄉原古統 GOBARA Koto
藤花雙鳥 *Two Birds and Wisteria*
1934
膠彩、絹 Gouache on silk
133.7 x 41.6 cm
郭雪湖基金會收藏 Collection of Kuo Hsueh-
Hu Foundation

53.
鄉原古統 GOBARA Koto
春之庭 *Garden of Spring*
1937
彩墨、紙 Ink and color on paper
170.0 x 93.0 cm (x2)
臺北市立美術館典藏 Collection of Taipei Fine
Arts Museum

54.
鄉原古統 GOBARA Koto
夏之庭 *Garden of Summer*
1937
彩墨、紙 Ink and color on paper
170.0 x 93.0 cm (x2)
臺北市立美術館典藏 Collection of Taipei Fine
Arts Museum

55.
木下靜涯 KINOSHITA Seigai
淡水觀音山 *Guanyin Mountain in Tamsui*
1930s
彩墨、紙 Ink and color on paper
113.3 x 36.2 cm
秋惠文庫收藏 Collection of Formosa Vintage Museum

56.
那須雅城 NASU Masaki
新高山之圖 *Nitakayama, the New Highest Mountain*
1930
彩墨、紙 Ink and color on paper
183.5 x 84.0 cm
國立臺灣博物館典藏 Collection of National Taiwan Museum

57.
呂璧松 LU Pi-Sung
赤壁夜遊圖 *A Night Excursion in Chibi*
1920s
水墨、紙 Ink on paper
136.5 x 53.5 cm
寄暢園收藏 Collection of Chi Chang Yuan

58.
林玉山 LIN Yu-Shan
庭茂 *Thriving Garden*
1928
膠彩、紙 Gouache on paper,
144.0 x 88.0 cm
私人收藏 Private Collection

59.
呂鐵州 LU Tieh-Chou
鹿圖 *Deer*
c. 1933
膠彩、紙 Gouache on paper
145.0 x 231.0cm
私人收藏 Private Collection

60.
郭雪湖 KUO Hsueh-Hu
萊園春色 *Spring in the Garden Lai*
1939
膠彩、紙 Gouache on paper
220.5 x 147.0 cm
國立臺灣美術館典藏 Collection of National Taiwan Museum of Fine Arts

61.
郭雪湖 KUO Hsueh-Hu
秋江冷豔 *Over the Cool Autumn Water*
1940
彩墨、紙 Ink and color on paper
152.0 x 225.0 cm
國立臺灣美術館典藏 Collection of National Taiwan Museum of Fine Arts

62.
陳進 CHEN Chin
山中人物 *Figures in Mountains*
1950s
彩墨、紙 Ink and color on paper
44.0 x 51.0 cm
私人收藏 Private Collection

63.
陳敬輝 CHEN Jing-Hui
東海邊色 *Scenery of East Coast*
1957
膠彩、絹 Gouache on silk
54.3 x 76.1 cm
長流美術館收藏 Collection of Chan Liu Art Museum

64.
林之助 LIN Chih-Chu
彩塘幻影 *Illusions by the Pond*
1958
膠彩、紙 Gouache on paper
118.0 x 78.0 cm
國立臺灣美術館典藏 Collection of National Taiwan Museum of Fine Arts

65.
西鄉孤月 SAIGO Kogetsu
臺灣風景 *Landscape in Taiwan*
1912
膠彩、絹 Gouache on silk
42.0 x 118.0 cm
松本市美術館典藏 Collection of Matsumoto City Museum of Art

66.
富田溪仙 TOMITA Keisen
臺灣秋色圖 *Autumn in Taiwan*
1909-1910
彩墨、紙 Ink and color on paper
133.5 x 30.5 cm
寄暢園收藏 Collection of Chi Chang Yuan

67.
河合新藏 Kawai Shinzo
臺灣所見（對幅）*Records of Taiwan (Paired Hanging Scrolls)*
1917
膠彩、絹 Gouache on silk
125.5 x 42.5 (x2) cm
台灣50美術館收藏 Collection of Museum 50 of Taiwan

68.
丸山晚霞 MARUYAMA Banka
臺灣高山花卉圖 *Mountain Flowers in Taiwan*
年代不詳 Year Unknown
彩墨、紙 Ink and color on paper
34.5 x 138.0 cm
寄暢園收藏 Collection of Chi Chang Yuan

69.
小澤秋成 OZAWA Shusei
臺北風景 *Scenery of Taipei*
1931
油彩、畫布 Oil on canvas
65.0 x 91.0 cm
國立臺灣博物館典藏 Collection of National Taiwan Museum

70.
小澤秋成 OZAWA Shusei
高雄風景 *Scenery of Kaohsiung*
1933
油彩、畫布 Oil on canvas
49.0 x 58.5 cm
台灣50美術館收藏 Collection of Museum 50 of Taiwan

71.
山崎省三 YAMAZAKI Shozo
戎克船之朝（ジャンクの朝）*A Junk in the Morning (Untitled)*
1933
油彩、畫布 Oil on canvas
58.5 x 71.5 cm
國立臺灣博物館典藏 Collection of National Taiwan Museum

72.
梅原龍三郎 UMEHARA Ryuzaburo
臺灣少女 *Taiwanese Maiden*
1933
油彩、畫布 Oil on canvas
39.5 x 27.5 cm
寄暢園收藏 Collection of Chi Chang Yuan

73.
藤島武二 FUJISHIMA Takeji
臺灣風景 *Scenery of Taiwan*
1935
油彩、畫布 Oil on canvas
37.6 x 55.5 cm
寄暢園收藏 Collection of Chi Chang Yuan

74.
顏水龍 YEN Shui-Long
熱帶魚 *Tropical Fish*
1973
馬賽克磁磚 Mosaic tiles
220.0 x 300.0 x D10.0 cm
國立臺灣工藝研究發展中心收藏 Collection of National Taiwan Craft Research and Development Institute

感謝誌
ACKNOWLEDGEMENT

中央研究院臺灣史研究所檔案館、小川稔、上山忠男、天本俊明、王福利、王蓓瑜、王騰雲、白雪蘭、江秋瑩、江容甄、安溪遊地、池田壼、何川騰讓、何佳修、何銓選、吳文富、呂玫、呂采芷、呂學偉、李子寧、李文清、李邦釗、李佳玲、李季眉、李宗哲、李宗嶧、李宗嶧、李延年、李依陵、李昀芳、李金爐、李偉仁、李景文、李景光、李慈媛、阮義忠、兒島薰、岡田実、林于昉、林文海、林宗興、林明弘、林俊成、林品佑、林柏亭、林陳秀蓉、林欽賢、林敬忠、林煥盛、林慧珍、邱裕惠、侯禎塘、施惠斌、施黃燁姬、柯輝煌、紀嘉華、倪朝龍、徐昀霖、徐蘊康、張元鳳、張宏如、張郭玉雨、張凱迪、張順易、張新儒、張嘉莉、梁鴻彬、莊士勳、莊永明、許耿修、郭双富、郭江宋、郭松年、郭家冶、郭鴻盛、陳子仁、陳子智、陳志揚、陳孟雪、陳建瑛、陳昭如、陳昭陽、陳國棟、陳婉平、陳敏、陳鄭添瑞、陳懷恩、曾得標、曾雅雲、森純一、黃于玲、黃士奇、黃士珍、黃位政、黃承志、黃明政、黃秋菊、楊永源、葉柏強、葉憲峻、鈴木惠可、歐怡涵、劉俊禎、劉耿一、蔡佩鈴、蔡婷逸、蔡貴煦、鄭安宏、鄭崇熹、鄭琇瑩、蕭成家、蕭美珠、賴麗雲、應廣勤、戴敬晃、簡玲亮、顏千峰、顏美里、羅恩妮、龔玉葉、國立臺灣師範大學文物保存維護研究發展中心（依照姓氏筆畫順序排列）

合作單位
COLLABORATION PARTNER

指導單位 Advisor	文化部 MINISTRY OF CULTURE
主辦 Organizers	MoNTUE 北師美術館　財團法人福祿文化基金會 Fu Lu Culture Foundation
協辦單位 Co-Organizers	山口縣立美術館 Yamaguchi Prefectural Art Museum、台陽畫廊 Taiyang Gallery、台灣50美術館 Museum 50 of Taiwan、呂雲麟紀念美術館 Lu Yun-Lin Memorial Art Museum、李石樵美術館 Li Shih-Chiao Art Gallery、李梅樹紀念館 Li Mei-Shu Memorial Gallery、李澤藩美術館 Lee Tze-Fan Memorial Art Gallery、防府市 Hofu City、松本市美術館 Matsumoto City Museum of Art、河上洲美術文物 Heshangzhou Arts & Antiques、林之助紀念館 Lin, Chi-Chu Memorial、長流美術館 Chan Liu Art Museum、阿波羅畫廊 Apollo Art Gallery、南畫廊 Nan Gallery、屏東縣政府 Pingtung County Government、秋惠文庫 Formosa Vintage Museum、財團法人陳進紀念文化藝術基金會 CHEN Chin Art and Culture Memorial Foundation、國立臺中教育大學 National Taichung University of Education、國立臺灣工藝研究發展中心 National Taiwan Craft Research and Development Institute、國立臺灣美術館 National Taiwan Museum of Fine Arts、國立臺灣博物館 National Taiwan Museum、寄暢園 Chi Chang Yuan、郭雪湖基金會 Kuo Hsueh-Hu Foundation、福岡亞洲美術館 Fukuoka Asian Art Museum、臺北市立太平國小 Taipei Municipal Taiping Elementary School、臺北市立太平國小校友會 Taipei Municipal Taiping Elementary School Alumni Association、臺北市立美術館 Taipei Fine Arts Museum (依單位首字筆畫順序排列)
合作單位 Collaboration Partner	北投文物館 BEITOU MUSEUM 公視
贊助 Sponsor	美術館之友聯誼會 museum friends association
設備支援 Equipment Support	SENNHEISER
媒體協力 Media Cooperation	讀冊生活 taaze.tw　志祺七七　今藝術&投資　非池中 ART EMPEROR　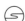
活動協力 Activity Cooperation	或者書店 OR Bookstore

不朽的青春——臺灣美術再發現
The Everlasting Bloom: Rediscovering Taiwanese Modern Art
2020.10.17-2021.01.17

國家圖書館出版品預行編目(CIP)資料

不朽的青春：臺灣美術再發現 = The Everlasting Bloom :
rediscovering Taiwanese modern art / 林曼麗總編輯. --
臺北市：臺北教育大學MoNTUE北師美術館, 2020.10
352面 ; 27.5*20公分
中英對照
ISBN 978-986-98359-7-8(平裝)

1.美術 2.作品集

902.33 109015542

圖錄 Catalogue

總編輯 Chief Editor	林曼麗 LIN Mun-Lee
統籌編輯 Managing Editor	劉建國 LIU Chien-Kuo
執行編輯 Executive Editor	王若璇 WANG Rocean
文字編輯 Editor	張閔俞 CHANG Min-Yu
作者 Writers	顏娟英 YEN Chuan-Ying、蔡家丘 TSAI Chia-Chiu、邱函妮 CHIU Han-Ni、黃琪惠 HUANG Chi-Hui、楊淳嫻 YANG Chun-Hsien、張閔俞 CHANG Min-Yu、呂采芷 Jessica Tsaiji Lyu-Hada、郭懿萱 KUO Yi-Hsuan、鈴木惠可 SUZUKI Eka、柯輝煌 KO Hui-Huang、雷逸婷 LEI Yi-Ting
英文翻譯 English Translator	黃亮融 HUANG Liang-Jung、劉書綺 LIU Shu-Chi
校對 Reviser	張閔俞 CHANG Min-Yu、王若璇 Wang Rocean、王欣翮 WANG Hsinho Elanor、Jasper Heeks、朱安如 CHU An-Ru
圖錄設計 Catalogue Designer	林秦華 LIN Chin-Hua
作品拍攝 Artwork Photographer	林宗興 LIN Tzung-Hsing
印刷 Printed by	富友文化事業有限公司 Fu-Yo Publishing Ltd.
發行日期 First Published in	2020/10
發行單位 Published by	北師美術館 Museum of National Taipei University of Education
	臺北市大安區和平東路二段134號 No. 134, Sec. 2, Heping East Rd., Da'an Dist., Taipei
電話 Tel.	(02) 2732-4084
網址 Website	http://montue.ntue.edu.tw/
ISBN	978-986-98359-7-8
GPN	109015542
售價 Price	NTD$ 950

展覽 Exhibition

總策畫 Producer	林曼麗 LIN Mun-Lee
策展研究團隊 Research and Curatorial Team	顏娟英 YEN Chuan-Ying、蔡家丘 TSAI Chia-Chiu、邱函妮 CHIU Han-Ni、黃琪惠 HUANG Chi-Hui、楊淳嫻 YANG Chun-Hsien、張閔俞 CHANG Min-Yu
執行總監 Executive Director	劉建國 LIU Chien-Kuo
展覽統籌 Exhibition Coordinator	王若璇 WANG Rocean
展覽執行 Exhibition Executor	徐珮琳 HSU Pei-Lin
媒體行銷 Public Relations	王欣翮 WANG Hsinho Elanor
教育推廣 Education and Promotion	王怡心 WANG Yi-Hsin、陳俐臻 CHEN Li-Jen
視覺設計 Visual Design	林秦華 LIN Chin-Hua
展場設計 Exhibition Design	別音設計 Noiz Architects
展場工程 Exhibition Construction	華宮工程有限公司 Hua Gong Engineering Corporation
運輸佈展 Shipping Partner	翔輝運通有限公司 Sunway Express Co., Ltd.
前導短片 Trailer	藝術很有事 Inside the Arts、木漏類比 komorebi
語音導覽 Audio Guide	王楡鈞 WANG Yujin
展場攝影 Photography	黃宏錡 HUANG Hong-Chi
展覽助理 Exhibition Assistants	夏子‧拉里又斯 NATSUKO LARIYOD、陳悅方 CHEN Yue-Fang、陳湘 CHEN Siang、劉彥均 LIU Yen-Chun、鄭凱文 CHENG Kai-Wen、羅友維 LO Yu-Wei、蘇兆翎 SU Chao-Ling
實習生 Interns	邱韻蓁 CHIOU Yun-Chen、呂亞璇 LU Ya-Shiuan、郭冠廷 KUO Kuan-Ting、郭姵瑩 KUO Pei-Ying、葉家妤 YEH Chia-Yu、賴冠羽 LAI Guan-Yu

「不朽的青春——臺灣美術再發現」展覽內容來自財團法人福祿文化基金會支持之「風華再現—重現臺灣現代美術史研究計畫」之研究成果，包含繪畫、雕刻、馬賽克作品圖版，及相關文字、文獻，特此致謝。

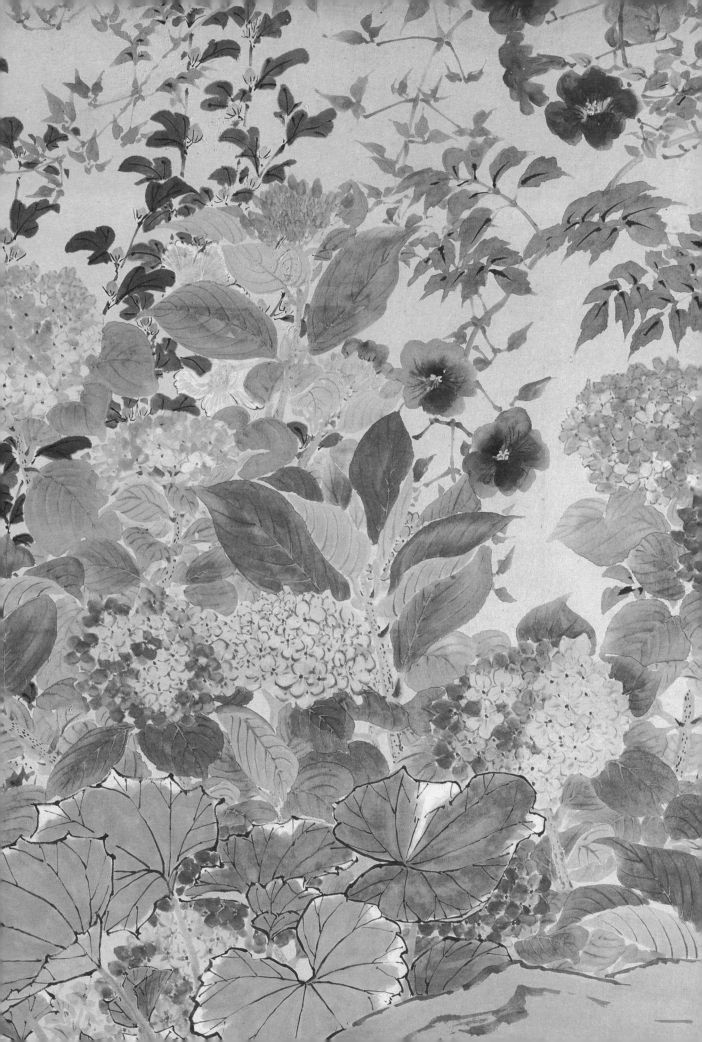

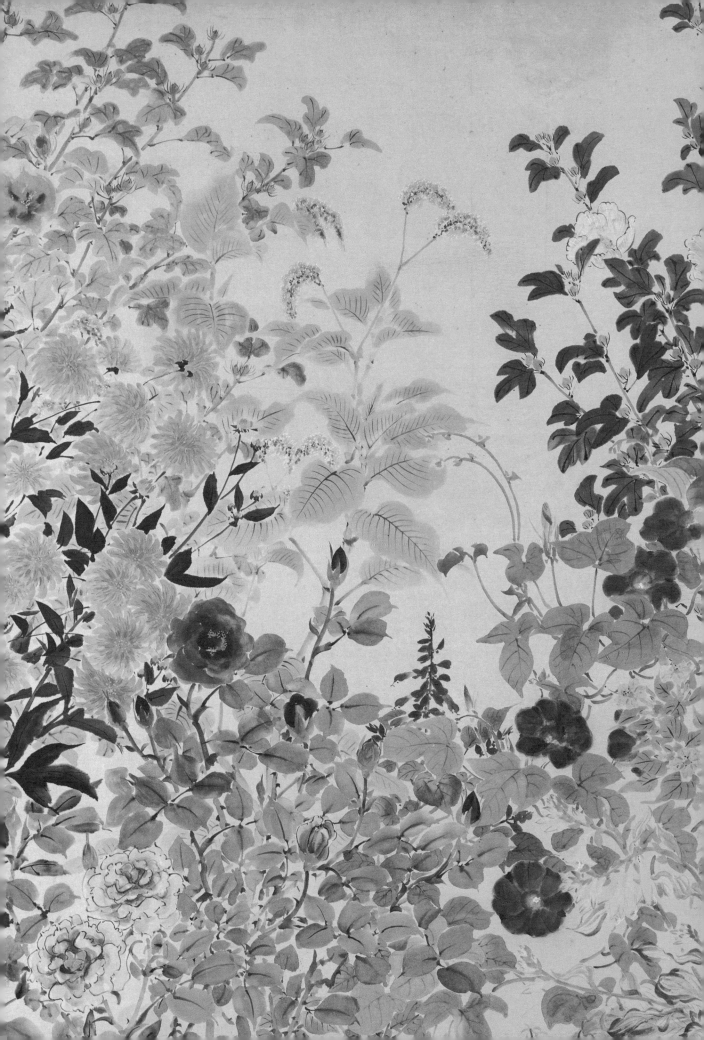